Wisconsin's Own

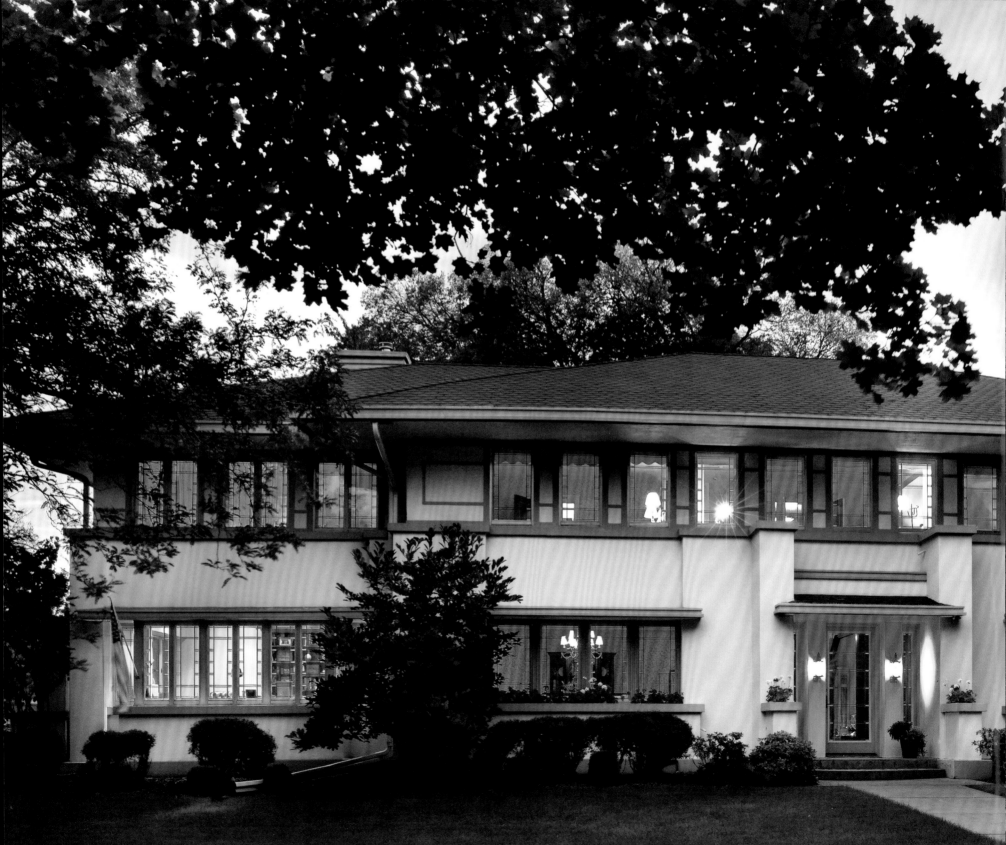

Wisconsin's Own

Twenty Remarkable Homes

M. Caren Connolly & Louis Wasserman

PHOTOGRAPHY BY Zane Williams

ILLUSTRATIONS BY Louis Wasserman & M. Caren Connolly

WITH A FOREWORD BY Ellsworth H. Brown

WISCONSIN HISTORICAL SOCIETY PRESS

Published by the Wisconsin Historical Society Press
Publishers since 1855

wisconsin**history**.org

Printed in the United States of America
Printed on New Page Centura dull milled in Wisconsin Rapids, Wisconsin
Book design by Brian Donahue / bedesign, inc.
Four-color and retouching by Timothy Meegan

14 13 12 11 10 1 2 3 4 5

Library of Congress Cataloging-in-Publication Data

Connolly, M. Caren.
Wisconsin's own: twenty remarkable homes/M. Caren Connolly & Louis Wasserman;
photography by Zane Williams; illustrations by Louis Wasserman & M. Caren Connolly
 p. cm.
Includes bibliographical references and index.
ISBN 978-0-87020-452-4 (hardcover : alk. paper) 1. Historic buildings—Wisconsin. 2. Dwellings—
Wisconsin. 3. Architecture, Domestic—Wisconsin. 4. Historic buildings—Wisconsin—Pictorial works.
5. Dwellings—Wisconsin—Pictorial works. 6. Architecture, Domestic—Wisconsin—Pictorial works.
7. Wisconsin—History, Local. 8. Wisconsin—History, Local—Pictorial works. 9. Wisconsin—Biography.
I. Wasserman, Louis. II. Williams, Zane. III. Title.
F582.C66 2010
977.5—dc22
 2010005588

Publication of this book was made possible by a generous grant from the JEFFRIS FAMILY FOUNDATION in Janesville, Wisconsin, which is dedicated to the preservation of the Midwest's architectural heritage for future generations.

1946–2009

———————————————

In memory of Henry Fuldner, who served on our foundation board for twenty-nine years.
He and his counsel will be deeply missed.

—Tom Jeffris, President, Jeffris Family Foundation

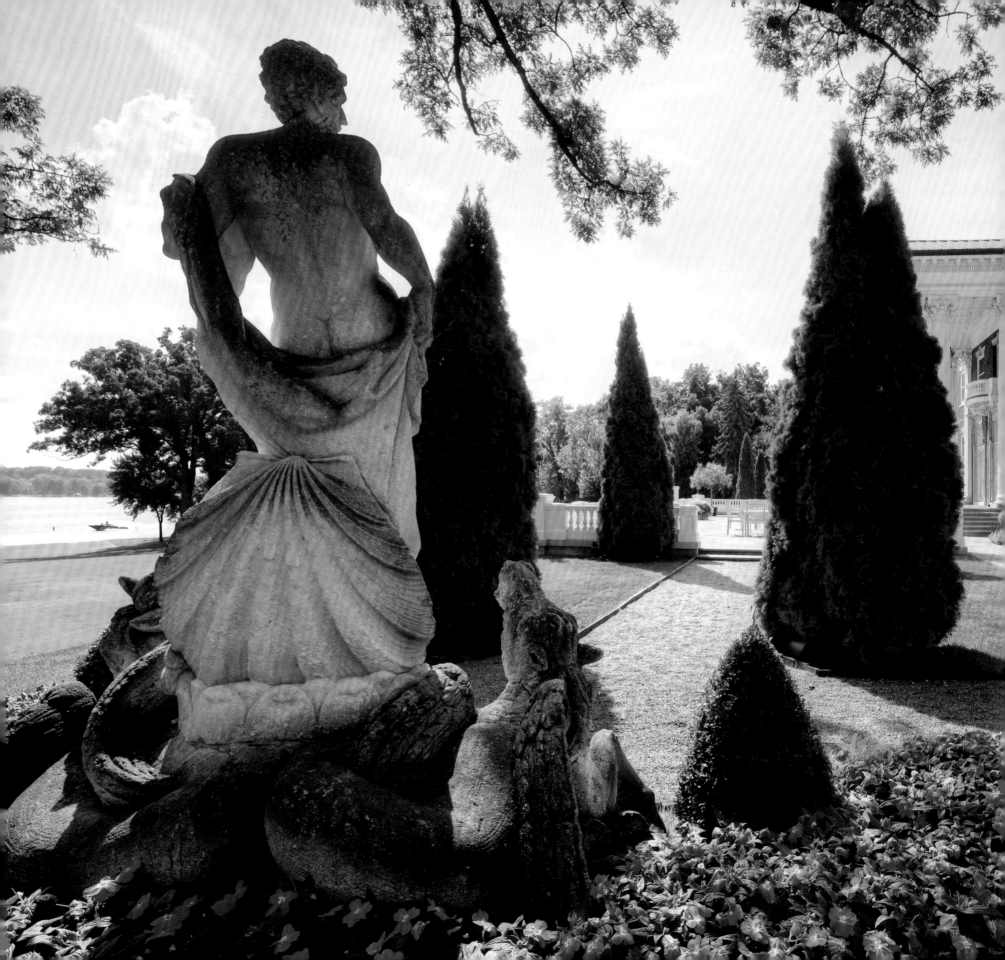

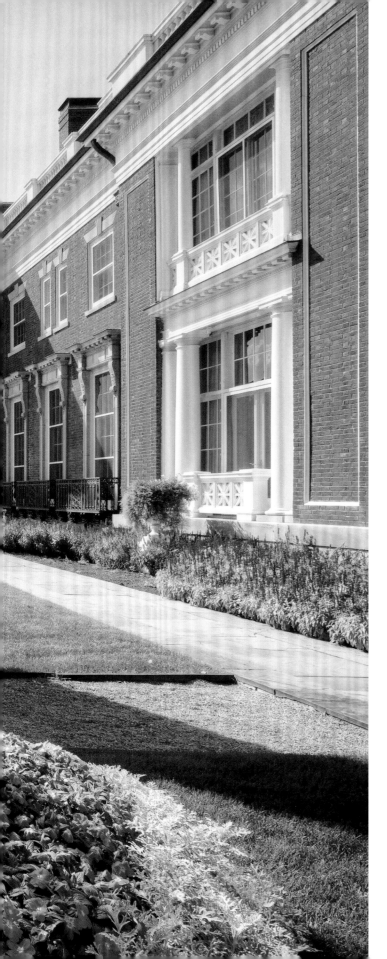

Contents

Foreword

CONSIDER THE DECISIONS that homeowners make in building their dream house. Practical considerations include a suitable site, proper building materials, heating, sanitation, lighting, and a comfortable floor plan. A house, however, is more than a foundation, walls, and a roof. The choices we make are laden with emotional and symbolic meaning whether we make choices or merely follow the current popular trends. Our homes are therefore inextricably tied into their own time and place, making each a cabinet of curiosities—a collection of individual and cultural bric-a-brac that reveal personal preferences, eccentricities, and the social and cultural constraints in which our choices are made. In this sense architecture is an art of the possible, for it brings these many decisions together into three-dimensional forms. Historic architecture allows us the opportunity to step back in time and immerse ourselves in a structured and fabricated environment of the past.

This book collects twenty of Wisconsin's most opulent, spectacular, and original historic houses. By its nature it is neither definitive nor complete; we recognize that we have not included great and worthy houses. However, by focusing on twenty houses, we have time for a lingering analysis of the choices made by homeowners with the economic means to realize their dreams, time to comprehend the inescapable relationship between the people who built these houses and the moment in history that shaped both them and their dwellings. The houses selected help us define Wisconsin and its people, illuminating our character.

Wisconsin is a diverse state. Its geography and natural resources form a varied landscape of limestone outcrops, glacial deposits, sand flats, rivers and lakes, and forests. Many people comprised its population and their descendants continue to enrich our state—Native Americans, Germans, Poles, Norwegians, Finns, and other Europeans, African Americans, Hispanics, and Hmong. This medley of people and landscapes has made Wisconsin a place of ideas where innovation is valued and creativity rewarded. The builders of the houses in *Wisconsin's Own* exemplify this Wisconsin spirit.

Naturally, these homes reflect the owners' ethnic roots, from the Swedish and English designs and furnishings of Ten Chimneys to the Germanic influences seen in the Pabst home. The owners chose to both honor their pasts and use their present to reveal their identities and origins.

The powerful men and women who built these houses were accustomed to thinking ahead, examining trends, and embracing new methods and technology. Educated, well traveled, and exposed to a world of ideas, they were intellectual and creative peers of the architects who gave form to their dreams. One can imagine they welcomed the challenge of the myriad decisions that would shape their homes.

Not surprisingly, the homes in this book reflect the professional ideals of their owners. The home of successful entrepreneur Herbert Fisk Johnson Jr. shows a spirit of innovation and invention. Frank Lloyd Wright's design for Wingspread resonated with Johnson because it mirrored Johnson's adventurous image as a corporate executive who piloted his plane 7,500 miles to Brazil in 1935 to personally see the source of the Carnauba wax that built the company fortune. Likewise, Ten Chimneys' exuberant stage-set interior formed the perfect backdrop for the daily lives of Alfred Lunt and Lynn Fontanne, America's most famous theater couple.

Similarly, capitalists and industrialists used their homes to physically express their business accomplishments. Van Ryn and de Gelleke's design for Cyrus C. Yawkey displayed his success as a lumberman by showcasing the finest available selections of maple, mahogany, walnut, and birch hardwoods in its lavish interior. Industrial designer Brooks Stevens's streamlined Art Moderne home in Fox Point was wrapped in a sleek shroud echoing the smooth lines and gentle curves that his own hand brought to the design of consumer goods.

Husbands and their wives both cared about the designs of these homes, which were symbols of themselves, imbued with cultural values that they wished to project to their friends, neighbors, and community. Victorian notions of women as the heads of their households supported the role of women as tastemakers. Those with educated aesthetic tastes were eager to show their friends and neighbors the height of their sophistication and learning. Charlotte Kohler's artistic training was evident in the design and furnishing of her painterly and picturesque Riverbend estate. Nina Dousman's love of the English Arts & Crafts style inspired her selection of British-born designer Joseph Twyman, whose brilliant redecorating of her home, Villa Louis, would find no peer in the modest community of Prairie du Chien.

Many of the homes in *Wisconsin's Own* are imbued with the spirit of Wisconsin as a place. The bold and rustic log complex of the evocatively named Island of Happy Days reflected the lumber business that Frank D. Stout's father had built into a family fortune, and it also melded perfectly into the forest landscape of northern Wisconsin. The George Mann Niedecken–designed interior of the Mayer house and the bold Prairie School design of the Salzer house are the culmination of a search for a proper aesthetic representation of the sensibilities and culture of the Upper Midwest.

So, what do these exquisite homes from Wisconsin's past mean to us today? Obviously they hold the stories of the influential business people and community leaders who built them and called them home. But perhaps more important, their preservation and renewal are potent and tangible symbols that we are a culture that values our past. The many families, donors, volunteers, and professionals who restored these houses have engaged in an optimistic pursuit, celebrating the past because they believed in their hearts that the past matters and will continue to matter. By renewing these magnificent homes, they connect us to our place and our past by preserving homes of enduring value. For that selfless act, this book celebrates them.

—Ellsworth H. Brown
The Ruth and Hartley Barker Director
Wisconsin Historical Society

Preface

WISCONSIN'S OWN ATTEMPTS TO ANSWER the questions we have all asked when we see a magnificent historic home. Who lived there? What brought them to this place? Why did they pick that style? Who was the architect? What is so special about that old house that it still stands? How did it survive changing trends, modernization, and time when so many other historic homes didn't?

The Wisconsin Historical Society Press contacted us in late 2007 to discuss our interest in writing a book about significant historic Wisconsin residences. We have long had an interest in Wisconsin's small towns and were excited about the possibilities of sharing our insights with a broad audience. After an initial meeting with Tom Jeffris, Jeffris Family Foundation board member and attorney Henry Fuldner, Barbara Fuldner, and staff from the Wisconsin Historical Society and the Wisconsin Historical Society Press, we all agreed there was not another book out there like the one proposed.

Collectively, we formulated criteria for selecting the homes. First, they had to be beautiful—a criterion fraught with challenge because beauty is subjective. Second, we wanted wide geographic representation. Third, the house had to have a good story: the owner, builder, and/or architect's narrative was critical, since residential architecture is as much a study in psychology as it is of architectural principles. Fourth, the group of houses had to represent as many different architectural styles as possible. Fifth, we determined that the time period represented should be between statehood and World War II. And finally, we wanted a mix of public and private residences.

We began our research by pinning up a map of the state in our office and recalling places we had visited as children. Not surprisingly, many of our memories revolved around the diverse beauty of the state. Caren had lived at Camp McCoy, now Fort McCoy, as a teenager; Louis had lived in Sheboygan from age two until college. We returned to make Wisconsin our home in the 1980s and traveled the state as design professionals and for pleasure with our children. Because we had both lived in many other states and countries we had the benefit of looking at Wisconsin as both insiders and outsiders.

Relying on the established criteria, we tackled the Wisconsin National Register of Historic Places and started sticking pins in the map to determine a research itinerary. After the 1,500 possibilities were winnowed down to 151 and then to 72, it was time to meet with our committee again. We papered the walls of a conference room at the Wisconsin Historical Society with images of the 72 candidates. It turned out beauty was not as subjective as we thought; it was one of the most easily agreed-upon criteria. After a productive daylong meeting, we'd gotten the list down to nineteen main contenders, with another twelve to consider. The committee gave us the green light to proceed with in-person research.

In our travels throughout the state during the summer and the fall of 2008, some houses were dropped off the list as other new discoveries took their place. Our scouting photos enabled us to work closely with Madison photographer Zane Williams.

Of the more than twenty books on architectural style in our architectural library, we have relied most heavily on *A Field Guide to American Houses*, by Virginia and Lee McAlester, because it is concise, consistent, and comprehensive.

Aside from the Prairie, organic, and Usonian influences, and the ranch housing types that found their genesis in Wisconsin, residential styles throughout the state and elsewhere are subject to an intensely democratic process of individual interpretation. Discussion of style in *Wisconsin's Own* is merely a starting point to the understanding and appreciation of homes made significant and remarkable by dint of their handsome proportions and elegant use of materials combined in architectural compositions of timeless grace that may or may not be dependent on the translation of or application to any particular style.

Wisconsin's Own features the stories of twenty significant Wisconsin homes arranged not by chronology or architectural style but by distinctive themes—Cornerstones, Vanguard, Rags to Riches, Setting the Stage, and Getaways—that arose as our research evolved. By grouping the homes into thematic portfolios it is our intent that the reader will form a more complete picture of the integration of Wisconsin's social and architectural history as they are both better understood in context than in isolation.

—*M. Caren Connolly & Louis Wasserman*

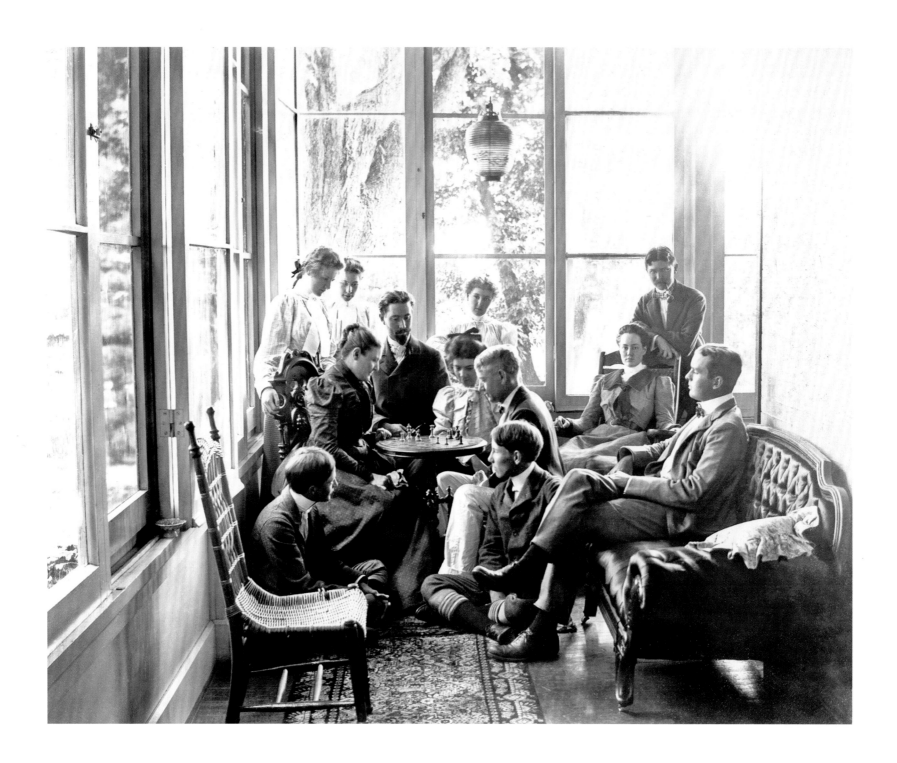

Acknowledgments

THIS BOOK, LIKE THE HOUSES THEMSELVES, could not have existed without the cooperation, participation, and permission of the current owners—whether individuals or institutions. Each of the current owners is as interesting as the original owners. Local historical societies, public and private libraries, descendants of the original owners, and professional and amateur historians have all been a treasure trove of information. We appreciate the cooperation of all the architects who shared historical drawings.

We could not have asked for more professional and knowledgeable partners than the staff at the Wisconsin Historical Society and the Wisconsin Historical Society Press. This book is as much theirs as it is ours. We thank Kathy Borkowski for this opportunity. Special thanks to editorial assistant Mallory Kirby for researching the historical images as well as writing the accompanying captions. The Wisconsin Historical Society acknowledges and thanks Michael Douglass for his contributions to the chapter on Villa Louis. Zane Williams's extraordinary photographs allow the reader to view the houses much as the original occupants would have viewed them. Tom Jeffris was the man with the vision, and his foundation made it all possible. It has been our pleasure to be part of the team that made it a reality.

—M. Caren Connolly & Louis Wasserman

IN PHOTOGRAPHING THE TWENTY SITES for *Wisconsin's Own*, I took the approach of photographing the various rooms, environments, and exteriors much as they would appear to a visitor or guest. This meant avoiding special tricks and devices such as superwide lenses and unusual vantage points for the camera. It meant working with available lighting for the most part and resisting the impulse to light and style these properties as if in preparation for a magazine feature. Ultimately, the views in this book represent the manner in which the owners or stewards of the properties have maintained and furnished them and the way they looked under the lighting conditions present at the time of my visit. That usually meant a combination of natural daylight along with the lighting from tungsten lighting fixtures and lamps found in these interiors. My hope is that visitors and guests to these sites will be able to clearly link the photographs in this book with the actual rooms and views of the homes.

Determining the photographs represented in *Wisconsin's Own* was largely a collaborative effort, with authors Caren Connolly and Louis Wasserman preparing shot lists based on site visits and preparatory research, followed by my efforts to find an appropriate balance between documentation and interpretation. We brought these two points together with the goal of producing photographs that complement the text and provide a fresh view of these notable subjects. Photographing all twenty sites over one set of seasons in 2008–09 presented a challenge. Approximately forty trips covering 6,500 miles were made in just over seven months. A number of sites were successfully photographed in one visit; several required four or five. There was no second chance at the seasons, but, interestingly, most sites were photographed in the season intended.

My deepest gratitude goes to my wife, Mary, for her unwavering support and assistance throughout this book project. Thank you to all the homeowners and site directors who generously opened their doors and allowed us to photograph as our needs and schedules required. Thank you to Kathy Borkowski, Laura Kearney, Elizabeth Boone, and contributing Wisconsin Historical Society Press staff who helped produce this book at a new level of excellence. Thank you to Brian Donahue for helping set this book apart from other books of its type through his keen eye and sensitivity to the subject matter. Thank you to Christopher Guess, whose long hours working to optimize all of the digital photographic images has resulted in faithful representations of the experience of being there. Thank you to Louis Wasserman and Caren Connolly for "opening the doors" to all sites and for their meticulous organization of all shot lists. Thank you to my assistants who provided insight and physical relief on-site: Greg Kebbekus, John Devereux, Greg Anderson, and Drew Cyr. Thanks to Georgene Pomplun, Nancy Warnecke, Gene Seidman, Ana Rodgers, Richard Dieters, Sue Fugate, Steve Agard, Christian Korab, Brian Williams, Jay Stewart, and other friends and colleagues for their contributions, advice, and encouragement. Finally, I am grateful to Tom Jeffris, for his willingness to support this project fully and help us make a truly exemplary book.

—Zane Williams

CORNERSTONES

Wisconsin has a unique geography—smooth hills and ridges, sandstone buttes, rounded hills and narrow valleys, thousands of lakes, large and small, miles of pine-covered sandy plains—one shaped by ice, water, fire, and people.

There were Indian nations living on the land that would become Wisconsin when the early French fur traders first arrived in the 1600s. Settlers from the East Coast and European immigrants from such countries as Germany, Ireland, England, Holland, Switzerland, Norway, and Belgium came in droves to buy cheap land and make homes for their families. Lake Michigan attracted settlements along its western edge. Two major rivers, the Wisconsin and the Fox, frame the state's population distribution, with the vast majority of Wisconsinites living south of the diagonal line between these rivers in the landmass that forms the cornerstone—the foundation—of the state.

Topography, geography, economics, and culture are all building blocks of meaningful architecture, but the interaction between client and architect is essential. The houses in this portfolio were chosen because they exemplify strong clients and architects, as well as the remarkable houses they built. Hercules Louis Dousman II commissioned Milwaukee architect E. Townsend Mix to design his Italianate home overlooking the Mississippi River to the west and the rugged bluffs to the east of Prairie du Chien. Two of America's most formidable architects, Louis Sullivan and Frank Lloyd Wright, built their last great Prairie homes in Madison and Wind Point, respectively. These homes prove that the interaction between client and architect is as critical as the intersection of two walls—or, in the case of John Richards's octagon-shaped house in Watertown, the intersection of eight walls.

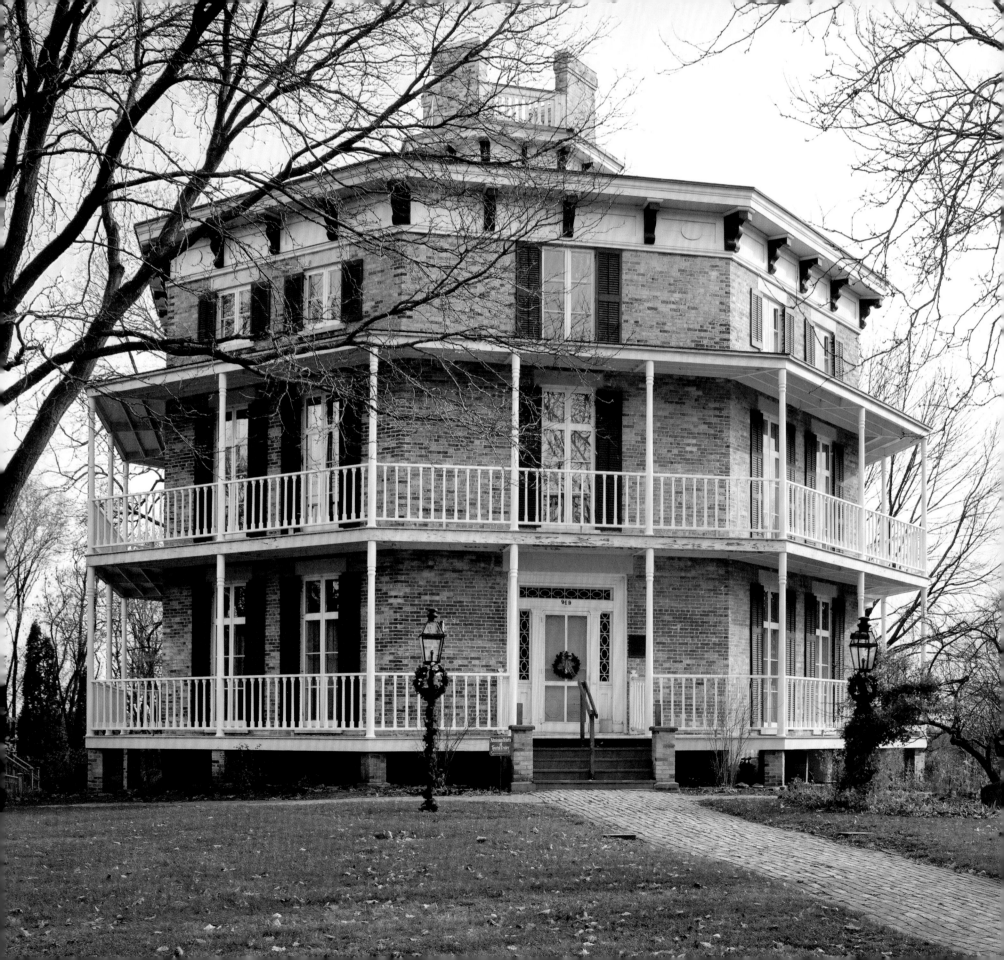

Octagon House

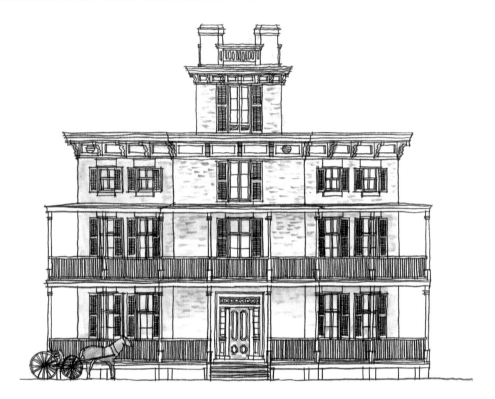

A CENTURY BEFORE FRANK LLOYD WRIGHT'S NAME became synonymous with modern architecture, an entrepreneur by the name of John Richards made a promise to his future bride that he would build her the finest and most modern house in the Wisconsin Territory.

Richards, a Williams College graduate, teacher, and attorney, migrated to this western territory from Massachusetts in the spring of 1837. No known records provide an explanation of why Richards and two friends set out on foot for the remote territory. In particular, one wonders why they chose Watertown. Timothy Johnson, Watertown's first European settler, had established a claim there only one year prior to Richards's arrival. Perhaps the depression of 1837 spurred the trio of young, ambitious, hardworking men to share an adventure in the belief that their prospects would be greater where they were going than where they'd been.

The burgeoning settlement of Watertown offered few of the social amenities to which Richards, a highly educated man for his time, would have been accustomed. The territory was a rough-and-tumble pioneer environment populated primarily by bachelors who lived, for the most part, in rude conditions. Watertown was growing because of its location on the banks of the navigable Rock River, a natural source of power for the new

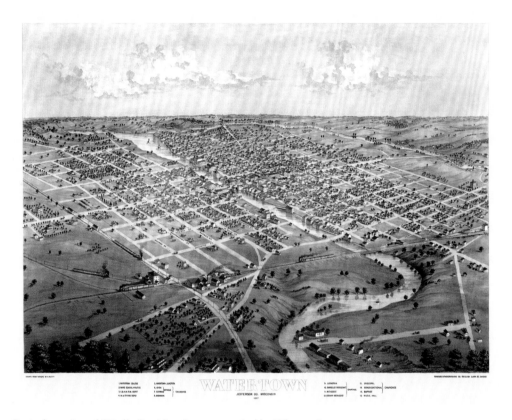

Part of a series of "Bird's-Eye View" maps created by Wisconsin artist A. Ruger, this Watertown map is dated 1867. Two years later John Richards was elected mayor of Watertown. He served one yearlong term.

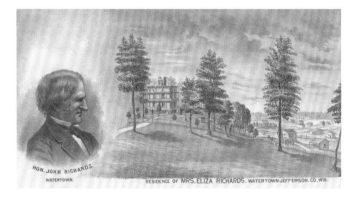

A sketch of the Richardses' home included in the 1878 *Illustrated Historical Atlas of Wisconsin.* Homeowners paid a small fee for their home to be featured, which offset the cost of producing the publication.

industries of flour and lumber mills. Forests, fertile land, and wildlife were abundant. Few women lived in Watertown, although this was not of great concern to Richards: his fiancée, Eliza Forbes, was waiting for him to return to Massachusetts to marry her. In 1840 he brought his new wife to Watertown.

John Richards worked hard, saved his money, and almost immediately began to invest in real estate. He started with a small farm, where he built a rough log cabin; the couple's first child was born there. By the 1850s Richards enjoyed a reputation as a man of substance. In addition to real estate, he owned gristmills, lumber mills, and the only linseed oil mill in town, and he employed mill workers.

By 1853 Watertown was a boomtown, second only to Milwaukee in population. The Watertown Plank Road connected the two, reducing travel time from four to three days in good conditions, and from six to four in inclement weather. This thoroughly modern transportation system brought down costs significantly, helping grain and lumber become even more profitable industries for Richards and other mill owners in Watertown. Legend has it that the first goods transported on the Watertown Plank Road were the Cream City bricks that face his second home.

Eventually, Richards purchased 105 acres of wooded land above the Rock River in Watertown—land known during this time as the "The Hill." It was on this site that Richards planned to build the "finest and most modern" home for his family, as he had promised Eliza when he proposed marriage. Richards wanted his home to reflect his social status, provide a comfortable and attractive setting for his growing family, house his employees, and be well built. The design of the house—known today as the Octagon House—was, in part, inspired by the writings of Orson Fowler.

Interest in octagon houses was strong in Wisconsin between 1844 and 1905 (records indicate there are at least thirty-seven extant octagon houses in Wisconsin), and the style was even more well received in Fowler's home state of New York. His book, *The Octagon House: A Home for All,* was wildly popular when first published in 1848; six subsequent editions were released between 1848 and 1857. Fowler traveled widely on the lecture circuit, speaking on the subjects of marriage, sex education, health, and phrenology as well as architecture. In 1844 he visited the hexagonal Milton House, in Milton, Wisconsin. He was so impressed with the grout construction of the hostelry that he discussed it at great length in *The Octagon House.* Fowler believed the heating and cooling efficiency and cost savings provided by the octagon form made the shape more beautiful than a wasteful circle or a difficult-to-construct square. The distinctive-looking houses were not really

a style but a form. Richards's choice of an octagon home implied that he believed function and comfort contribute as much to beauty as form and decoration. Many of Fowler's claims concerning the economic benefits of building an octagon house were not borne out and no one really figured out how to utilize the odd corners. The phenomenon of octagon homes lasted for little more than a decade on the East Coast and then faded.

An educated man such as Richards would have been in the custom of buying current books to fill his library. He likely owned a copy of Fowler's book and at least some of the seven handbooks on design written by Asher Benjamin, an American architect and authority on both the Federal and the Greek Revival styles, whose most notable contributions to architecture were his pattern books—the first written by an American architect. His book *The Architect, or Practical House Carpenter* (1830) is a standard reference in most contemporary architects' offices today. Benjamin's admiration for symmetry is obvious in the elevations of the octagon: the paired windows, shutters, paired chimneys, and balanced proportions of positive and negative space (or the solids and voids) are a lesson in geometry and balance. Benjamin prescribed sidelights, pilasters, and a light (or window) over the doorways of Federal and Greek Revival–style homes. The Asher Benjamin design Richards chose for his front door has leaded lights and is much more ornate than any of the French doors or windows elsewhere in the home.

SET INTO A HILL, the house is three stories at the front elevation and four from the rear one; the family kitchen is located in the back of the ground floor. Eliza Richards may have come from a well-to-do East Coast family, but she fully participated in the hard work of pioneer life: the family had no full-time servants. Instead, they hired local women and men when extra help with seasonal or heavy work was needed. Eliza could bake twenty-four loaves of bread at one time in the Dutch oven—which was important when cooking for a large number of people three times a day.

The top floor contained seven bedrooms of varying sizes for the employees of Richards's mills. Workers accessed their rooms via a separate stair off the family living room. While the eight-and-a-half-foot ceilings on the top floor are lower than those on the two family floors, all the rooms are cheerful, with a single or double set of large, double-hung windows that provided both natural light and cross ventilation. The mill workers ate with the family on workdays in the ground-floor kitchen. Since the family had no servants, it was easiest for Eliza Richards and her daughters, who were responsible for meal preparation, to serve everyone together.

The ground floor was designed for efficiency. A dumbwaiter transported prepared food from the kitchen up to the buttery

At the center of this octagon plan is a square core flanked by four almost square rooms, with the remaining spaces neatly composed of four triangles. At a time when math and science were used to explain the universe, especially by philosopher Orson Fowler, the "architect" of America's octagon movement, this geometric simplification of our world made the octagon form a functional plan for a home.

The square core, which is accessible from each of the adjacent square rooms, affords, thanks to the cantilevered spiral staircase, entry into all the spaces on each floor. The open stair core also functions as a vent chimney, providing passive natural ventilation in summer as hot air rises and is expelled out the third-floor roof vents. In this central core is an early example of an indoor plumbing system in Wisconsin.

The span from the exterior walls of the first floor's square parlor, music, dining, and family living rooms to the supporting square core was ideal for the lumber of the day. The remaining triangular rooms serve as supporting entry vestibule, buttery, conservatory, and a bedroom. On the two upper floors this organization is repeated with the spaces devoted to large square and small triangular bedrooms.

The second stair, which is off the living room, enabled John Richards's boarding workers to move about without interfering with the family's movement through their home. The use of French doors instead of sill-height windows makes the continuous porches wrapping the first and second floors more accessible and therefore more functional while enhancing natural ventilation. Function is the operative descriptor for this plan that encloses the most volume with the least envelope.

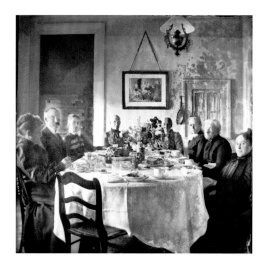

adjoining the first-floor formal dining room, where china and silver were stored. The basement kitchen was warm and cozy in the cold Wisconsin winters; in summer, heat from the lower-level cooking stove did not overheat the first-floor family rooms. The large, wood-burning furnace behind the cooking stove provided central heating for the major living rooms and bedrooms via heating vents in the wall in lieu of fireplaces. The only fireplace in the Richards home is in the living room. With just one fireplace, the necessity and mess of carrying wood and ashes throughout the home were eliminated. A wood storeroom was next to the basement door leading outside.

Rather than being a purely decorative element, the cupola topping the house is the epitome of the synthesis of economics, aesthetics, and efficiency. A roomy octagonal lantern, the attractive architectural feature also brings light and fresh air into the interior. The far-ranging view from the cupola is one the Richards family would have thoroughly enjoyed, especially upon realizing they were looking at the beauty and order of Watertown that they had helped create. The cupola also holds a basswood funnel lined with zinc that captures rainwater from the roof. Running cold and almost hot water was part of the home's original design. Water was transported down the pipes to a cistern in the ground level, with excess flowing down the hill. Water from the ground-floor reservoir was heated through a coil in the kitchen range and then directed to spigots in niches on the second- and third-floor landings. The finely appointed guest bedroom on the second floor had its own spigot over a permanent washbasin. Family members could easily fill a pitcher for daily washing up; in 1854 Wisconsin, this was a rare luxury.

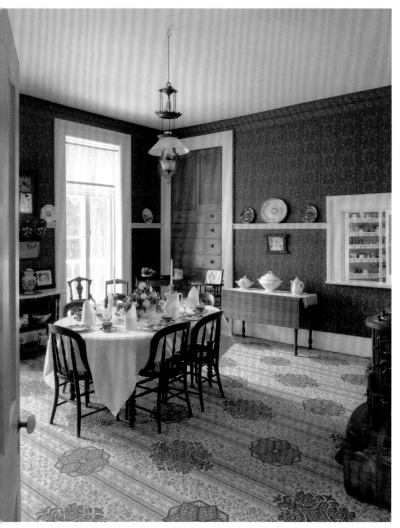

The family did have a bathtub, located in a hall outside a daughter's bedroom on the second floor. Fowler was a proponent of indoor toilets in the case of a family member being old or infirm, but the prejudice against sewer gas was enough for most people to prefer outhouses. The Watertown octagon has never had an indoor toilet, in spite of the fact that it was occupied by a Richards family member until 1937.

Part of the home's original design included early central heating and air circulation and cooling systems. Hot air was directed through four chimney flues through vents into the twelve major rooms. The air circulation system consisted of vents in the wood frieze-band. Each of the major rooms had air intakes below the eaves, and outlets were located in each of those rooms. Operable windows at the top of the cupola allowed hot air to be vented out of the house and cool air to come in. Richards, who had a scientific mind, respected the thoughts on the health-giving properties of cleanliness and fresh air. Less forward thinking people believed the night air brought disease and illness.

Fresh air and daylight were important aesthetic considerations. The Richardses' house, at thirty-two major rooms, was one of the largest homes built in Wisconsin before the Civil War. Instead of windows on the family floors, Richards specified French doors that led to verandas encircling those floors.

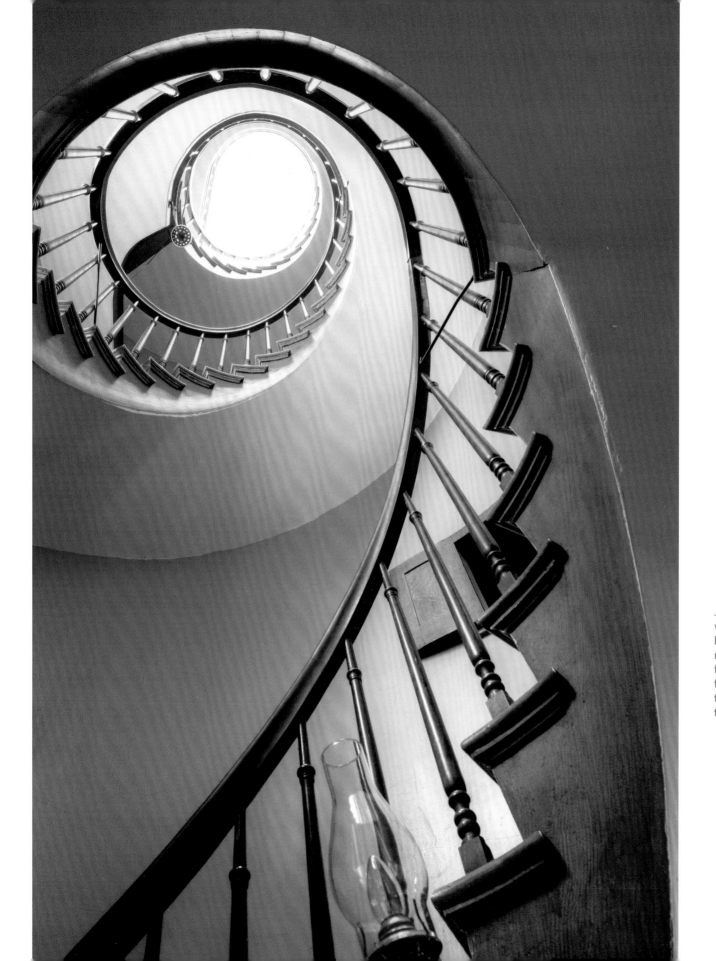

John Richards used various woods from his property to build much of the original furniture. He chose chokecherry for the handrails and basswood for the treads of the daylit, three-story, center-spiral cantilevered staircase.

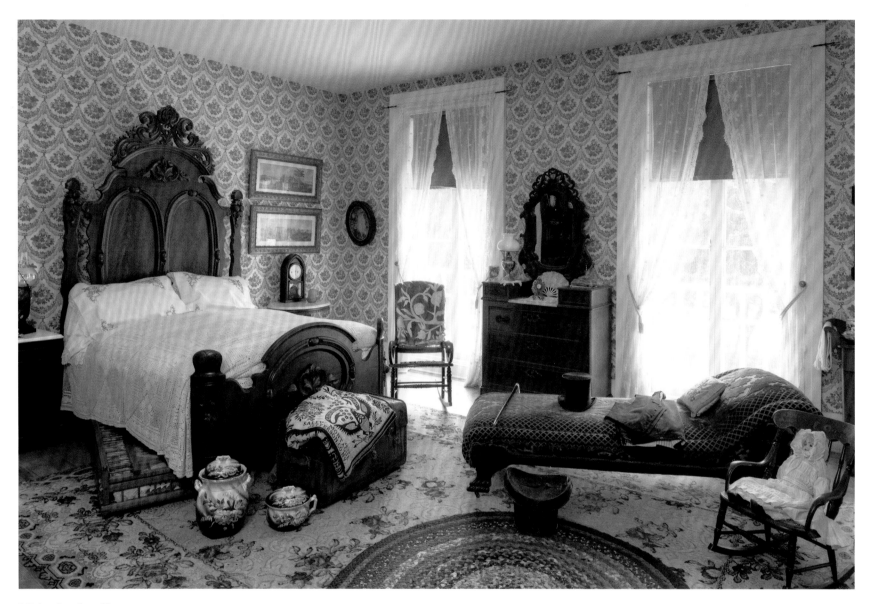

Mixing floral motifs was especially popular from the 1830s to the 1860s. The walnut bed with a trundle bed in the second floor's Lincoln Bedroom was made in St. Louis. It resembles the one in the White House's Lincoln Bedroom.

JOHN RICHARDS BUILT HIS OCTAGON house to last. He used quality materials and superior construction techniques throughout his entire home. Basswood, oak, and cherry harvested from his land and milled in his mills were used in the construction. Hand-hewn, 10-by-14-inch oak beams support the floors. Pine, used in the construction of the verandas and French doors, was floated down the Rock River from the northern pineries and locally milled. Watertown brick formed the 13-inch-thick interior walls, which were plastered and, in the family-floor rooms, painted or covered with wallpaper from New York State.

Richards was influenced by Fowler, but his Watertown octagon is not a direct copy of any Fowler plan. Sketches in the house in Richards's own hand show changes, innovations, and modifications—namely the additions of the top floor, the secondary staircase

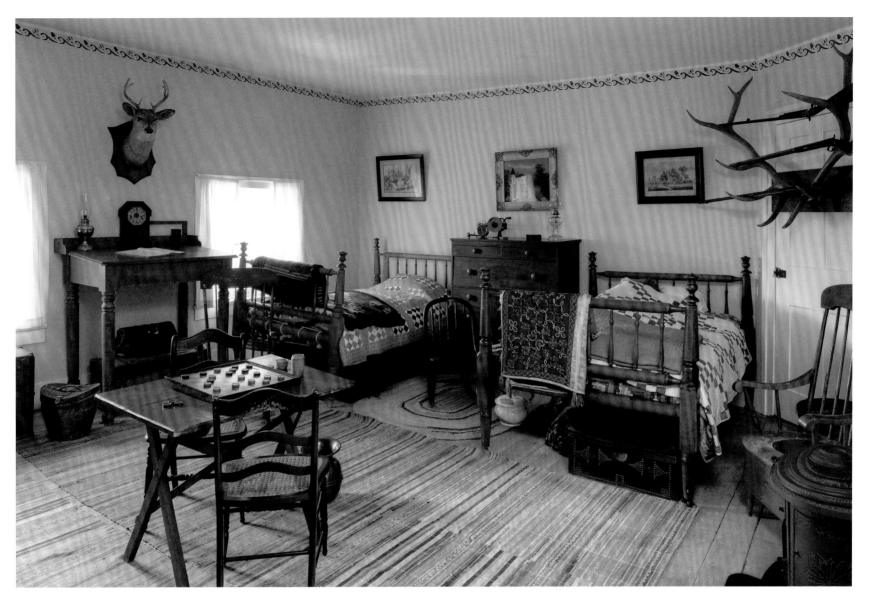

for the boarders, and the water spigots on the stairway, which allowed all in the house to get water on their way to their bedrooms before retiring for the night.

Fowler touted eliminating hallways as a great efficiency. Richards created a lively flow between the rooms on the main floor and increased the usable square footage by following this suggestion. But the omission of hallways on the second floor meant that someone had to pass through a large bedroom to get to their small bedroom. However, with eight children (five of whom lived to adulthood), it is doubtful that John and Eliza Richards had any illusions of privacy.

The basement and the boarders' floor may have been designed with economics and the efficiency of pioneer life in mind, but the first and second floors, the two family floors, are a reflection of the elegant and gracious hospitality associated with Victorian society.

Workers from John Richards's mill boarded on the third floor and took their meals in the kitchen. The third-floor ceilings are lower and the windows smaller than on the other floors, but the accommodations were comfortable and convenient.

What Was/Is an Architect?

The definition of an architect is as diverse as the assortment of individuals involved in the process of making a building and is representative of a debate as old as the practice of architecture. *Architect* is derived from the Greek word meaning master builder or carpenter. Described as the second oldest profession by dint of our basic need for housing, architecture did not receive recognition as an acknowledged profession until the mid-nineteenth century.

The medieval guilded mason craftsman who graduated to "master mason" of the construction of the great cathedrals is often described as the practical precursor of the architect. When the mason was elevated to master and given creative control over the other crafts, he was moved to his own "tracing shed," where the drawings produced effectively communicated design instructions to all involved in what was becoming a complex and labor-intensive building process. In the Renaissance, the masterpieces by Brunelleschi and Michelangelo among others were attributed to those who were first artists and secondly "architects."

Through the patronage of the wealthy and powerful, scale has always been important in the survival of architecture: larger, more significant projects are better able to physically and financially weather the storm and vicissitudes of time—at least long enough to survive for a historian to write about them. Such patronage led to royal architectural academies, which were established first in Holland in the mid-seventeenth century and then in France.

Along with acknowledgment of architecture as a profession came the need to define its training and education. In the guild system a young apprentice would commit to a master craftsman for years of training, instruction, and work, with the only compensation being room and board. The medieval guild system of apprentice to journeyman to master continued to prepare many practitioners, but the system could be abused. The French École des Beaux-Arts and even the English Architectural Association, where an acknowledged master would provide loosely defined instruction, grew out of dissatisfaction with the apprenticeship system.

The opportunities of the New World created enormous demand for the talents of those who knew how to build. By the mid-nineteenth century the needs of the United States were being met by a diverse group of »

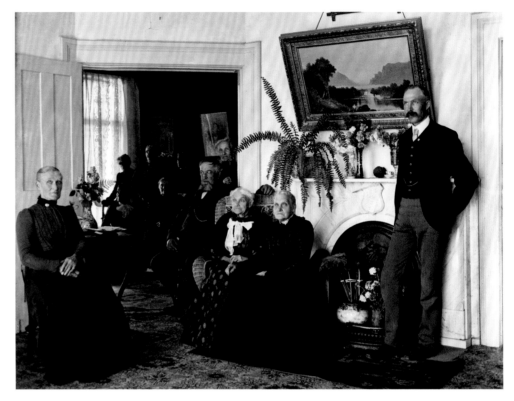

Mrs. Eliza Richards, seated center in the wicker chair in her parlor, circa 1901. Family and friends overflow into the adjacent music room.

The vestibule opens into both the parlor and the music room, the more formal entertainment rooms. Eliza brought the piano in the music room with her from Massachusetts; the Vermont marble fireplace mantel in the parlor was a wedding gift from her parents, which the couple had to wait to enjoy until their fine house was built.

THE RICHARDS OCTAGON remained a family home until it was given to the Watertown Historical Society by the extended family; it has been open to the public as the Octagon House, a house museum, since 1938. The experience today is one of visiting a home, not a museum. The dining room set is original and the cozy family living room contains some of the original furnishings. Great care has been taken by the historical society to make appropriate choices when furnishings have needed to be replaced. For example, Brussels lace curtains came from New Glarus, wallpaper was shipped from New York, and donations of furniture from the late 1800s were incorporated. Original kerosene chandeliers still hang in many of the rooms. Electricity was added only after the home was given to the historical society.

Resources for house museums are not limitless, so bedroom floors are often less fully appointed than formal living areas. Happily, the Octagon House gives the visitor an authentic glimpse into intimate family rooms of the mid-1800s. The four large bedrooms

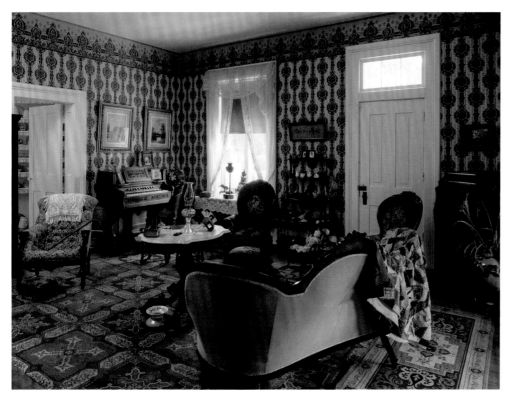

The family living room illustrates the Victorian theory of harmony by contrast in which red and green—opposites on the color wheel—were a favorite color scheme. White walls were considered distressful to the eyes, though white-painted woodwork was acceptable.

» *continued*

building professionals. There were guilded craftsman for the various trades (often called mechanics) who might assume the more complicated coordination tasks that are now the work of general contractors (back then they were called "undertakers"). There were artists, engineers, surveyors, and even developers. Into this mix were added those educated in the Beaux Arts system or in English offices who considered themselves professionals. Practitioners in the United States who had studied at European academies would also provide training in their office through internships, much like the guild apprenticeships, for which they would charge students a fee. The popularity of pattern books by Asher Benjamin, Orson Fowler, and Andrew Jackson Downing enabled every American to be their own "architect," with built examples like the Octagon House in Watertown and the House of Seven Gables in Baraboo.

In 1857 the American Institute of Architects (which replaced the unsuccessful American Institution of Architects of twenty years earlier) added further legitimacy to the field of architecture, along with movement toward licensure, registration, and university training. People wondered if architecture was a profession for a proper young gentleman, and the response was the introduction, in the 1870s, of schools of architecture such as the University of Illinois, Massachusetts Institute of Technology (MIT), and Cornell to legitimatize the calling and provide training to design more complex buildings.

Louis Sullivan studied at MIT and the École des Beaux-Arts, and had apprenticed in the office of Frank Furness. Frank Lloyd Wright had two years of civil engineering at the University of Wisconsin and worked with George W. Maher in the office of Joseph L. Silsbee, but considered his time as an apprentice to Sullivan his real training. Shepley Bullfinch and Rutan were successors to H. H. Richardson, who had studied at the École des Beaux-Arts and established his own atelier where an office-complemented education was the goal. George Bowman Ferry had attended MIT and the École des Beaux-Arts, while his partner, Alfred C. Clas, had taken the route of apprenticeship for his training. Richard Philipp apprenticed at Ferry and Clas before striking out on his own. David Adler studied architecture at Princeton and apprenticed with Chicago's famous Howard Van Doren Shaw.

In 1917 Wisconsin passed its architect licensing law, which further legitimatized and disciplined the profession in the state.

have high ceilings (nine and a half feet) and a set of French doors that open to the veranda; the three smaller bedrooms open to the veranda as well. It is easy to imagine the Richards children running in and out of the doors playing hide-and-seek. The rooms are bright and airy. Beds, cradles, and some of the Richardses' artifacts are in place.

The Watertown Octagon House is a testimony to John Richards's attention to detail in planning and construction. More than 150 years after the home's construction, its plaster is largely intact, the basswood floors shine, and the original octagonal ceramic tiles still grace the foyer. The centrally located sculptural cantilevered stair is still a work of art and functional, its hand-turned spiraling cherry rail and spindle gleaming in the light cascading from the cupola. All sixty-three doors and windows continue to open and close, and their original hand-cut limestone lintels and sills have not cracked or settled. The built-in drawers in the dining room and master bedroom are serviceable, evidence that the 50-by-5-foot foundation has settled very little. Built-in storage was one of Fowler's suggested efficiencies that Richards included in his home.

A house this large comes with maintenance challenges, especially one exposed on eight sides to the cold, snowy winters of Wisconsin alternating with hot summers. The verandas have been rebuilt twice in 150-plus years: They were disassembled and removed in

the 1920s and were only reinstalled in the early 1980s and completely rebuilt once again in 2008–09. Obviously, the pine of the 1850s was more dimensionally strong than what is currently available.

Today, Richards's house on a hill is a good yardstick against which to measure contemporary notions of sustainability. It was built of local materials with energy efficiency, fresh air and light, recycling of rainwater, and heat all considered in the original construction. The oddly shaped yellow brick house is still structurally sound after 155 years. •

The House of Yesterday and the House of Tomorrow

One of the most popular displays at the 1933–34 Century of Progress Exposition, or the Chicago's World's Fair, was the "Homes of Tomorrow" display. Technological innovations in new materials and prefabricated parts produced in Art Deco and streamline designs were highlighted here.

Most striking and influential was a twelve-sided polygon glass home called the House of Tomorrow. Cantilevered from one central steel-pipe column was a first floor containing an airplane hangar and garage, a second floor with a living room and bedrooms, and a top floor consisting of a solarium. This three-story home was clad in what was then a modern application borrowed from skyscraper construction: a floor-to-floor glass curtain wall. The great expanse of glass helped to passively heat the space in winter but overwhelmed the air-conditioning technology of the day. Architects William and George Fred Keck designed this home, building on their reputation as pioneers in passive solar design and leading-edge modernism. This futuristic design was later moved to a site at the Indiana Dunes National Lakeshore. The Keck brothers were born and bred in Watertown—within sight of John Richards's eight-sided housing solution, which they updated to twelve for their version at the World's Fair.

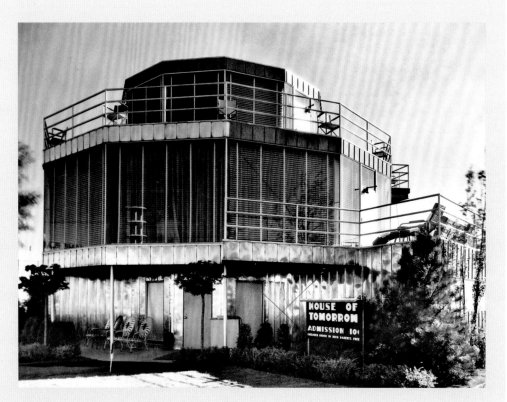

Keck & Keck's octagon-inspired design, 1934

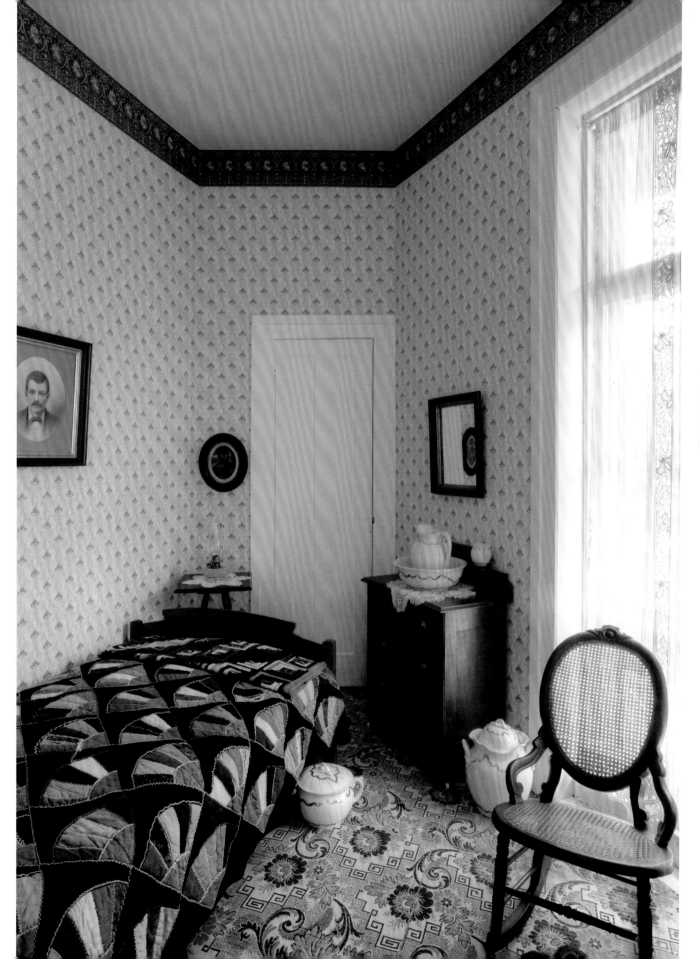

The triangular rooms were used as children's bedrooms, each with a closet. The floor-to-ceiling window provided daylight as well as healthful fresh air.

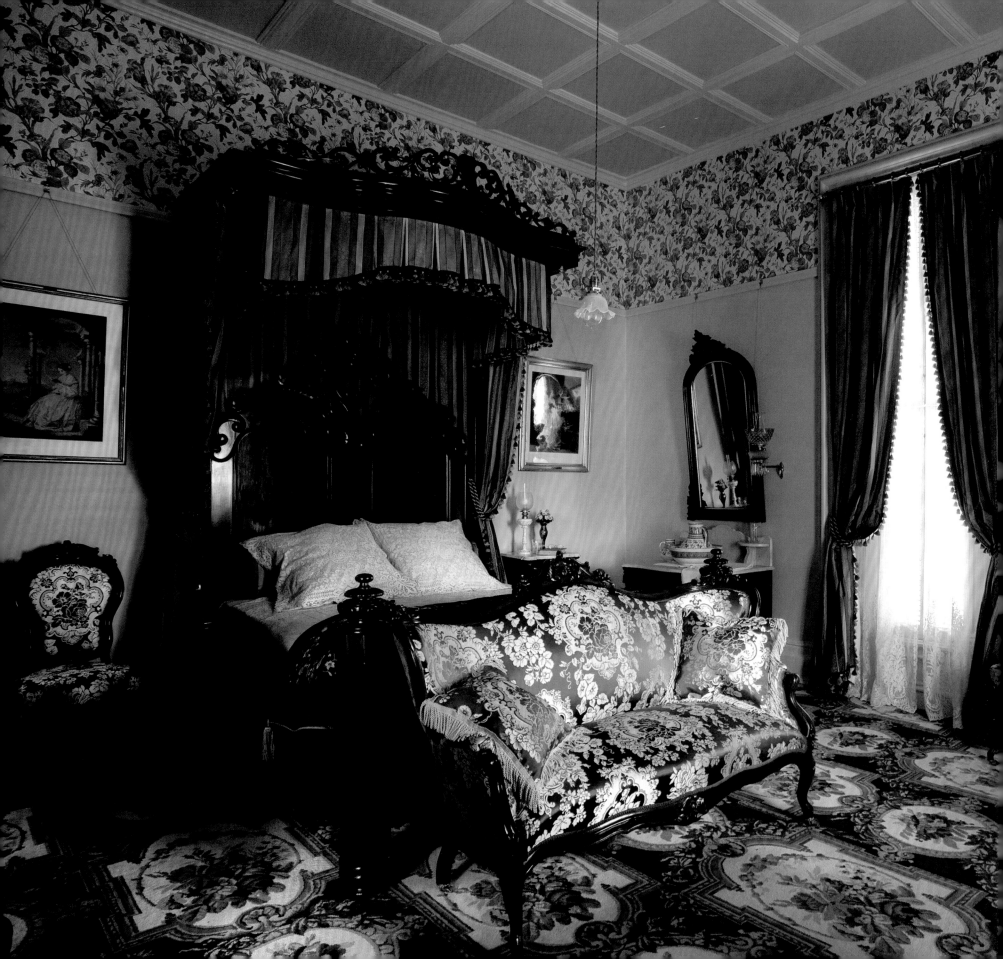

Villa Louis

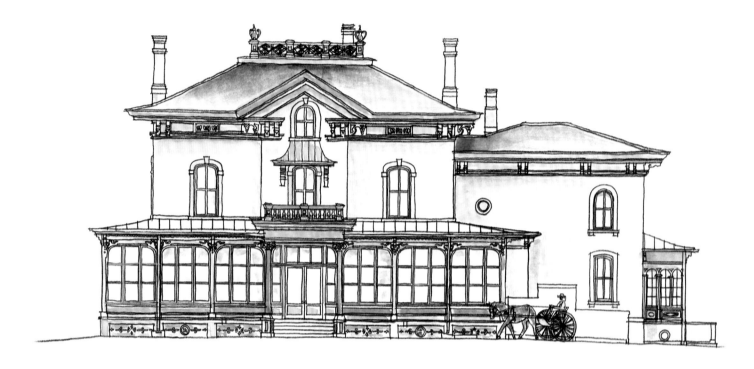

OPPOSITE: At the restored
Villa Louis, the first floor's
elegant rosewood guest-room
bed is a half-testor (only the
head portion is covered by a
canopy). A small fragment of
original wallpaper discovered
intact during the restoration
was enough to enable the
restorationists to reproduce
the pattern.

IT IS LITTLE WONDER that Wisconsin author August Derleth had enough material to write two epic novels about the Dousman family. Their story is an engrossing personal narrative that intertwines love, drama, wealth, and the history of early Wisconsin. Through the generations, the Dousmans made an impressive foray into architecture, building, rebuilding, and renewing their family home, always in a high style.

The story continues beyond the Derleth novels, when Hercules Louis Dousman II commissioned a Milwaukee architect to build a new home, in the Italianate style of 1870, on the site where his father's Brick House on the Mound had stood. After the younger Dousman's death in 1886, his widow, Nina Sturgis Dousman, remarried and moved to New York City. Following a divorce and the death of her young daughter, she returned to Prairie du Chien to spend nearly twenty years as hostess of the elegant estate she had renamed Villa Louis in memorial to her first husband.

HERCULES DOUSMAN WAS BORN into a family of fur traders on Mackinac Island. His father had relocated to the island from the Pittsburgh area in 1796, the year that Mackinac Island was opened to American traders. The senior Dousman took full advantage of being on the cutting edge of frontier development and pursued a multifaceted business plan of fur trading, farming, milling, military contracts, and land speculation.

Hercules left the island in the early 1820s for business training in New Jersey. By the mid-twenties he was back in the Michigan Territory and in 1826 accepted an appointment from John Jacob Astor's American Fur Company to come to Prairie du Chien to work as a clerk for the legendary Joseph Rolette. In 1856 James Lockwood, a contemporary of Dousman's recalled that Dousman "came to Prairie du Chien in the employ of the American Fur Company, and has ever since steadily pursued what he appeared to have most taste for, the accumulation of wealth, until at this time he is considered very wealthy."

Dousman's arrival in Prairie du Chien coincided with epic changes for the fur trade community largely composed of French-Canadian and Indian families. A series of treaties with the U.S. government forced Indian people to relocate. The discovery of lead in the region brought a rush of miners and farmers. The influx of new settlers upset the balance among the region's Indian nations and violence erupted again and again. The final and most tragic chapter was the Black Hawk War of 1832. With the end of this conflict came permanent changes for the region's Indian community. The stream of immigrants from eastern, established states was swollen by more and more arrivals from abroad. They also brought new marketing opportunities for established and savvy businessmen like Hercules Dousman.

John Jacob Astor retired form the fur trade in 1834 and the American Fur Company reorganized under Ramsey Crooks. A new partnership, called the Western Outfit, was created along the Upper Mississippi with Hercules Dousman, Joseph Rolette, and Henry Sibley controlling the region from the confluence of the Wisconsin River to the Falls of St. Anthony and modern-day St. Paul. Traditional fur trading was changing and now money could be made through Indian land treaties, annuity distribution, and other aspects of the changing relationship between the U.S. government and Indians. In the 1830s and 1840s Dousman aggressively pursued land development. He also became engaged in transportation, first investing heavily in steamboats and later in rail.

When the U.S. Army abandoned the flood-prone site of Fort Crawford on St. Feriole Island, Dousman purchased much of the site including a large earthen mound first built by Indians. In 1843 he began construction of a brick house on this prominent and flood-proof mound. Combining classical features from both the Georgian tradition and the Gothic Revival style, the new house was a grand statement of Dousman's position as the town's wealthiest and most influential resident. In a document detailing the cost of the elegant house, Dousman referred to his new residence as the "Brick House on the Mound." Throughout the next decades the structure would be transformed into the centerpiece of a sprawling estate with numerous outbuildings, gardens, and other landscape embellishments. While paying homage to other grand houses in the Midwest, the home was certainly the grandest rural residence in the western part of the Wisconsin Territory.

In 1844 Dousman's Brick House on the Mound fully came into its own with the addition of Dousman's bride, the former Jane Fisher Rolette, a woman of rich fur trade lineage and ample dowry. She was also the long-estranged widow of Hercules's partner

Joseph Rolette. The new Mrs. Dousman exemplified the social and charitable prominence expected of high-status Creole women in the fur trade culture of early Wisconsin. Dousman's own lineage was assured with the birth, in 1848, of his son and heir, Hercules Louis Dousman II. Known throughout his life in the Francophone form of *Louis,* he was born just one month before Wisconsin became the thirtieth state to join the Union. A new era had begun for the territory and for the Dousman family estate.

AS THE FUR TRADE CONTINUED to move farther west and diminish in profit, Hercules Dousman focused more time and attention on land sales and business development. As a member of the board of directors for the Milwaukee and Mississippi Railroad Co. he was able to influence the railroad's route through western Wisconsin to its terminus in Prairie du Chien. By 1857 the route from Milwaukee to Prairie du Chien was complete. Cities and towns along the rail route and the economy of western Wisconsin experienced a boom, due to the quick and efficient transport of goods. Both Prairie du Chien and Hercules Dousman prospered. Dousman expanded his estate with new outbuildings, gardens, a hothouse, vineyard, and large addition to his house. The property embraced land that Mrs. Dousman had brought to their marriage and was now truly a country estate.

In the autumn of 1868, Hercules Dousman died, ending an era that had witnessed the settlement of a fur trade wilderness and the advent of steam-powered transportation. Twenty-one-year-old Louis left school in Madison to return home and help his mother deal with his father's complex estate, made more complex by the absence of a will. By the

The Brick House on the Mound, shown here in 1858, was the Dousman family home prior to the construction of Villa Louis on the same site.

early part of 1870 all claims were settled; Louis emerged with significant wealth and the responsibility for the family businesses, property, and his widowed mother. Undaunted by his new status, he embarked immediately on a major building project with Milwaukee's leading architect, E. Townsend Mix. Mix was commissioned to build a new and stylish home embracing the latest principles in design. It would replace the graceful and aging home of his childhood, the Brick House on the Mound.

Edward Townsend Mix was a Connecticut-born architect raised in Andover, Illinois, and New York City. He began the study of architecture at age fourteen and eventually apprenticed to Connecticut architect Sidney Mason Stone. In 1855 Mix moved to Chicago and began a brief partnership with architect William W. Boyington. The firm's work took Mix to Milwaukee, where he decided to begin an independent practice in 1856. Mix dissolved his partnership with Boyington and began designing homes and businesses for Milwaukee's leading residents.

Mix, who served as Wisconsin's state architect in the mid-1860s, became well known for large, imposing, highly decorative commercial buildings and churches. In the 1870s he designed a number of Italianate homes for prominent Midwestern families, such as the Patrick Fitzgerald House in Milwaukee and Montauk, home of Iowa governor William Larabee, in Clermont, Iowa. Later Mix shifted his design focus to the Second Empire style. The Dousman residence dates to Mix's Italianate era, predating his elaborate design for Alexander Mitchell's Milwaukee Second Empire mansion by four years and the Queen Anne Allyn mansion in Delavan by fifteen years.

Architects, especially society architects, were in high demand to build new homes for Chicagoans displaced by the Great Chicago Fire of 1871. Luckily for Dousman, his contract with Mix was dated March 1870: the contract stated the old home was to be razed and the new one completed by December of the same year. If Dousman had waited one year he may have had a difficult time convincing Mix to commit to such a tight timetable for a project all the way across the state.

Architects in Mix's time often played a critical role in supervising day-to-day construction, offering on-site interpretation of plans and drawings. The general contractors were Bentley & Son, a Milwaukee firm with whom Mix had worked on many important building projects both public and private. Mix was able to reuse building materials from

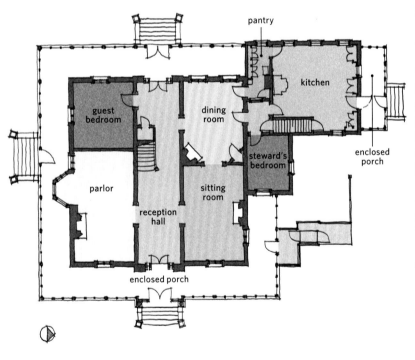

The Dousman estate developed over time and in response to evolving functions, fashions, affluence, and a changing cast of characters. It was the task of architect E. Townsend Mix to bring order to the design of a new Italianate home built on the site of the Dousmans' Brick House on the Mound.

Principal entry to Villa Louis is made from the east through an enclosed veranda surrounding three-and-half sides of the house. This feature is unusual for a Mix design and may reflect the wishes of the client, who had enjoyed a similar feature on his family's earlier Brick House on the Mound. The entry hall is like a preamble: as in most Italianates and Victorians this reception hall organizes the family's public sector by establishing circulation and the visual criteria upon which the rest of the house is viewed. Symmetrically distributed along this east-west axis are a sitting room and dining room across from the parlor and the first-floor bedroom that was typical of this period. Stairs at the west of the main hall lead to the private bedroom floor above. Off the dining

room Mix added a back hall that leads to the service wing comprising the north facade. This organization maintained the family/servant room arrangement of the earlier house while reserving the more comfortable rooms of the house for the family. Between the dining room and kitchen was the bedroom of the family's longtime servant, Louis Le Brun. The kitchen porch, with a north entry, allowed for easy access and egress to the house by servants and deliverymen as well as passage to the ice house, summer kitchen, and other working parts of the estate.

The western hall entry may have been a carryover from the time when steamboat traffic brought visitors from this direction. Under Mix's plan the entrance provided a vista of a broad lawn and vineyard stretching to the banks of the Mississippi River. A Victorian caller would be met at the east entry of the main or reception hall by a maid or butler, whereupon a calling card would be presented for the consideration of the residents.

the first house—a practice that is now a tenet of green architecture. A close scrutiny of Villa Louis today reveals recycled bricks in the walls, recycled beams in the floor, and recycled doors in out-of-the-way locations such as the basement, attic, and servants' wing. While this practice is good for the environment, it does pose a challenge to architectural historians in determining accurate dates of construction.

The Italianate style with its identifying features of boxy proportions, wide eaves, numerous brackets, and a gently sloped roof was one of the most ubiquitous residential styles between 1850 and 1880; it was a particularly popular choice for the country villa on the East Coast. Andrew Jackson Downing, a popular author and tastemaker of the time, wrote, "The Italianate style is one that expresses not wholly the spirit neither of the country life nor of town life but something between both, and which is a mingling of both." The style fit well into the existing cultural landscape of the Dousman residence, gracing the ancient Indian mound where it was set, exuding a certain confidence and grandeur without ostentation.

Italianate homes were typically built with balloon framing, which was a simplified construction technique. Mass production of building materials in the 1870s and railroad transportation made it possible for less skilled carpenters to economically build homes removed from large cities and sawmills. The Italianate style can be found throughout Wisconsin, generally in smaller towns or on prosperous farmsteads. Not all Italianate-style homes were clad in brick; lumber baron Gideon Hixon built a stunning wood-clad Italianate house in La Crosse in 1859. While balloon framing may have been an option for Villa Louis, Mix chose the more traditional method of solid masonry construction, building the walls twelve inches thick on the main block of the house and eight inches thick on the kitchen. He was able to recycle red brick from the first Dousman residence for the inner walls and faced the exterior with Milwaukee-made cream-colored brick.

DURING THE CONSTRUCTION of the new Dousman residence, Louis began to spend more time away from Prairie du Chien. St. Paul appears to have been a frequent destination, perhaps because that is where Henry Sibley resided. Sibley had been Dousman's father's business partner and was the first elected governor of Minnesota. Now a man of substance and position, he could mentor young Dousman and introduce him to St. Paul society. In 1873 Louis met the daughter of General Samuel Davis Sturgis. Nina Linn Sturgis—bright, sophisticated, stylish, creative, and fluent in French—had just graduated valedictorian from the Sacred Heart Academy in Manhattanville, New York. She and Louis would begin a courtship that ended in marriage in 1873. Meanwhile, Louis' mother remained in Prairie du Chien, heading the household of the elegant new Dousman residence.

Louis and Nina Dousman originally planned to stay in St. Paul and engaged E. Townsend Mix to design a new house, one significantly larger and more urban than the Prairie du Chien residence. When Nina's father, General Sturgis, was relocated to Jefferson barracks near St. Louis, the St. Paul plans were shelved and the young couple sought to establish themselves in St. Louis. Their family grew quickly and by 1884 there were

five Dousman children. There were frequent treks to Prairie du Chien for extended visits with Grandmother Dousman and personal conversations with the estate manager. Nina and Louis also found time for travel and began collecting paintings, fashionable furnishings, and decorative objects for their St. Louis residence. Louis also pursued an interest in sulky racing and American Standardbred horses.

The couple enjoyed a privileged life in St. Louis and maintained a large circle of stylish friends. Their travels took them to Midwestern cities and, upon occasion, to New York.

The success of Louis Dousman's Artesian Stock Farm was short-lived. His wife, Nina, sold the horses at a significant loss following his death in 1886. This image—with carriages passing in front of his home—appeared on the cover of his 1884 catalog of horses.

Their trip to New York in the fall of 1876 may have included a visit to the Centennial Exposition in Philadelphia and most certainly included visits to Tiffany & Co., where elegant purchases were made for both their home and their persons. Louis was influenced by the art exhibited at the Centennial Exposition in Philadelphia and soon began to amass a collection of European paintings dominated by French Academic painters working in the Neoclassical and Romantic styles. As his collection grew he built a large gallery addition to his St. Louis property that was open to the public one afternoon each week. For three years Louis served as art director for the annual fair in St. Louis. Nina and Louis reveled in the dazzling socialite life of the Gilded Age.

After a prolonged period of ill health Jane Dousman died in 1882. As one of Prairie du Chien's last elite Creoles, she had been regarded as a link to a time when Wisconsin was significantly French influenced. Her death marked the passing of a member of a generation of Wisconsin's earliest residents whose family roots stretched to the beginning of the French-Canadian fur trade. It also forced Louis to make a decision regarding the Prairie du Chien property. He ultimately decided to establish a Standardbred horse-breeding farm on the site of his childhood home. To raise money for his venture, he sold his painting collection at a public auction in New York City. The *New York Times* called the sale "Fair but not Spirited," and suggested that Dousman's tastes might have drawn more interest among western buyers.

The Prairie du Chien estate included the Dousman residential complex of more than twenty buildings as well as two farms located north of the city, the Campbell Coulee Farm and the Mill Coulee Farm. The two farms totaled more than 5,000 acres and were built in deep ravines cut into the bluffs running perpendicular to the Mississippi River. With rich meadowlands, unlimited artesian water, and plenty of space for breeding and exercise, this was the perfect setting for Louis to realize his dream of creating a breeding stable and racetrack, and of raising his family in the country.

While Louis was busy developing the myriad equine features of the Artesian Stock Farm, Nina focused her attention on the house. In the fifteen years since it was first built, major advancements had been made in plumbing, heating, and electrical systems, as well

as early telephones and electric call bells. More importantly, the Dousmans required a larger kitchen suite and more rooms for live-in domestic help. There was also the issue of interior decoration, with Nina and Louis having keen eyes and taste for the latest fashion of artistic British-inspired wallpapers, carpets, and textiles.

Prairie du Chien builders possessed the skills necessary to complete the house additions and room configurations, but for the interior design the Dousmans turned to the Chicago firm of John J. McGrath and sophisticated design skills of Joseph Twyman. Twyman was British by birth and had relocated to Chicago shortly after the fire. He was a proponent of the English Arts & Crafts style and a devotee of the work of William Morris, poet, artist, and writer as well as the founding member of the highly influential firm of decorators and manufacturers bearing his name. Through Twyman, the McGrath firm became agents for William Morris and Co. In his plan for the Dousmans, Twyman drew from the designs of Morris and his contemporaries to create an original and brilliantly crisp color palette of red, blue, and gold worked in numerous permutations. Inspired by Morris's golden rule—"have nothing in your houses that you do not know to be useful, or believe to be beautiful"—Twyman created an artistic interior that transformed the boxy polished plaster walls of Mix's house into a warm and inviting jewel box of, color, pattern, and texture.

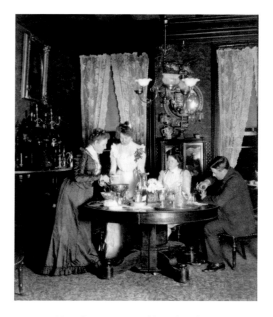

ABOVE: Nina Dousman and her daughters Virginia and Violet serve beverages in the dining room, circa 1898. This image was particularly helpful to Villa Louis staff during the late 1990s restoration of the dining room. BELOW: Guests from St. Paul filled the home in the summer of 1898. Billiards was a favorite pastime. Violet Dousman, right, lines up a shot as friends and family look on.

THE PAINT WAS BARELY DRY on the redecorated residence when sadness once again fell over the Dousman family. After a rapid decline, believed to be appendicitis, Louis died at age thirty-seven, in January 1886. Within a month Nina had decided that the Dousman estate should forever be a memorial to her late husband and renamed it *Villa Louis*. Though the mother of five children aged two through ten, the thirty-four-year-old widow was not prepared to live out her years in the social isolation of Prairie du Chien. In 1888 she married again, a union that would also end in sadness. The family relocated first to Chicago and then to New York, where another daughter, Florence, was born. Within a short time her marriage began to disintegrate and Nina took the unusual step of seeking a divorce. More unhappiness followed when three-year-old Florence died of pneumonia in January 1893. Mrs. Dousman brought her daughter to Prairie du Chien for internment in the family cemetery and, perhaps with new thoughts of home and family, or perhaps because of the nation's economic depression, she spent the spring formulating a plan for return to the Dousman family home. They arrived in September, just in time to attend the World's Columbian Exposition in Chicago, with Nina once again bearing the name Dousman.

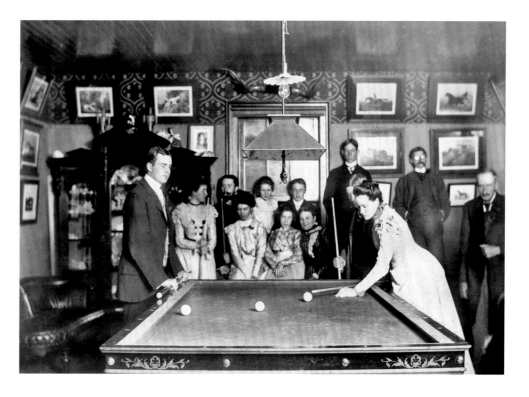

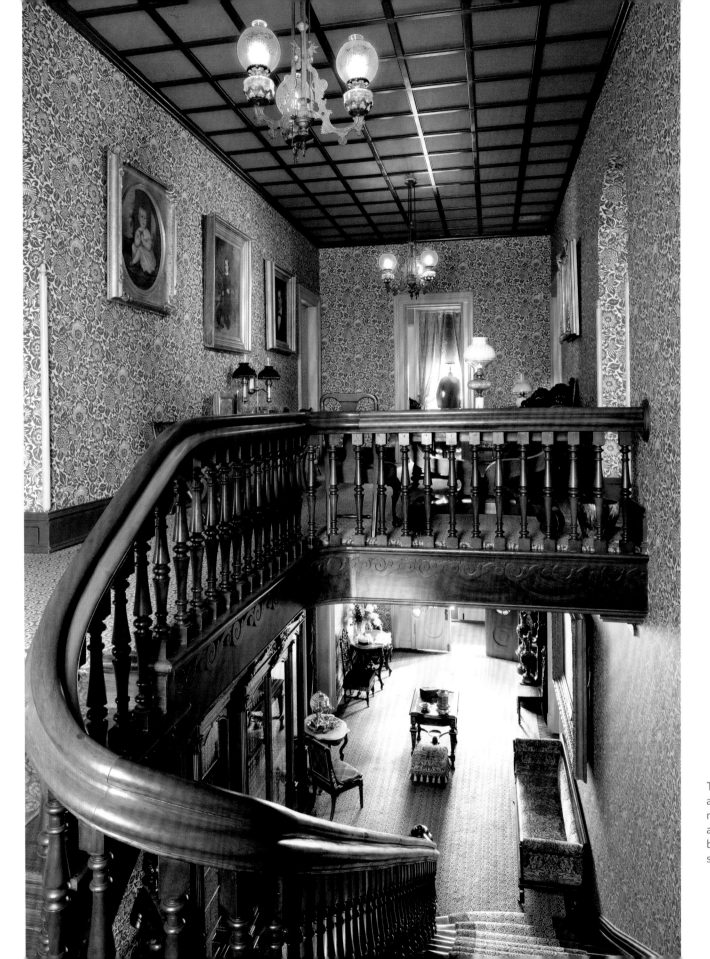

The stairway spindle accentuates the movement of both people and architectural space between the main- and second-floor hallways.

Upon their return to full-time life in Prairie du Chien the Dousmans embraced their new situation with enthusiasm. The children now ranged in age from ten to nineteen, and Villa Louis was enlivened with social activity. The summer season brought new designs for garden beds and a busy round of visits from friends and family, but ended in tragedy with another family death. In early August daughter Nina, aged fourteen, was fatally burned in a domestic accident. The accident prompted Mrs. Dousman to relocate her family to St. Paul in the fall of 1894, where she could enjoy the comfort of her widowed mother, as well as a sister and brother.

The new arrangement must have suited her social and familial sensibility for it would continue for the ensuing decade. Summers were spent at Villa Louis, where from July through September and an ever-evolving house party flourished with the continual arrival and departure of both short- and long-term guests. In the fall Nina Dousman returned to St. Paul. As her children became adults their social activities blossomed to courtship and marriage. In all cases marriage included plans to resettle

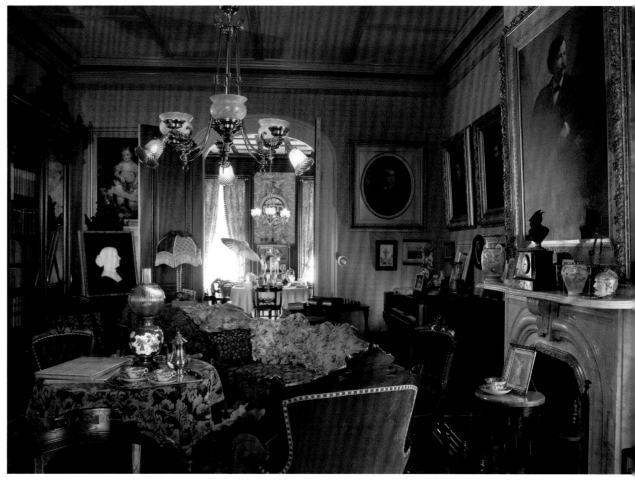

Over the parlor's marble fireplace hangs a portrait of Hercules Louis Dousman II by American genre and portrait painter Eastman Johnson. There is renewed interest in Johnson's work for its realistic depiction of American life in the late nineteenth century.

in distant cities including St. Paul, New York, and, in the case of Louis De Vierville Dousman, Billings, Montana. Louis married La Crosse native Sarah Easton in 1910 and the family hoped to move to Billings and enter business life in the bustling western city, but there were many loose business ends in Prairie du Chien and his mother seemed less and less capable of dealing with them. So the Dousman sisters prevailed upon him to take up residence in Villa Louis for whatever time would be required to sell the remaining farms, commercial real estate, and Villa Louis itself.

Louis soon discovered that it is often difficult to find a buyer for a large, aging house: he found buyers for all the Prairie du Chien property except the residence. Finally, in the summer of 1913, he found not a buyer but a tenant: the headmaster of a boy's boarding school who wished to relocate from Mercer, Wisconsin. The four adult Dousman children went through a lengthy process of dividing a seventy-year accretion of furniture, artwork, and household accessories. Some things were sold, some given away, some packed in the spacious mansion's attic. By August the dust had settled, the Dousmans were packed and gone, and the era of Villa Louis as a private family residence had come to an end.

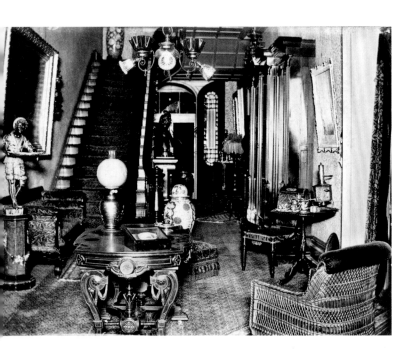

This 1898 photograph of the main hall allowed researchers to match the wallpaper and select appropriate furnishings for the space.

THE KEEWATIN BOYS SCHOOL was only the first of several renters and short-term occupants of the estate. More than twenty years had passed since the family actually lived on the property and now the nation was in the midst of the Great Depression. The citizens of the City of Prairie du Chien were experiencing an awakening of awareness and interest in their rich and storied past. The crumbling stone walls of the old Fort Crawford hospital were refashioned into a museum and street names were changed to honor pioneer residents. The Dousman family was approached with the idea of establishing a museum on the Villa Louis property and, in 1934, came forward with a novel plan to deed the property to the city but to retain ownership of all objects and to direct a major restoration. Virginia Dousman led the charge that would result in the creation of "Colonel Hercules Dousman's Historic Ante-bellum Home," a house museum open to the public.

During the 1930s transformation of Villa Louis into a house museum, the family had made the decision to restore the home to the 1850s Brick House on the Mound period. Tales of a wily fur trader wresting statehood out of an untamed wilderness, although exaggerated, had a romantic appeal that may have seemed more compelling both to the Dousmans and to the public they hoped to attract.

Throughout the war years, attendance declined, and the burden on the city for the upkeep of the home and the land surrounding it, which by this time included a municipal park with a swimming pool, playground, and an athletic field, was onerous. By 1949 Villa Louis was in need of serious maintenance. Dousman family members, who had never lost interest in their family home, fostered discussions between themselves, the City of Prairie du Chien and the State of Wisconsin that, after much tumult, resulted in the 1952 designation of Villa Louis as the first historic site to be owned and operated by the Wisconsin Historical Society.

Providentially, it appears the Dousman family was incapable of throwing anything away: when Mary Young Janes, the only child of Violet Dousman Young, Nina and Louis's eldest daughter, died in 1989, she bequeathed many family heirlooms to Villa Louis, including a treasure trove of several hundred photographs, letters, and business records. These photos and documents from the 1880s to early 1900s enabled Villa Louis staff to re-create a visual record of the most important house interiors. They also provided clues for an architectural scavenger hunt that led staff to search under porches, beneath moldings, in boxes of curtain remnants, and in trunks of wallpaper fragments. Architectural fragments long-stored in attics and basements now made sense, and a picture of the past emerged with greater clarity than previously believed possible.

As early as the 1970s Villa Louis staff had undertaken research in the hope of establishing a more cogent story line that connected the architectural history, the extensive collection of furnishings and accessories original to the house, and the remarkable saga of the Dousman family. With the receipt of Mrs. Janes's bequest, they knew they had an opportunity to create a historic context that, as Michael Douglass, director of Villa Louis, says, allows us to "transcend our own time and enter another. Places like Villa Louis can

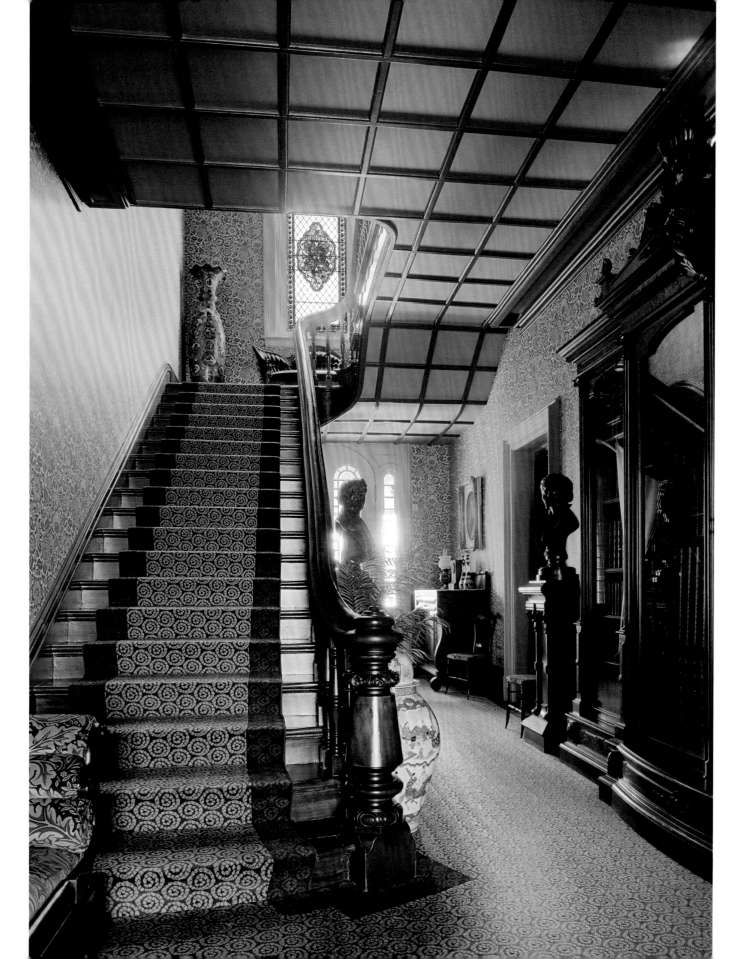

Mirrors were integrated into most Victorian rooms. The reflected light made the rooms appear brighter and larger, and style-conscious Victorians also checked their appearances frequently.

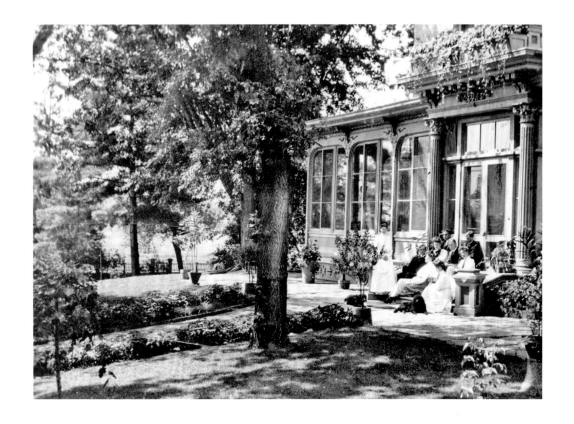

ABOVE: The Dousmans and their friends enjoy a lovely summer day on the steps of Villa Louis, circa 1898. RIGHT: A glass porch has remained a constant feature throughout all the renovations.

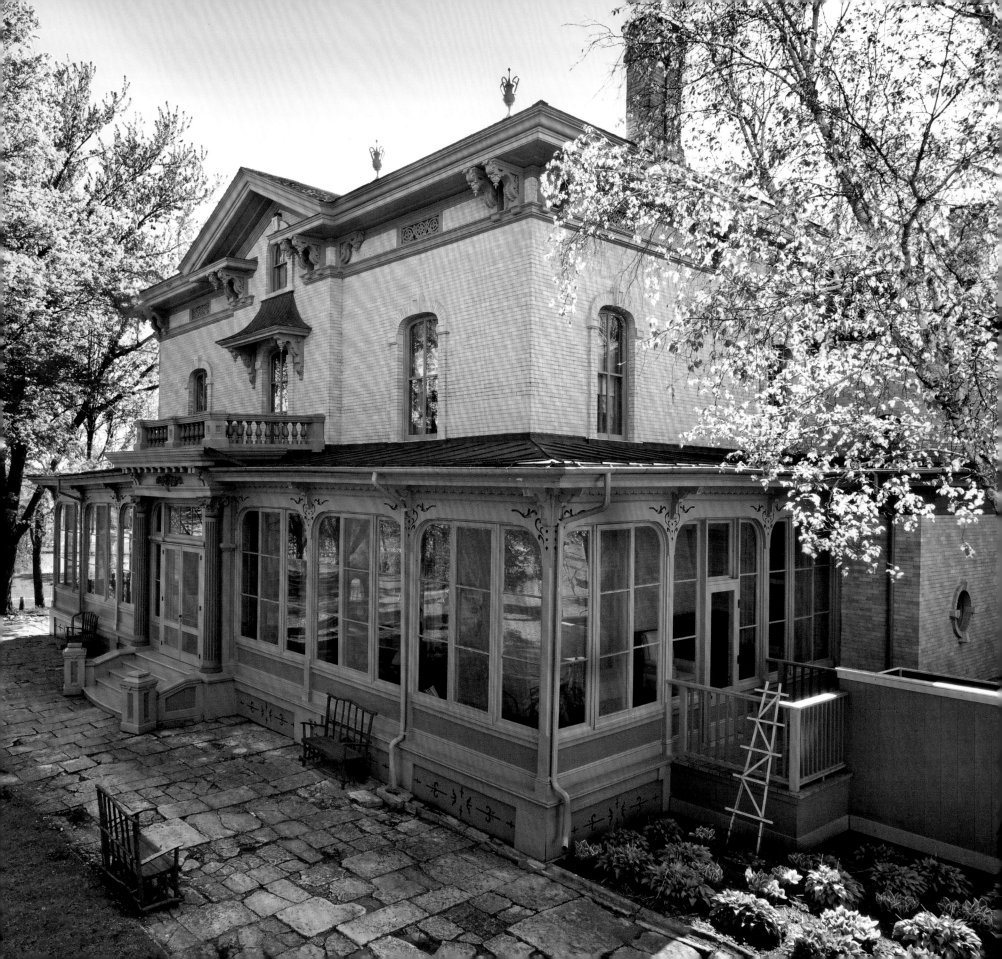

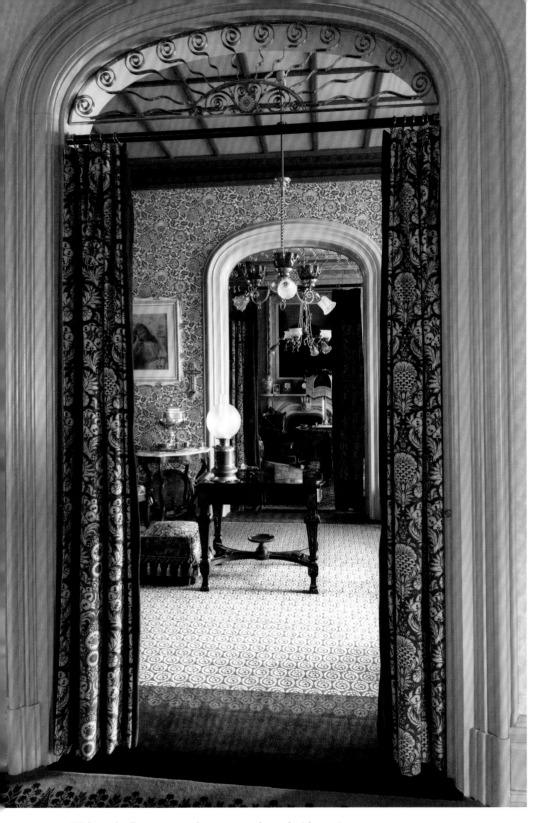

Wide and tall ornamented entryways draped with portieres minimized drafts, while the archway grill allowed light and air into the rooms.

help us find meaning in our own lives because we connect with the past through people."

Mrs. Janes's legacy helped Villa Louis staff build a compelling case for an unusually well-documented restoration of the site to its late-nineteenth-century appearance. In 1994 a grant was received from the Jeffris Family Foundation of Janesville to develop a restoration master plan. The master plan sparked additional funding from the foundation, the State of Wisconsin, and numerous private donors that helped bring together a team of national and international experts including historians, architects, engineers, artisans, craftsman, and builders. Restoration was implemented in three distinct phases, with the first phase completed in 1998, the second in 2003, and the third in 2005.

A GLASS PORCH MAY SEEM an odd feature for a Wisconsin home, but southwestern Wisconsin summers can be hot and humid. The center window in each grouping of three hinges and is screened, permitting a column of fresh air to enter the porch from all directions. Tall, narrow, hood-molded, symmetrical arched windows draw the eye up to the cornices decoratively inscribed with curved scrolls. The large house is not showy; it's a place of refuge, fitting comfortably into the surrounding acres.

Villa Louis, like the Octagon House in Watertown, is uncharacteristic of house museums in that all areas of the home are restored and accessible to the public. Generally, the bedrooms, kitchen, and servants' quarters are the last to be restored to as high a level of accuracy as major living areas. In the Victorian era, it was considered improper to photograph intimate rooms, such as bedrooms, bathrooms, and kitchens. On the other hand, public rooms were often professionally photographed. Those images, kept in family albums, were proudly displayed. Such photographs later provide, as was the case at Villa Louis, information to historians, curators, and fabric and paint restorers as to how a house looked during a specific point in time.

Crossing over the threshold of Villa Louis, it is possible to imagine that John J. McGrath, Joseph Twyman, and their crew of workmen just exited through the back door, packing up their tools before heading back to Chicago. The fabrics are brilliant, the furnishings gleam, and the carpets are thick beneath your feet. The reception hall, sitting room, parlor, and dining room yielded the most extensive documentation, not only from

historical photographs but also from surviving fragments and samples of wallpapers, curtain fabrics, trims, and upholstery. Moreover, an unusually large percentage of the original furnishing, paintings, and other decorative accessories remain in these rooms. As a result they are the most faithful representations of Twyman's elegant design and Nina Dousman's taste.

All of the family bedrooms on the second floor, along with Nina Dousman's dressing room, the family bathroom, and a wide hall furnished as a comfortable sitting room are restored. Each room conveys the tenor of the inhabitant and the Villa Louis staff added interpretive details to help tell the story of the former residents' lives. These family rooms stand in contrast to the spare and almost anonymous quality of servants' bedrooms where a constant stream of young women, often recent immigrants, lived and worked.

The Villa Louis household always included a staff of servants in addition to the Dousman family. At least five such servants had bedrooms in the residence, with the placement of their rooms reflecting their status and responsibility. Housekeeper Penelope McLeod

The Evolution of a Plan

Contrary to the stereotype that Victorian houses are comprised of a rabbit's warren of lowly lit and overly cluttered rooms, the Victorian house plan is not necessarily visually or spatially constricted.

The Victorian interior presents a myriad of visual stimuli. The Victorian sensibility and style was one of presenting rich colors, decorative wall patterns, and ornate fittings as a backdrop to the items that represented the Victorian world. During this first consumer age, a plethora of books as well as objects of science and art were meant to present or place the Victorian in his or her time and in this world—and therefore were prominently displayed.

But if we turn up the lights, open those pocket doors, and draw open those curtained partitions, we can enjoy a phenomenally rich play of space from one defined room to another.

The larger Victorian home was typified by the importance of the central hall as the organizing element. Here a servant would meet a visitor, who, before the advent of the telephone, would request a meeting in person and deliver a calling card. The family would use this hall to move between the parlors, the library, and the dining room, or to ascend the stairs to the bedrooms above. A service stair provided servants with access from the kitchen and pantry to the basement below and to their quarters above. A service corridor between the dining room and the kitchen on the main floor was mirrored above with a corridor connecting the family sleeping quarters to the domestics' quarters and service stair.

Around 1890, as is clearly illustrated in David Handlin's *The American Home* and Jessica Foy and Thomas Schlereth's *American Home Life, 1880–1930,* economic and social changes came to bear on the American home and its architecture, changes that diminished the dominance of the Victorian style. By the 1900s the popularity of the bungalow made a home economically feasible for a burgeoning middle class bursting out of American tenements. Economic realities forced efficiencies in design such as a more open plan that maximized room size while minimizing corridors where possible. Servants or hired help could find more lucrative jobs in the factory workforce, so servant quarters shrank or disappeared. Without live-in help, the upkeep of multistory homes became a burden to their owners. New homeowners directed their budgets away from the great entry hall to modern services like plumbing and central heating. Modern lighting and good heat distribution allowed the functions of several different Victorian spaces to be combined effectively in one room—as seen, for example, with parlor and library spaces becoming one living room. Rooms may have grown smaller, but more windows and electricity provided better illumination. The application of home economics and public hygiene created more efficient layouts in the kitchen, pantry, and bathroom. Thick carpets covered with oriental rugs were replaced by light-colored wood floors that provided clean, crisp hygenic spaces.

The bungalow had begun to "open" up the plan, and Prairie plans expanded on this by removing even more interior walls and using multiple windows to create a closer connection to the landscape in smaller housing that felt more expansive. Revival styles of the 1920s returned to more conventional plans but in more expansive ways. Art Deco and modernism replaced walls with the transparency of glass and ever-expanding—and shared—space.

The Great Depression and then World War II curtailed most construction while increasing the need for new housing. The open Prairie plan combined with the demand for modern housing materials and designs to fuel the popularity of the postwar ranch. The pendulum movement back and forth between modern approaches to residential floor plans and more conservative stances continues today.

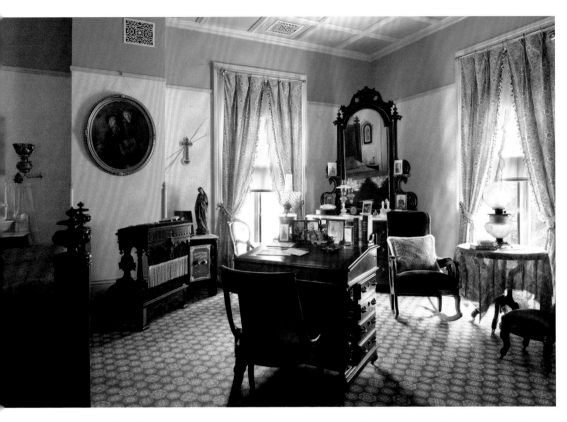

ABOVE: Mrs. Dousman's bedroom was her private retreat. Its furnishings relate to her activities: prayer, correspondence, and private conversations. The low, armed or armless chairs allowed for the long, full skirts of the day. RIGHT: Louis Dousman's self-sufficient estate included a two-story building housing the estate office and guest quarters (right) as well as the ice house and preserve house (center).

and manservant Louis Le Brun together served the Dousman family for nearly seventy-five years and their bedrooms are set apart from those of other servants. Decorative details including a bit of sanitary wallpaper discovered during restoration planning suggested that they may have had a voice in the decoration of their rooms. These choices seem to reflect design tastes more pedestrian and mainstream than the artistic tastes expressed in the rooms occupied by the Dousman family.

Villa Louis today presents a sense of unbroken continuity from the first Dousman occupancy of the Brick House on the Mound. The Cream City–brick Italianate home sits high upon the ancient Indian mound. Surrounded by tall, arching deciduous trees, artesian wells, and a broad expanse of lawn with flower gardens, one almost expects to see the Dousman family playing golf or croquet or conversing by the stone grotto. Contemporary life is far removed from Villa Louis, creating the illusion that no time has passed since Louis and Nina came home to Villa Louis along the rolling Mississippi River to raise their five children. •

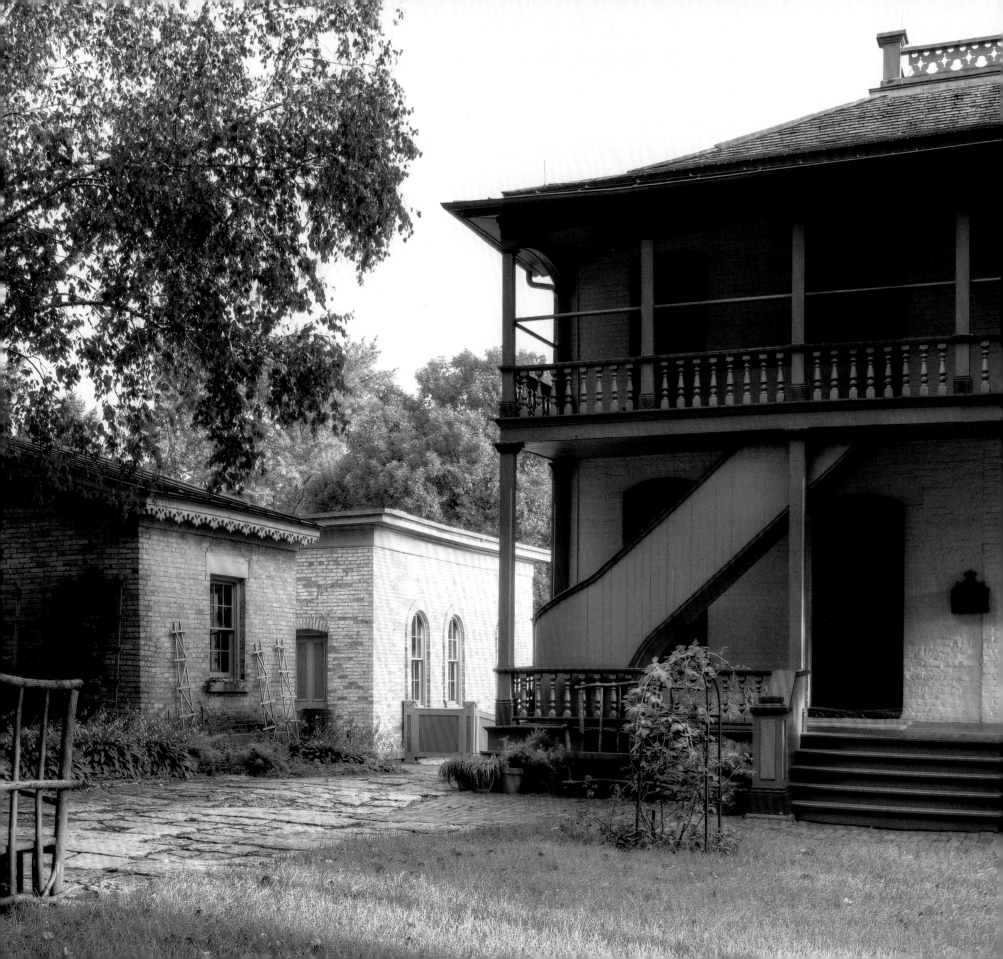

Harold C. Bradley House

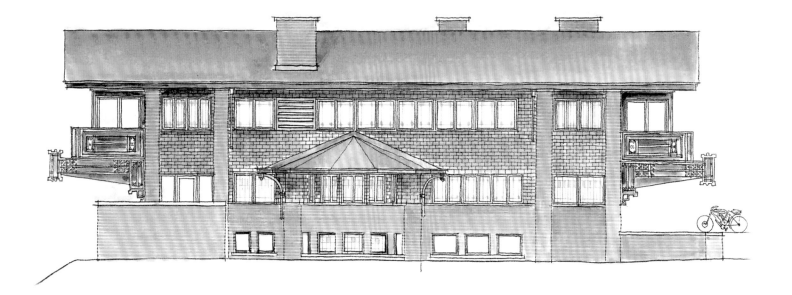

ON SEPTEMBER 15, 1915, the University of Wisconsin chapter of the Sigma Phi Society assumed ownership of the Louis Sullivan–designed Prairie School house on North Prospect Avenue in Madison from Harold and Josephine Bradley. Sigma Phi had been looking for a permanent home with character in which its twenty members could live under one roof.

As an organization, Sigma Phi believes that architecturally significant houses contribute to its core values of scholarship, character, and leadership. Sigma Phi's Bradley house has been called the first or second most beautiful fraternity house in the United States. Its primary competition is Sigma Phi's Greene and Greene–designed home near the University of California–Berkeley campus.

IN 1906, JOSEPHINE CRANE was a junior at the University of Wisconsin when she took a class taught by Professor Harold C. Bradley, a native Californian who had received his Ph.D. from Yale and was teaching biochemistry and physiology at Madison. Two years after they met she accepted his marriage proposal. The couple lived for a while in rental property near the campus. By the time they had two small children, they started thinking about building a home. Professor Bradley purchased an oak-covered hilltop in the University Heights neighborhood, and Josephine's father, Charles C. Crane, came forward with a gift that would cover the costs for the design and construction of the couple's home.

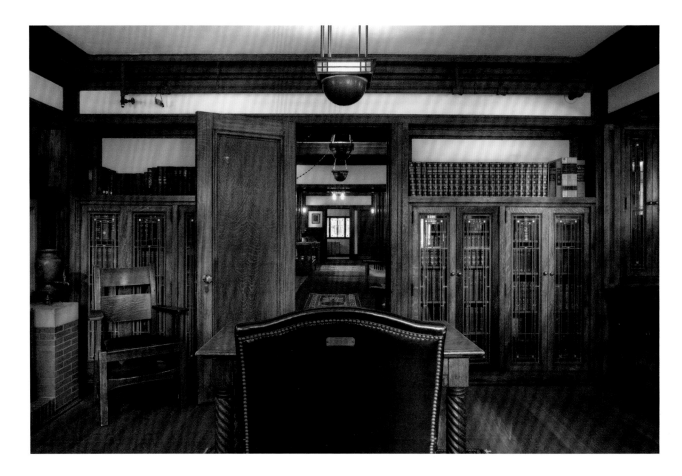

This room originally was Harold Bradley's study; today it is the Sigma Phi president's office and library. After a devastating fire in 1972, a fire-suppression system was artfully fitted in along the upper molding throughout the building.

Charles Crane was a plumbing and elevator magnate from Chicago and a longtime friend and business associate of renowned architect Louis Sullivan. In 1909 Crane told the couple he wanted Sullivan to design their home. They accepted the generous offer. Sullivan had designed several homes, but he was not primarily regarded as a residential architect. Along with his partner Dankmar Adler and his protégé, Frank Lloyd Wright, Sullivan was a leader of the Chicago School of design. Among his Chicago projects were the Auditorium, the Schiller Theater, the Transportation Building at the 1893 World's Columbian Exposition, and the world-famous Schlesinger and Mayer department store (later home to the Carson, Pirie, Scott & Company) known for its modern, glassy design and its rich, cast-iron ornament. Sullivan's skyscrapers—such as the Wainwright Building in St. Louis, the Guaranty Building in Buffalo, New York, and the Bayard Building in New York City—set the standard for the new combination of technology and style.

Early in Sullivan's practice with Dankmar Adler, Wright joined the firm and was assigned many of the residential commissions. Wright suggested that Sullivan hire George Elmslie, a Scottish architect with whom he had worked in the office of Joseph L. Silsbee. Elmslie was well regarded for his exquisite draftsmanship and detailing, particularly of ornament.

Elmslie became the project architect who took Sullivan's concepts for residential projects and realized them as architecture. In Sullivan's later years he was a difficult man for clients to deal with and, because Elmslie assumed responsibility for working out the details of Sullivan's residential projects, many have attributed the Bradley house design to Elmslie. But in a letter to Wright, Elmslie wrote that the Bradley house architectural concept was entirely Sullivan's, with his own contributions being client relations and developing the concept into architectural drawings.

The Panic of 1893, followed by another financial panic in 1907, created economic hardship for architects, but especially for those with an impressive portfolio of built work, stature in the architectural community, and a prickly temperament, as Sullivan had. With little architectural work, Sullivan spent less time in his Chicago office and more time in his private club writing about his theories of transcendentalism and architecture. The Bradley home was Sullivan's only commission in 1909.

BOOKS ON THE WORK OF LOUIS SULLIVAN include a photograph or two of the exterior of the Bradley house, typically a detail of the massive cantilevered eastern sleeping porch. It is rare when more than a paragraph is dedicated to discussing the design and plan of the house. More often, the paragraph is a dismissive statement about the difficult relationship between the architect, patron, and client.

It is generally agreed that the Bradley house was not a proper fit for the Bradley family. There was an earlier design that the Bradleys rejected as far too grand for a professor and his family. Although they were well-to-do, they claimed they did not want their home to stand out from other professors' homes. Most architects consider the executed plan to be the superior one, for it connects with the site in a meaningful way. The first plan was

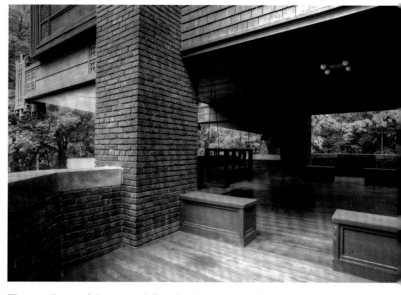

The cantilever of the second-floor bedrooms over the western porch provides shelter from the elements and a quiet place to watch an approaching Midwestern thunderstorm.

If architect Louis Sullivan described walls of brick as tapestries, we can also use this fabric analogy to describe his Bradley floor plan.

Consider the Bradley plan as a bolt of tartan cloth composed of vertical and horizontal dotted lines representing the structural module used to support the house as well as to impart a sense of rhythm as the visitor moves from the entry at the north through the space to the south. The plan's solid brown fill, or *poché*, represents the columns and walls that are the structure; wall voids describe glazed openings, portals, or half-wall guardrails at the cantilevered decks. The plan's architectural tempo is reinforced by Prairie elements such as repetitive windows throughout and flanking expressed columns along the entrance hall that culminate at the library, with its harmoni-

ous curved wall of leaded casement windows.

At the intersection of the north-south and east-west wings, the lines of structure are carried into the ceiling by expressed soffits that imprint the building's geometry onto the open floor plan while also defining the separate zones of east terrace and dining room and that of the living room and west terrace. The second-floor cantilever wings so evident from the exterior are here apparent in the supporting walls of the first floor, which are conveyed by the east and west line projections on either side of the living and dining rooms.

The beauty of this Prairie plan lies in the creative interweaving of different elements in a tartanlike geometric organization that yields a cohesive and visually dynamic result.

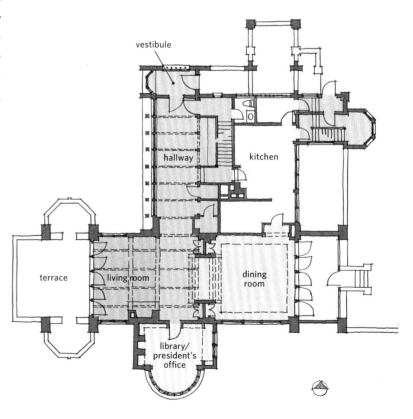

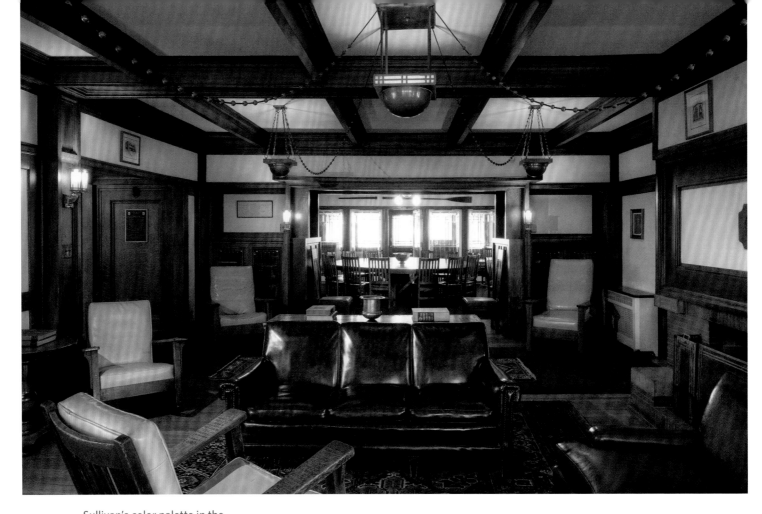

Sullivan's color palette in the Bradley house is simple: light-colored plaster contrasted with the dark oak woodwork and maple floors. Symmetry and balance, as seen in this view from the living room to the dining room, are his major design tools.

a fairly ostentatious design, with an elaborate arrival sequence and a servants' wing jutting off at a 45-degree angle from the main house. The excess was apparently too much for the young Bradley family, who said they were more interested in camping, hiking, tennis, cycling, and skiing than in impressing the neighbors. Sullivan's second design proposal for the Bradleys was built.

Both Harold and Josephine Bradley were avid outdoors people. Harold was a strong proponent of the Greek philosophy of the integration of mind and body, and he was a founder of the University of Wisconsin Hoofers, an outdoor sporting organization open to students and the university community. The Bradleys were both committed to the Sierra Club. Harold would serve as director and national president; his father had been a founding member. The couple was known for their philanthropy to worthy causes.

One might think that a shared love of nature would have bonded Sullivan with the Bradleys. Sullivan often turned to nature for inspiration, which he references in this quote from his essay "Ornament in Architecture": "But for this we must turn again to Nature, and, hearkening to her melodious voice, learn, as children learn, the accent of its rhythmic cadences. We must view the sunrise with ambition, the twilight wistfully; then, when our eyes have learned to see, we shall know how great is the simplicity of nature, that it brings forth in serenity such endless variation." Nature-derived botanical motifs were incorporated into his design for the Bradleys.

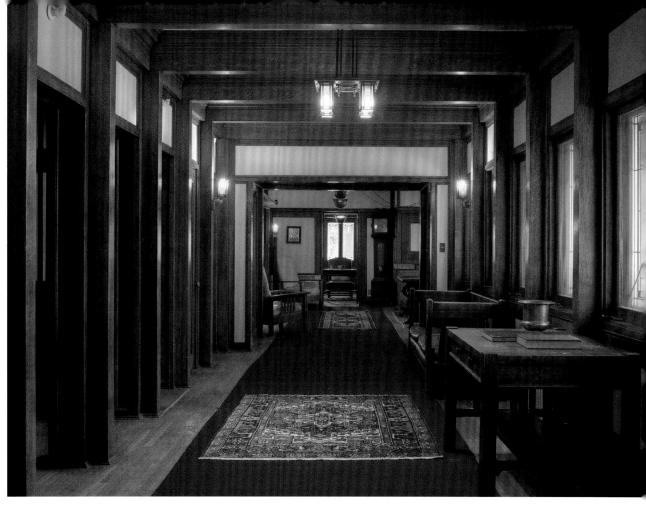

Still, the house didn't fit the family. The fault was not with Sullivan. He was doing what he did best: grand architecture on a grand scale. Mr. Crane could not be faulted: he was trying to help out an old friend while giving his daughter and her husband a gift. Nor were the Bradleys ungrateful. The home was beautiful, inside and out. The first impression is of its overall massing formed by a dark palette of the building materials, from the roof and siding shingles to the earthen-red brick. Upon closer inspection, the details of the irregular shapes of the wood shingles and the brick and the rich composition of delicate stained glass imbue the home with a warm, tactile character. Inside, the oak woodwork glows warm against the white plaster walls, and the colors and geometric shapes in the stained glass glisten and glint. Much of the furniture was designed specifically for the house, to complement the interior spaces in terms of proportion, color, and material. Josephine had worked closely with George Elmslie on the design of the interiors. But not long after the couple and their children moved in, they were already considering a different home, by a different architect, on a different site.

The reception hall visually terminates at what was Professor Bradley's office. Perhaps architect Louis Sullivan was making a statement about the importance of the head of the household—or perhaps he was demonstrating that every axis has a terminus.

Some critics have reasoned that Sullivan's residential projects were failures because he had no concept of family life, having been raised by his grandparents in rural Massachusetts. Married late in life, and for a very short time, Sullivan and his wife, Margaret, lived either in hotels or rented rooms and had no children.

A common criticism of the Bradley house plan is that the room arrangement was unsympathetic to the fact that Josephine was deaf. The relationship of rooms off dominant hallways would be a challenge for a wife and mother who wished to have a stronger visual command over her home. Why Sullivan did not acknowledge Josephine's deafness as a design criterion is a mystery. Why the Bradleys were unable to communicate their design needs is also unclear. In a letter he wrote years later, Harold Bradley noted that Sullivan considered Charles Crane to be the client. He also found the architect to be diffident toward his and Josephine's concerns.

There had been many elements of the Sullivan-designed home that the Bradleys did not appreciate. They thought the living room was too small and too dark, the dining room too cavernous, and the halls too wide. The east-west orientation of the living rooms was ill-considered for the long Wisconsin winters, and the deeply projecting sleeping porches

contributed to a shadowy atmosphere in the home, even in summer. The dark-stained oak throughout the entire house was too formal and gloomy for the young family. There is little documentation of what the Bradley family thought about the exterior: the charcoal-colored wood and earthen-red brick give the house the appearance of a silhouette—even in broad daylight.

THE 10,000-SQUARE-FOOT HOUSE sits on a wooded corner lot and, as massive as it is, it reveals its elevations slowly. The most striking feature is the almost overwhelming cantilevered front sleeping porch ornamented in true Sullivan brilliance. Sullivan referred to the cantilever supports as "everlasting arms." Most of Sullivan's bas-relief ornament in his commercial building projects was fabricated in terra-cotta or cast metal, as befitted the large scale of skyscrapers and department stores. Here, we see such decorative elements in the cantilever's stylized flower motif. To achieve the same quality of craftsmanship in wood—a material more in line with the human scale of residential design—is a great compliment to the carpenter and to Sullivan's belief it could be accomplished.

When built, the Bradley house occupied an entire block in the up-and-coming University Heights neighborhood. One of the Bradleys' architectural neighbors was the Prairie School–style Gilmore House (known as the Airplane House, for its sharply angled, projecting second story), which was designed by Frank Lloyd Wright the same year he designed the Robie house in Chicago. The fast-growing neighborhood began to feel too densely populated for the nature-loving couple.

A real estate agent who was developing a hilly, wooded subdivision on the west side of Lake Mendota approached Harold Bradley with a proposal. He asked if the Bradleys would like to build a new residence on one of his Shorewood Hills lots if he could sell their Sullivan-designed home. The agent just happened to know that the Sigma Phi Society was looking for a residence that could accommodate twenty college men gracefully. Once the decision to move was made, the Bradleys began selling off parts of their property. In 1914, building on a positive working relationship developed during the design of their first home and cemented during the fruitful process of designing their summer home on Cape Cod, the Bradleys commissioned George Elmslie to design their next Madison-area

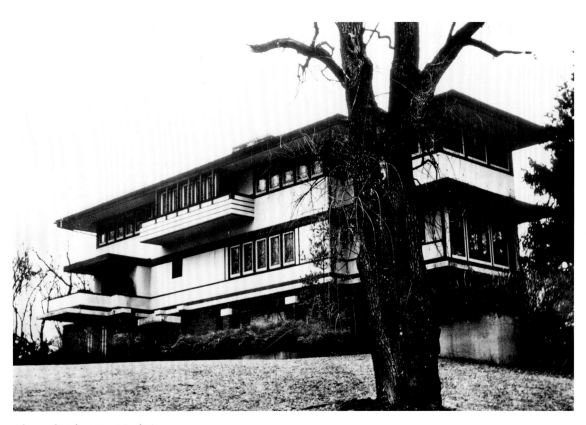

After only a few years in their home by Louis Sullivan, the Bradleys moved into their second Madison-area home, which was designed by Sullivan protégé George Elmslie.

Prairie School Hallmarks

Principally favored in the Midwest between 1900 and the 1920s, the Prairie School movement found its philosophical impetus in the transcendentalist writings and the organic aesthetic works of Louis Sullivan.

Low-pitched hipped roofs ❶ with wide overhanging eaves ❷ typify Prairie School architecture. Eaves, cornices, and monumental bases of masonry ❸ with raked joints were used to emphasize horizontal planes that were often punctuated with large vertical supports for porch or entryway. In addition to these "tapestries of brick," Prairie palettes included stucco; horizontal board-and-batten siding and wood trims in window sills and rectangular window boxes; and flowers in flat, geometric pedestal urns. Windows, generally arranged in ribbons or continuous planes ❹, featured geometric patterned glazing in casements or the top sash of double-hung windows. Upper floors tended to be treated in contrasting colors or materials to help them "soar." Decorative friezes and door surrounds composed of bands of nature-inspired and geometric details in Prairie architecture are often called "Sullivanesque" ornamentation (see here in the cantilevers) ❺.

In period, temperament, and palette, the Prairie School had much in common with the Arts & Crafts style. While Frank Lloyd Wright was the best-known practitioner of Prairie in Wisconsin, additional examples of Prairie architecture in the state were executed by Purcell and Elmslie, Walter Burley Griffin and Marion Mahony Griffin, Percy Dwight Bentley, Russell Barr Williamson, Louis Claude and Edward Starck, Arthur Heun, and George W. Maher. The Bradley house stands as a fine example of a Prairie design as translated by Sullivan, yet influenced by the work of his students.

residence. In 1915 the Bradleys sold their home, at very favorable terms, to the members of Sigma Phi.

The Bradley family was much happier in their new home, a sun-filled Prairie-style design by the firm of Purcell and Elmslie. Elmslie had left Louis Sullivan's office and, given his discussions with Josephine on the design of the interiors of their North Prospect Avenue home and his 1911 design of the Bradleys' Cape Cod cottage, Josephine felt confident that he understood their priorities: a lighter colored exterior, brighter interiors—essentially a home that was less brooding and more cheerful in appearance. The houses do resemble each other closely. The Bradley II house interiors are cloaked in dark oak, sleeping porches abound, and the windows are delightful compositions of linear leading and geometric colored glass. Given that the couple had seven sons, the hallways, dining room,

The Badger, the yearbook for the University of Wisconsin, featured the new home of the Sigma Phi Society for the first time in 1918, three years after its members took up residence.

and living room in their second home were more spacious than most homes at that time, but less imposing than their first home.

In an odd way, the Bradleys' rejection of Sullivan's design placed them in the unique position of being the clients for two architecturally significant homes in the Madison area. Only a few college professors can claim that distinction.

SOMETIMES A HOUSE is just waiting for the right family. A family composed of twenty men requires a more formal scale of living spaces and more shared spaces than a family with small children would desire. The Bradley house is much more suited to a social organization than a family.

It is one thing to love a house for its architecture, as the Sigma Phi Society did when it purchased the Sullivan-designed home. It is another to take on the expense, inconvenience, and responsibility of restoring it when the building has been devastated by fire. On an exam night in 1972, flames shot out of the attic. In a short time the roof, attic, and entire second floor were almost completely destroyed. Water and smoke caused extensive damage to all areas of the house, from the roof to the basement. Fortunately, everyone in the house escaped.

After careful consideration, the active members of Sigma Phi and alumni decided to restore the home rather than relocate or rebuild—in spite of having been advised that restoring a Sullivan design would be unlike other restoration projects. There were a great many serious concerns. Where would they find craftsmen with skills to match those of the turn of the century? Would they be able to locate a set of original drawings? Where could they find wood species and colored leaded glass to match the originals? Could they accurately estimate the cost of such a large undertaking? Could they raise enough money to meet the proposed budget? What would happen to their fellowship if members were scattered all over campus for two years or more? And, finally, if they went ahead with the restoration would they regret their decision?

There was an upside to the disaster. After almost sixty years of use as a home for college men, the house would benefit from updating. A new and more energy-efficient mechanical system could be installed along with a comprehensive fire-protection system. Art glass windows, while beautiful, were not energy efficient; the addition of storm windows would be a good conservation measure. The heavily used kitchen and bathrooms could be modernized. It also seemed like an excellent time to create an informal lower-level recreation room out of an unfinished basement to relieve some wear and tear on the formal living room. The lower level, similar to an English basement, has sizable square windows on the south and west sides that bring in daylight; access to the spacious backyard is just a few steps up. The sunny, southern, lower-level bay would be the perfect place for additional study space. All of the proposed improvements would add to the quality

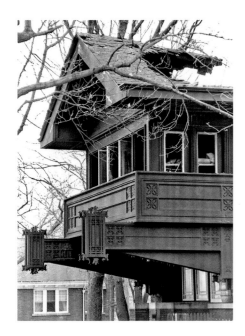

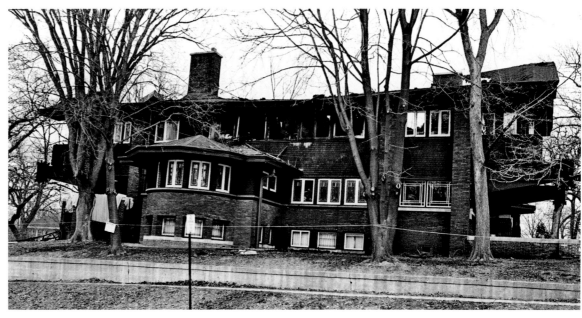

of student life and be of long-term, cost-saving benefit to Sigma Phi. More and more, it seemed as though restoration was not just the right thing to do, but the only thing to do.

As with any architectural project, a good team is necessary for success. More than two hundred Sigma Phi members, alumni, and friends stepped up when asked for financial donations. As is the case with most fund-raising efforts, one person became the financial guardian angel: for the Harold C. Bradley House that person was Arthur C. Nielsen, a highly successful businessman who had been a top University of Wisconsin student, an avid tennis player, and a member of Sigma Phi.

Once the Sigma Phi Society had a financial guarantor for the restoration, a team including architect Mark Purcell along with contractors and consultants was put together to perform the task of rebuilding the house in time for it to be rededicated in October 1973—only seventeen months after the horrific fire. Sigma Phi members past and present came from all over the country to participate in the celebration, which was an affirmation of the contribution that great architecture makes to a society such as theirs—and to the larger society as well.

DINNER AT SIGMA PHI IS A RITUAL for all active members. The spacious square dining room with its oversized round dining table perfectly expresses the classical architectural circle-in-the-square geometry. The intersecting oak ceiling beams and wall columns dominate the living room warmed by the brick and wood fireplace meant to be symbolic of community life. The mellow glow emanating from pendant brass lights bounces off the living room's brass-beaded swags.

College students live by a different clock than the majority of the population. Diurnal rhythms are less important to them as they seem to live a twenty-four-hour day. Students

LEFT: Although the 1972 fire destroyed much of the roof, attic, and second floor, the house remained largely intact.
RIGHT: Extensive fire, smoke, and water damage did not stand in the way of Sigma Phi's determination to repair and rebuild their home.

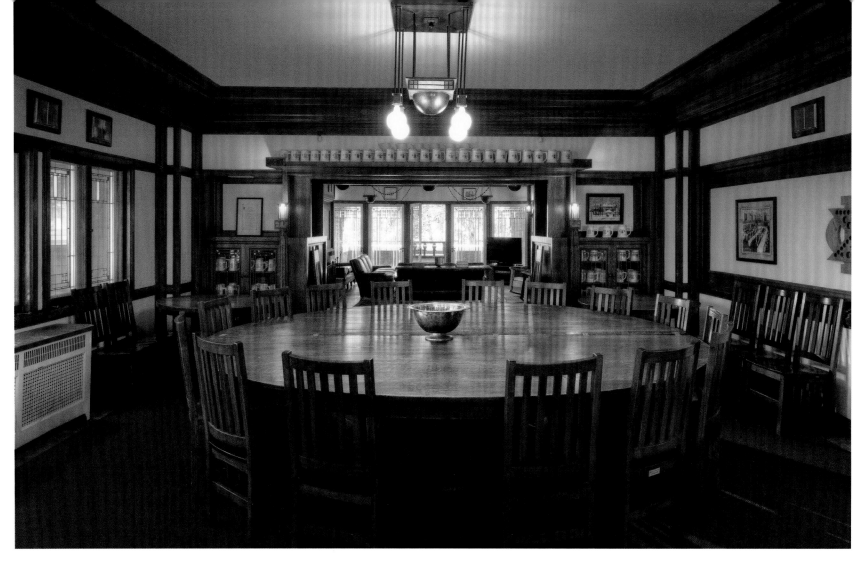

Sullivan advised his students that every architectural problem contains its own solution. While the Bradleys found the house to be overscaled for their casual family, it is an ideal home for the Sigma Phi family.

are gone for the entire day attending classes, so late nights and weekends are the times when the house members have a chance to interact. Orientation for sun is less critical under these circumstances than it was for the Bradleys. The hallways on both the first and second floors serve as a sort of interior street. While the Bradley family found the halls too wide, the students use them as hang-out space where they can catch up with each other without impeding traffic or disturbing roommates who may be sleeping or studying in the rooms.

The Sigma Phi men do enjoy carrying on the Bradley family tradition of sleeping—all winter long—on sleeping porches. The second floor of the Bradley home has seven bedrooms, all fairly generous in size, and several sleeping porches. Professor Bradley's study is now a library and office. After the fire, a second library was built on the lower level, and while it is a contemporary addition, it is entirely sympathetic to the style of the home.

The Sigma Phi Society continues to be an excellent steward for this architectural treasure, which was designated a National Historic Landmark in 1976. The only other home designed in Sullivan's office during this period was the Henry Babson house in Riverside, Illinois, which was built in 1909. Demolished in 1960, bits and pieces of the Babson home can be found in period rooms in museums and on offer at auction houses. Given

the fire damage to the Bradley house, the Sigma Phi Society could have turned its back on history and allowed the Sullivan design to be destroyed and its artifacts sold off. Instead, its members made the brave choice to preserve the house, which is the only extant residence designed by Sullivan in the twentieth century. People come from around the world to Wisconsin to pay homage to Sullivan and his magnificent contribution to modern American architecture. •

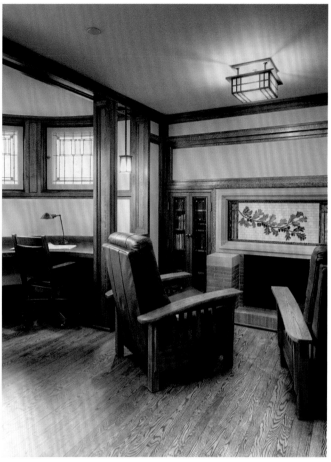

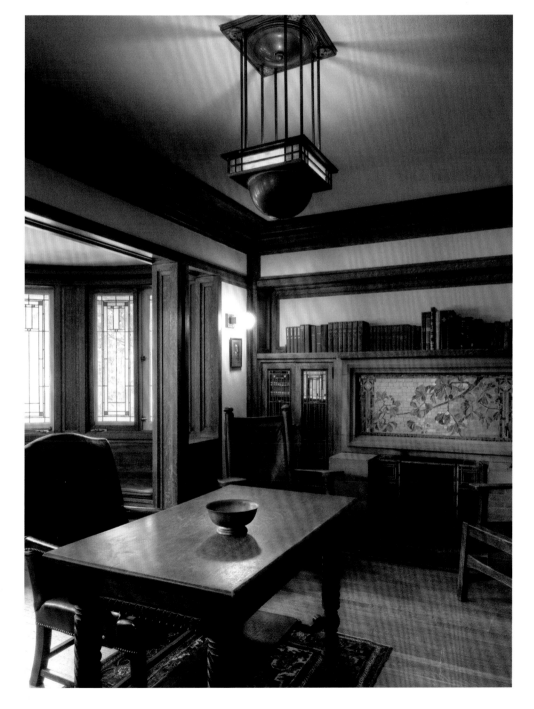

LEFT: Geometric stained glass, angular mosaic tiles, and warm woods embellish Harold Bradley's study with the details employed by architect George Elmslie. ABOVE: When Sigma Phi needed additional study space, the society, with architect John W. Thompson, renovated basement storage, taking cues from the original design upstairs while avoiding mimicry with a fresh interpretation.

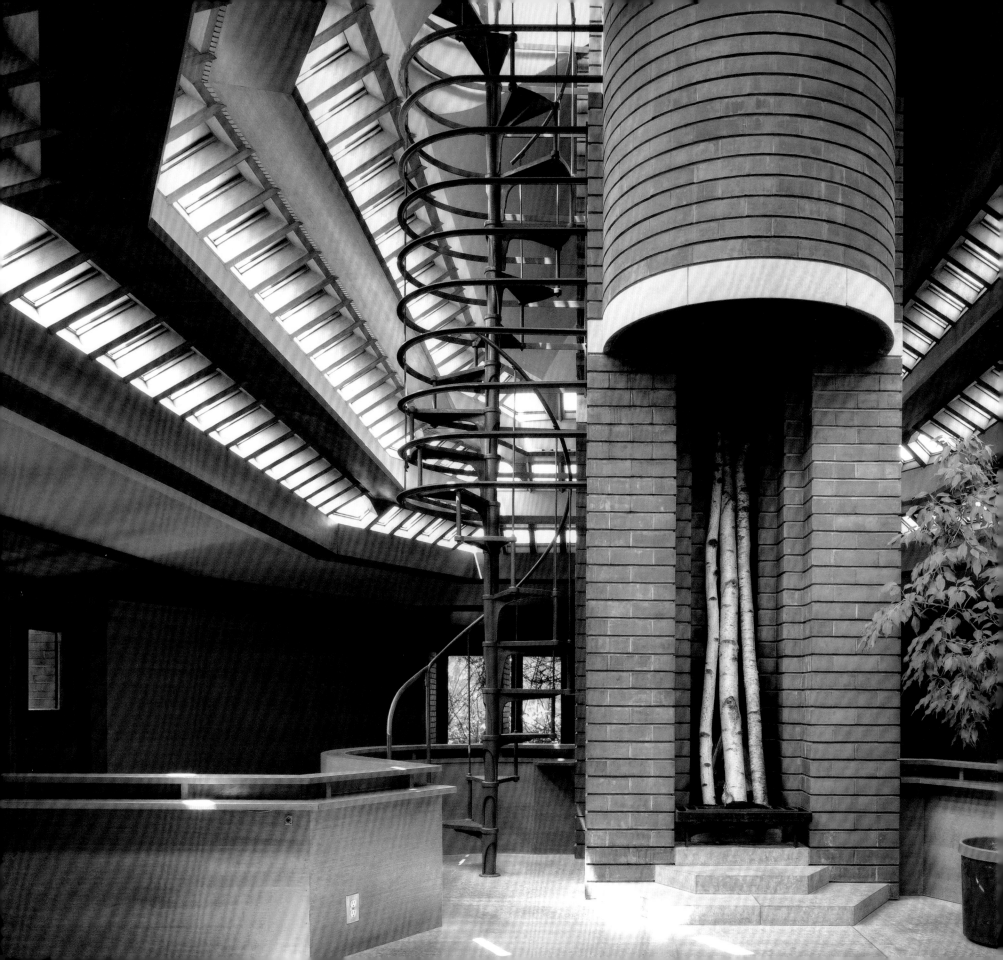

IN 1922 HERBERT FISK "HIB" JOHNSON JR. was celebrating his graduation from Cornell University; by 1928 he was the president of the S. C. Johnson company, the third Johnson to head the Racine-based, family-owned company started by his grandfather Samuel Curtis Johnson, a carpenter who realized he could make more money selling floor-care products than installing floors. The company had prospered under Herbert Fisk Johnson Sr., who added to the line of products and took the company international. Hib was twenty-eight when his father died in 1928; the following year the Great Depression threatened the company and its five hundred employees worldwide.

Facing the daunting responsibility of keeping the family business alive and his employees employed, Hib Johnson did not sit still. Other business owners may have been immobilized, but he got moving.

Johnson was a big believer in marketing and its power to get people excited about new products. Marketing was a new field, made necessary by expanding markets. A strong local reputation was no guarantee of capturing and keeping customers. In 1929, in an unusual move for the economically depressed times, the S. C. Johnson company bought a Taperwing WACO, a two-person open-cockpit biplane, to use as a marketing vehicle.

When Johnson company executives would fly in to deliver cases of wax to local department stores, it was news; crowds (and reporters) would show up for the spectacle. Johnson obtained his pilot's license and named his WACO cabin plane the Johnson Wax-

OPPOSITE: Spiraling toward the sky, the skeletal steel stair culminates in a private perch— the aptly named crow's nest— where Johnson's children could watch for the approach of his plane.

wing after his most successful product, Johnson's Prepared Wax. Johnson, always very involved in the company, used the plane to fly himself to meetings. In 1935 he took a daring, 15,500-mile flight to Brazil in search of locations of the Carnauba palm, a plant whose leaves produce the raw material for a superior wax. Hib Johnson, his company, and his employees not only survived the Great Depression, they thrived. Johnson was a man on the move in 1936. His next big step was a major facilities expansion. Johnson needed an architect as dynamic as he was.

Jack Ramsey, S. C. Johnson's general manager at the time, was uncomfortable with Johnson's selection of a local architect to design a new office building for the company. The architect was a good man and a good architect, but Ramsey thought there had to be another architect who could better fulfill Johnson's desire for a building that was more inspirational than the typical "drab and dull" working environment. Ramsey just did not see a spark in the proposed drawings, and persuaded Johnson to meet with Frank Lloyd Wright, whom he considered a talent equal to Johnson. Both men enjoyed a challenge and were unafraid of exploring the unknown, whether in architecture or industrial chemistry. Two days after speaking with Wright, Johnson requested that the local architect stop work. Johnson was aware of Wright's fame, an attribute that makes news and generates interest. The architect had potential to replace the plane as a marketing vehicle.

THE GREAT DEPRESSION WAS A DIFFICULT TIME for high-profile architects such as Wright. In reality, commissions for Wright had been sparse for almost twenty years following the personal tragedy of the murder of his mistress and her children by a deranged houseman at Taliesin, his home and studio in Spring Green, in 1914. Overcome with grief, in the year between 1914 and 1915 he designed only five projects in addition to ongoing work at Taliesin.

At the end of World War I, Wright was able to resume travels to Japan that had been interrupted by the war to begin, in earnest, on the commission he'd received in 1914 from the Imperial Emperor of Japan to design the Imperial Hotel in Tokyo. He spent most of the next six years in Japan designing and supervising construction of the hotel, where he perfected his use of the cantilever (overhanging interior and exterior balconies) and interlocking spaces (the visual meshing of two or more separate spaces into one complete composition)—skills he would later call on in the design of Johnson's home.

Upon his return to the United States, Wright reinvented himself as a California architect. The majority of his built work between 1922 and 1934 was located in Southern California and Arizona. He did have work in the Midwest and New York and even a project in Egypt, but nothing compared to the Imperial Hotel in scope or prestige. Wright spent a considerable amount of this time at Taliesin, rebuilding various structures and implementing his educational program, the Taliesin Fellowship.

Professionally, things began to turn around for Wright in 1934 when he met Edgar Kaufmann, a successful Pittsburgh businessman. In December of that year they visited the property Kaufmann owned in Bear Run, a rural area of western Pennsylvania. By May

1935 Wright began preliminary sketches for what would become one of his most iconic residential projects: Fallingwater. Wright's confidence was undergoing reconstruction.

In 1936, at age sixty-nine, Wright was likely perceived by younger architects as out of step with the streamlined, machine-age ideas of International-style architecture. During this period Wright was known more for his writing, particularly his theories of organic architecture—his belief that a building should be in harmony with its natural environment in its proportions, materials, and design as well as appropriate to the era in which it is created in terms of technology, materials, and social patterns—and his antipathy to cities than for new built works. Wright began writing about his idea for a new city prototype, which in his words was the result of "wedding the city and the country." His ideas struck most architects as odd; few could envision a time when skyscrapers would rise out of the open land of the countryside. Wright thought his chance to prove his theory may have come when Hib Johnson approached him.

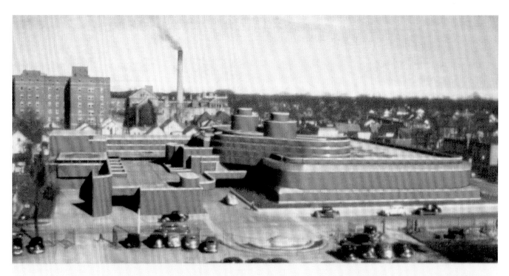

• An authentic original in the world's modern architecture. The new headquarters office of S. C. Johnson & Son, Inc., Makers of Johnson's Wax, Racine, Wis. Designed by Frank Lloyd Wright.

Frank Lloyd Wright designed the headquarters for Johnson's company prior to being commissioned to design his home. The Johnson Wax Administration Building was declared a National Historic Landmark in 1976.

Wright tried to talk Johnson into relocating the Johnson Wax Administration Building from the City of Racine to the countryside. His suggestion was rejected. However, the building, completed in 1936, was not only a huge and welcome commission but also an opportunity for Wright to test new ideas and add a large commercial building to his repertoire—a building type he had not done for many years.

In 1938 *Time* and *Architectural Forum* magazines showcased Wright on their covers as the nation's greatest architect. Not surprisingly, the startling engineering capabilities of the Johnson Wax Administration Building's dendriform columns and use of glass tubing in lieu of glass panes was much profiled. Those articles were the impetus for Wright's comeback. Over the next ten years he completed thirty-four residential commissions, as well as numerous university and public projects. In 1944 he designed the Research Tower for S. C. Johnson & Son.

IN 1936, JOHNSON AND JANE ROACH, his second wife, were living in the Victorian-style Johnson family home in Racine. Now a family with four children, his son and daughter and her two sons, the Johnsons had been thinking about building a home that better accommodated their blended family. By this time Johnson, who had been gradually assembling land, owned 50 acres in Wind Point, a small community on Lake Michigan north of Racine—the perfect site for their new home.

An oft-told story of how Wright got the commission to design Johnson's home is that Johnson made an offhand remark about how he liked his new building so much he would just bring in a cot and sleep right there. Wright's response was, "I'll build a home for you."

And he got the project. Upon completion, Wright would call Wingspread—so named for the spreading "wings" of the four living zones across the site—his greatest residential design.

Wright designed according to his theory of organic architecture and his belief that a building should be in harmony with its natural environment. He had a great love of nature, with a capital *N*. A typical first step in Wright's design process was to walk the property with the client and think about where the house should be sited, what the views to and from the home would be, and what site improvements would be made. Wright considered the site and the building as partners.

Wright had six principles that he applied to his residential architecture, the third of which—"a building should appear to grow easily from its site and be shaped to harmonize with its surroundings"—was clearly invoked at Johnson's home and the rolling field upon which it was built. Wright's site-planning principles still set the standard for many architects and landscape architects.

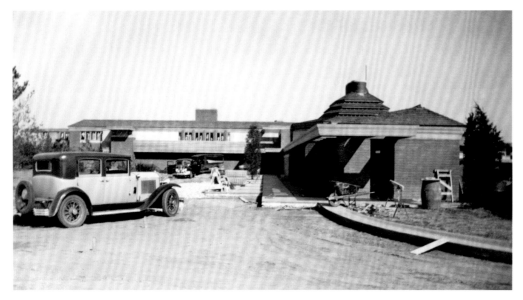

Even during construction Wright's design principles were clear: the Johnson home would be a long, low, horizontal building that rose from the ground.

The Wingspread site is almost always described as a prairie; in fact, the original site was a combination of agricultural land and woods. To attract birds and wildlife, Johnson, who was fond of going on nature walks with his children, dammed a stream to form a pond. Early on, Johnson registered the land as a state wildlife preserve to protect the land from future development.

The word *prairie* came to be associated with the restrained quiet horizontality of the Midwestern landscape. In Prairie School architecture, low roof lines, overhanging eaves, and horizontal banding were all used to reinforce the horizon line where the broad fields of the Midwest meet the skyline. There is an ongoing debate as to whether Wingspread is the last great Prairie house or Wright's first residential step into modernism. Arguments for Prairie cite Wright's six architectural propositions:

- Simplicity and repose
- There are as many kinds (styles) of houses as there are kinds of people.
- A building should grow from its site.
- Natural colors (earth and autumn) are easier to live with.
- Do not force materials onto a building but respect their natural abilities and individual abilities.
- A house that has character stands a good chance of growing more valuable as it grows older while a house in the prevailing mode, whatever that mode may be, is soon out of fashion, stale, and unprofitable.

All six of Wright's Prairie principles were achieved at Wingspread.

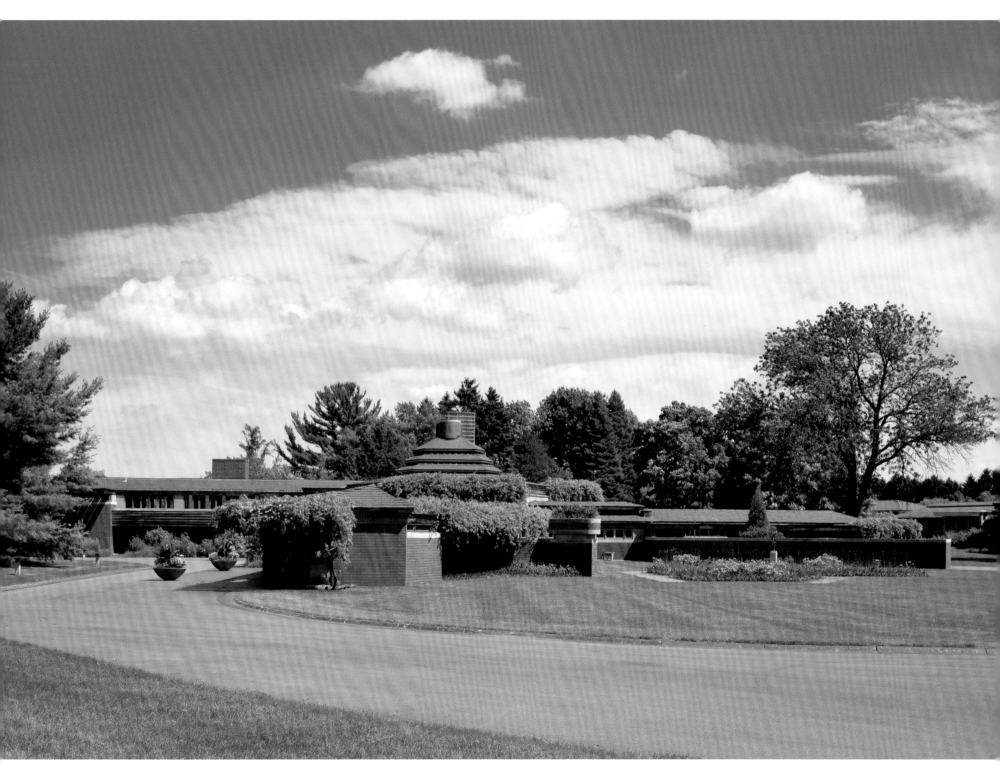

On approach, Wingspread appears to be a series of pavilions within a walled garden.

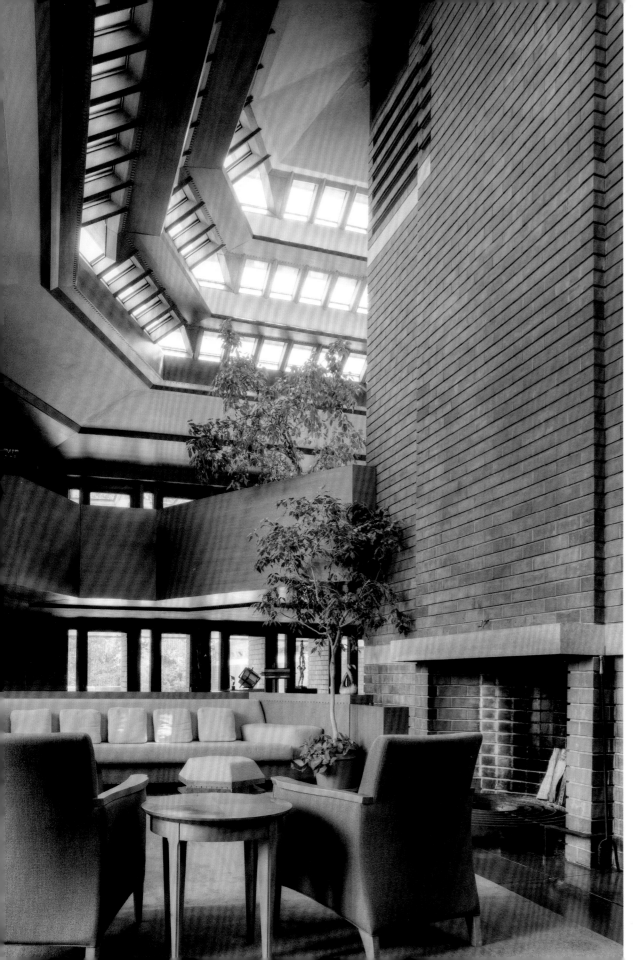

AT 14,000 SQUARE FEET, with a length of 300 feet in one direction, Wingspread is the largest and longest house Wright ever designed. The 24-by-40-foot Great Hall has the same footprint as a typical bungalow. The extreme open plan at Wingspread was a modern idea: neither the living room, family room, dining room, nor library was enclosed by full or even half walls as in typical homes. Instead, one goes from room to room by turning one's gaze, revolving around the fireplace core or ascending or descending short flights of stairs. The seemingly floating cantilevered interior mezzanine is also a modern idea.

The sprawling appropriation of the landscape by the "wings" of the house is not only modern but also suburban. Gone were the constraints of sidewalk setbacks of tight urban blocks. Wingspread belonged to the landscape, not to the city, as was the case for most Prairie School homes, which tended to be built in cities or in dense, first-tier suburbs rather than rural areas. Another modern hallmark is the complexity and contradiction of a very angular and aggressive exterior contrasted with the fluid and encompassing interior. Wingspread is all angles outside, all curves inside.

It is commonly known that Wright liked to control all aspects of the design process, from site planning to china settings. Apparently, Wingspread is one of the few examples where Wright listened to the client for some design direction. On their preliminary site walk, Wright explained his zone theory to Johnson. Wright believed a house should have one open central zone, dominated by a fireplace. This zone,

Layered horizontal banding of the brick courses, the wood mezzanine, and the radiating light shelves ground the soaring ceiling vault. In the three-story volume, the hearth still dominates.

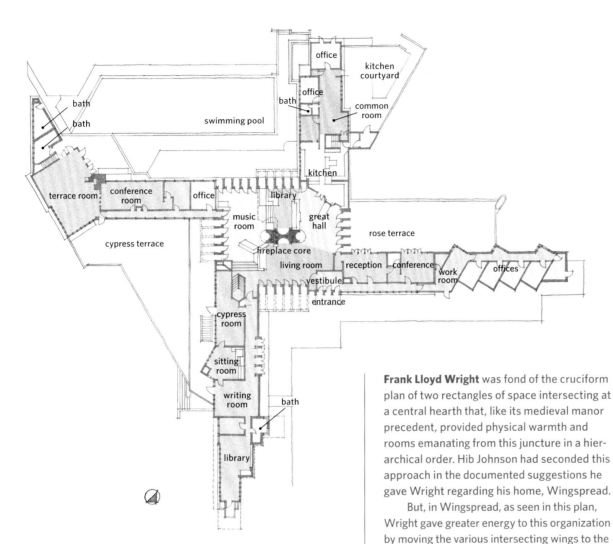

Frank Lloyd Wright was fond of the cruciform plan of two rectangles of space intersecting at a central hearth that, like its medieval manor precedent, provided physical warmth and rooms emanating from this juncture in a hierarchical order. Hib Johnson had seconded this approach in the documented suggestions he gave Wright regarding his home, Wingspread.

But, in Wingspread, as seen in this plan, Wright gave greater energy to this organization by moving the various intersecting wings to the opposing edges of the central ordering space in a pinwheel form. The two-story wing of the master and daughter's bedrooms (now library and writing room) alternated with the service wing; a children's wing (now a large conference room) opposed the guest and garage wing. These private functions were brought together in the public sector of living, dining, and music rooms (which still enjoy these basic functions today) in a dramatic skylit volume that gives visual and functional heart to the plan. Always the master of geometry, Wright overlaid the square and triangle to create the home's physical center locus and the visual focus: the fireplace core stretching up to the octagonal skylight.

which included the living room, dining room, and kitchen, was the heart of the house. Radiating from this area were the service wing, children's wing, the wing with the daughter's and master bedrooms, and the guest and garage wing. Johnson then turned the tables on Wright by handing him a sketch of an architectural concept of four zones radiating out from a center living space. According to Craig Canine, author of *Wingspread,* the official Johnson Foundation guidebook, the central fireplace and skylight were Johnson's idea. The two men clearly were on the same page when envisioning the architectural concept of the home. Interestingly, Johnson used the Drake hotel in Chicago as his design precedent. Wright, who had designed the Imperial Hotel in Tokyo, must have felt very comfortable with his client's vision.

Wright wrote a note asking Karen and Sam Johnson, ages thirteen and nine, what features they wanted him to incorporate in their home. One suggestion—being able to climb to the highest point of the two-story living room—was fulfilled with the glass crow's

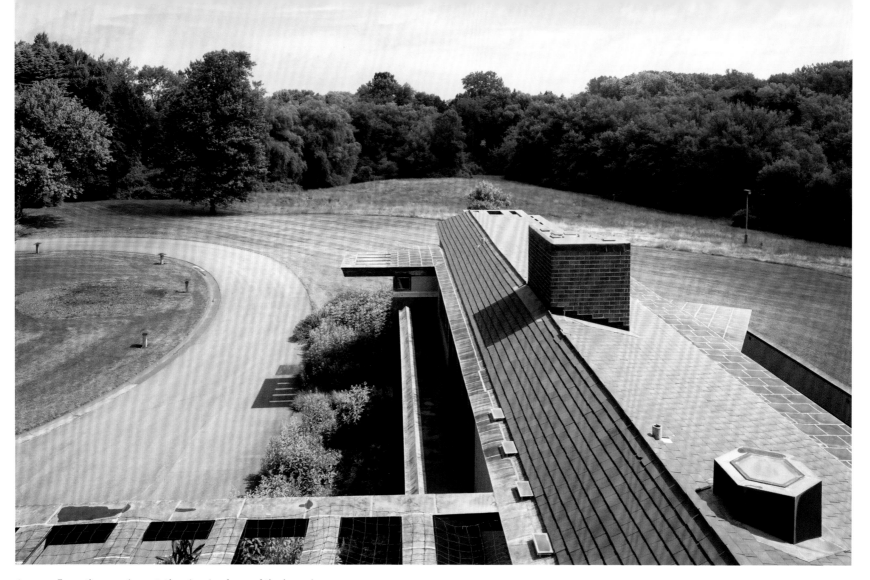

ABOVE: From the crow's nest, the view is of one of the home's wings spreading out into the landscape. BELOW: The children's wing was on the first floor near the playroom and swimming pool.

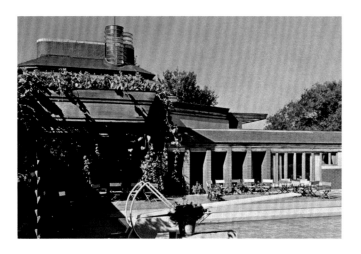

nest, which the children likened to a pilot's cockpit. They would climb up to see their father fly over in his plane on his way back from business trips. Karen requested a balcony off her room, like the one she had seen at Wright's home in Spring Green. The swimming pool was a late addition to the plan; Wright referred to it as a reflecting pool. The kids could burst out from their playroom and jump right into the pool. And then there were the 30-plus acres of lawn, woods, and vegetable gardens, as well as the 20 acres in conservation, to explore with their friends. Lake Michigan and a historic lighthouse were only about a half-mile bike ride away. Wingspread must have been a great place to grow up.

As it is with all families, even the perfect house is not a guarantee of protection from sadness and loss. When Jane Roach Johnson died in 1938, before Wingspread was completed, Wright convinced Hib and his children that the house would be a source of healing for them and that the project should continue. (The home was originally designed for a family with four children, but Jane's children returned to live with her family.) And, as it is with most families, happiness did find its way. When Johnson married Irene Purcell in 1941, Wingspread came alive with people and parties.

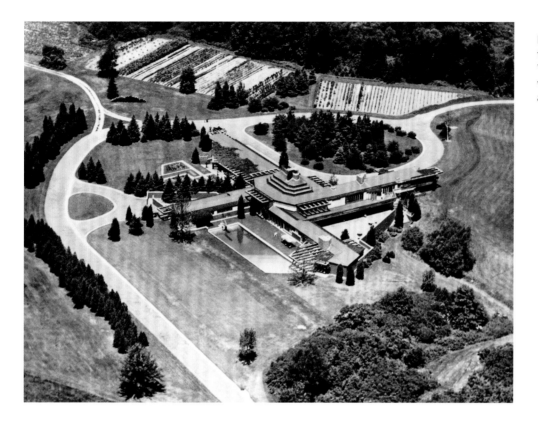

Named for the four wings that jut out across the prairie, Wingspread interacts well with its setting—just as its architect intended.

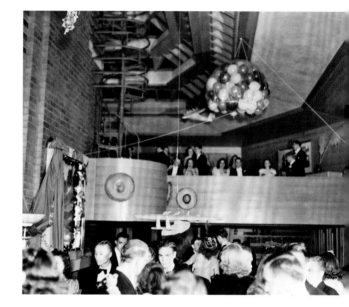

Once called "the perfect party house" by Irene Purcell Johnson, Johnson's third wife, Wingspread was the site of this 1940s bash held in honor of Karen Johnson.

WRIGHT FOUND BEAUTY in the craftsmanship of brickwork. At Wingspread, the horizontal brick that Wright favored is employed on both the exterior and interior walls. Wingspread's Great Hall is an awe-inspiring space: one cannot enter the brick-walled room without immediately stopping and turning one's face upward—it is a completely natural and involuntary response. Soft light from the clerestory windows bathes the entire room throughout the day. Walls of sixteen-foot-tall windows create framed views of the courtyards.

Renowned architectural historian Vincent Scully Jr. observed that the Johnson period was when Wright began exploring curves as a dominant geometry in his architecture, breaking away from the orthogonal relationship of shapes in Western architecture and moving toward the non-Western architecture that looks to earthen forms and light for inspiration. It is often said that Wright sculpted with light; the interior of the Great Hall proves he sculpted with brick, glass, concrete, and steel as well as light and earth. The eight-sided living room—which is not an octagon but rather an elongated 40-by-60-foot space with a glazed tiered ceiling reaching up 30 feet—is certainly not a box. As a pilot, Johnson could appreciate the radiating geometry of his house as he flew over it.

Cherokee-red Streator brick walls with widely expressed raked mortar joints are found inside and out. The floors are a polished, red-tinted concrete that was an early experiment in radiant heating. The golden Kasota limestone sills quarried in southern Minnesota and the white oak wood were materials as simple and quiet as the landscape. Built-in and freestanding furniture, most designed by Wright, eliminates visual clutter. Level

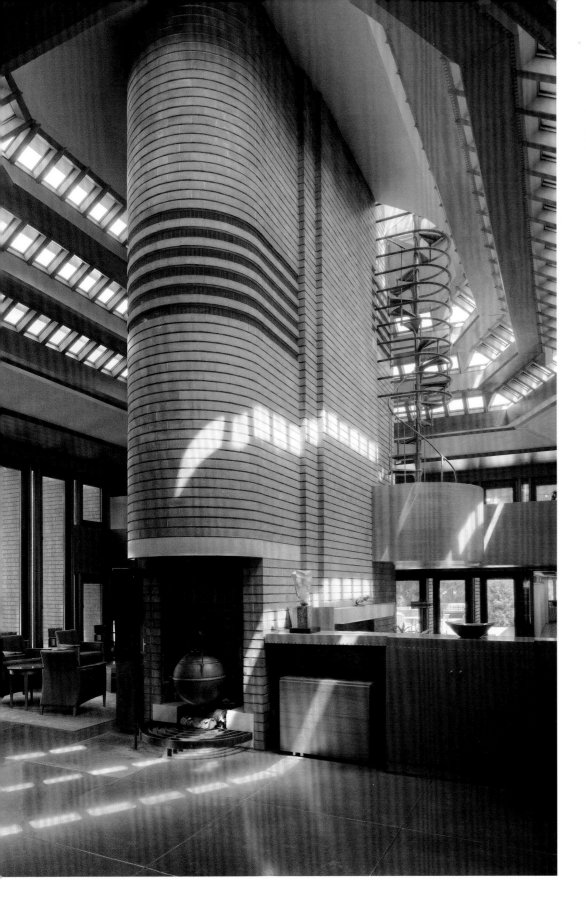

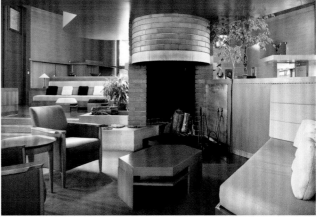

LEFT: Like a sundial, light plays across the central hearth, subliminally creating an awareness of the passing of the hours. TOP: At Wingspread, Wright fully demonstrates his ability to design intimate niches amid grand volumes, enhanced by furnishings he designed. ABOVE: Hib Johnson shares a private moment with his son, Sam, in the Great Hall, 1939.

changes within the house and in the landscape provide the opportunity to experience multiple views of both the interior of the home and the exterior simultaneously. The narrow width of the wings was critical in achieving a sense of enclosure while being in nature. Wright believed that "doors and windows should be integral features of a structure and if possible act as its natural ornamentation." The placement, size, and scale of windows—framing views of the landscape—replaced the need for hanging art.

The home's second floor is the more intimate space. A small sitting room projecting out over the first floor has an excellent view over the living space below and the landscape beyond. Anyone seated in the sitting room is screened from the view of those on the first floor by the low, curving white oak wall that forms the perimeter of the balcony space. A narrow, curved, vertical fireplace on the mezzanine allows for the burning of vertical logs—an unusual and stunning effect. Adjacent to this fireplace is a beguiling, twisting and turning steel stair that leads to the ceiling's peak where, perched on a small platform, the children could look out to Lake Michigan and the surrounding countryside.

His-and-hers bedrooms, two bathrooms, and a sitting room form the master suite. The daughter's bedroom, with its romantic cantilevered balcony, is adjacent to the parents' suite. The boys' rooms were designed as three small, spare rooms off the playroom on the ground floor.

HIB AND IRENE JOHNSON LIVED IN THE HOUSE until 1959. With his children grown, the Johnsons moved into a smaller house, designed by a California architect, that overlooked the property's

Wright framed seasonally changing views between the frames of the glass doors, turning the walls into a gallery of nature's wonder.

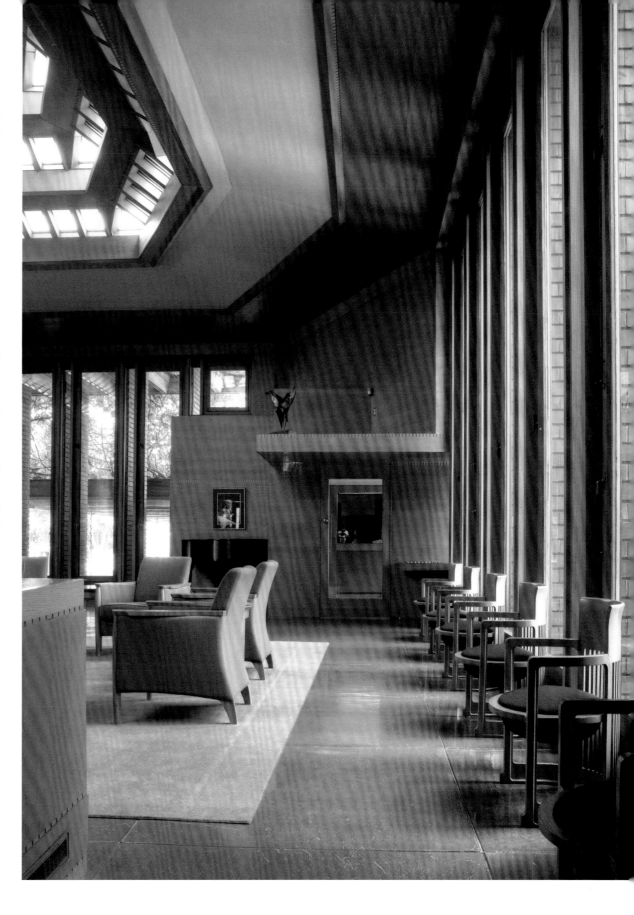

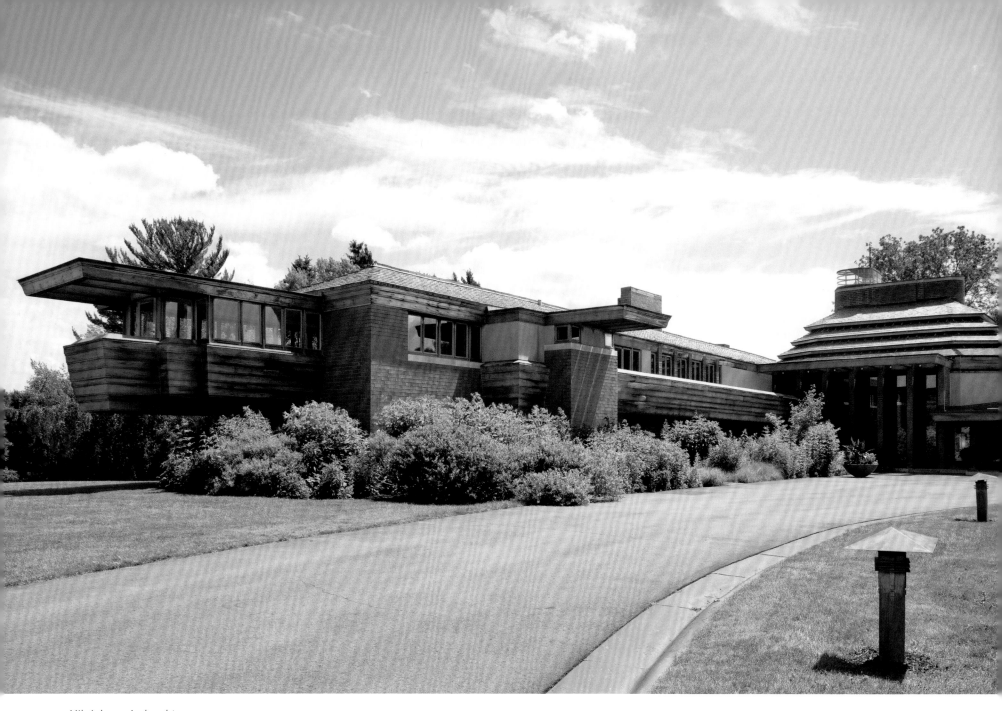

Hib Johnson's daughter occupied the second-floor bedroom of their Frank Lloyd Wright–designed residence. With its cantilevered Romeo and Juliet balcony and windows on three sides, it's the home's most transparent and romantic room.

pond. It was decided that the best way to retain control over Wright's design and maintain Hib and Irene's privacy was to donate it to the Johnson Foundation. The house underwent two years of renovation to make it suitable as a public space. Wright's design was remodeled again in 1978 and 1990 to better serve as office space for the foundation, including the remodeling of the original garage into office spaces. Extensive repairs to the roof were completed in 1997.

Today Wingspread, which was designated a National Historic Landmark in 1989, serves as a conference center for the Johnson Foundation, providing a cohesive and

tranquil environment where people can come together to discuss diverse ideas and solutions for issues facing their communities; democracy, community, family, philanthropy, and environmental topics have all been explored. Thousands of people a year come for conferences and meetings and to tour the building.

Frank Lloyd Wright is an icon of American architecture due to his fierce independence, his belief that he could design the best buildings in the world, and his mythic influence on architects. His personal failures are forgiven by many because of his incredible professional triumphs. From 1889 to 1959 Wright realized more than four hundred built projects; Wright was his own client for nine of those projects at Taliesin.

Almost everyone knows of Wright as a Wisconsin architect. In the early 1900s he designed a number of small summer cottages on Lake Delavan and started his lifelong development of Taliesin. From 1905 to 1917 his Wisconsin projects were houses, including the Frederick C. Bogk house in Milwaukee. The Bogk house is not a Prairie design; it owes its form and ornamentation to the influence of Wright's design for the Imperial Hotel.

From 1917 to 1925 Wright's office was in Los Angeles. He returned to Wisconsin in 1925, and Hib Johnson's commissions for his company's headquarters and for his home brought Wright back into the limelight and gave his practice another rebirth. Only World War II slowed the number of commissions. During that time Wright was primarily involved in the design of the Guggenheim Museum in Manhattan. After the war, Wright designed twenty-one projects in Wisconsin. Wingspread, thanks to the support of the Johnson Foundation, is among the best-maintained examples of Wright's work in the state. •

Wright's Herbert Jacobs Usonian house in Madison

Wright's Careers

Frank Lloyd Wright was gifted with genius and longevity. His career was equal to that of three evolving architects producing masterpieces of great and different creativity, with each career punctuated by the dramatic exigencies of history. Where Picasso had pink and blue periods, Wright had periods derived from the geometry of squares, circles, triangles, and octagons. Always "organic"—in the sense of architectural interiors and landscape being part of a unified, natural whole—Wright's work was derived from the Shingle style, evolved to the Prairie style, and was followed by his version of modernism, as seen at Wingspread and at Fallingwater. He found his creative coda in the Usonian home.

Deep into the Great Depression, when commissions were slim, Wright designed two of his largest and most extravagant residences: Wingspread and Fallingwater. At the time, he was also working on the Herbert Jacobs Usonian house in Madison, a more modest project that incorporated a career full of residential innovations. With his Usonian designs (the name was derived from an abbreviation of United States of North America) Wright intended to create a distinctly American style that was democratic and affordable. The open plan in his Usonians consisted of functions spatially knit together in a way that lent these small designs a feeling of larger presence. Meeting a con-struction budget of $5,050 plus an architect's fee of $450, Wright's 1,500-square-foot gem for the Jacobs family serves both as a prototype for the modern ranch and classic contemporary of the 1950s, and as an exemplar of what we call today the "not so big home."

The functional L shape of the Jacobs Usonian consisted of private (bedroom) and public (living and dining rooms) zones joined at a hinge comprised of a utility core that, in an economic use of space, included the kitchen and bath behind the entry foyer. The central location of the kitchen afforded excellent visual control of the home from this core vantage point. The home was pushed tight to the property line to maximize outdoor space for a private backyard garden that was visible and accessible from both wings.

Wright used a 2-by-4-foot organizing grid that was inscribed in the floors and onto the interior and exterior walls of Ponderosa pine boards with redwood battens. Radiant heat in the floors eliminated the need for a basement and radiators. This, along with plentiful built-ins, maximized comfort in a relatively small space.

Wright designed fifty-seven Usonian homes; twenty-six were built throughout the country—a testament to their ability to adapt to an array of climates and sites. Natural materials and the interplay of spaces imparted a feeling of serenity, variety, and security in a design solution that represented ideas Wright had experimented with for years.

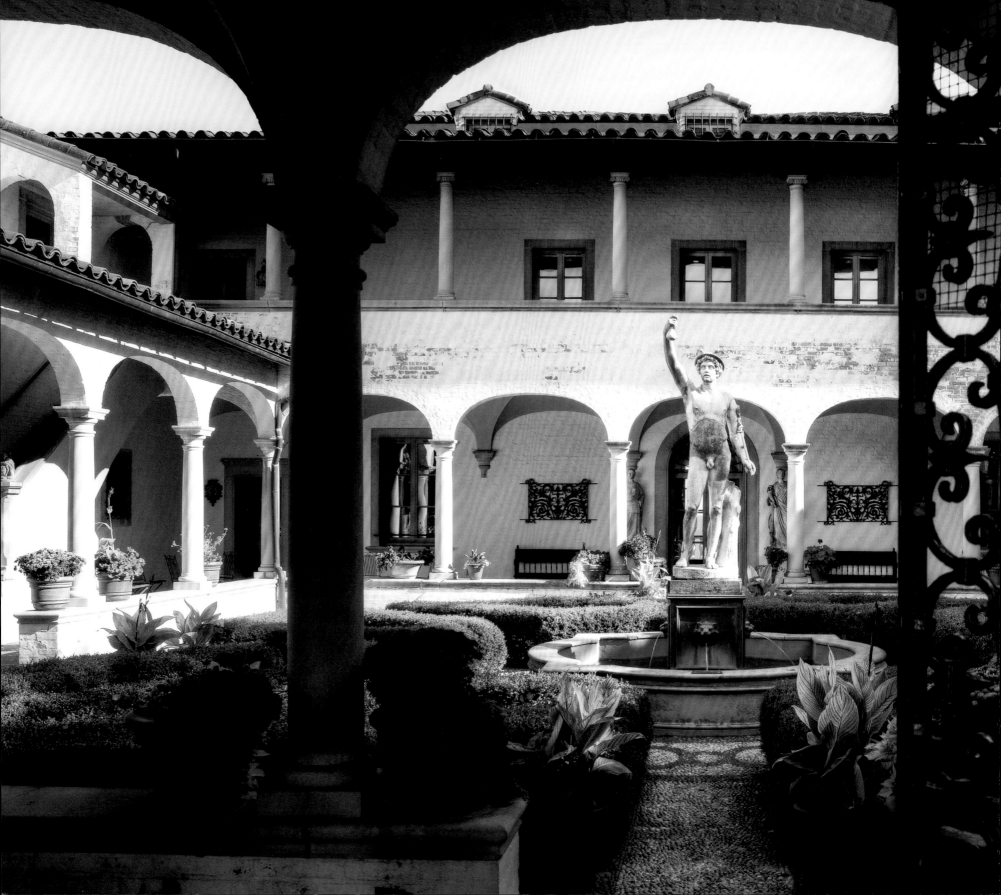

VANGUARD

WISCONSIN'S ABUNDANT NATURAL RESOURCES provided both raw materials and sources of energy, while waves of immigrants supplied an eager and hardworking labor force. Early immigrants to the state had highly valued skills. Many were carpenters, furniture makers, ironmongers, plasterers, and painters who brought beauty to what was then known as the West. Education at an Ivy League college was one route to success for Americans, but a more typical path was that of the entrepreneur, the innovator, and the risk taker.

Wisconsin has been in the vanguard in the development of products from carriages, cheese, cigars, cranberries, paper, plumbing, lumber, lead, leather, boats, beer, bratwurst, bicycles, toilets, tobacco, and typewriters to milk, motors, motorcycles, fur, engines, pens, and cleaning wax. Many prominent businessmen whose companies were associated with these products built remarkable homes as symbols of the success that could be achieved through hard work.

Fairlawn in Superior was built to impress, and from the mansion's windows Martin Pattison could see ships on Lake Superior carrying away the iron ore that made his fortune. Cyrus C. Yawkey moved his family from an island in timber country to a stately Classical Revival two blocks from downtown Wausau when it became obvious that the wild lands were all but played out and the future was in developing cities. Lloyd R. Smith built the stunning Villa Terrace on the eastern bluffs of Milwaukee overlooking Lake Michigan, the shipping port for his industry. And Walter J. Kohler Sr., with great prescience, built a secluded mansion at a bend in the Sheboygan River. Even today one cannot see another building, including his state-of-the-art plumbing fixture factory in the village he built, from within the grounds of his former estate.

It would be fair to state that the majority of the homes represented in this book could have been placed under the Vanguard heading due to the leadership in industry, commerce, or the arts that each of the homeowners exhibited. The four homes selected were chosen as much for the business acumen of the residents as for the way in which Wisconsin's landscape was incorporated into the vision of the home.

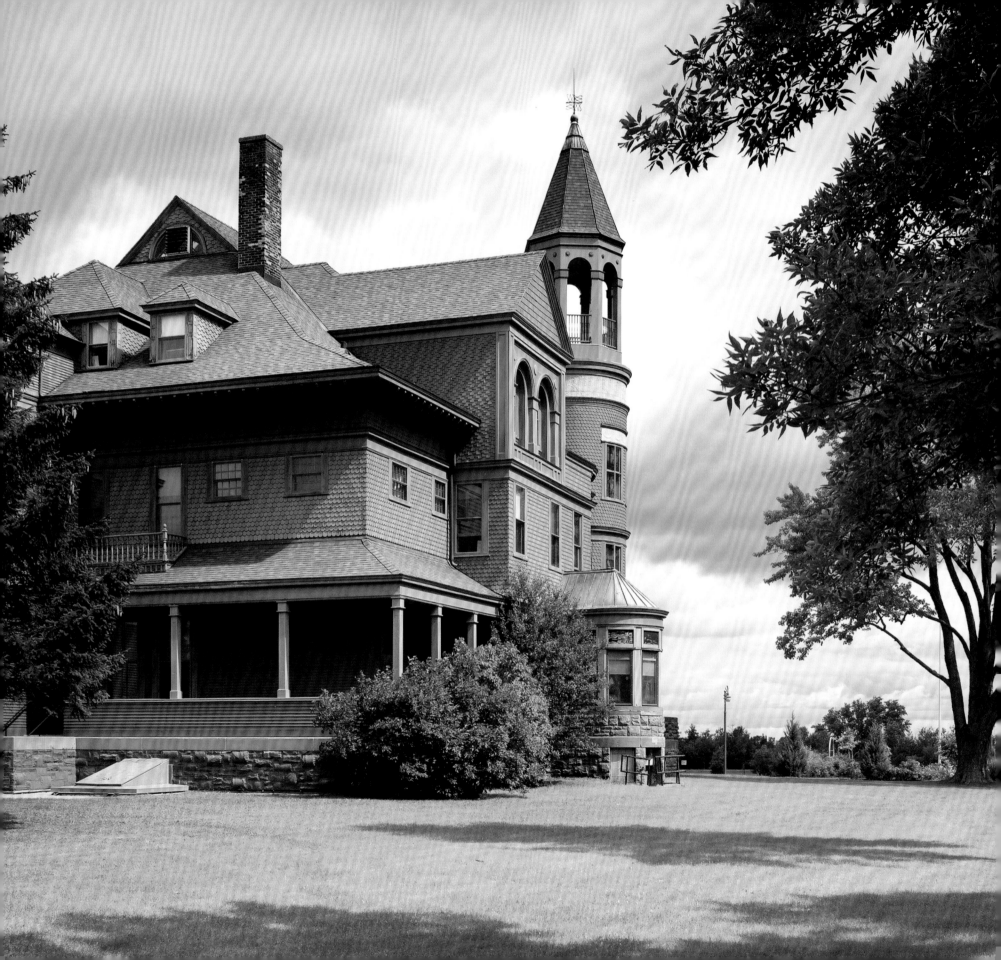

Fairlawn |

OPPOSITE: Fairlawn's expansive grounds with a view of Lake Superior

SOUTH OF SUPERIOR, a geologic and hydrologic phenomenon known as the Continental Divide, or the St. Lawrence River Divide, separates the two principal drainage areas of Wisconsin. Endowed with abundant water, wood, and iron ore, the area attracted dreamers and schemers.

Prior to the incorporation of the City of Superior, the area was home to Indian nations and fur traders. In 1853, only one log cabin stood where the city would eventually rise, but land speculators from Chicago and St. Paul were already greedily buying up land, dreaming of a time when rail, not water, would carry iron ore from the port of Superior all the way to Los Angeles, and Superior would rival Chicago in shipping power and wealth. The Panic of 1857 and the Civil War, however, put the schemes of early investors on hold.

The railroad arrived in Superior in 1881. In 1889 Douglas County was the fourth largest county in Wisconsin due to immigrants arriving daily from the East Coast and fifteen countries in search of jobs, land, and fortune. That year the population of Superior was 9,000; three years later it had mushroomed to 35,000, making Superior second only to Milwaukee in population. Manufacturing concerns boomed, from nine to seventy-nine during that period. Rail freight tripled and locals could choose from four daily news-

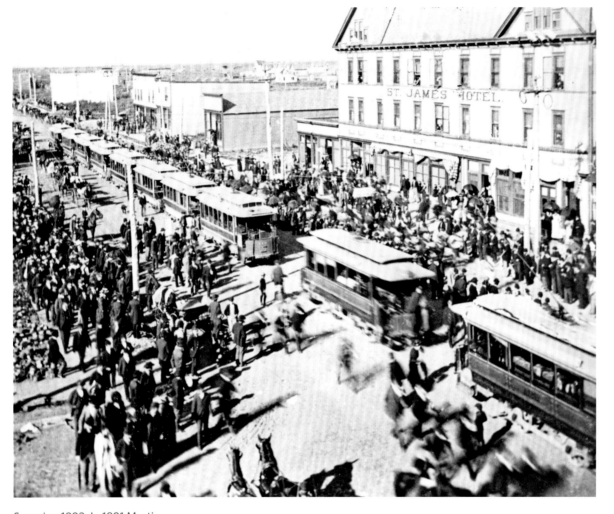

Superior, 1892: In 1891 Martin Pattison, then mayor, commissioned thirteen miles of streets to be paved; a year later the first streetcars were installed.

papers in a variety of languages—Finnish, Norwegian, and German in addition to English—for their news.

Martin Pattison was one of those early dreamers. His parents had moved from Canada to Michigan when he was a boy, and at age seventeen he began to work in the lumber industry as a laborer. Hard-working and ambitious, Pattison and a business partner had their own lumber operation by the time he was twenty-five.

In 1879 Pattison and his brother moved to Wisconsin to run a logging operation twelve miles south of Superior. Pattison left a previous life—a first wife, Isabella Murdock Thayer, and their two children, and his birth name, Simenon Martin Thayer (Pattison was his mother's maiden name)—behind, and he prospered in Superior. While lumber gave him his start, iron ore gave him his fortune.

Adventuresome and bold, he sold his lumber interests and began exploring Minnesota's Vermilion Range for iron ore. Untrained as a geologist, Pattison depended on his observation skills and self-confidence, which led to his discovery of one of the greatest deposits of iron ore in all of Minnesota. Some, however, attribute part of his discovery to the knowledge he gleaned from stories of his second wife Grace's family and their early mining explorations in the region.

WHILE SUPERIOR WAS OFF THE BEATEN PATH as far as high society was concerned, Martin Pattison built a home that made East Coast visitors and investors take notice. In the 1880s increasing numbers of individuals were amassing fortunes from banking, railroads, manufacturing, raw materials, insurance, and other industries. This phenomenon of a class of self-made millionaires was fascinating to the general public and exhilarating for the millionaires, and it set social convention on its head. Few of the nouveau riche knew the rules of polite society and, consequently, new rules had to be written. Lists of wealthy people—and how much they were worth—began showing up in newspapers and magazines in the 1880s. So-called Blue Books (an allusion to bluebloods, or aristocrats) published the names and addresses of "socially acceptable" families in large cities such

as New York, Chicago, and Milwaukee. In 1886 New York society published the first Social Register, an agreed-on, invitation-only list based on "defining the boundaries of acceptability"; entry was by letters of recommendation only.

East Coast society had to admire the pluck and boldness of the fortune makers of the West—such as those who saw opportunity for rebuilding and riches after the Great Chicago Fire of 1871—even if they weren't ready to acknowledge Westerners socially.

Pattison acquired considerable wealth on his own. His goal—to move Superior from an isolated boomtown into a dynamic modern city—was more civic than selfish. In the 1880s he was the sheriff of Douglas County and a Superior school board member. He served three terms as mayor of Superior in 1890, 1891, and 1896. He belonged to many fraternal organizations and was an active church member. An ardent outdoorsman, Pattison particularly enjoyed water sports. In 1917 he discreetly bought 660 acres along the Black River to thwart the building of a proposed dam that would destroy Wisconsin's tallest waterfall, the scenic Big Manitou Falls, which was near the site of the logging operation he and his brother had when they first came to Superior. He donated the land to the state in 1918; two years later it was dedicated as Pattison State Park. Pattison admired Teddy Roosevelt, who, in all likelihood, inspired him to preserve land for public use.

THE GILDED AGE ECONOMY was driven by heavy industries: iron, steel, lumber, and railroads. Martin Pattison was the right man in the right place at the right time. He was one of the wealthiest men in Wisconsin from 1880 until his death in 1918, and like many other well-to-do industrialists his home was extravagant beyond measure.

At this time, most business activities were still a male bastion, but polite society was determined by personal invitations: to be invited to someone's home was a clear indication of being recognized as part of and confirmation of being accepted into society. One's home was a physical manifestation of one's social ranking. Pattison's forty-two-room mansion above Lake Superior—with its distant views over the harbor—was a highly visible symbol of Pattison's wealth and the pride he took in his social standing. The house and carriage house occupied a full city block and could be seen from great distances. Wealthy visitors to Superior, such as John D. Rockefeller, who invested in iron ore carriers known as whaleback ships, and James J. Hill, the railroad executive known as the "Empire Builder," were sure to have seen Pattison's home while traveling to Superior and Duluth, Minnesota.

Construction of Pattison's mansion began in 1889. A newspaper article stated that a contractor had been chosen and work was to begin on Superior's grandest home, but there was no mention of an architect and, to date, no original drawings have been discovered. Some sources suggest that local architect John De Waard was the designer. As with many Queen Anne homes, the plan and elevations are highly personal. It is quite possible that Pattison and his wife, Grace, selected a plan from one of the many popular architectural plan books and then, with their contractor, made revisions that suited their specific desires and needs.

The three-story home was embellished with a four-story turret, projecting cross gables, balconies, and porches. Its foundation was constructed of rock-faced ashlar Lake Superior brownstone quarried in the Arcadia quarry in nearby Amnicon. (Quarries in and around Bayfield, Washburn, and the Apostle Islands supplied much of the brownstone that built block after block of row houses in Chicago, Brooklyn, Harlem, and Boston.) Patterned metal fascia and wood shingles enliven the exterior. At the peak of the attic bay, "1890" is stamped into the copper tympanum. At the time of construction three large ornamented chimney stacks rose from the roof. Typical of the Victorian style in general, windows were abundant and varied, from arched, single, and paired double-hungs to grand bay windows. Ornamental copper panels encircling the turret and front pediment were decorated with wreaths and stylized organic forms.

Originally a wrought-iron fence with a tulip motif and simple finials surrounded the spacious grounds. A scattering of deciduous trees, vines, and small shrubs formed the foundation planting. While no written documentation exists as to why the house came

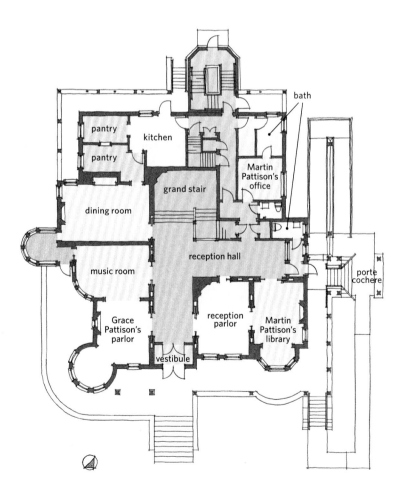

The Queen Anne style is often described as the culmination of Victorian-era housing styles, liberally using pattern, volume, and ornament to define its envelope. But beyond this asymmetrical, eclectic mix is a style that was, for its time, adventurously expressive of its functions and its inhabitants' aspirations.

Principal hallmarks of the style are irregularly shaped, steeply pitched roofs with decorated gables that usually face front; patterned shingles or siding; turrets; and small, upper-floor cantilevers. Chimneys are exclamation points repeated throughout. A decorative porch, defining the entry or wrapping around two elevations, provides the "icing."

Architect Richard Norman Shaw and others in 1860s and 1870s England developed a style that allowed for the expression of their interest in craft and detail. What has been termed the Queen Anne style is not related to the architecture of the reign of Queen Anne. Rather, the style drew on various precedents, including Elizabethan and Jacobean architecture as well as vernacular English architecture of the sixteenth and seventeenth centuries. The English Commission's buildings at the 1876 Centennial Exposition in Philadelphia along

with H. H. Richardson's glorious 1875 William Watts Sherman home in Newport, Rhode Island, introduced the Queen Anne style to a receptive America.

The use of balloon framing and 1870s affluence combined to make Queen Anne immensely popular and obtainable. Americans' newfound prosperity and identity on the world stage found further expression in floor plans that were unencumbered by the demands of symmetry and so easily tailored to individual needs. In large houses, great entry halls visually culminated in grand stairs. Circulation patterns might turn the great hall into an L shape to accommodate additional means of entry. Around this lengthened circulation area the many public rooms were distributed, with a study or office placed, such as Martin Pattison's was, near an exit so the man of the house could slip in and out without encountering visitors. Kitchen services, as seen here, were tucked into the back of the home.

While we have no record of who the architect was or how this plan was personalized for the Pattisons, it is so representative of the period and the style as to indicate that it might have been adapted from published plan books.

to be called Fairlawn, early photographs show a picturesque, sweeping lawn. A vast lawn was considered very English and, in the case of Pattison's home, provided an unimpeded view of the lake. Naming residential properties has long been a tradition that Americans adopted from their European counterparts.

When Martin and Grace Pattison moved into their new home they had four children; they later had two more children. While Fairlawn's first floor was formal, the second and third floors and the basement were planned for family life. Martin and Grace enjoyed panoramic northern views of the harbor from their second-floor rooms at the front of the house. He had his suite of rooms and she had hers—then a typical arrangement among wealthier families. A woman's bedroom often doubled as her bathing room, child's sick room, and birthing room. Men in the Victorian age had very little, if anything, to do with hands-on childcare. There were five other bedrooms of varying sizes on the second floor, and a grand hall at the top of the second floor provided privacy and distance between the children's bedrooms and their parents' suites. Two maid's rooms were on the third floor's south end.

During long, cold, snowy Wisconsin winters, indoor play options for the children were abundant. On the third floor a large ballroom adjacent to the turret was perfect for running and jumping games. For the adults there was a billiards room, a smoking room, and a small third-floor room for card playing that had a great view of the Minnesota side of Lake Superior. Fairlawn's basement, which was daylit by square windows on all sides, was not a typical damp, dreary, and dark dungeon. Instead, it housed a bowling alley and plunge pool (that room had direct access to the side yard)—amusements that must have been unusual amenities in Superior. The deep concrete pool—too small to swim laps but deep enough for water exercise—is a bit of a mystery. One probable explanation is that it offered therapy for the Pattisons' youngest daughter's arthritis. At the time water therapy was considered healthful for everyone, and cold water therapy in particular was a common treatment for the relief of arthritic pain.

Fairlawn was the second house in Superior to be electrified; it was wired for electricity and piped for gas when it was built. It had indoor plumbing, for family as well as servants, and the heating system was sophisticated enough to warrant mention in the newspaper as being planned by the country's top experts. The decorative steam radiators provided consistent heat in comparison to the heat generated by wood-burning stoves in other period homes. An operable stained-glass roof window in the stairwell allowed hot air to escape and cool air to downdraft through the stairwell; this window also dissipated the unhealthy buildup of gas from the gasolier lamps. This 1890s mansion was outfitted with the latest residential energy technology. In fact, with its vent chimney, it still would be considered in the vanguard of green architecture today. An electric elevator ran from the basement laundry to the second floor; a dumbwaiter on the first floor provided great efficiency in enabling staff to get tea, breakfast, and snacks to the family on the upper floors.

Vent Chimneys

Today's concerns with both environmental and economic sustainability call out for systems that can preserve the environment, reduce energy costs, and contribute to the health of a building.

Active energy systems use mechanical or electrical equipment, such as fans or pumps, to provide heat or cooling. Passive systems, such as the siting of a building to maximize the sun's rays and using natural ventilation, can provide energy savings but do so passively, or without the costly intercession of machines or electricity.

Vent chimneys are "new" passive energy systems that have been used for more than ten thousand years. Hot air rises just as cold air falls in what is called "the stack effect." In winter, residential towers like staircases can capture the heat rising to the top of the tower and recirculate that heat to the rest of the home. In summer, vented windows can expel the rising heat throughout the day, while those same windows can capture cool evening air and send it to the spaces below. Stone or concrete foundations at the base of these towers serve as thermal banks that store the tempered air and then radiate it throughout the day. This stack effect contributes to air movement and to the introduction of natural ventilation.

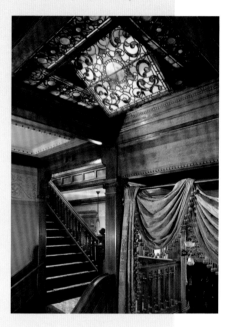

Fairlawn's stained-glass vent chimney

As a passive system, vent chimneys represent a commonsense approach to house design that we see employed in Fairlawn, the Pabst Mansion, and the Octagon House. The multitude of gas-burning fireplaces throughout many of the other grand homes in *Wisconsin's Own* suggests that they may also have had double duty as summer vent chimneys cooling and ventilating their spaces.

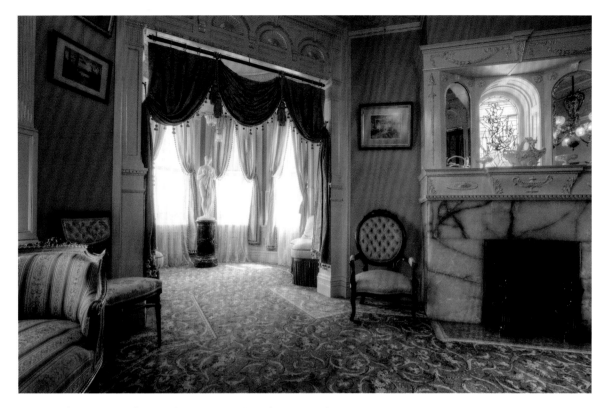

ABOVE: The turret windows in Grace Pattison's parlor received early morning light that softly washed the peach-toned walls. Blue was typically used just as an accent color, as Victorians considered all-blue walls depressing. RIGHT: Lake Superior brownstone forms the foundation for the porte cochere.

A few years after the home was complete, Martin Pattison hired architect John Chislom to design a botanical conservatory to the east of the dining room. A newspaper article from 1894 outlines the extravagant addition in detail: the domed glass-and-iron structure was 1,100 square feet and the potting shed was 224 square feet. Exotic plants and flowers from the world over filled it—probably to relieve the mind from the numbing cold of Superior's winters.

Guests arrived at the Pattison home via a circular drive off Bay Street (now Highway 2) and entered the home through two large mahogany doors into a vestibule tiled in a mosaic of granite chips, where the letters "MP" are formed in tile. This permanent monogram left no doubt as to whose home this was. An additional set of double mahogany doors, adorned with beveled glass insets, opened into the spacious reception hall.

As strong and assertive as the home's exterior is, the interior truly displays a desire to create beauty through harmony. The soft paint tones of the decorated ceiling with its delicate designs provide an overarching sense of unity and serenity. The reception hall is largely symmetrical, which was in line with Mr. Pattison's ordered and focused character. Opposite the entry vestibule is a broad stair landing with both floor and fireplace ornamented with colorful geometric patterns in encaustic tile. This sizable landing was designed to accommodate a group of musicians to entertain guests. In the Pattisons' time an Edenically themed tapestry covered the back wall. Facing doorways lead off the reception hall, one to the reception parlor and the other to Mrs. Pattison's parlor with its curved seating beneath the turret windows. Other openings off the reception hall lead to the music room, the dining room, and a side entry where guests arrived by carriage under cover of the porte cochere.

The reception hall demonstrates a celebration of expert craftsmanship and love of—and abundance of—fine materials. Plush wall-to-wall carpeting (which was actually many panels stitched together), elaborately carved oak woodwork, damask swags and draperies, exquisite brass-and-glass combination gasolier and electrolier light fixtures, ornately cast steam radiators, embossed and gilded friezes, and lushly upholstered furnishings were all on view—simultaneously. The pièce de résistance is the magnificently hand-painted coved ceiling.

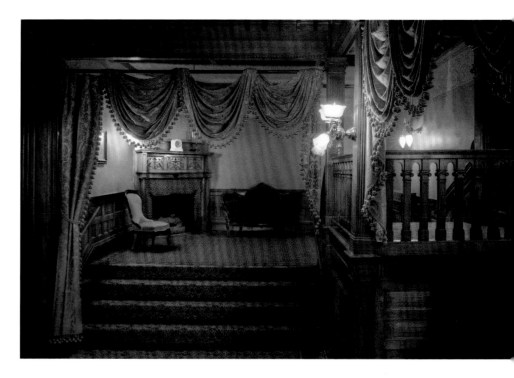

Fairlawn's fireplaces were more sculpture than heat source since the radiators served that purpose. The home originally had nine fireplaces, each finished in different materials, each firebox's design unique. In Mrs. Pattison's parlor, the fireplace is faced with white-veined Mexican onyx and its mantle decorated with Grecian-inspired wreaths and urns. Mr. Pattison's very masculine library fireplace is faced in Egyptian marble; a ribbon carved into the mantle is inscribed with "East or West Home is Best" and the firebox is trimmed in silver. The dining room fireplace employs a restrained blue-gray, highly glazed floral motif tile framed by a simple, classical-motif oak mantle. Most of the first-floor fireplaces had an earthy palette—colors found in the woods and in the iron ranges.

In the second-floor bedrooms, highly glazed tiles—some were rectangular, others square, the colors were white and blue—decorated the fireplaces. The third-floor smoking room's fireplace surround was oak. The mantles were much simpler than those on the first floor, yet each firebox was ornate. The fireplaces were gas, not wood burning, which may surprise us today but was not at all uncommon. In fact, Fairlawn was built with a "massive furnace" according to an 1891 *Superior Evening Telegram* newspaper article. Fireplaces were an opportunity to integrate art into the design of the room.

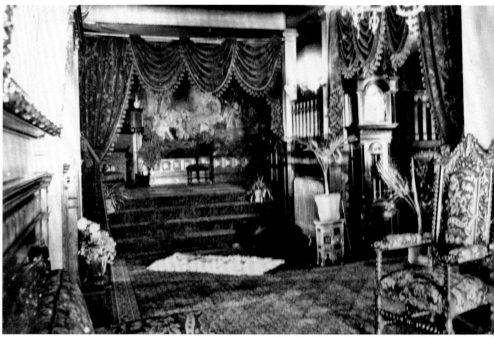

AS BEFITTED HER SOCIAL STATION, Grace Pattison was actively engaged in civic and charitable organizations in Superior. One of her most ardent affiliations was with the Superior Children's Home and Refuge Association. When Martin died in 1918, Grace began to plan for her future and the future of Fairlawn. The Pacific railroad link from Superior to the West Coast had failed to materialize and Superior was no longer a boomtown. Large homes, especially mansions like Fairlawn, were not in high demand. Grace decided to move to Los Angeles with her youngest daughter and donate Fairlawn to the Superior Children's Home and Refuge Association to serve as its new home. Over forty-plus years Fairlawn was home to more than two thousand children. In 1962 the association closed Fairlawn's doors.

TOP: The floor and fireplace of the first-floor stair landing are composed of encaustic tiles with patterns formed not by glazes but by different types of clay. These tiles, which were popular in the late nineteenth century, were mass produced in Ohio and New Jersey. BOTTOM: This David F. Barry photograph of the stair landing and main hall captures the lavish interior decoration, circa 1895.

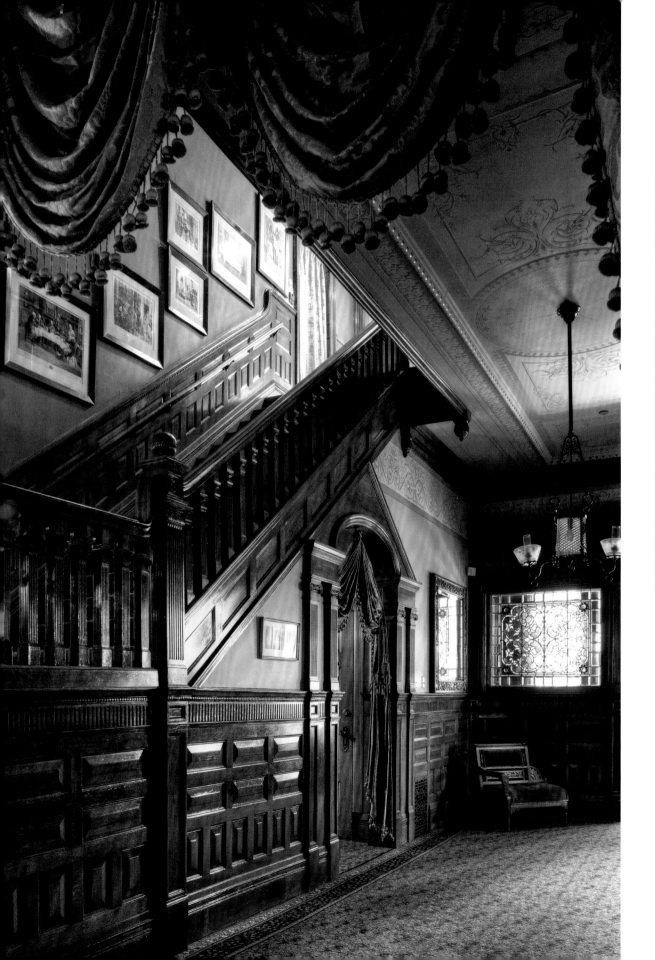

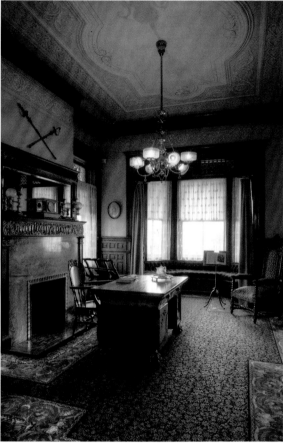

LEFT: Hallways in Victorian houses established social decorum. Front halls were largely ceremonial greeting spaces. Areas for hanging hats were provided and coats were taken by servants. Family typically arrived at a side hall, and rear halls were for service. ABOVE: The painted ceilings throughout the first floor, as in Martin Pattison's library pictured here, are Fairlawn's crowning glory. During the 1990s restoration, contemporary Wisconsin craftsmen painstakingly restored the beauty that had been painted over during the years Fairlawn was owned by the Superior Children's Home and Refuge Association.

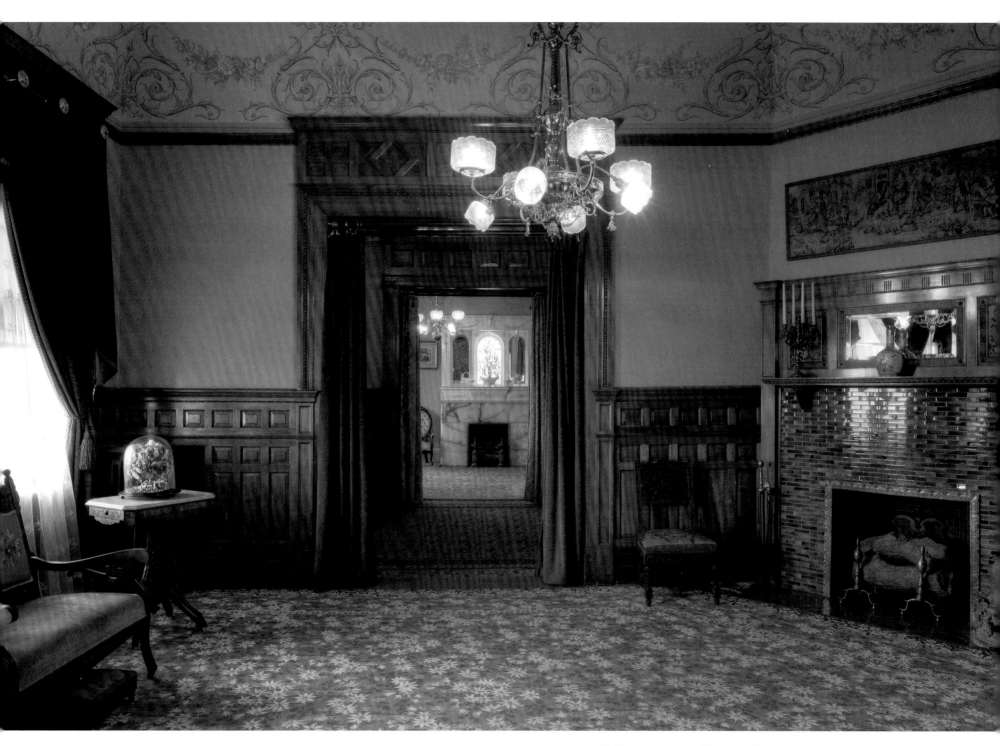

Fairlawn was built with central heating; its fireplaces were just for show—and what a show. Fireplaces of Egyptian marble, Mexican onyx, and English glazed tiles (as seen here in the reception parlor) and fireplace surrounds ornamented with silver edging and gold adorn the first-floor rooms.

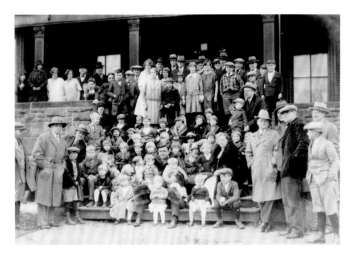

Many celebrities, including baseball star Babe Ruth, seated in front on the stairs, made the long trip to Superior to visit the orphans at the Superior Children's Home and Refuge Association. Ruth, who had been orphaned, felt a connection with the children.

Budget constraints prevented the Superior Children's Home and Refuge Association from maintaining Fairlawn's splendor, and much of the mansion fell into disrepair. The ornamental woodwork on the first floor was, however, maintained by the children, who were responsible for cleaning and polishing it weekly.

By this time a number of changes had occurred. The carriage house was destroyed by fire, and the conservatory had been torn down due to deterioration. Part of the turret had blown off in a windstorm in the 1950s, and the iron fence went missing. When the mansion's use changed, exterior fire escapes and interior sprinklers were required as safety measures. Ceilings were dropped to cut heating costs, and wood floors were covered with linoleum for ease of maintenance. Understandably, the second and third floors were the most altered to accommodate dormitories and today remain the least authentic. The elaborate exterior had been swaddled in inexpensive siding in the late 1920s. Age, neglect, and lack of funds all took a toll on the glory of the mansion.

Historical photographs of the children's home show that in spite of its financial challenges, the association was a good steward of Fairlawn. Children are seen gathered on the first-floor stair landing with the elaborate frieze still intact, the woodwork shines, and the fabulous fireplaces serve as backdrops in other photos. The large house continued to be a home.

THE 1960S IS NOW KNOWN as the decade during which many historic buildings were destroyed. Cities were struggling and it was believed that investors wanted cleared lots for new modern buildings. Old buildings signified the past and required large budgets for restoration, and old floor plans did not meet current needs or building codes. Fairlawn, even in its depressed condition, was one building the city did not want to lose. In 1963 Fairlawn became home to the Douglas County Historical Society. Restoration of Fairlawn became a civic priority and the heirs of Grace Pattison were in agreement. However, without an endowment, it was exceedingly difficult to have a master plan. For almost thirty years restoration was limited to volunteer efforts and whatever funds became available.

In the 1990s the director of planning for the City of Superior applied for and received a Community Development Block Grant, which involved federal, not local, dollars. By 1995 the community saw its efforts taking root and the historical society was encouraged to approach the Jeffris Family Foundation. Although the landscape restoration proposal was turned down, the foundation was interested in Fairlawn and Superior's desire to save it.

The home's painted ceilings were a major focus of the interior and exterior restoration process that took place from 1995 to 1998. During the restoration, which was funded in part by the Jeffris Family Foundation and in part by the city and citizens of Superior, the fireplaces were capped, making it unnecessary to rebuild the chimneys. Today Fairlawn has fewer chimneys than it originally had.

Because there is very little written documentation about Fairlawn, it is fortuitous that the Pattisons followed the popular trend of hiring a professional photographer to record their home. It is even more fortunate that the photographer was one of great skill: David F. Barry, nationally known for his iconic portraits of Native Americans. He had settled in Superior in 1890 and opened a photography studio. Barry was retained by the Pattisons to photograph their home a few years after its completion.

The still-brilliant historical photographs proved invaluable guides throughout Fairlawn's restoration as they showed in great clarity details of portieres, mantels, floor coverings, ceiling paintings, and objets d'art collected and displayed by the Pattison family. Obviously, the black-and-white photographs do not inform the viewer of the color palette, but the rich detail derived from glass negatives show texture and nuance that is sometimes overwhelmed by color. The Barry photographs are of the main floor and the exterior.

Visitors today see the exterior and the first floor in the full glory of the Pattison era. Although Grace Pattison took her personal items when she moved to California, over time some original furnishings have been returned to Fairlawn, the most valuable piece being the statue of Pandora in Mrs. Pattison's parlor. A charming four-panel velvet screen is in its original place in the music room, and Mrs. Pattison's expert needlework is on exhibit on the dining room chair seats as well as on a chair and footstool in the reception parlor. Much of the Pattisons' silver is also on display. The second floor, though not fully restored, offers a glimpse of guest and family bedrooms, and the third floor tells the story of the children's home period.

Martin Pattison was the epitome of the vanguard, one who was in the forefront of many aspects of life in Wisconsin: lumber, mining, civic life, education, land preservation, and architecture. His participation in local politics and as an education advocate was a means to promote civic and economic development for the entire community. Pattison's mansion was a worthy recipient of the efforts of those with the architectural, engineering, interior finish and decorative arts expertise, time, and money who returned it to its Gilded Age grandeur. •

Late-nineteenth-century East Coast investors arriving in Superior could not have avoided seeing Martin Pattison's residence, a commanding presence overlooking the water.

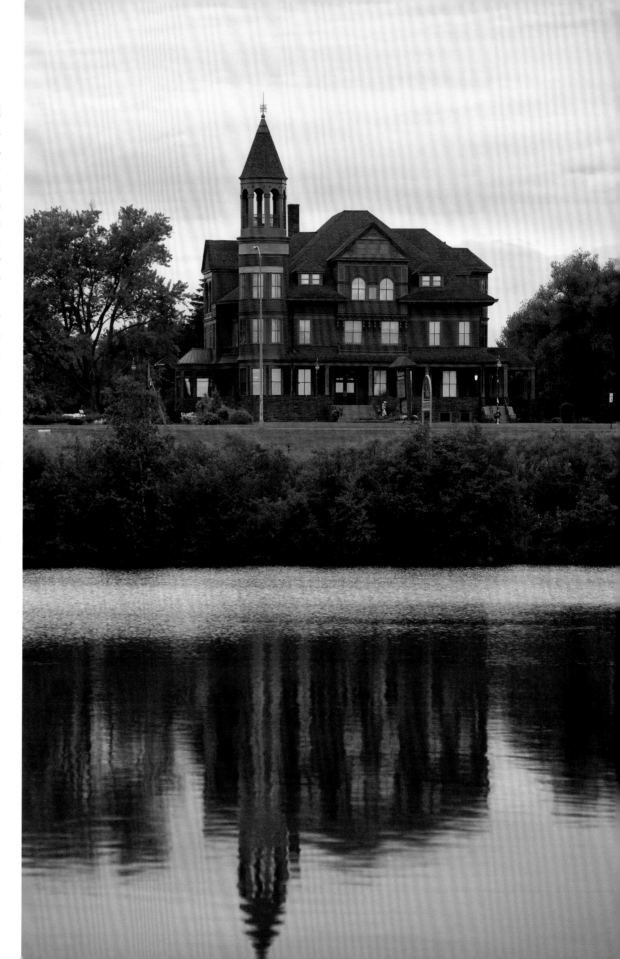

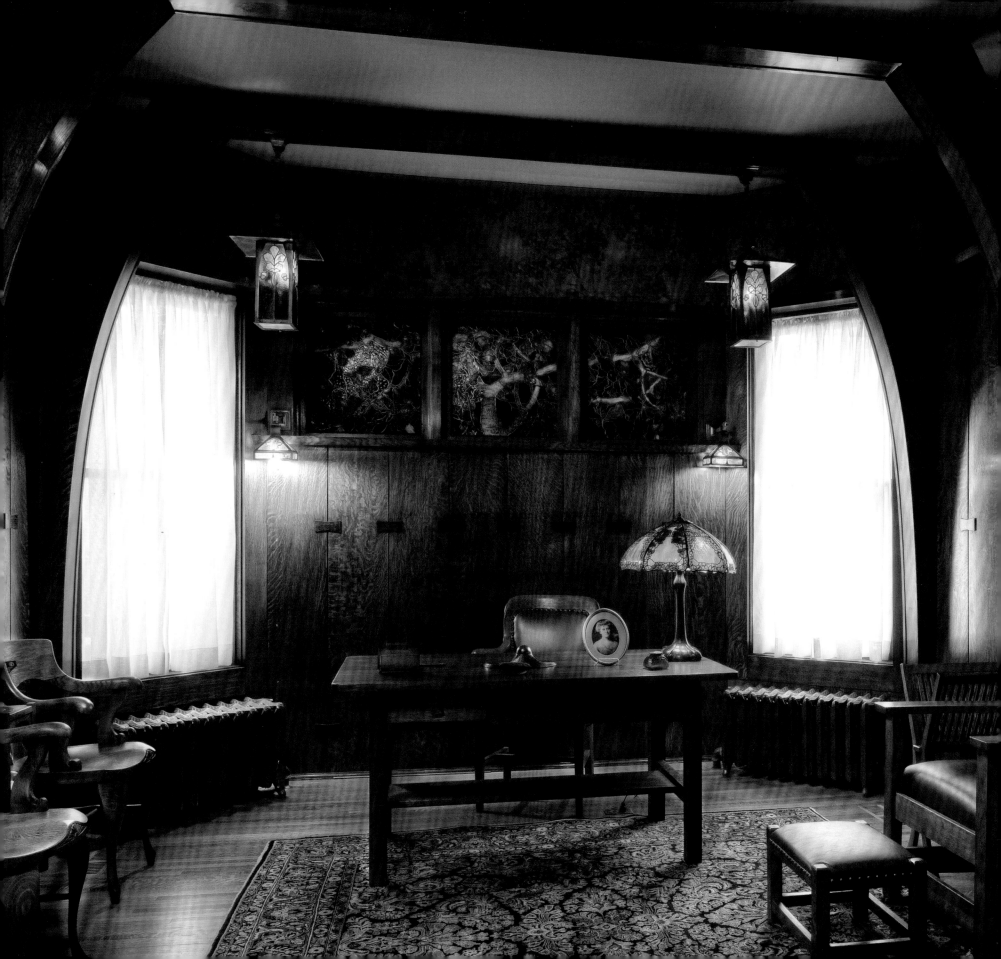

Cyrus C. Yawkey House

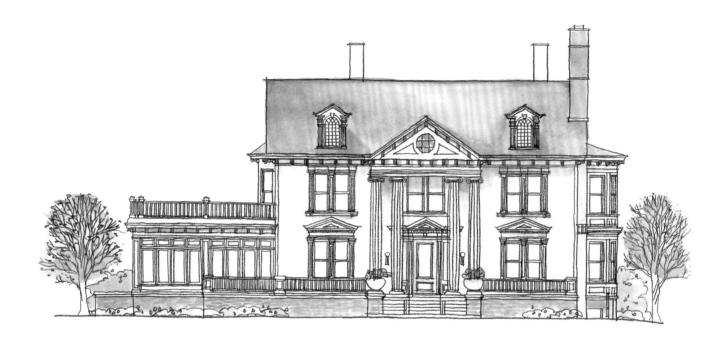

along the Wisconsin River was one key to its success as a booming lumber town in the mid- to late 1800s. Indian nations had employed the river as a major transportation route for both goods and people, and, until the railroad came to Wausau in 1874, much of the state's pine lumber was shipped via the Wisconsin. Even after the arrival of the railroad, the river continued to be an important power source for the sawmills.

The natural beauty of the Wausau area, with the river and Rib Mountain providing scenic and recreational opportunities, attracted settlers. By 1900 Wausau was one of six cities in Wisconsin with a population of more than ten thousand and by 1908 it boasted the Marathon County Normal School, a passenger railroad station, streetcars, telephone service, electric service to businesses as well as homes, and a public library. Wausau was surviving and thriving by diversifying with tanneries, door and window manufacturing, hospitals, and tourism. Lumber was still important, but it was not the only business in town. A group of forward-thinking businessmen made sure of that.

CYRUS C. YAWKEY WAS a third-generation lumberman from Michigan who founded the Yawkey and Lee Lumber company town of Hazelhurst in 1893 with his uncle and another partner. Within a year they had built up the Oneida County town, with forty company

OPPOSITE: Cyrus C. Yawkey was a lumberman who felt at home in the lumber camps of northern Wisconsin. After he moved to the city, he created a den out of the finest woods.

houses, a boarding house, a company store, and a post office to support their business. Anticipating that Hazelhurst, and all of north-central Wisconsin, would become a vibrant economic center, Yawkey and his wife, Alice, built a home for their family on the shore of Lake Katherine, just south of Hazelhurst.

The much-anticipated growth did not come to northern Wisconsin: what had seemed to be a promise of endless forest and profit proved to have limits. In 1892 four billion board feet of lumber was cut in Wisconsin—the most ever in one year—and that would remain the record. At the urging of their friend Walter Bissell, Cyrus's fellow lumberman and a Wausau resident, the Yawkeys left Hazelhurst for Wausau in 1899, just as the world was entering the twentieth century and the Victorian and the lumber eras were beginning to wane. Yawkey, who was hesitant to leave the Hazelhurst operation as it was still profitable, maintained an office there until he finally relocated the main office to Wausau in 1906. With their move to Wausau, the Yawkeys were also seeking better educational opportunities for their young daughter, Leigh.

In 1900 Wisconsin led the nation in lumber production, but Yawkey and other lumbermen acknowledged that the glory days of the Wisconsin pineries were nearing the end. He began meeting with a group of like-minded businessmen including Walter Alexander, Walter Bissell, John Ross, Alexander Stewart, and Neal Brown to explore options of how to shape their futures, financial and personal, in Wisconsin, and in Wausau in particular. They became known as the Wausau Group.

One of their first group projects was building a 450-foot dam over the Wisconsin River, which created Lake Wausau. The dam supplied waterpower for the Marathon Paper Mill, which Yawkey invested in, and the artificial lake was intended to attract summer visitors who enjoyed boating and excellent fishing for walleye, crappies, sunfish, and perch. Recreation and tourism were part of their plan to diversify the local economy. In later years, after Wisconsin passed the first comprehensive workers' compensation program in the United States in 1911, the Wausau Group—seeing opportunity rather than constraint—formed the Employers Mutual Liability Insurance Company, which later became Wausau Insurance, as an investment. It quickly became a highly touted model for other insurance companies.

Building on their shared expertise, the Wausau Group developed lumbering concerns in Arkansas, Mississippi, British Columbia, Oregon, Washington state, and Michigan. The group grew and used its resources to develop working capital, which the members invested in their own companies and in proposals other entrepreneurs made to them. The structure of the Wausau Group was fluid: not all partners participated in all projects equally. And, as they were bold in their decisions, not all investments were successful.

Cyrus Yawkey and other members of the Wausau Group were prime examples of the progressive City Beautiful movement that was sweeping the country. Nationwide, middle-class businessmen were joining civic organizations, getting involved in city planning issues, and lobbying for public parks and the creation of civic spaces they believed were important to the character formation of good citizens and to the economic survival of towns.

Many Neoclassical libraries, civic buildings, and banks, as well as parks and tree-lined boulevards in towns across the country are visual reminders of this movement. In Wausau, Cyrus Yawkey made gifts of land and money for four parks, including Yawkey Park.

UPON THEIR ARRIVAL IN WAUSAU in 1899, the Yawkeys decided to build just east of the center of town on a double lot in a select neighborhood where other prominent Wausau families had fine homes.

Through the years Yawkey devoted much of his time and energy to civic causes: he was a member of the Masons and the Rotary Club, director of the chamber of commerce, active in leadership of the Boy Scouts, and president of the Marathon County Park Commission. In addition to his interests in Wausau, he also served on the boards and committees of banks and businesses in Milwaukee.

Alice Yawkey was as active in community affairs as her husband. Her interests lay in the arts—drama, literature, and music—as well as gardening. In addition to her artistic pursuits, she was a member of several patriotic women's groups and an active member of their church. Their Wausau home was designed not only for entertaining but also for the exhibition of Alice's collections of Victorian glass baskets, jade carvings, and porcelain birds that she purchased on the family's trips abroad.

Automobiles line Third Street in this photograph of a modern, thriving Wausau, circa 1910.

Milwaukee architects Henry van Ryn and Gerrit de Gelleke were commissioned to design the Yawkey home. Van Ryn was born in Milwaukee in 1864, the son of Dutch and German immigrant parents. At age seventeen, though not formally trained as an architect, he went to work for Milwaukee architect Charles A. Gombert. In the following years he also worked for or with such architects as James Douglas and E. Townsend Mix. In 1897 van Ryn formed a partnership with de Gelleke, a graduate of the University of Pennsylvania's architecture program who was born in Milwaukee in 1872 to Dutch immigrant parents. For nearly forty years, the firm of van Ryn and de Gelleke received commissions, including residences and several notable public buildings. But school design was a specialty: from 1912 until 1924, they were the architects for the Milwaukee School Board.

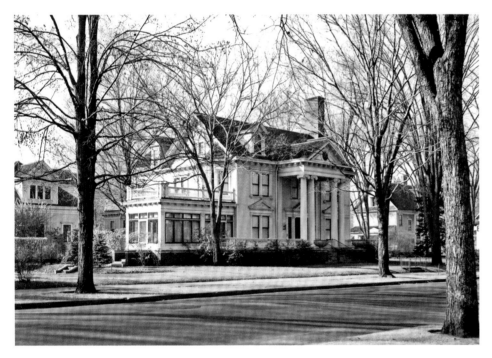

The home shortly after Leigh Yawkey Woodson and her daughters donated it to the Marathon County Historical Society in 1954.

Many of their school designs of this period were executed in the Collegiate Gothic style; their residential designs were in the popular styles of the period.

Van Ryn and de Gelleke's design for the Yawkeys reflects the renewed interest in Classical and Colonial American precedents in domestic architecture at the turn of the twentieth century. The 1893 World's Columbian Exposition had shaped the public's attitudes regarding architecture. While the fair's main buildings led civic architecture to aspire to monumental classicism, some of the state pavilions connected fairgoers with the country's Colonial past. Virginia built a replica of Mount Vernon; Independence Hall inspired the design of Pennsylvania's building; Peabody and Stearns replicated the 1737 Thomas Hancock house for the Massachusetts State Building. By the turn of the century, the classically inspired precedents had tamed the exuberance of Queen Anne architecture, and the home became more boxlike in footprint, turned porch posts became columns topped with classical-order capitals, and decorative details such as swan's neck pediments and Palladian windows decorated the increasingly simplified wall surface.

The size and massing of the Yawkeys' new home, the absolute symmetry of the main block's facade, and the prominent dormers are all features of the Georgian style. The large, projecting two-story portico with Ionic columns draws inspiration from Neoclassical designs. These elements herald the entrance to the gracious home that was designed with social gatherings in mind.

The 1901 van Ryn and de Gelleke house included an on-center foyer, with rooms flanking either side of the reception hall: a music room, men's parlor, formal parlor, dining room, and kitchen composed the first floor. As befits the home of a successful lumberman, the woodwork is exquisite. In all rooms—the one exception being the music room, where the woodwork was painted white to complement the upholstery—the rich beauty of walnut, mahogany, maple, and birch glows with the natural variation of tone and texture

of each species. This diversity of woods is somewhat uncommon in houses of the period but very characteristic of the homes of lumbermen, where the use of a wealth of wood conveyed the business acclaim of the occupant. Typically, Colonial Revival and Neoclassical interiors have painted trim. This much natural woodwork is uncharacteristic of the style but in keeping with Yawkey's occupation.

The reception hall floor, with its parquet of mahogany and oak, has an elaborate geometric design that rivals the intricacy of an oriental carpet. The flared, sculptural, honey-toned curly birch staircase seamlessly transitions from stair to wainscoting to ceiling. Care was taken to emphasize the overall composition of the hall as a work of art: wherever the eye alights, from the stenciled reception hall ceiling to the curve of the stair spindle, there are details to admire. A pair of double-hung stained-glass windows, each topped by a fixed transom, light the capacious stair landing, with the glass coloration decreasing in hue from a rich ruby red at the sill to a pale pink at the top of the window. The salmon pink walls of the stair hall are edged with a white impasto stencil of swags and plant forms. The sum of the individual components succeeds in creating a striking and engaging entry.

JUST AS THE YAWKEYS WERE COMFORTABLE with the rapid economic and social changes of the times, they aspired to have their home reflect the aesthetic advances of the new century. In 1907, just six years after their Classical Revival home was completed, they turned to Chicago architect George W. Maher for a major remodeling project. Although known and admired as a Prairie School architect, Maher remained faithful to the exterior of the van Ryn and de Gelleke design. His changes were new first-floor interior spaces designed in the Arts & Crafts style and Leigh Yawkey's Art Nouveau–inspired bedroom suite. While Classical Revival and Arts & Crafts were diametrically opposed styles in terms of their underlying philosophies—one rational, the other romantic—Maher's remodeling neither overpowers nor ignores the intent of the original architecture.

The reception hall reflects Henry van Ryn and Gerrit de Gelleke's original Classical Revival design, with patterned inlaid wood floors, wood wainscoting, a graceful stair, hand-painted ceiling, deep beams, and pocket doors flanked by double-damask portieres.

Wall tapestries, impasto swags, and ornate stair spindles seen in the second-floor landing were decorative holdovers from the Victorian era. The lack of ceiling molding and use of simple base molding indicate a move to the modern era.

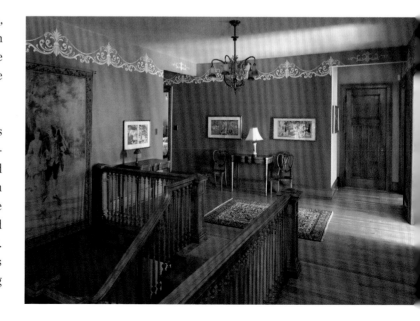

Much of the motivation for the remodeling appears to have been the return of the Yawkeys' 20-year-old daughter, Leigh, who was graduating from the Ogontz School for Girls at the Jay Cooke mansion and estate outside of Philadelphia. The goal of this finishing school was, according to its mission statement, "to prepare [the students] for the elite society into which they had been born." Surnames of alumnae confirm that the students were from some of the country's wealthiest families: Armstrong, Campbell, Gillette, Heinz, Sperry, Squibb, McCormick, and Wrigley. In addition to her formal education, Leigh accompanied her parents on travels abroad, including a 1910 trip to Egypt.

George W. Maher designed many Prairie-style homes on Chicago's North Shore, including his own home in Kenilworth, Illinois. The 1905 commission for the Neoclassical Wausau public library (it opened in 1907) led to introductions to many of the city's business leaders. Maher and Alexander C. Eschweiler, a Milwaukee architect who was well respected for his residential designs, were among the architects of choice for the homes of Wausau's business elite. While Eschweiler's Wausau homes were typically in various revival styles, Maher brought in the Prairie and Arts & Crafts styles that were then so popular in Chicago.

AT AGE THIRTEEN, Maher had been apprenticed to Chicago architects Augustus Bauer and Henry Hill. Hill and Bauer both came to the United States from Germany, Bauer in the 1850s and Hill in 1872. They responded to the urgent need for architects to rebuild Chicago after the devastating 1871 fire. Their practice was diverse: they designed residences, banks, and hotels. It is clear Maher received an exceptional architectural education under their tutelage.

Following his ten-year apprenticeship, Maher was hired by Joseph L. Silsbee, an architect as well as a professor and an inventor. Like many successful contemporary architects, Silsbee had offices with different partners in several cities. He was also known for hiring and training architects who would go on to be quite successful in their own right, particularly in residential design: Frank Lloyd Wright, George Elmslie, Irving Gill, and Maher all achieved high professional acclaim. During Maher's brief tenure at Silsbee's office, he worked with both Wright and Elmslie. He then had a five-year partnership with Cecil Corwin, brother of the better-known muralist and painter Charles Corwin. There is very little on record concerning Maher's projects during the Corwin years.

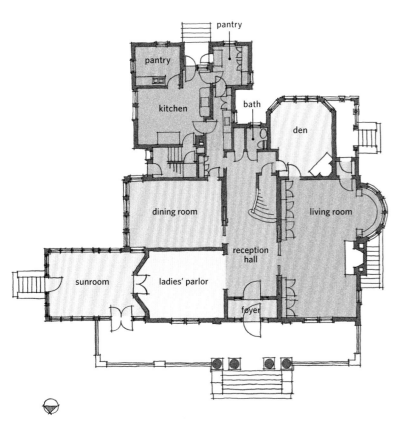

Like the formality of the van Ryn and de Gelleke exterior, the original Yawkey plan was symmetrical: an imposing grand entry hall was flanked by public zones of parlor, dining room, living room, and library, with kitchen services in the back. The Maher touches of the 1907–08 renovation, including the addition of a den with Arts & Crafts detailing, the sunroom addition, and the enlarged living room, with its semicircular window seat, fashioned out of the original living room and library, all serve to lend this plan its distinction, with the sunroom addition converting it to an asymmetrical layout.

After the dissolution of the Corwin partnership, Maher spent a year in Europe studying architecture and drawing. Maher was profoundly affected by the use of architectural ornamentation by the Vienna Secession, whose architects and artists believed daily life could be enhanced by blurring the boundary between fine and decorative arts with a closer collaboration between architects and craftsmen. One of their goals was to integrate art into functional, everyday objects. Inspiration was found through the combination of geometry with natural forms.

Many of Maher's Prairie-style homes include striking examples of stained glass as an integral element of the interior architecture. He had learned a great deal through his friendship with stained-glass master Louis J. Millet, a professor of interior decoration at the Art Institute of Chicago. During his time in Chicago, he was introduced to ornamentation. Working side by side with Frank Lloyd Wright, Maher was exposed to Wright's theory of organic architecture and love of integrated ornamentation.

With his background in Prairie School-style ornamentation and exposure to Vienna Secession influences, Maher developed a theory he called "rhythm motif": he would select an element from nature, such as a flower, and abstract it in stained glass, fabric, ironwork, light fixtures, and, if allowed, the furniture design. Two excellent examples are the tulip motif of the Stewart house in Wausau and the poppy motif of the Winton house in Minneapolis. At auctions today, architectural elements designed by Maher, such as the Winton house glass doors, have appreciated greatly.

MAHER'S EARLY TRAINING with Joseph L. Silsbee gave him an appreciation for historical styles. Nevertheless, his modernization for the Yawkeys was not timid. It included removing interior walls and even shifting the living room fireplace a few feet for interior symmetry. On the first floor, changes were made to the floor plan. Both the living room and the dining room were enlarged and new rooms were added: a den for Cyrus and a sunroom for Alice off the music room. The enlarged living room and dining room better accommodated numerous guests at social gatherings. On the second floor, above the den, a suite was added for Leigh.

The modern white sunroom with red-glazed tiled floors was a casual space, reflecting the new era that embraced natural light and ventilation. The light-filled room was the perfect environment for Alice to display her collection of glass baskets on glass shelves attached to the windows, giving casual passersby the pleasure of viewing the dazzling colors and shapes. Steps off the sunroom lead to a paved terrace with a fountain, flower gardens, a vine-covered trellis, and a lawn large enough for croquet, badminton, or a wedding reception. Leigh's wedding in the family garden to attorney Aytchmonde Perrin Woodson was said to have been the social event of 1911.

The Yawkeys hired the Minneapolis landscape architects Arthur Nichols and Anthony Morell, who began their practice in 1910 and later achieved success as park, university, and institutional landscape architects. Once again, Yawkey was in the vanguard when he hired a new firm in an emerging profession to design the first formal

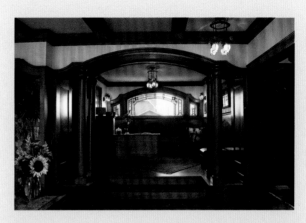

The Stewart Inn, another George W. Maher design in Wausau, has a tulip motif throughout.

George W. Maher and the Prairie School

George W. Maher was a successful and fluid practitioner of Prairie architecture throughout the Midwest.

Maher, along with Myron Hunt, Robert C. Spencer Jr., Marion Mahony Griffin, and Walter Burley Griffin, joined Dwight Perkins in the loft space at his Steinway building in Chicago. Influenced by Louis Sullivan's inventive work and his writings on transcendentalism, these young architects began an energetic artistic dialogue dedicated to creating a uniquely American architecture derived from American and Midwestern roots. Originally called the Chicago Group, it later came to be known as the Prairie School, which also included William Purcell, George Elmslie, Parker Berry, William Drummond, Arthur Heun, William Steele, and, its dominant force, Frank Lloyd Wright.

While the appeal of Prairie architecture appeared to flag in light of conservatism after World War I, Maher sustained continued support in the Midwest. His work and perhaps his success lay in his ability to use original forms in highly personalized designs in place of historical references while appealing to the conservative values embraced by his bourgeois clientele. Evocative ornament with themes derived from nature, lush palettes, and masterful fireplace surrounds contributed to works of visual richness and spatial Prairie-style harmony.

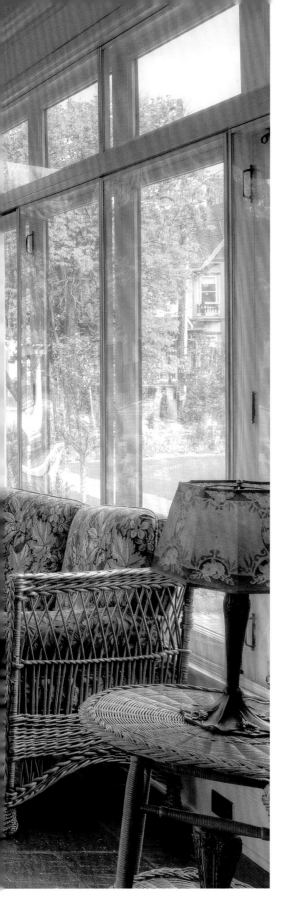

garden in Wausau. The garden took full advantage of the double corner lot in terms of providing views from the house to the garden and spaces for outdoor activities. Its design also reflects the formality of the house.

Telephone and electric service came to Wausau in the 1890s. Due to the expense, the telephone was not common in all residences, but by 1910 most well-to-do families had one. Since visiting could be done over the phone, the telephone phased out the ritual of afternoon social calls, and the formal setting of the ladies' parlor was no longer a necessary component of home design. Evolving social conventions also meant that respectable matrons such as Alice Yawkey were no longer confined to the home for social calls; instead, they were actively engaged in the social, political, and cultural workings of their communities. The compartmentalizing of the floor plan into ladies' parlor, men's smoking room, and formal parlor became outdated with the acceptance of a more relaxed attitude toward the mixing of the sexes and age groups in social situations. One large living room was a better fit than several discrete parlors. Increasingly efficient heating systems replaced coal furnaces and fireplaces as the primary heating source and eliminated the practical reasons for portieres and pocket doors, though they often were retained for purely ornamental aspects. With the Maher remodeling, Yawkey's late-Victorian house was becoming as modern as its residents.

As the number of serving staff was reduced in the 1900s, buffet dining became more prevalent. Maher expanded the Yawkeys' dining room a few feet to the east to provide space for a buffet. Maher was influenced by the Art Institute of Chicago's

LEFT: The thoroughly modern sunroom provided a casual alternative for gathering than the more formal music and living rooms. The newly renovated garden is as lovely a wedding site as when Leigh Yawkey married there in 1911. ABOVE: The formal garden has undergone numerous changes at the direction of both the Yawkey family and Marathon County Historical Society staff. This 1950s image shows the garden as it looked around the time of Alice Yawkey's death.

ABOVE: The single, flowing living room made from the library and sitting room. Removal of the interior wall that separated the two rooms literally broke down barriers of social convention. Men and women became freer to socialize in the early twentieth century. RIGHT: The 1907–08 remodel combined the original library (left) and sitting room (right). OPPOSITE: The dining room's autumn leaf–patterned wall covering and upholstery along with the pinecone chair finials and the floral carpet illustrate the fondness George W. Maher had for employing a motif derived from nature in his interiors.

interior architecture faculty, who embraced the Arts & Crafts movement. The remodeled dining room, with its fine wood joinery and dark fumed wood, expresses the hallmarks of the style, which emphasizes honest, natural materials and the obvious expression of handcrafted workmanship. The space is also a wonderful study in color theory: the Lincrusta wall covering has an embossed leaf pattern painted in deep greens, plums, and browns—exactly the same hues that the dark oak wainscoting and beamed ceilings reflect in the late-afternoon light.

Cyrus Yawkey did not give over the entire house to socializing. His very masculine den was his retreat. The massive curved oak ceiling beams and wide, oak-plank wainscoting with the bowtie-shaped connectors common to the Arts & Crafts style lend the room the feel of a captain's ship cabin. One can almost picture Cyrus sitting at his desk, eyes half closed, imagining he was gently rocking on the waves of some faraway sea. Encircling the room just below the ceiling, a hand-painted mural of a sylvan scene done in rich earth tones recalls the forests around Hazelhurst. Stained-glass windows with an abstracted design of oak branches and leaves—Maher's rhythm motif for the Yawkeys—cast rich, jewel-toned shadows across the dark woodwork. Acorn-shaped brass light pulls continue the oak motif as do the carvings in two mantels. A stunning feature is the angled corner inglenook fireplace faced with unusual variegated bowtie brick—a pattern that is mirrored in the room's wainscoting.

The glass lamps and windows installed in the living room, dining room, and den during the remodeling are of particular interest. The Quezal Glass Company of New York—which was formed when Louis Comfort Tiffany's chemist Martin Bach and master gaffer (glassblower)

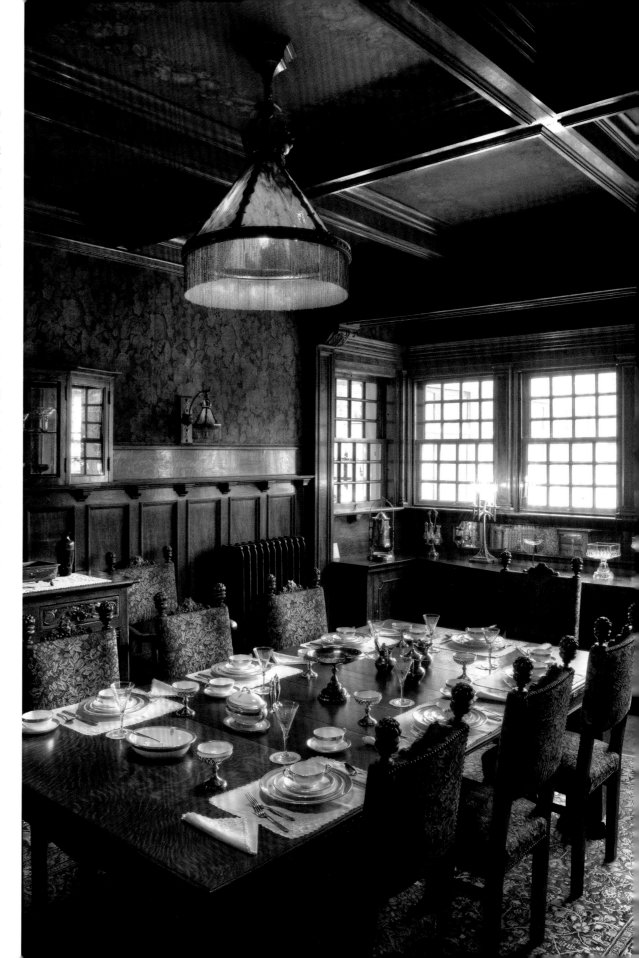

The combination of bow-tie brick and egg-and-dart terra-cotta is rarely seen in fireplaces. This unique corner fireplace in Cyrus Yawkey's study modestly adds variation and texture to an already rich room that Maher designed in the Arts & Crafts style.

Thomas Johnson got together after they had independently left the company—provided a vast array of stylish ceiling fixtures. Shimmering rainbow colors and Art Nouveau styling were its signatures. Quezal lamps were designed to be electrified; the incandescent light enhanced the iridescent quality of the glass. Maher would have been attracted to the naturalistic designs derived from flowers and other natural forms.

Quezal's prices were high; the company was obviously aiming for the luxury market. Its art glass was displayed in showrooms in Milwaukee, Chicago, and Minneapolis in the 1920s. Alice had been collecting European glass for many years, and the Yawkeys' early purchase of Quezal shows them to be more collectors than consumers. Early Quezal competes favorably with Tiffany in contemporary auctions.

WITH THE EXCEPTION of Leigh's suite, the second floor is far simpler than the first floor. Ceiling moldings and wood baseboards are greatly simplified or not incorporated at all. The bedrooms are spacious, with white painted woodwork in keeping with the Classical Revival style, and walls painted a warm ochre. Pairs of long, narrow double-hung windows afford broad views of the gardens and neighboring houses. Simple fireplaces grace the master suite, Leigh's sitting room, and the guest room. The floors are highly polished maple.

Leigh's suite is the most elaborate set of rooms on the second floor. While Maher brought Arts & Crafts to the den, Leigh's suite mixes Art Nouveau, Art Moderne, and Louis XV influences—a perfect example of eclecticism. It is feminine, but not girlish; it was designed for a woman, not a child. Her sitting room is outfitted with a brick fireplace

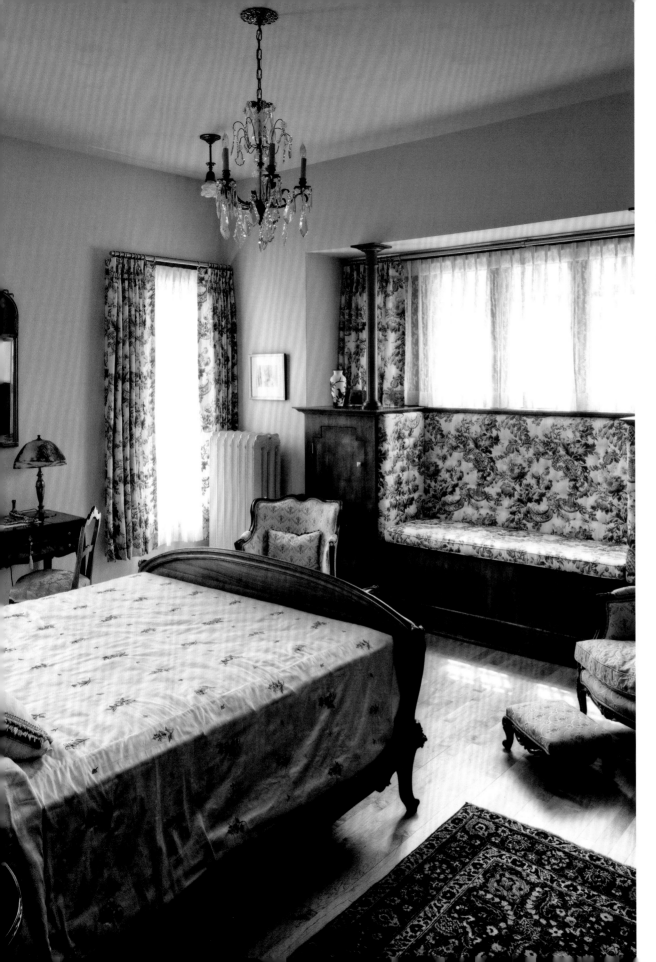

in variegated sandstone hues; today a chaise longue and wing chairs with a shared footstool impart the impression that she and her friends had a comfortable setting for long chats. Glass cabinet doors—with a design of abstracted bluebells—are in the Art Nouveau style.

Swinging glass saloon doors demarcate the bedroom from the sitting room while encouraging—along with two round-topped, open arches above the cabinets—the flow of light and air through the rooms. All of the suite's casework is trimmed with dark varnished wood, while the floors are light bleached maple. A cozy arrangement of a window bench and two overstuffed chairs allowed Leigh to have breakfast in bed and company at the same time. Stained-glass windows decorated with a rose motif provide accent color to her bathroom's white subway tile and white fixtures.

AFTER CYRUS YAWKEY DIED in 1943, Alice continued to live in their home until her death in 1953. The following year, Leigh Yawkey Woodson and her daughters gave the mansion to the Marathon County Historical Society shortly after it was founded, for whatever use it deemed appropriate. For years the former residence was used for exhibits and as the historical society's archives. Offices were in the third floor's former ballroom until 1995, when they were moved across the street to Leigh and Aytchmonde Perrin Woodson's home—another George W.

Leigh Yawkey's bedroom: Brightly painted walls, light-toned woods, cheerful floral prints, and sheer window coverings are a far cry from dark, heavily furnished Victorian bedrooms in which natural light and fresh air were avoided.

Maher design, this one with a lotus flower motif—so the Yawkey home could be transformed into a house museum. Starting slowly, they repainted walls, refinished floors, and restored stained glass—much the same things ordinary homeowners do when they have big dreams and limited funds.

By 2002 the first floor was ready to receive visitors. As is the case with most historic homes, the second floor proved to be a greater challenge. The family had removed most of the furniture after Alice Yawkey's death, and rooms had been reconfigured in 1954 to accommodate the Marathon County Historical Museum's exhibitions. Fortunately the historical society located a set of Maher's original floor plans, detail sheets, and elevations—a rare happenstance. Not all the drawings were located before the restoration began, so some construction was based on best-guess detective work. They had enough information to know they could do an accurate restoration, if they could raise enough money. Between the Jeffris Family Foundation seed grant and fund-raising efforts, the historical society raised $3 million in just six months.

The furnishings in the house today are appropriate to the period but were not necessarily owned by the Yawkeys. Few interior photographs taken during the Yawkey years have come to light. Alice Yawkey's records concerning her furnishings—there are inventories dated 1933, 1934, and 1953—were invaluable in the 2008 restoration, with choices made based on Alice's inventory lists, existing furniture, and floor plans. Alice's preference for historic French and Italian furniture was expressed in the music room, dining room, and bedrooms; Cyrus's den best reflected his preference for Arts & Crafts; and Leigh's bedroom was a combination of her parents' tastes.

The mansion is restored to the Maher design, using 1915 as a locus date. The garden had previously undergone several renovations, the first major one being shortly after the Maher remodeling was completed. In lieu of detailed drawings, the designers worked from a site plan and an original Nichols and Morell plant list to get a feel for what the Yawkeys experienced. The present garden reflects the imagery of a 1900s residential garden while accounting for the specific requirements of a museum garden meant to accommodate public gatherings; the renovation, therefore, required more hardscape and universal accessibility than would a private garden.

The house, which had been added to the National Register of Historic Places in 1974, reopened to the public in 2008. The Marathon County Historical Society received the 2009 Historic Preservation Award from the Wisconsin Historical Society for its preservation efforts related to the home, gardens, and carriage house. Cyrus C. Yawkey took his responsibility as a local businessman and civic leader seriously. His Classical Revival home and its grounds continue to serve as an example of how architecture can set the tone for a city and its citizens. •

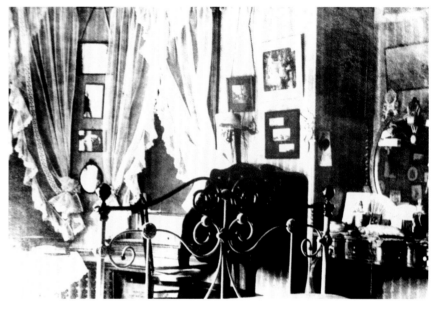

Leigh Yawkey's bedroom as it looked in 1904. Her original bedroom was converted into a sitting room after the Maher remodel of 1907–08 called for an addition that included a new sleeping chamber.

NEXT PAGES: The new century brought rapid changes in attitude toward architectural styles. Built in 1901, the Cyrus C. Yawkey home was extensively remodeled in 1907–08. The three-season sunroom was part of the remodeling efforts to adapt the house to the more casual lifestyle of the twentieth century. As part of the update, the carriage house became a two-car garage.

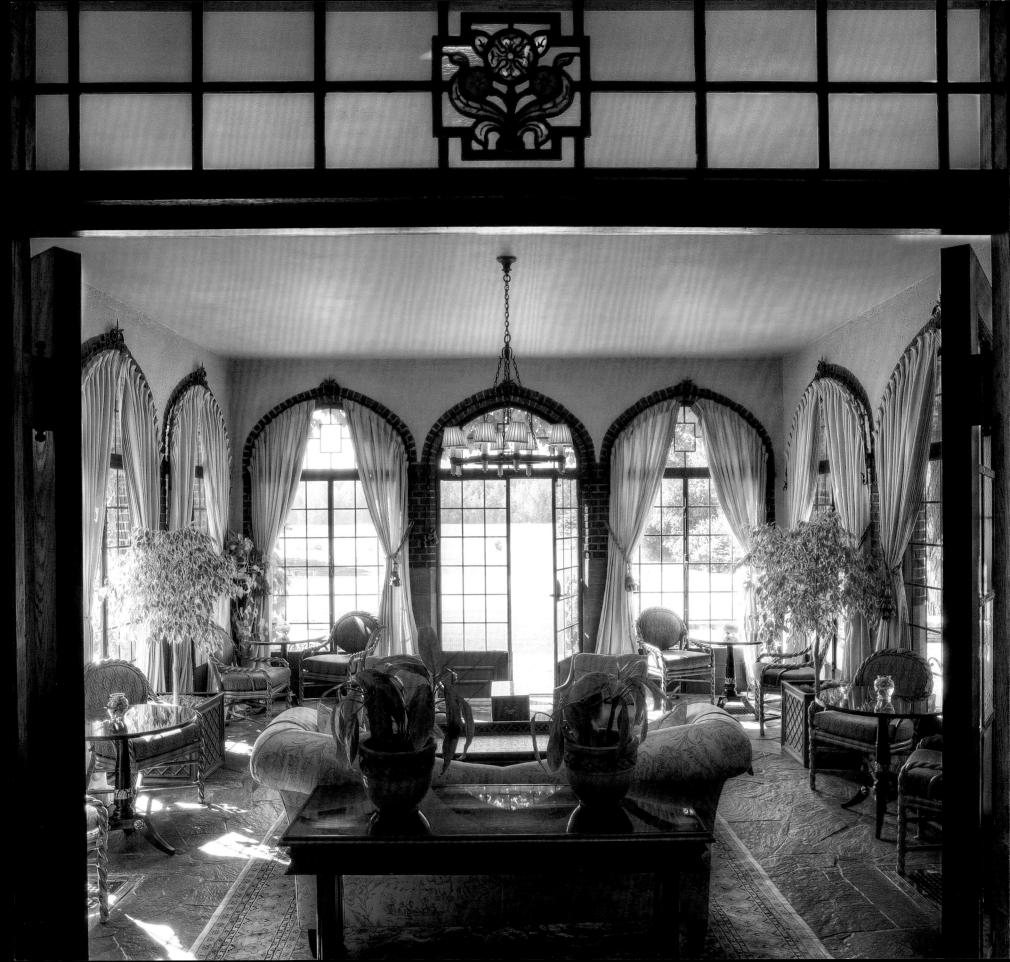

Riverbend |

GOOD DESIGN IS FLEXIBLE. The Kohler family first proved that concept when, in 1883, John Michael Kohler took a long look at a cattle trough, coated it with enamel powder, baked it at high heat, and declared, "With feet it will be a bathtub." Innovation and good design have been a hallmark of Kohler Co. ever since.

Throughout more than a century, John Michael Kohler and succeeding generations of Kohlers transformed their small steel and iron foundry in Sheboygan County into an international conglomerate with a wide array of interests, from plumbing products, furniture, generators, and engines to real estate and luxurious hospitality venues. Along the way they also created a new village, named Kohler in their honor. And in that village, Walter J. Kohler Sr., John Michael's second son, commissioned one of the most admired houses in the United States.

JOHN MICHAEL KOHLER was an Austrian immigrant whose family became farmers in Minnesota. As a young man he worked as a delivery driver in St. Paul. In 1865, at age twenty-one, he moved to Chicago, where he became a salesman, a clerk, and a traveling salesman for a wholesale grocery and a furniture company. After the Great Chicago Fire of 1871, he settled in Sheboygan, Wisconsin, where he met and married Lillie Vollrath and started a family.

OPPOSITE: The sunroom, which faces south, is aptly named. The beauty of Riverbend's grounds can be enjoyed here throughout the seasons.

Kohler Plumbing

While sanitation systems can trace their history to ancient Greek and Roman examples, it was the simple development of the vent stack in the 1870s that made indoor bathtubs and toilets both "politely" acceptable and economically viable. By extending a pipe of sufficient diameter from the sewer connection to each fixture and then beyond the roofline to break its vacuum, sewer gas could be eliminated. The ongoing nineteenth-century debate about the deleterious and embarrassing effects of sewer gas—a dialogue that swung from polite discussion of unpleasant smells to the dangers of murderous sewer gas—was here firmly resolved on the side of technological advancement.

The year 1873 was an auspicious time for improvements to indoor sanitation: John Michael Kohler and a partner purchased the Sheboygan Union Iron and Steel Foundry. There, Kohler produced cast-iron and steel implements for area farmers. Ten years later he adapted his horse trough. Pictured in his catalog, it was described as "a horse trough/hog scolder, [that] when furnished with four legs will serve as a bathtub." More than 135 years later, the company Kohler founded continues to dominate the plumbing fixtures industry.

During the Panic of 1873, Kohler, with his partner Charles Silberzahn, made a bold move and bought the Sheboygan Union Iron and Steel Foundry from Lillie's father. It was hardly a propitious time to start a business venture. Kohler's foundry made farm implements, castings for the many Sheboygan furniture manufacturers, and ornamental iron pieces. In 1878 Silberzahn sold his interest. Since his endeavor was so successful, Kohler decided to expand the plant in 1883 and started making a line of enameled ware.

John Michael Kohler had four sons: three with his first wife, Lillie, and a fourth, who was born to his second wife, Lillie's sister Minnie. Walter J. Kohler Sr. was born in 1875 and left school at age fifteen to enter the family business, starting as a laborer enameling furnaces. Learning the business from the ground up, he became a foreman in just three years and seven years later was a superintendent of the factory.

The year 1900 promised to be an exciting start to the twentieth century: the Kohlers had just completed construction on a new factory west of Sheboygan, and Walter married Charlotte Schroeder, an art teacher from Kenosha. Unfortunately, tragedy struck twice. First was the sudden death of John Michael Kohler at age fifty-six; then the new factory burned to the ground. The three oldest sons regrouped, moving production back to Sheboygan and setting right back to rebuilding the factory. By 1905, following the unexpected deaths of two of his brothers, thirty-year-old Walter became president of the family company, a post he held until 1937.

It is easy to imagine that all the pressures of assuming so much responsibility at a young age would produce a driven, one-dimensional businessman. Walter Kohler had a wide variety of interests: he enjoyed music, dancing, theater, sports, natural beauty, horses, reading, travel, art, and architecture. With the design of his estate, Riverbend, and the planning and realization of the Village of Kohler (originally known as Riverside) it can be said that Walter J. Kohler did choose architecture—and in a manner that continues to positively affect the working and personal lives of thousands of people.

AFTER HIS FATHER'S DEATH and prior to building Riverbend, Walter, his wife Charlotte, and their four sons lived in one of Sheboygan's finest houses, a grand Cream City–brick Italianate home that John Michael had built when his foundry became prosperous. Today, the home is part of the John Michael Kohler Arts Center. The galleries in the house portion of the museum retain the look of the family home, with glazed tile and waxed stone floors, dark wood paneling, and leaded-glass windows—many of the same features later incorporated into Riverbend.

Walter's longtime friend Richard Philipp was in partnership with Peter R. Brust. The young architects met while in the office of George Bowman Ferry and Alfred C. Clas, a preeminent Milwaukee architecture firm highly regarded for its civic and residential designs, including the 1892 Pabst mansion in Milwaukee. Philipp and Brust were primarily known for residential designs, particularly in revival styles, for successful businessmen in Milwaukee's eastern and northern neighborhoods. In the 1920s their firm was the largest in Wisconsin.

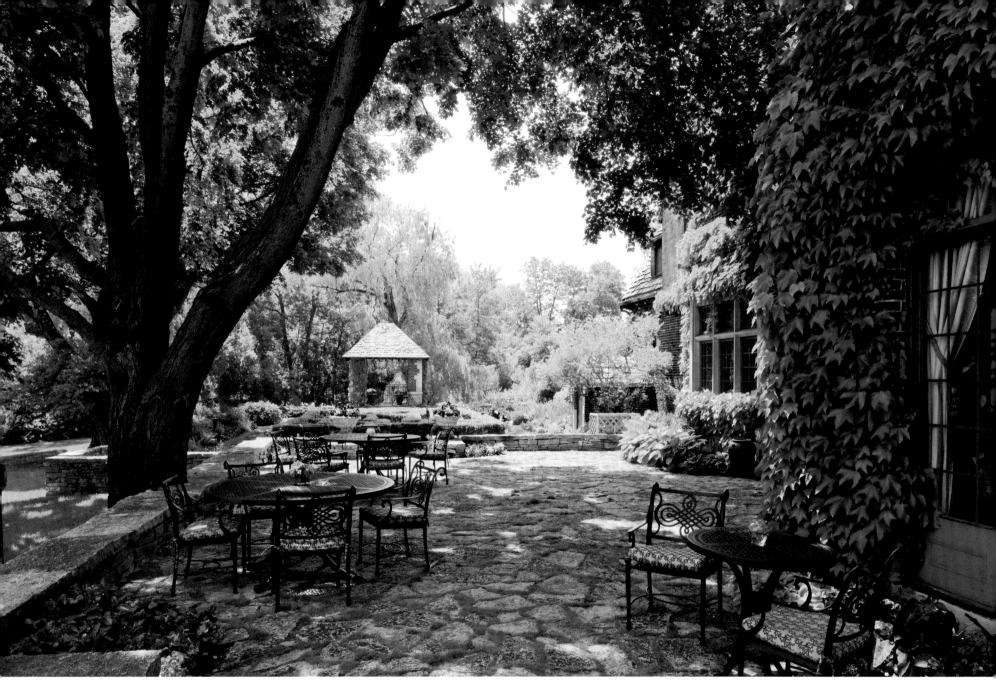

Walter and Charlotte took several trips to Europe to study residential architectural styles and to examine built examples of new industrial towns. On occasion, Philipp accompanied them, filling sketchbooks with drawings. In 1913 they all traveled to planned communities such as Port Sunlight, England, which was built for the Lever Brothers soap company; the Krupps company town in Essen, Germany; Letchworth, England; and other developments based on Ebenezzer Howard's Garden City movement that was the model for industrial housing. (Howard's influential book, *Garden Cities of Tomorrow*, had been published in 1902.) World War I curtailed their travel, but their trips resumed soon after the war.

Throughout the house and the grounds, architect Richard Philipp designed "rooms" in which a solitary person or a party of fifty could take pleasure.

Grand Tour

In *Democracy in America,* Alexis de Tocqueville observes the "restless curiosity" of Americans who find an outlet in travel. As the nineteenth century brought improvements in transportation and increased opportunities for leisure, tourism began to take shape as Americans formed a conception of their own grand tour. Those who felt the intellectual need and could afford the expense took to the new American roads and canals and boarded the new steamboats with increasing enthusiasm.

Borrowing from the European tradition, a grand tour of travels through Europe was seen as a pilgrimage to our art and architectural precedents. In a time before easy access to information through books and magazines, this tour provided first-person exposure to art and architecture, an experience that formed many Americans' basic aesthetic vocabulary and influenced their tastes in residential architecture.

Travel books of the 1890s and 1900s, from Baedecker to Rolfe and Crocket, described this quest and its preparation in great detail, outlining what to see, when to see it, and even how to organize your trunk and what underwear to pack (silk; wash it out at night and it's dry the next day). For architects and clients, like Richard Philipp and Walter J. Kohler Sr., sharing this grand tour experience could yield successful results, as we see at Riverbend.

Walter and Charlotte Kohler, with dog Pal, in front of their home in the late 1920s

The concept of garden cities was new to the United States, and Walter Kohler was excited about it. He had worked grueling twelve-hour days as a laborer in the factory, experiencing the mind-numbing effects of hard work in less than optimum conditions. In addition to building a wonderful home for himself, he wanted to build a community that would attract and retain quality employees. The town would not be modeled on the paternalistic and controlling company town of so many earlier American industries. It would be a planned community that would allow for a balance of work, recreation, education, shopping, and home life.

Other Midwestern industrialists were also exploring the option of building new towns. F. A. Seiberling of Goodyear Tire and Rubber in Akron, Ohio, built one of the first, Goodyear Heights, in 1912. The architects were Mann & MacNeille and the land planner was Warren Manning, a well-regarded New York landscape architect who also designed the grounds for Seiberling's sixty-five-room mansion by Cleveland architect Charles Sumner Schneider.

Seiberling and Kohler were similar in terms of their success in business and in their built projects. In addition to overseeing the development of their company towns, they both built large Tudor Revival mansions based on precedents they saw on European tours. They both employed local architects and East Coast landscape architects. But Kohler and Seiberling were not emulating English lords of the manor who collected rent; they were American businessmen who set up real estate arms and credit unions as separate entities from their factories to encourage their employees (including management) to invest in home ownership and their community. The homes in their model villages were sold to anyone who could qualify for a mortgage; they did not have to work at the companies. In the 1920s a single-family home in a small village was the ideal, since many families wanted to leave congested cities for clean air and new construction. Members of the middle class could afford a car, and they followed the new roads to new communities. The houses in the original Village of Kohler, which were not designed by Philipp, were intentionally small and built either in a cozy cottage style or a crisp Colonial Revival. Philipp was the architect for all of Kohler Co.'s major buildings, including the American Club, a residential club for single men who worked for Kohler (it's now a luxurious resort); the Recreation Hall; and the factory and production sheds. Most were constructed before 1930.

Planning for the Village of Kohler had begun in earnest in 1913. Walter Kohler retained planner Werner Hegemann in 1915; Hegemann brought in landscape architect Elbert Peets a year later. In 1922 the partners became best known as authors of *American Vitruvius: An Architect's Handbook of Civic Art,* a monograph still popular with urban planners and students. (Between 1935 and 1938 Peets was also involved in the planning and landscape design of Greendale, Wisconsin, one of the federal government's planned Greenbelt cities.) For a variety of reasons, Kohler terminated his relationship with Hegemann and Peets; they were replaced as planners by the Olmsted Brothers, successor to Frederick Law Olmsted and Sons.

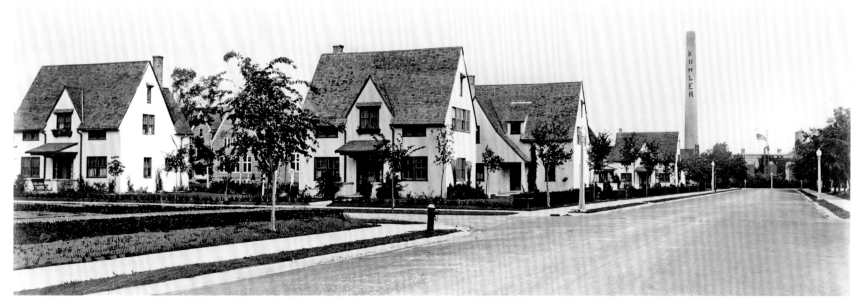

Homes in the Village of Kohler's planned community, seen here in an image from 1925, were designed to emulate those in a picturesque English village.

WORLD WAR I OFFERED CHALLENGES and opportunities for Kohler Co. Planning for a new town and a grand home were put on hold while Walter focused on providing materials for the war effort: precision valve fittings, a variety of electric generators, mine anchors, projectiles, and shells. Another side effect of the war that influenced the planning for the Village of Kohler was the legacy of landscape architects and architects working for the government, designing and planning communities for war workers. The government, thinking the war would be prolonged, decided that permanent and well-built communities should be constructed rather than temporary tent cities or barracks living. The best known of these communities are Nitro, West Virginia, and Alcoa, Tennessee. In Wisconsin, 360 Dutch Colonial homes were planned for Eclipse Park in Beloit, where workers were to build internal combustion machines for the war effort. These effective, pleasant, and landscaped communities affirmed Kohler's supposition that well-planned living environments maintain and boost worker morale. The Olmsted Brothers was one of the planning firms involved in the war effort. In 1924, the year after construction on Riverbend was completed, Kohler commissioned the firm to provide the landscape design for the grounds of his home as well as a fifty-year landscape plan for the Village of Kohler and its growth over that period. The Olmsted Brothers plan was formally adopted in 1925.

Construction on the fifty-room mansion began in 1921 and was completed in 1923. The Kohlers' four sons were in their twenties and late teens when the family moved in. The result of careful planning, thoughtful design, and high-quality construction details and materials, Riverbend was designed as a reflection of Walter Kohler's success.

Like many other prosperous industrialists, Kohler chose Tudor Revival as the style for his home. Colonial Revival was a popular choice for successful businessmen of the

1920s, but industrialists who chose to live in the country preferred the Tudor Revival style because its sprawling nature is sympathetic to large grounds. It was an ideal style for wealthy Americans eager to emulate the British landed gentry's refined lifestyles; in the Kohlers' case, the design included a polo field and a croquet court.

Riverbend was built in the middle of the American Country Place era, which dates from 1890 to 1940. Very few of these American Country Place homes were actually in the country and even fewer were estates since they were not inherited; most were built by self-made men. Scores of them were constructed in New York state, and many estate landscapes were designed by the Olmsted Brothers. In Chicago's North Shore grand homes proliferated, with Jens Jensen and Warren Manning as the favored landscape architects.

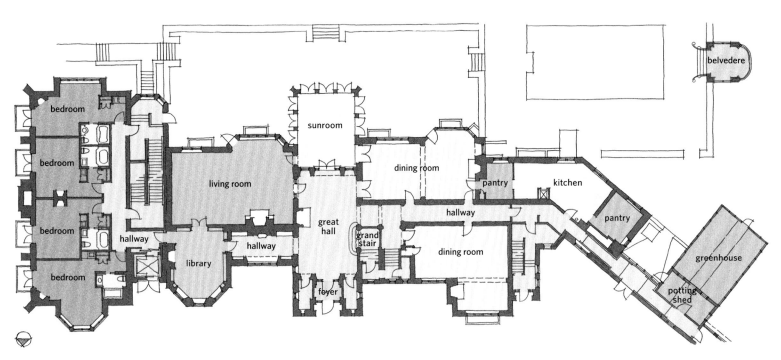

At the dawn of the twentieth century, architecture was very much a debate between an eclectic reinterpretation of different historic styles and evolving new approaches. One striking aspect of the Tudor Revival style is that it intentionally creates the appearance of a building constructed over time, with subsequent generations adding a wing—despite the fact that the home was actually built all at one time. Riverbend is an exception: a large, three-story wing was added seventy-five years after construction was completed, when the residence was converted to a private club. This eastern wing beyond the living room and library is on the footprint of the unbuilt natatorium that was part of the home's original plan.

Riverbend's modified cruciform plan has flanking public wings intersected with a grand entry hall and sunroom. A ceremonial staircase leads to bedrooms above. In this gracious home's second life, the original billiards room was converted to additional dining space.

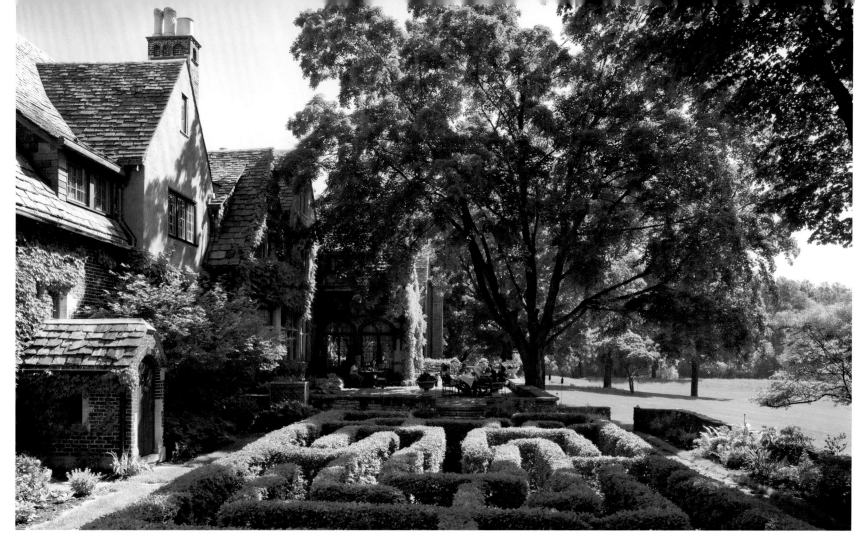

Tudor Revival was loosely derived from English Gothic and Renaissance examples of the late sixteenth and early seventeenth centuries, in particular of Elizabethan and Jacobean times. Hallmarks of the style include steeply pitched roofs with steep side gables; half-timbering and stucco are frequent veneers. Tall, multifaceted, grouped windows alternate with massive chimneys topped by decorative chimney pots. Brick and stone cladding are used individually or together to suggest a structure of an older pedigree that has been updated with a complementary masonry patch. Roofs of tile, stone, and even thatch were used in early Tudor Revival permutations. Punched (or deep) doorways of Tudor (or flattened) arches are often graced with Renaissance details such as heraldic carvings.

RIVERBEND IS ONLY A FEW MINUTES' DRIVE and a healthy walk from the Kohler factory and offices, along curving, landscaped streets offering picturesque and varying views. As the name suggests, the house overlooks a bend of the Sheboygan River and, as magnificent as Riverbend's architecture is, its 40-acre landscape is a perfect complement. The approach to the house is through a brick and wrought-iron gate that opens onto a winding road with distant views of wooded ridges and closer views of the river, a low waterfall, and sweeping fields. Large wolf trees (those too large to be removed from a farmer's field) rise

ABOVE: The small belvedere overlooks a bend in the river and the grounds—a setting where one can be apart without feeling isolated.
RIGHT: Graceful and generously scaled openings in the stair create an interlocking sequence of first- and second-floor spaces. The constant wash of light from the northern window highlights the artful masonry detailing.

out of an open field. The house is screened from view with layers of naturalistic plantings of native trees and grasses. It is only after one crosses an arched stone bridge that the three-story Tudor mansion—which is more welcoming than overwhelming—is revealed.

The exterior is believable as a historic baronial home; it is difficult to see all of the elongated front elevation in a single glance. Gables, dormers, grouped windows, and chimney pots of assorted sizes and shapes delightfully animate the long brick and stone corbeled elevation. Rusticated stones are large and varied in hue, leaded-glass windows are adorned with heraldic crests, and the three-paneled oak front door set into a cove of arched limestone hints at the grandeur within.

In *Great Houses of America* (1969), Henry Lionel and Ottalie K. Williams selected Riverbend as one of the country's forty most beautiful homes. They noted that the beauty of the materials—stone, slate, brick, and wood—and the artistry with which they were combined resulted in a delightful expression of residential architecture well suited to its natural setting. The authors also noted that the Kohlers never made any pretense of reproducing an authentic Tudor interior; instead, they delighted in natural materials and exquisite decorative details. Kohler Co.'s archives document that more than twenty con-

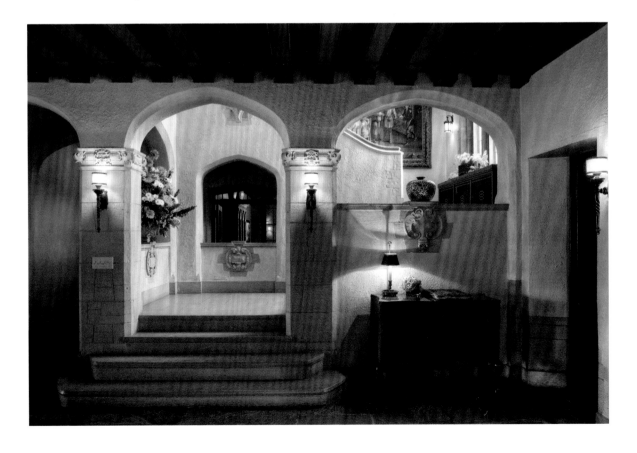

sultants collaborated on the construction and interior design. Many of the building materials were supplied by local businesses such as a Plymouth quarry, and many of the furnishings came from England and Europe. The roof's green slate came from Vermont, as did the granite of the entrance hall floor.

The home's textures and details underscore the fact that craftsmen created these spaces from natural materials, as seen in the twenty-three hand-carved oak beams of the oak-paneled ceiling in the impressive entry. There, a roughened, earth-toned granite floor is in rich contrast to butter-colored plaster walls. (The walls were painted dark tones in the 1920s and white in the late 1940s.) A Madison stone fireplace projecting two feet into the hall—its massiveness symbolic of the generous hospitality offered within the residence—is opposite an expansive staircase of highly polished Mankato stone. Charlotte Kohler's artistic skills and training as an art teacher are on display throughout her home.

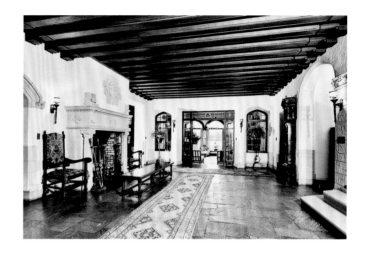

One can enjoy different views from the hall: To the east, down a narrow stone hallway one is afforded a glimpse of the intimate wood-paneled library and its glaze-tile fireplace surround. To the south is the light-filled sunroom, with leaded-glass French doors overlooking the moss and flagstone terrace for a distant view of an open field and a far tree line, not another building in sight. Arched brick doorway openings and windows are ornamented with carvings. Some animal carvings with smiling countenances are humorous, while other heraldic carvings are more formal and traditional. The living room, which is discovered after passing through more intimately scaled rooms, is perhaps the

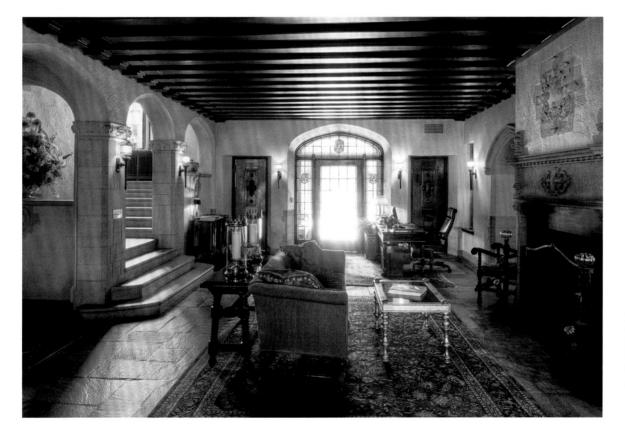

ABOVE: The expansive entry hall, circa 1965. LEFT: As in twentieth-century homes, the reception hall at Riverbend was designed with hospitality in mind. Burning logs in the massive fireplace could warm guests entering on the coldest winter night.

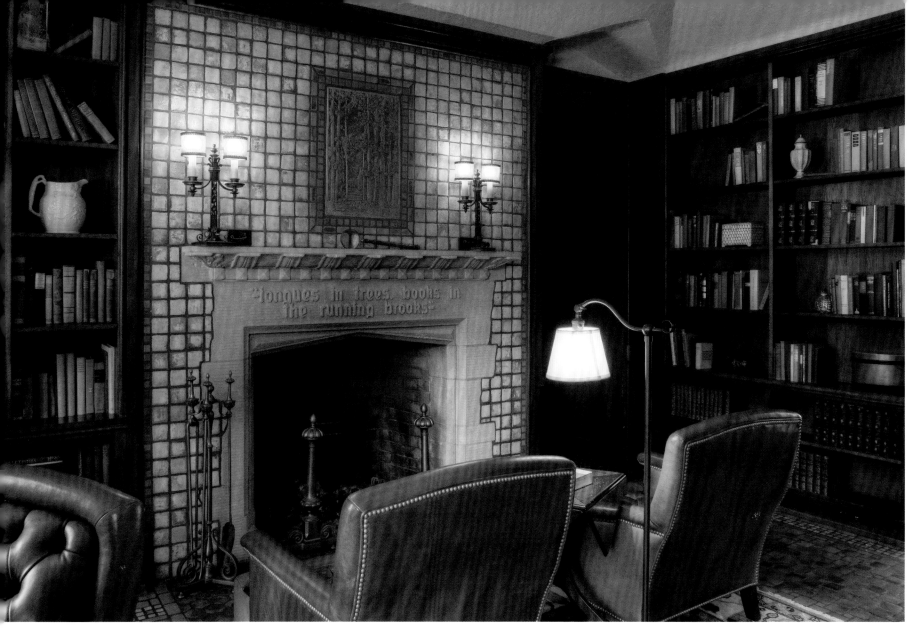

The library fireplace is scaled for two; at the time the Kohlers built their estate, their sons were almost grown. Reading was an important part of the family's life.

simplest of all: the floor consists of wide oak planks, the walls and ceiling are plaster, and the ceiling has a simple treatment of a band of raised plasterwork. Its most elaborate feature is the fireplace, its pilasters crowned with carvings of small ferrets. The room's simplicity could be a reflection that the intended ornaments were the guests attending large parties; the space would allow them to effortlessly mingle.

The Kohlers enjoyed hosting holiday parties, family celebrations, company picnics, and political gatherings as when Walter ran for—and was elected—governor in 1928. A news article from 1920 noted that the house "was made for entertaining. . . . It is at its best when it is full to capacity."

During the Walter J. Kohler Sr. era, a linen curtain separated a family dining room and a breakfast room; today this space overlooking the brick garden terrace is one dining

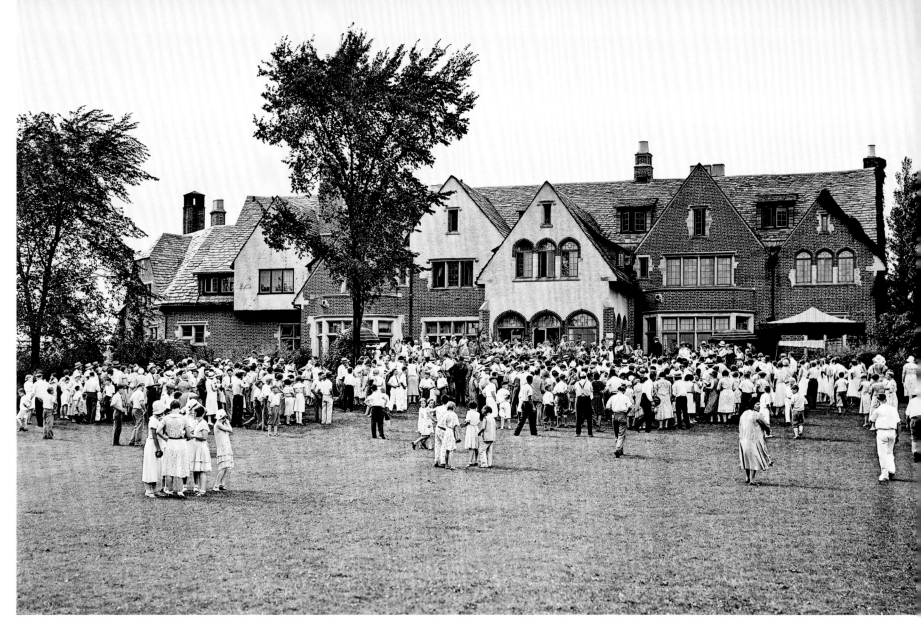

A 1930s gathering on the front lawn of Riverbend

room, with a rich red Moravian tile floor in a circular design, which can seat thirty. Across the hall was a billiards room, complete with tiled floors and a fireplace. A recreation room in the finished basement highlighted the family's interest in sports: stained-glass windows behind the bar show a skater and a skier, the fireplace carvings have an equestrian theme, and metal sconces are shaped like a horse jumper and hockey, football, and polo players.

Riverbend was constructed with nine bedrooms on the second floor, each with an en suite bathroom, so there was plenty of room for the Kohler boys when they come home with college friends and, later, their wives and children. The second floor also housed two guest rooms, each with its own bath, and a sleeping porch was accessible from the hallway. The third floor housed three more bedrooms and baths for staff. Additional staff quarters were located in outbuildings.

THIS CHAPTER BEGAN with the statement that good design is flexible: it accommodates new owners and new uses and, in the Kohlers' case, applies to residential design as well as bathtub design.

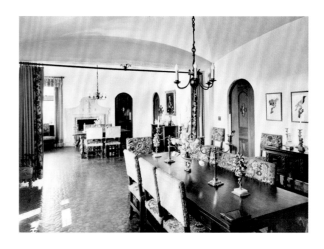

Walter J. Kohler Sr. died in 1940. Charlotte lived in the home until her death in 1947. At that time John Michael Kohler III and his wife, Julilly, bought the house from his siblings. While raising their four children in the home, they made minor changes. Riverbend was never regarded as a museum. It was a family home that was redecorated to reflect the tastes of the presiding family members. The changes were largely in color palette and furnishings. Few structural changes were needed or wanted.

In 1984, four years after the home was placed on the National Register of Historic Places, John Michael and Julilly's children transferred ownership of Riverbend to the National Trust for Historic Preservation through the Gifts of Heritage Program. In 1986 Kohler Co. purchased Riverbend, which had been unoccupied, from the National Trust for Historic Preservation. Herbert V. Kohler Jr., a nephew of Walter's and chairman of the board and chief executive officer of Kohler Co., examined the empty home. In the aging house that was too large for most families today, he saw the potential for a new use, one that was functional, self-sustaining, and a perfect fit: a private club with all the benefits of ownership and amenities of an elite hotel.

In 2000 Kohler Co. began a complete renovation of Riverbend. The design integrity of the building and its grounds still existed, but over the years deferred maintenance had taken its toll. Due to an easement placed on the property to protect its notable architectural and landscape elements, there were constraints on what could be done in the renovation. The rediscovery of Richard Philipp's original drawings in the Kohler Co.'s archives provided the key to un-

RIGHT: A curtain separated the family dining room from a breakfast space during the Kohler family's time in the home, as seen in this 1965 image. BELOW: When the young Kohler men brought their college friends home with them, the basement recreation room was a popular place to gather.

locking the limitations: the drawings showed a three-story addition with a natatorium that was never built. Herbert took the drawings to Washington, D.C., and spoke to officers of the National Trust for Historic Preservation about the possibility of building the addition, which would allow Riverbend to continue to be a vibrant part of Kohler—this time as a private club and conference center. The proposal was approved, proving once again that good design is flexible.

The addition provided enough square footage to get to the magic number of guest rooms (thirty-one) that would make the club financially viable. A spa, exercise facilities, and an indoor-outdoor swimming pool—the design of which is charmingly integrated into the original lily pool design by the Olmsted Brothers—add amenities desired by private club members. The grounds and gardens have been restored and members enjoy the same privacy and service the Walter Kohler family enjoyed.

The first floor was refurbished with minor spatial alterations. Some original pieces, such as the piano and Jacobean chairs, add an air of family to the club. The second floor, where the family bedrooms were, and the third floor underwent major changes when they were remodeled to accommodate the new function of private club and to seamlessly flow into the addition, which provides more guest suites. Needless to say, any Kohler home would have the latest and finest bathrooms, and all the bathrooms have been updated with Kohler products.

Three traits common among those in the vanguard of industry are the ability to look at one thing and see another, to look farther into the future than others are capable of, and to recognize that changing times provide opportunities to be creative without dismissing the past. Riverbend exists today because the Kohler family members have always been passionate about it and continue to be so. They had the desire to find the highest and best use for their significant historic home. As a private club, Riverbend endures as a fine residence—albeit for a different sort of extended family of temporary guests who are all members. Membership creates a sustainable economic environment for Riverbend that preserves not only the building and grounds but also the lifestyle of a baronial estate. •

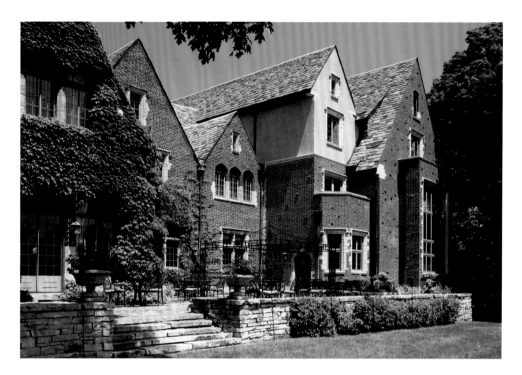

TOP: Note the subtle use of clinker brick in the two-gable addition to differentiate it from Richard Philipp's original design.
BOTTOM: The spa in the newly constructed wing fashions a delightful indoor-outdoor connection.

Villa Terrace | Milwaukee 1923

OPPOSITE: The architecture of Villa Terrace takes its cues from the topography.

PERCHED HIGH ON A BLUFF OVERLOOKING LAKE MICHIGAN, Villa Terrace is an elegant interpretation of a sixteenth-century northern Italian villa. Originally christened Sopra Mare by the Lloyd R. Smith family, its neighbors are equally impressive homes of some of Milwaukee's other entrepreneurial families. The villa speaks of history, culture, and sophisticated taste in art and architecture. It is the result of a brilliant collaboration between industrialist Lloyd R. Smith and architect David Adler, who were grandsons of two early Milwaukee settlers, Charles Jeremiah Smith and Isaac David Adler.

IN 1847, MILWAUKEE, RACINE, AND KENOSHA were the largest cities in the Wisconsin Territory; by 1850 Milwaukee had more than twenty thousand inhabitants. The northern half of the territory was a wooded wilderness, while the southern half was a developing agricultural region fueled by an influx of immigrants who could provide much-needed goods and services to a rapidly growing population.

Charles Jeremiah Smith, known as C.J., was an English metal journeyman who sailed to America in 1843. During the crossing, he met a lovely young woman who inspired him to change his plan to settle in New York City and instead follow her and her parents to the rural settlement of Spring Lake, west of present-day Mukwonago. In 1845 the newly

married Smiths moved to Milwaukee, where C.J. opened a blacksmith shop that became among those listed in the first City of Milwaukee Directory published in 1847. To support his young family, C.J. sold the business in 1854 and took a position as a machinist for the Milwaukee Road Railway. For the next twenty years C.J. worked for the railway, but, ultimately, he knew his fortune lay in following his own strong work ethic and penchant for innovation. In 1874, at age fifty-four, he started his own machine shop, specializing in the manufacturing of parts, mainly for baby carriages and bicycles. By 1895, C. J. Smith & Sons was the largest manufacturer of steel bicycle parts in the United States, due in large part to C.J.'s experiments in perfecting the design and manufacture of a seamless steel tube that was both economically competitive and lighter in weight than the ubiquitous iron frame.

At age seventy-five, C.J. decided to expand the company. His engineer son Arthur Oliver (known as A.O.) returned to Milwaukee from Chicago in 1896 to oversee construction of his father's new office building. A.O. then stayed on to manage the family business. C.J. retired in 1899 and five years later the company name became A. O. Smith.

When A.O. died in 1913, his thirty-year-old son Lloyd Raymond (or L.R.) became the company's president. L.R., whose first job at the company was as a water boy for workers constructing the new building, would boldly take business into the modern era by diversifying the product line and investing in engineering talent. This pragmatic businessman displayed his visionary side when he commissioned Chicago-based architect David Adler to design a home for his family in 1923. The industrialist and the architect were almost the same age and each had strong Milwaukee family connections, but it was Adler's reputation as a highly sought-after architect of country estates for Chicago's North Shore elite that secured the alliance.

BORN IN MILWAUKEE in 1882, David Adler was named for his grandfather, a Bohemian immigrant and baker's apprentice who sailed into New York's harbor in 1843 and later opened David Adler & Sons, a retail clothing business in Milwaukee that by the 1880s employed nine hundred people and had annual sales in excess of $1 million.

Adler grew up surrounded by fine architecture. His grandfather's home, a double house, or duplex, built in 1885–86 and designed by noted local high society architect James Douglas, was located on Prospect Avenue, Milwaukee's "Gold Coast." His uncle Emanuel lived ten doors north, in a home designed by Alfred C. Clas. Clas (who in 1890 would join forces with George Bowman Ferry) was an architect favored by prominent businessmen, including Captain Frederick Pabst of the Pabst Brewing Company and Emil Ott, president of one of Milwaukee's largest wholesale grocers. Henry C. Koch, architect of the Milwaukee City Hall, designed the elder David Adler's seven-story Richardsonian Romanesque factory building. The Adler family was interested in design, whether the object was clothing or architecture.

The younger David Adler spent the seven years following his graduation from Princeton University traveling and studying in Europe, ventures financed by his uncle Charles

OPPOSITE: The loggia is accessed from the second-story hallway. Facing west and protected from northern winds, these outdoor rooms could be enjoyed late into the fall when the distinctive neighboring homes became more visible.

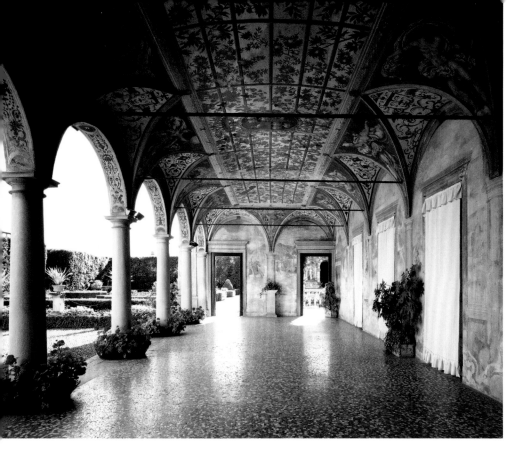

Villa Cicogna Mozzoni, the Italian Renaissance inspiration for the Smiths' Milwaukee home

Stonehill, a wholesale milliner in Chicago who later became president of the Chicago Mercantile Exchange. Adler began his architectural studies in Munich at the Polytechnic (the Adlers spoke German at home) and then studied at the École des Beaux-Arts in Paris. It was there that he met Henry Dangler, his first partner.

The extended time spent in Europe was critical to Adler's development as an architect. In lieu of studying architectural history in a classroom, students interested in architecture were expected to travel at length in Europe, experiencing the ancient buildings in three dimensions.

During his travels Adler acquired the habit of collecting postcards. It is well known that he was not an accomplished draftsman, which is somewhat odd for someone who attended the École des Beaux-Arts, which offered a program of study that highly valued both the quick sketch and exquisite finished renderings. But Adler was much more interested in the details of architectural design than in drawing buildings. While he did not return with the volumes of sketchbooks that typified the grand tours of his peers, his postcard collection provided hundreds of images of significant buildings; he had made copious notes about their details and materials. He also began to collect books on English, Swedish, French, Italian, and Spanish architecture.

Considering the precedent for David Adler's design, Villa Cicogna Mozzoni, Villa Terrace fits firmly into the Italian Renaissance Revival style of 1890–1935. Hallmarks are symmetrical plans and elevations with tile roofs of low pitch and eave extensions. Important doorways are called out with Italian Renaissance–style arches, and the first-story windows are often veiled by imposing classical pilasters, columns, or, as seen here, an arched colonnade. Smaller, simpler windows are often found on the upper story. Historic urban palazzo precedents such as rusticated floors and decorative grated windows on the ground floor are often used.

True to the home's historical influence, Villa Terrace's zones of private, public, and service wings wrap around and enjoy the ben-efits of the outdoor courtyard. Adler's design is rarely more than one room wide, which maximizes the interior and exterior views while ensuring the best orientation for passive solar heating and natural ventilation.

As an atrium plan this example also shares many characteristics with the similarly dated Mission and the later Spanish eclectic styles. The popularity of the atrium plan in those styles may be attributed to a more benign geography than the Upper Midwest; the Southwest and California were less densely populated, so it was economically more feasible to build a home with an atrium, given its requirements for a larger site than most urban infill sites permit. Those regions had more sympathetic climates for this Mediterranean transplant.

Adler's uncle also encouraged David's sister Frances's interest in interior design and financed several trips to Europe so she could travel with her brother. Frances Adler Elkins later became a renowned interior designer and collaborated with her brother on many of his projects. Throughout his life, Adler returned to Europe to look at architecture or buy decorative arts, furniture, and paintings—as often as not for his clients or for consideration for purchase by the Art Institute of Chicago. Adler served as a trustee for the museum for many years.

In 1911, following his travels in Europe, Adler returned to Chicago. Both he and Henry Dangler worked in the Chicago office of Howard Van Doren Shaw, an accomplished and prolific society architect. It was while Adler was in Shaw's office that his uncle Charles Stonehill offered Adler the opportunity to design a home for his family in Glencoe, Illinois. The French Normandy–style estate was the beginning of a wondrous career of designing grand and eclectic homes and gardens for the very wealthy, not only in Chicago but throughout the country and in Hawaii as well. Dangler and Adler left Shaw's office to set up their own practice high above Michigan Avenue and just south of the Art Institute, on the top floor of the Daniel Burnham–designed Orchestra Hall, completed in 1904.

A. O. SMITH HAD TAKEN THE FAMILY COMPANY from the manufacture of bicycle parts to the manufacture of automobile parts. In 1906 the company built ten automobile frames a day until that April, when it received an order from the Ford Motor Company for ten thousand to be delivered in six months. A.O. saw that the answer to this daunting request was technology, not manpower, and he devised the world's first frame-assembly plant. This made the company the leader among the automotive industry frame providers.

Decisiveness was obviously a family trait. In 1915, two years after L. R. Smith was thrust into the presidency, he worked quickly to automate his manufacturing operations. World War I interrupted his plans but provided an economic boon to the company, thanks to government contracts to produce millions of bomb casings and other products for the war effort. A technological breakthrough in welding propelled the company's efficiency forward. By 1920, with the war ended, automobile production revved up and work resumed on the frame-assembly plant. The new mechanized plant opened in 1921. The time was right for L.R. to build a home that reflected his business success and personal aesthetic.

L.R. and his wife, Agnes, considered two sites for their new home: one in the then unincorporated Village of Fox Point north of Milwaukee and the other on Terrace Avenue, in a dense urban neighborhood of fine homes designed for families such as the Pabsts, Falks, and Blatzes by some of the best architects in Milwaukee, including Alexander C. Eschweiler, Ferry and Clas, and Otto Strack. Agnes Smith expressed her opinion that many Milwaukee homes looked alike; she wanted something different. Perhaps the couple's choice of an Italian Renaissance–style villa was influenced by their honeymoon trip to Italy, or perhaps it was a reaction to the heavily ornate Germanic and Flemish styles that dominated Milwaukee residential architecture at the time.

The "Harvestore" silo

Made in Milwaukee

From its Milwaukee roots, the A. O. Smith Corporation has exerted national influence. Established in 1874 by C. J. Smith, the parts maker for baby carriages soon gravitated to the bicycle industry and then pressed-steel automobile frames for Henry Ford, General Motors, and most of the American auto industry.

Always forward-thinking, A. O. Smith introduced the first large, single-piece, glass-lined brewery tank after the end of Prohibition. Based on his research on fusing glass to steel, in 1936, Smith patented the process of glass lining for a residential water tank that became the industry leader for hot-water heaters. Domestic mass production of an affordable hot-water heater began three years later but was curtailed by the company's wartime efforts. The postwar years saw the development of coil-type, instantaneous water heaters. A further application of this glass-fused research was in the A. O. Smith Corporation's production of blue "Harvestore" silos still seen across the rural landscape.

The genius of architect David Adler was his understanding of how people move through space. In his hands, a doorway is a staging area in which to pause before entering the open arena of the living room.

It is often suggested that Villa Cicogna Mozzoni, built in the Lombardy district of northern Italy between 1400 and 1580, was the model for the Smiths' home. David Adler quite possibly visited the villa himself; he certainly would have known of it from his copy of Edith Wharton's *Italian Villas and Their Gardens* (1904). Adler also admired the work of architect and landscape designer Charles Platt, author of *Italian Gardens* (1894), who designed the McCormick family's Villa Turicum, a Mediterranean courtyard residence on the shore of Lake Michigan in Lake Forest, Illinois, between 1908 and 1918—the time frame during which Adler's Stonehill residence was under construction.

Adler often worked with two Platt protégés, Rose Standish Nichols and Ellen Biddle Shipman, on his Lake Forest garden commissions. Both Nichols and Shipman were accomplished landscape designers, and Adler relied on them for their expertise in planting design. His designs were comprehensive: exterior space was integrated into his building designs as one complete experience. It is believed that Nichols, an authority on the history of Italian gardens who authored *Italian Pleasure Gardens* in 1928, assisted Adler with the design of the water stairway—a water feature typical of Renaissance gardens—at the Smiths' Sopra Mare. Absolute certainty about the various contributors to Adler's projects is problematic. Nichols had no assistants and her family destroyed her office records shortly after her death. The Art Institute of Chicago has more than nine thousand Adler drawings, but most of them are construction details, not design drawings.

The Smiths' desire to include a water stairway like the one at Villa Cicogna Mozzoni at their Sopra Mare prompted Adler to select the Terrace Avenue site. The drop in elevation from the street to the bottom of the bluff is one-hundred-plus vertical feet—obviously enough for a dramatic staircase. Lincoln Memorial Drive, which today forms the eastern limit of the property, was not built until 1927. Prior to that, the grand mansions on Terrace Avenue had direct and private access to the Lake Michigan beachfront. Many of the homes had swimming piers and boat docks. And while Villa Cicgona Mozzoni was designed so its owners could enjoy a view of the snow-covered Alps as well as the shore of Lake Lugano, Sopra Mare—which means "above the sea"—offered the Smiths magnificent vistas of Lake Michigan.

Much has been made of the oddity of an Italian Renaissance–style villa on the shores of Lake Michigan. But is it really any more unusual than a Flemish Renaissance– or Tudor Revival–style home? The villa designed by Adler added diversity to the already eclectic neighborhood and illustrated that the Smiths were independent thinkers.

DAVID ADLER WAS ACCOMPLISHED in historical styles, but never as a copyist. His works were interpretations of various styles, from French chateau to Georgian Revival. His genius lay in understanding the importance of creating a complete experience—what the Beaux-Arts call the *marche,* or the movement through space. Adler made no distinction between garden design, architectural design, and interior design. His Beaux-Arts training emphasized the classical principles of symmetry, proportion, and scale to ensure that the beauty of each building and how it relates to its site gradually unfolds. One has to

Robert, Suzanne, June, and Lloyd Smith on the water stairway, 1926

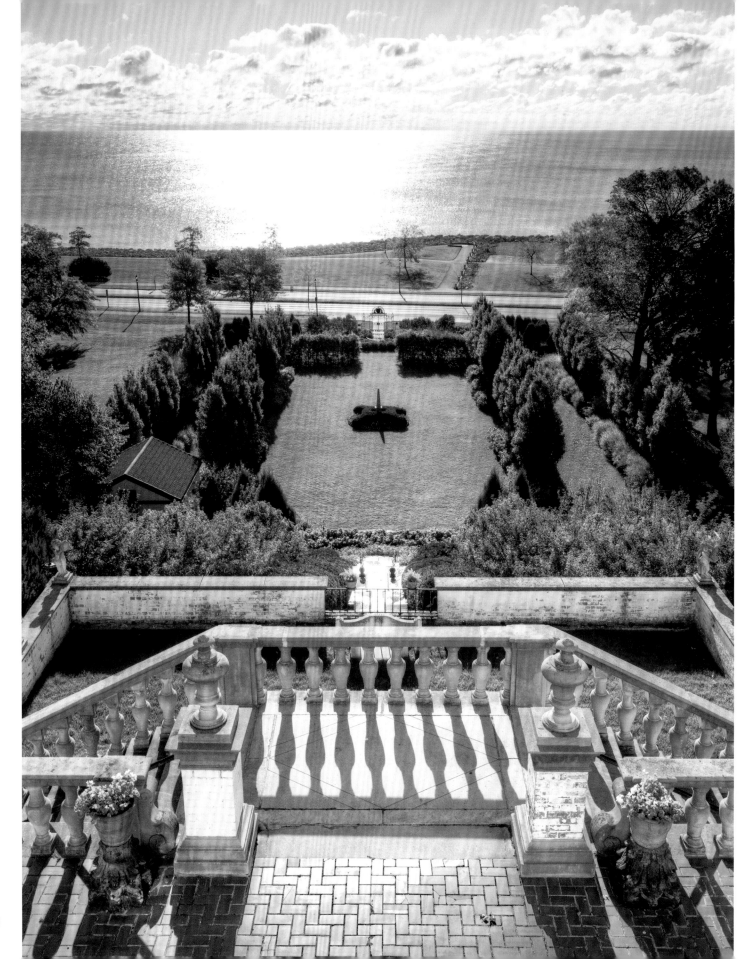

In 1997 the Friends of Villa Terrace rescued the overgrown gardens and decaying water stairway. Today the garden is a popular setting for celebrating weddings, fund-raisers, and reading Sunday papers. The house is a landmark along the Lake Michigan lakefront.

physically move through Adler's homes to truly comprehend his command of creatively adapting a historical style to reflect the cultivated taste of his contemporary clients. The interior details were as important to him as any exterior detail.

If Villa Cicogna Mozzoni was indeed the precedent for the Smith home, Adler largely borrowed from it the idea of the experience of coordinated interior and exterior spaces. Villa Cicogna Mozzoni is a grandiose three-story residence with decorated arched colonnades, frescoed exterior walls, marble staircases, enormous fireplaces, elaborately adorned interiors, intricate trompe l'oeil painting, and gilded coffered ceilings. It has two distinct garden spaces: one an entry court and the other a series of landscaped terraces with a dramatic water stairway. In comparing the scale of the two villas, Villa Terrace is much more intimate, but the influence of Villa Cicogna Mozzoni in Adler's design is still evident.

Each elevation of Adler's residence for the Smiths was carefully studied. The house is unusual because it does not follow the typical Milwaukee hierarchy designating the street-front elevation as dominant and the "rear" elevation subordinate. The Terrace Avenue elevation is only glimpsed through layers of garden walls capped by clay Mission-style tile roofs. Compared to the impressive neighboring homes, Villa Terrace has a discreet presence. The Lake Michigan elevation, high on the bluff, is sublime. As mentioned earlier, at the time the home was designed, the lakefront was private. The magnificent terraced gardens and water stairway cascading down the center were not designed to impress strangers; they were designed for the family (and sailors on the lake) to enjoy. Today, thousands of walkers, joggers, commuters, and boaters enjoy a full view of the villa and its gardens from Lincoln Memorial Drive as part of their daily routine.

A VERY IMPORTANT BOOK in Adler's library was the 1897 edition of Edith Wharton and Ogden Codman Jr.'s *The Decoration of Houses.* Wharton is known today primarily as a novelist, but prior to writing fiction she was recognized as an authority on Italian gardens, landscape, interior design, and architectural design. (An aside: She was the only daughter of George Frederic Jones of New York. The expression "Keeping up with the Joneses" is said to have been coined to describe her family's wealth and social standing.) Codman was an architect from an old and wealthy Boston family. His New York office was highly regarded for its reserved and well-designed interpretations of Colonial Revival and other eighteenth-century-revival styles.

Chapter listings for *The Decoration of Houses*—"Walls," "Doors," "Windows," "Fireplaces," "Ceilings and Floors," "Hall and Stairs"—read like a guidebook to Sopra Mare. The chapter titles make the book sound straightforward, but the writing is hardly a checklist of dos and don'ts; rather, it offers a thoughtful discussion of the principles of composition and use of materials to achieve a desired effect.

In the opening chapter, "The Historical Tradition," Wharton and Codman admonish their readers concerning the sudden demand for "style" due to the utter confusion by architects during the "garbled" Victorian period. Wharton and Codman cautioned their

David Adler and Modernism

Society architect and scion of Neoclassicism David Adler played a vital part in bringing modernism to the United States.

In 1936, when Chicago architects Jerrold Loebl and John A. Holabird were on the search committee for a new head for the Armour Institute of Technology, they encountered Adler on the grand staircase of the Art Institute of Chicago. He enthusiastically endorsed their inquiry about Ludwig Mies van der Rohe as a candidate for the position. Adler led them across the hall to the Burnham Library to show them photos of Mies van der Rohe's Barcelona Pavilion and Tugendhat House. After accepting the post, Mies van der Rohe established a Midwestern beachhead for European modernism that gave him international influence in the practice and teaching of architecture. Armour merged with Lewis Institute in 1940 to form the Illinois Institute of Technology; its campus was anchored by the iconographic architectural designs of Mies van der Rohe. In 2005 the college grounds, highlighted by Mies van der Rohe's Crown Hall and Carr Memorial Chapel, were added to the National Register of Historic Places.

While Mies van der Rohe's work may seem to have little in common with Adler's classic villas, both architects' designs share an appreciation of the classic plan, the big conceptual idea, elegant materials, and studied restraint. God was in the details for both. Mies van der Rohe lauded Adler as a man of "dedication and perfectionism."

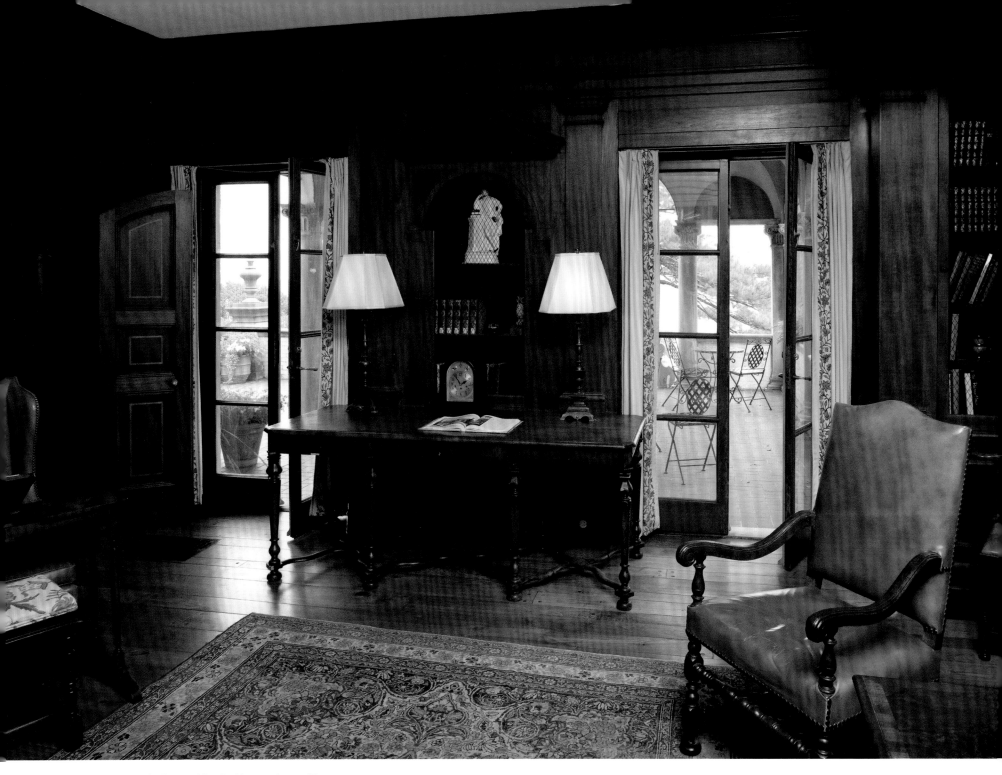

Every room in the house, like the library pictured here,
has a strong visual connection to the outdoors.

readers: "The essence of the great styles lay in proportion and the science of proportion is not to be acquired in a day." This last sentence could have been Adler's professional credo.

The Smith residence is a study in the beauty of symmetry and proportion. The footprint of the home is a truncated H shape, but it is experienced as two U shapes. The floor plan is an actualization of the served and servant *parti* (*parti* being a French word to describe the big idea behind a design). The north wing of the villa is the servant area that houses such functions as the kitchen: the first floor contains the service drive and entry, butler pantry, silver vault, kitchen, cook's pantry, servants' hall, and a servants' bedroom with private bath. An interior stair leads from the servant area to the second floor, with additional north-facing sleeping rooms for servants; no servant's bedroom windows overlooked the family sleeping quarters on the second floor's eastern and southern arms. Access to the basement—a warren of rooms, including a wine cellar, laundry facilities, and tandem garages—is through the servant's hall. Attention to fine materials was carried through even in the kitchen and butler's pantry, where Delft tiles face some of the walls.

As with most of Adler's smaller homes, the main entry is not at the center of the primary elevation; here, while the courtyard is visible and accessible, the entry door is at the southeast corner, under the covered walkway. The main entry hall opens into the family stair hall, where a cantilevered concrete stair gracefully winds up to the second floor. Its braided, forged-iron baluster was crafted by Cyril Colnik, a master blacksmith who also designed the home's gates, grilles, door hardware, and light fixtures.

From the entry hall, a guest could freshen up in the women's powder room, complete with double cloak closets and a guest half bath, or directly enter either the library or the living room. West of the powder room was a bedroom with a through bathroom to the children's playroom that opened onto the enclosed courtyard with a black-and-white-pebble floor like those found in Portugal and Brazil (pebbled courtyards were a favored design motif of Adler); clipped boxwood plantings; and, during the Smiths' time, a large water basin fountain (today a statue of the Roman god Mercury stands in that center location). A four-sided arched colonnade provides shade and protection from snow and rain; its roof of variegated clay Mission-style tiles ranging in color from charcoal gray to terracotta provide a warm contrast to the pink brick overpainted in white. An exterior stair on the courtyard's northern wall leads to the open-arcaded second-floor balcony.

The 45' by 27'6" living room with 10-foot ceilings has views of both the western courtyard and Lake Michigan to the east through symmetrically placed 8-foot-tall windows. Two identical fireplaces are centered on the north and south walls, each flanked by arched doorways. The hand-stenciled beamed ceiling is of Pecky cypress, a wood favored for the variety of patterns its holes create. The use of Pecky cypress was unique at the time; it became popular in late-1950s residential architecture. Massive hooded limestone fireplaces and white plaster interior walls replicate the look of rustic Italian hunting villas.

Many of the decorative fireplaces and hearths throughout the home are stone, although some are faux-painted to resemble marble. The plethora of fireplaces is somewhat amusing since the A. O. Smith Corporation manufactured the most up-to-date hot-

The atrium home built by Mr. and Mrs. Frank Lauerman in Marinette, Wisconsin.

A Northern Wisconsin Atrium

The atrium house traces its lineage to the ancient Romans. It resurfaced as a popular American housing type in mid-eighteenth-century California with Spanish Colonial examples.

In running his successful Midwestern department stores, Frank Lauerman made frequent buying trips to Chicago in the early 1900s. There he was told of a new Prairie School of architecture and its major proponent, a fellow Wisconsin native. Mrs. Lauerman would have none of it for the new home they were planning to build. She then saw the August 1900 *Ladies' Home Journal* featuring a Mission-style atrium home in Alhambra, California, by architect L. B. Valk. The atrium had an exotic appeal in the face of harsh northern Wisconsin winters. Correspondence with Valk ensued, with the architect adding a glass cover to the courtyard and making other minor revisions to the published example to create the Lauermans' home that year: a domestic oasis of a sky-lit palm tree court surrounded by its own Marinette Mediterranean villa.

Colnik "Masterpiece," 1893, part of the Villa Terrace Decorative Arts Museum's collection

Cyril Colnik

Born in Austria in 1871, Cyril Colnik was trained as a metal artisan in Munich and was enlisted by the German government to represent his craft at the 1893 World's Columbian Exposition. It was at this World's Fair in Chicago that he was encouraged to relocate to the "German Athens" to the north. Colnik soon settled in Milwaukee, where he opened a successful studio and worked until his retirement in 1955, enjoying commissions from beer barons such as Herman Uihlein of the Joseph Schlitz Brewing Co. and Captain Frederick Pabst, and other prominent Milwaukee industrialists.

Adept at working in many styles and with many Milwaukee architects, Colnik's special art was in coaxing elaborate forms from wrought iron made pliable in its transitory, red-hot state.

In addition to the decorative wrought-iron entry gate at Villa Terrace (there is also a Colnik example across the street) and a curved stair handrail, a permanent exhibit of this craftsman is displayed (including pieces from his World's Fair debut) in a second-floor gallery of the L. R. Smith family home, which is now a decorative arts museum.

water systems and the house was thoroughly modern in terms of its utilities. The fireplaces were there for the romance.

Throughout the Smiths' home, Adler paid rapt attention to the material treatment of the floors, doors, and ceilings. Walls are, for the most part, plaster. Exceptions include the library, which is paneled in walnut, and a large second-floor sitting room covered with exquisite Zuber wallpaper. Hand-printed in France using wood blocks, Zuber wallpaper is most familiar to Americans as the backdrop in the White House's Diplomatic Reception Room. The closet doors of Mrs. Smith's dressing room are ornamented with charming paintings of birds, and the master bedroom has a hand-painted, low-relief coffered Pecky cypress ceiling. Tile floors are either hexagonal or herringbone; other floors are wood, with some being wide-plank and others pegged walnut parquet.

Wharton and Codman wrote, "Rooms may be decorated in two ways: by a superficial application of ornament totally independent of structure, or by means of those architectural features, which are part of the organism of every house, inside as well as out." It is obvious Adler chose the latter.

As ELEGANT A PIECE OF ARCHITECTURE as Sopra Mare is, it was designed as a home for an active family with six children. Family photos show the children playing in the snow, and there are stories of the children flooding the upper terrace to create an ice skating rink.

The Smith children in the courtyard

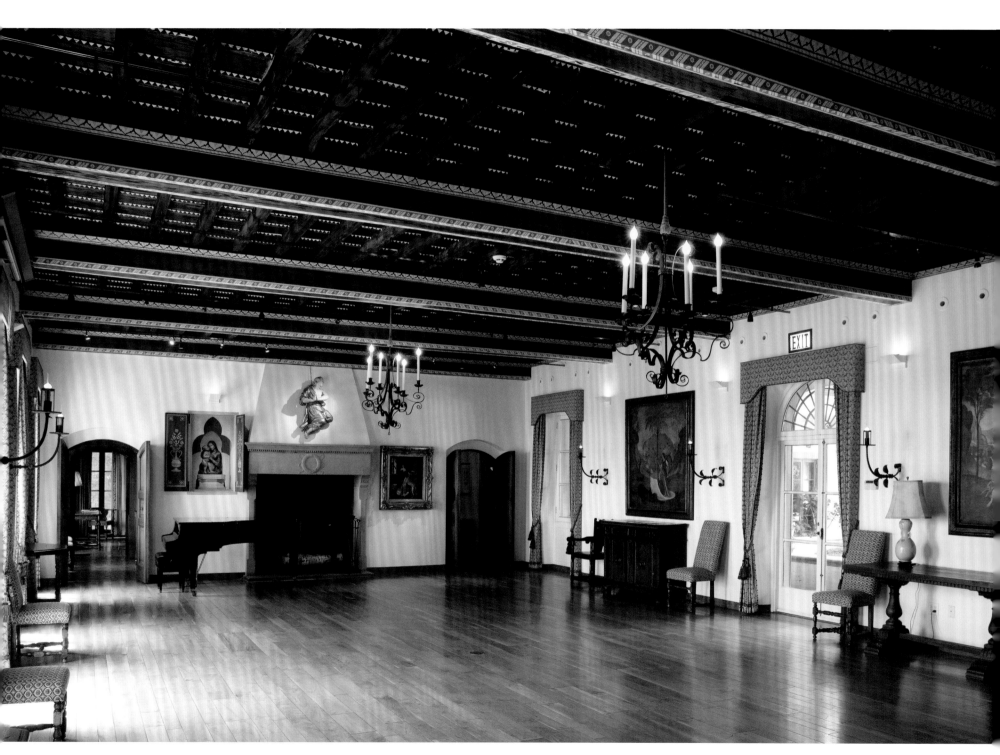

Unlike painted ceilings of the Victorian era, Adler's designs for ceilings honestly expose structure and create an arresting decorative element.

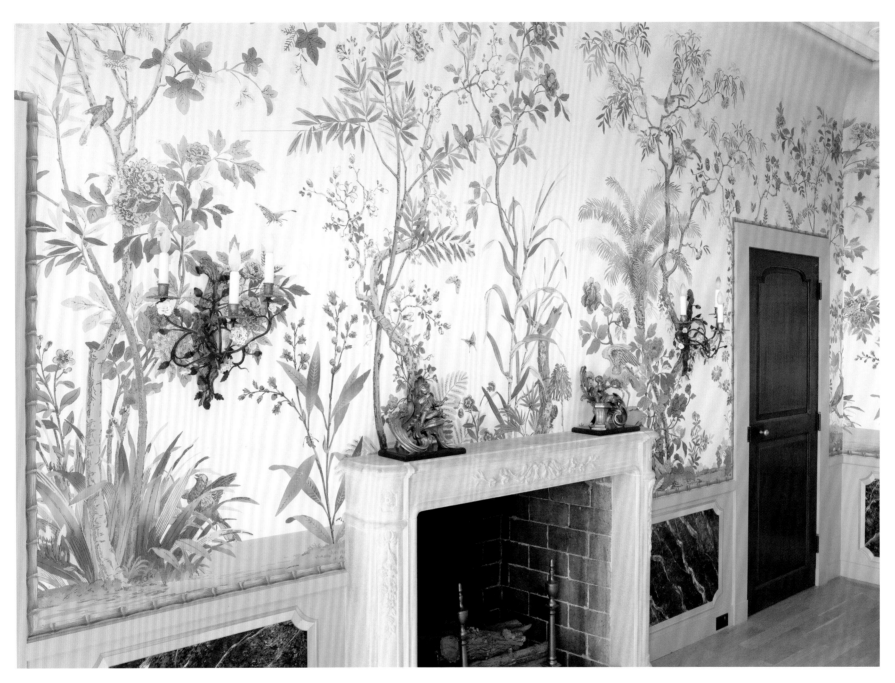

The Zuber wallpaper in an upper bedroom (now gallery) was re-placed after a fire in 2002. Fortunately, the original woodblocks were still at the factory in the tiny village of Rixheim in France's Alsace region.

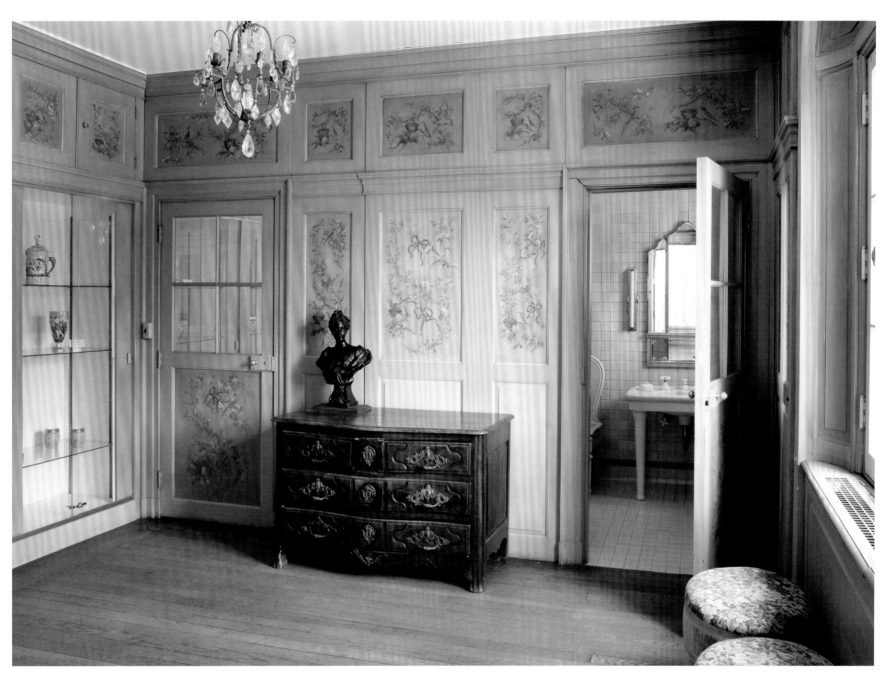

Mr. and Mrs. Smith shared a master bedroom, and each had his or her own dressing room and bathroom. Behind the hand-painted doors are closets specifically designed for shoes, hats, and accessories—as well as clothing.

Wharton and Codman wrote that proportion was the good breeding of architecture, and symmetry may be defined as the sanity of decoration. The sanity that David Adler crafted in the design of his only Milwaukee project must have provided great solace to L. R. Smith during his times of financial uncertainty and great responsibility to a large workforce.

Smith and his company survived and prospered during the difficult years of World War I, the Great Depression, labor strikes, and World War II. The A. O. Smith Corporation, which has been part of the Milwaukee landscape since 1874 when Smith's grandfather began his small company, continues to design and build innovative and energy-efficient motors and water heating systems that are sold worldwide.

Lloyd R. Smith died in 1944. With her children grown and the grand home too large for her, Agnes Smith donated it to Milwaukee County in 1966 for use as a decorative arts museum; it opened that year. The Adler-designed residence has been on the National Register of Historic Places since 1974.

Today, Sopra Mare is known as Villa Terrace. As a decorative arts museum it is not a house museum in the traditional sense of replicating how the family lived in it, for Agnes removed the family furnishings. Instead, smaller rooms are devoted to displays of the museum's permanent collection as well as traveling exhibitions. The spacious rooms and gardens are well suited to corporate retreats, meetings, weddings, and receptions.

For many years access to the gardens was denied because of safety concerns related to the steep slope. The Friends of Villa Terrace spearheaded the 1997 renovation of the gardens—a grand effort to create an Italian Renaissance–style garden, not to replicate Adler's design. This garden is one of eighteen Save America's Treasures projects in Wisconsin. (Others include Ten Chimneys and the Cyrus C. Yawkey home.)

In its transformation from a residence to a decorative arts museum, the rooms have become gallery spaces. As one moves through the galleries, the sounds of the hollow tap of footsteps on the wood and stone floors reverberate. Adler believed that the details, interior and exterior, gave true expression to the architecture, not the furnishings. As a result, the essence of the Smith family home lingers. •

During the Victorian era dining rooms were dark, somber, and ornate. This bright, white, spare 1920s dining room allowed the focus to be on the guests, not the decor.

RAGS TO RICHES

RAGS TO RICHES IS A FAMILIAR PLOT line in literature. In an archetypal rags-to-riches fairy tale, the protagonist is down and out, typically an orphaned or lost child who is in a frightening situation and longs for the security of a loving family. Upon reaching utter desperation, the child whispers a plea for help and miraculously a benevolent person or spirit appears to provide a chance for the child to prove him- or herself beyond what anyone anticipated. Then, if the right choice is made, he or she lives happily ever after; the wrong choice returns the person back to where he or she started.

The real-life Wisconsin rags-to-riches stories are less formulaic and more interesting than fiction or fairy tales, but they do share some of the situations of their literary counterparts: Frederick Pabst overcame poverty; John Adam Salzer responded to a religious call; Havilah Babcock received help from a benevolent person; and the Fromm brothers proved themselves—and exceeded all expectations in doing so.

The Wisconsin architectural story is bound up in the story of immigrants from Europe and emigrants from the East Coast who literally built the state. All four of these successful men established their wealth late in life. John Salzer never built a home for himself, but his son (and business successor) built a home worthy of his father's success. Obstacles they faced included acclimating to a strange land, with different topography and culture, and assimilation as first-generation Americans with parents who held fast to the Old World ways. Frederick Pabst and John Salzer had to learn English; Havilah Babcock had to make his own living with little family support; and the Fromms' venture was beset by natural and manmade hardships. The difference between fable and fact is that the Wisconsin rags-to-riches protagonists depended mainly on their own character, drive, ingenuity, and fortitude to create their fortunes. Along the way they educated themselves and gave back to their communities. And not a one ended up in dire straits.

Each of the men's fortunes enabled him to build a home that is a physical biography of his wealth. Tales are told in the choice of the style of the home, the expression of the building materials, the iconography of the details, and the decoration. The owners spent more than money: they spent time choosing their architects and their building sites. They knew these buildings would become more than family homes: they would tell an important chapter in the story of Wisconsin.

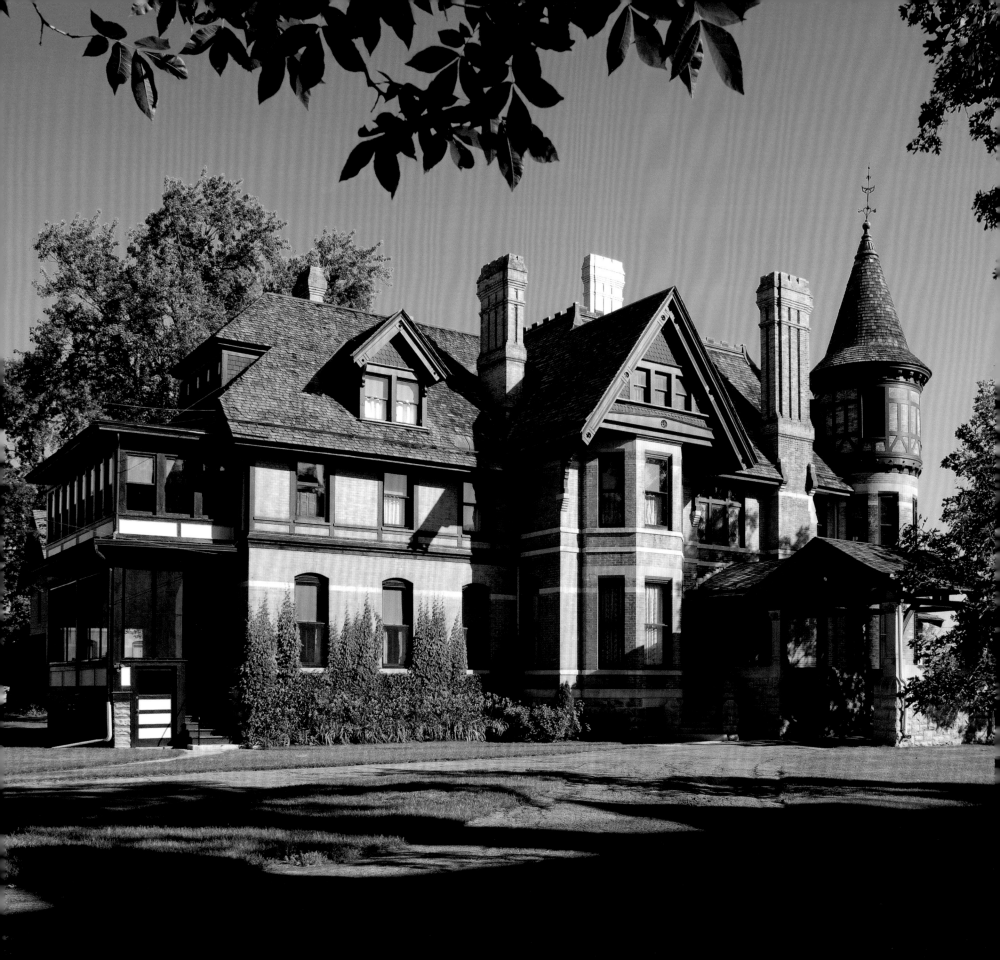

Havilah Babcock House

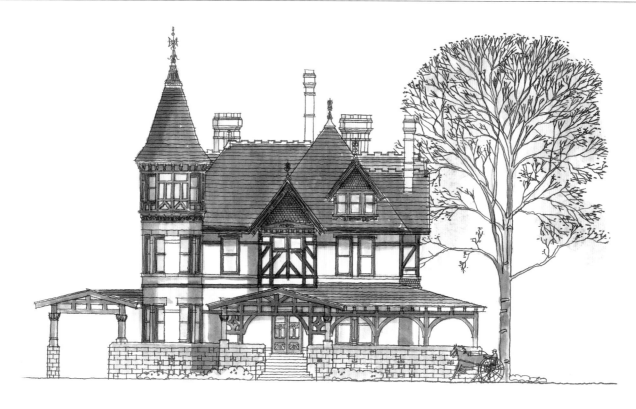

OPPOSITE: Elaborate use of patterns, materials, and window shapes and sizes creates an impressive Victorian side elevation for Havilah Babcock's Queen Anne. The transition from public to private rooms is suggested by the gradual reduction of ornamentation on the side and rear elevations.

FIRE FANNED THE FLAMES of many fortunes in Wisconsin.

William Waters was a civil engineering student at Rensselaer Polytechnic Institute in New York state when he decided to leave school and seek his fortune in the West. His destination was Oshkosh, Wisconsin, which was literally rising from the ashes: the first of four major fires struck the city in 1859, the second in 1866. Waters arrived in 1867 and more fires followed in 1874 and 1875.

The City of Oshkosh had been incorporated in 1853. Its strategic location on the Fox River and Lake Winnebago, downstream from the Wolf River pineries, quickly attracted the lumber trade, which was dependent on the waterways for transporting logs and powering the mills. The sobriquet "Sawdust City" referred to the status Oshkosh enjoyed as Wisconsin's largest concentration of sawmills—their output of sawdust contributing to the last and worst of the fires. After the Great Chicago Fire of 1871, the rebuilding of the city fueled the demand for lumber and contributed to the lumber boom in Oshkosh. By 1873 Oshkosh boasted twenty-four sawmills, fifteen shingle mills, and seven sash and door companies. The rapid economic growth also attracted lumber barons hoping to cash in on quick profits but who remained long enough to build mansions to show off

their wealth and showcase their lumber. Their architect of choice was the enterprising William Waters.

Waters's architecture practice was not limited to residential projects; he also designed churches, schools, hospitals, opera houses, banks, hotels, and commercial buildings. His work attracted national attention when he was awarded the commission for the Wisconsin Building at the 1893 World's Columbian Exposition held in Chicago. More than ten years earlier the architect had captured the interest of Havilah Babcock, a founder of Kimberly, Clark and Co., one of Wisconsin's most prominent paper manufacturers.

East Wisconsin Avenue in Neenah today could be a location shot for a film that requires a perfect turn-of-the-twentieth-century residential street. The impressive homes have a splendid view over Riverside Park to sailboats harbored in a bend of the Fox River. Wide sidewalks shaded by sugar maples and edged by lush lawns paint an idyllic image. Among the street's most outstanding homes are those of Henry Sherry, a lumberman and real estate investor; Franklyn C. Shattuck, of Kimberly, Clark and Co.; and George O. Bergstrom of the Bergstrom Brothers Stoveworks. Sherry and Bergstrom retained William Waters; Shattuck reached out to Milwaukee architects George Bowman Ferry and Alfred C. Clas, who were designing Captain Frederick Pabst's mansion in Milwaukee the same year. The homes were all built between 1883 and 1893. The Waters designs are a variation of the eclectic Queen Anne style; the Ferry and Clas is Georgian Revival.

East Wisconsin Avenue in Neenah was serviced by one streetcar line in the early twentieth century. The Babcock home is second from the right.

Waters designed one of the finest houses in one of Neenah's most genteel neighborhoods for Havilah Babcock and his family. The Babcocks were part of a select social set composed of bankers, paper millers, and manufacturers. It was a very close-knit group, with many marriages made within its confines, turning business connections into family connections. In fact, Havilah Babcock married Frances Elizabeth Kimberly, the first cousin of one of his business partners, John Alfred Kimberly, in 1872.

As an elder of the First Presbyterian Church and an active member of its choir, Babcock was widely respected. He enjoyed literature, good food, social occasions, nature outings, sailing, hunting, fishing, picnicking, and spending time with his family at the summer home they affectionately called Camp Babcock, located on Lake Kentuck near Eagle River. His children went to the finest East Coast preparatory schools, and Babcock took an avid interest in their studies and their progress. His two sons, Harry and George, were graduates of Yale University and his daughter Callie was a gifted sculptor and a student of the famed Daniel Chester French, who created the Abraham Lincoln statue at the Lincoln Memorial. The Babcocks had two other daughters: Nell, their eldest child, and Bess, their youngest.

Babcock, like most of his contemporaries, would have considered himself a "Westerner." His family had humble beginnings. His father, Marvin Kinney Babcock, was a Vermonter whose family had come from England. Marvin brought his family to Waukesha, Wisconsin, in 1846 and settled in Neenah shortly thereafter. Neenah had abundant natural resources: good soil for growing hay, grasses, and grain; hardwood forests to the south and softwood forests to the north; and the Fox River for transporting goods. The area was largely unsettled and promised diverse opportunities for those with ambition and vision.

In 1849 Marvin Babcock's carpentry skills helped him secure the contract for the Neenah locks being constructed to promote boat traffic between Lake Michigan and the Mississippi River. These locks were key to Neenah's growth as they made river traffic flow more easily and created more direct routes.

Marvin Babcock and his wife, the former Elmira Wheeler, lived in Neenah with their six children. After Elmira's death in 1851 and Marvin's quick remarriage, then-sixteen-year-old Havilah, Marvin and Elmira's third child, struck out on his own. Havilah had attended school and could read, write, and do figures. He was also handy, having learned carpentry skills from his father. This background helped him obtain a job as a clerk in a general store. Havilah was tall and good looking, and he had a great memory for each customer's likes and dislikes—positive attributes in the mercantile business.

John Alfred Kimberly, known as Alfred, was one of Havilah's boyhood friends; they met while attending services at the First Presbyterian Church. Though their backgrounds were very different they became lifelong friends, business partners, and cousins by marriage.

Kimberly had moved from Troy, New York, to Neenah with his parents in 1847, when he was nine years old. Kimberly's father, John R. Kimberly, was a successful building contractor who had brought a load of goods with him from the East to stock a dry goods store, along with $15,000 to build a flour mill. The senior Kimberly continued to thrive in Neenah and was able to send Alfred to Lawrence University in nearby Appleton. Alfred may have had educational and economic advantages that Havilah did not, but both generations of Kimberlys recognized Havilah's intelligence and business acumen. In recognition of these qualities, John R. Kimberly offered both his son and Havilah equal partnerships in their own dry goods store. Because both partners were under legal age, Alfred's father had to sign the company's checks on their behalf until they reached majority age of twenty-one.

The two partners split the duties and responsibilities—buying stock, traveling, marketing, and sales—fifty-fifty. Within six years, Alfred and Havilah were well established as part of Neenah's merchant class. One sign of this was that, at age twenty-four, Havilah became one of the founders of the First National Bank of Neenah. Not content with their level of success, the duo had their eyes on the future—and that future involved wheat.

By the Civil War, Neenah had become the state's second largest flour milling center, topped only by Milwaukee. Alfred and Havilah realized if they bought wheat—one of the major crops of local farmers—then it was likely the farmers would shop at their store. The flour mills that processed their wheat did not require skilled labor, large animals, or a huge outlay in capital, but they did require a building and waterpower. In 1868 Alfred and Havilah decided to harness the energy of the Fox River and build the four-story stone Reliance Mill alongside it in Neenah to process local wheat into flour. Alfred's father provided them with the financial backing as he had with the store, which had become one of the largest of its kind in the region.

The flour trade had appeared to be a growth industry in 1868, but by the 1870s the wheat trade was moving north and west to Minnesota and South Dakota, just as trade had earlier shifted away from New York farmers to those in Michigan and Wisconsin. Chicagoan Cyrus McCormick's invention of the mechanical reaper and the growth of the railroad made the Midwest—with its acres of undeveloped rich soil—more profitable than smaller, overworked farms of the northeast. But milling was a seasonal and unpredictable industry, due to bad weather, storage, spoilage, and shipping problems. The financial strain on investors was steep because profit was never a sure thing.

The power generated by the Fox River was clean and constant, both of which were essential to the manufacture of paper. This made the region well situated to lead the transition from flour mills to paper mills because mill buildings and mill workers could easily go from making flour to making paper. The manufacturing process for paper required more labor than flour milling, so jobs were plentiful and, unlike wheat milling, provided steady, year-round employment. Wisconsin's growing population, which was seeking stable jobs at a decent wage to replace seasonal work at a low hourly wage, welcomed the opportunities the paper mill provided.

Even though Babcock and Kimberly had no papermaking experience, they saw the possibilities, they had some capital, they had a mill, and they had the river. They just needed a couple more partners with money and business experience. John R. Kimberly was opposed to the change—he did not want the young men to give up their flour mill, nor did he want them investing in paper—and declined to back their newest venture.

Partnering with Franklyn C. Shattuck, a traveling salesman, and Charles Clark, a Civil War veteran and hardware store owner, the four put together $30,000 to start the paper company in 1872. Kimberly, Clark and Co.'s presence was soon expanding throughout the Fox Valley, and by 1888 its capital investment was increased to $1.5 million. The group even hired D. H. and A. B. Tower, internationally respected architects and civil engineers, to retrofit the Reliance Mill in Neenah and, later, to build mills in Appleton, Kimberly, and the Babcock & Shattuck paper mill in De Pere, Wisconsin.

1714 — River View, Neenah, Wis.

Kimberly, Clark and Co., founded by John Alfred Kimberly, Havilah Babcock, Franklyn C. Shattuck, and Charles Clark, purchased this paper mill in 1874 and incorporated it into their existing enterprise.

THE PAPER COMPANY MADE Babcock a wealthy man, but the day-to-day business did not satisfy his aesthetic nature in the way his involvement in retail had. In 1880, looking for an outlet for his appreciation of beauty and material objects, Babcock commissioned William Waters to draw up the plans and elevation for a residence to be built on East Wisconsin Avenue in Neenah. The three-story, pale yellow brick home overlooking the Fox River is a restrained anglicized version of the Queen Anne style. The half-timbering and wood trim, painted a somber, dark umber, have a calming effect on the overlapping shingle shapes and incised ornamentation of the wood fascia boards. The vertical orientation of the conically capped, half-timbered turret topped by a whimsical wrought-iron finial is nicely balanced by six brick chimneys and a series of cascading gables. The massive gray

limestone porch and string courses of tooled white stone give this Queen Anne a strong horizontal line—which is in contrast to the upward thrust of most Queen Anne designs.

The home's stone foundation was built in 1881. Babcock, a cautious man, insisted the foundation settle for a year before the walls of the house were constructed. When the family moved in, in 1883, the house was finished but basic. The walls were bare plaster and some furnishings were brought in, but the installed gas and electricity would not be hooked up until 1887. Babcock then set about to design the home's decor, working with an interior designer from Milwaukee. He had previously contracted with the respected Matthews Brothers of Milwaukee to build much of the first-floor cabinetry. The wainscoting, ceiling, and wall trim display a variety of woods: cherry, oak, and mahogany. Majolica tiles in rich golds, greens, and bronze tones are offset by fireplace surrounds elaborately carved with acanthus leaves, vines, and geometric patterns.

The interiors were finally complete by 1890, when the Babcocks hosted the "at home" reception for Mr. and Mrs. W. Z. Stuart; the new Mrs. Stuart was Alfred Kimberly's daughter. More than six hundred guests were welcomed into the Babcock home to present their

The Victorian-era Babcock, Fairlawn, Pabst, and Allyn homes all have similar plans because their designs responded to similar requirements of the day. Each home needed a front door for formal visitors and a side door to accommodate a porte cochere, or carriage porch. Porte cocheres were typically placed to the side because their proportions and massing would interfere with the front door's appearance. The most important or primary entry "fronted" the major street to afford visual and physical communication with the outdoors and traffic. Homes of great stature—whether a palace in Versailles or a paper magnate's home in Neenah—demanded formal entry usually detailed in impressive materials.

The European differentiation between ground and first floor derives from medieval times when rural farmhouses held animals on the "ground" floor and people lived above on the "first" floor. Though separated from these agrarian precedents, American homes still equated height with prominence. Midwestern conditions called for foundations below the frost line and raised floors to provide light to the basement's storage and service areas.

Utilitarian functions were put to the back of the Victorian-era home, making them off-limits to most visitors. With carriage houses and stables behind the home, placing the raised porte cochere to the side (on the way to the stable) made alighting from a raised carriage easier—especially for ladies wearing the corsets and bustles of the time. In the Babcock, Fairlawn, Pabst, and Allyn homes, the "L" of circulation in the plan connects the carriage entryway to the pedestrian's front entry. Proximity to the man of the mansion's space—be it a library or smoking room—indicates that the side entry, while less formal, was important to the business of the house.

More than a third of the Babcock plan is devoted to the service wing. Pantries for china and cutlery, dry goods, and "refrigerated" items serve the kitchen. The second-floor master bedroom was positioned near the servants' quarters so Babcock could take note of their activities.

The front porch of the Babcock home was revised from wood to stone plinths in 1905; a rear service porch was added a decade or so later. Long after the carriage was replaced by the automobile and the man of this mansion had departed, an elevator was installed off the side entry to provide easier access to the upper floors.

well wishes to the newlyweds. An orchestra played from the upper stair hall on the second floor, and the event was catered by a Milwaukee firm. A newspaper article from the *Neenah Times* described the home as a "palatial residence."

Havilah Babcock was an Anglophile when it came to literature, architecture, and interior decoration. He looked to Charles Locke Eastlake, an English Arts & Crafts architect, furniture designer, and author, for design inspiration. Eastlake's *Hints on Household Taste,* published in England in 1868, had become a bible of interior decoration for those who preferred a simplified, more geometric and coordinated design vocabulary over the more ornate High Victorian style. Eastlake was a strong proponent of truth in materials and rebelled against the faux painting and staining of wood, which was very much in vogue in Wisconsin at the time.

Eastlake decried the loose appropriations of his designs in the American market. No less than six furniture companies in Sheboygan were rapidly manufacturing furniture, some in the Eastlake style. Babcock preferred to slowly collect quality furnishings, much of it in the Eastlake style. One of the exceptions was the tufted blue velvet couch bought specifically to accommodate his height and postlunch naps in his library. Babcock was not a purist: he selected furniture that pleased him with its quality construction and expression of good taste. Different styles of furniture are found throughout the home.

Havilah Babcock and architect William Waters's glittering reception hall, with its oak paneling, brass fittings, and stained glass

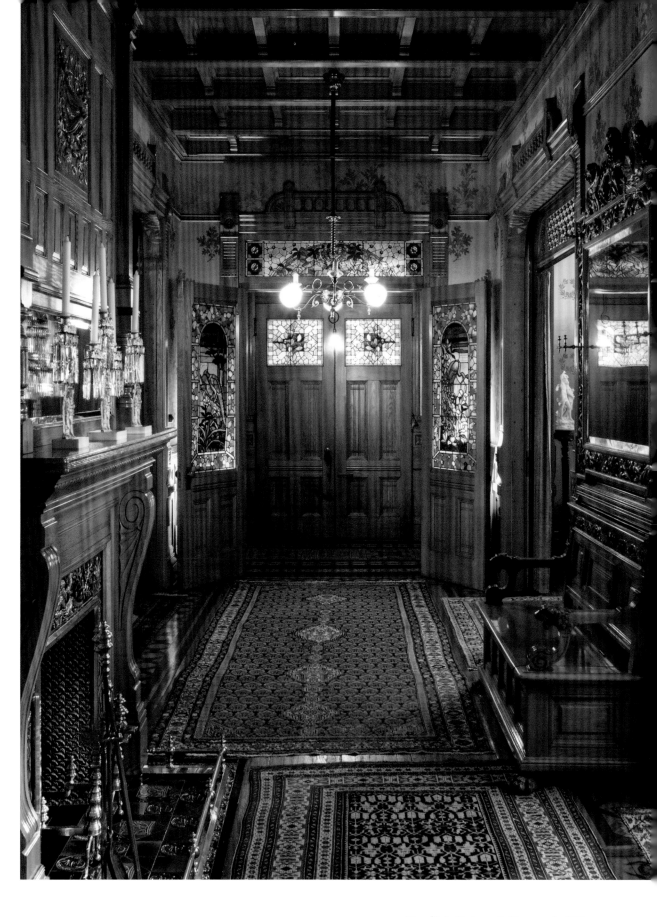

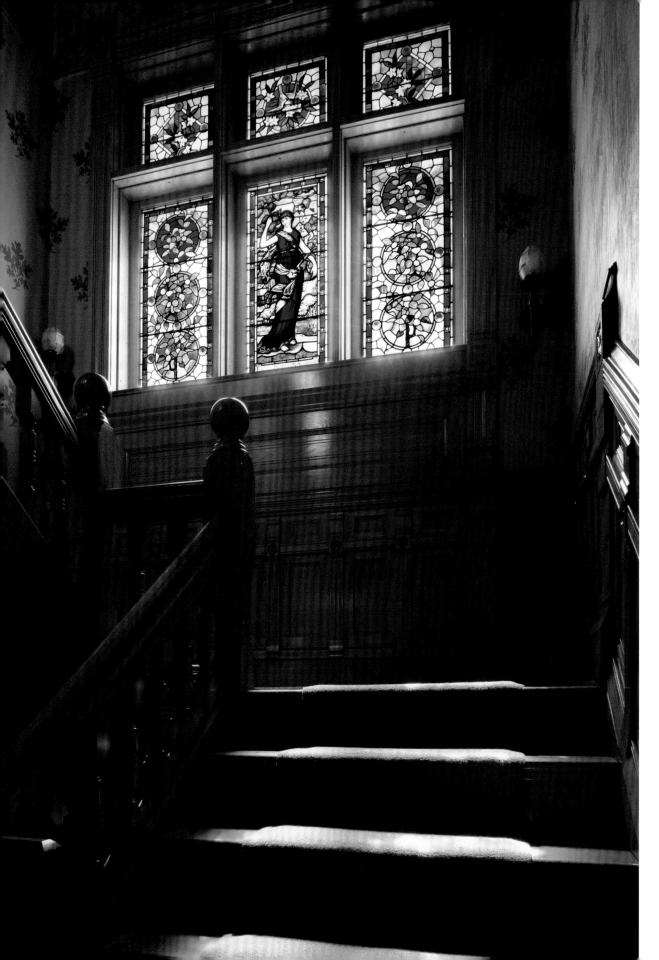

Narrative and didactic ornament was an important aspect of Victorian decoration, as the Victorians never lost an opportunity to teach a moral lesson. Much of the ornament in the Babcock home is allegorical, starting with the majolica tiles in the reception hall fireplace. These represent Sir Lancelot and Guinevere, whose story was a cautionary tale about love and loyalty. On the second-floor stair landing, stained-glass windows depict the Roman goddess Pomona, who was associated with tended gardens and vineyards. Perhaps Babcock chose the image of Pomona to encourage his children to blossom and grow. Anglophiles preferred Roman imagery to Greek imagery, due in large part to the popularity of the historical novels of Sir Walter Scott.

It is also interesting to speculate about the choice of the peacock and pheasant in the stained glass of the vestibule doors. Pheasants have represented both literary refinement and attractive males since the tenth century B.C., when they were embroidered on the robes of Chinese emperors. As Babcock was well read, considered quite handsome, and understood his charm, his selection of these welcoming symbols of the attractive male is particularly telling.

The painted canvas wall covering in the reception hall bears the stenciling of oak leaves, a symbol of both patriotism and hospitality. While the home overall is very masculine—with warm woods laid in angular parquetry on the first floor; rich colors in the stained glass, carpets, and furnishings throughout; and bold geometries

The colorful stained-glass windows provided illuminated ornamentation and privacy while doing away with drapery.

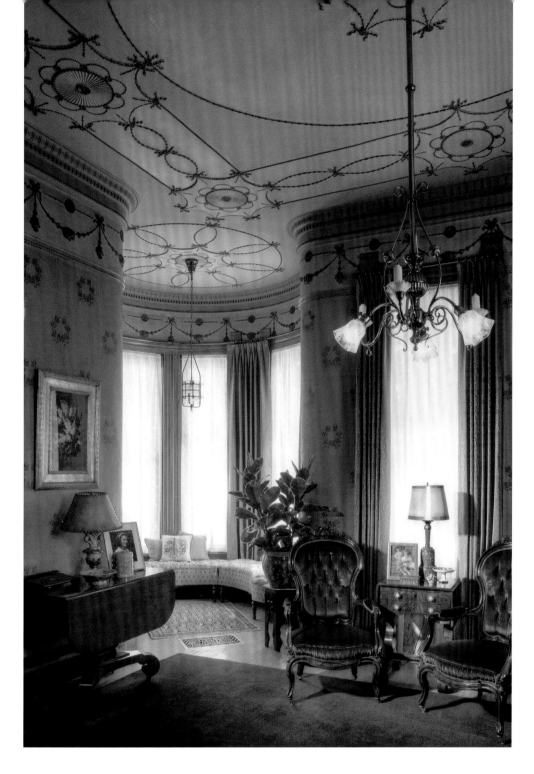

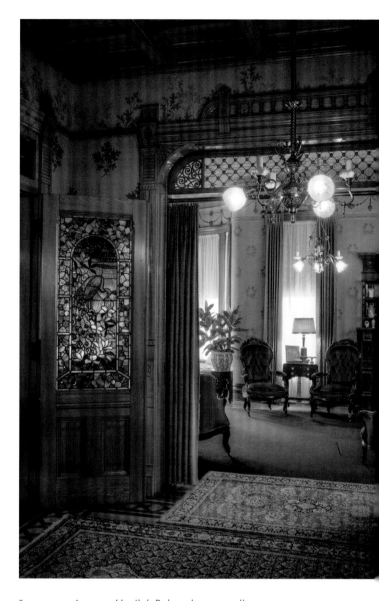

LEFT AND ABOVE: Havilah Babcock personally oversaw the interior design details of his home. For his wife's sitting room he went against the tide, choosing rich colors and limited patterns in the upholstery, draperies, and wall and floor coverings. The delicately toned ceiling is adorned with mathematically precise impasto swags that express the room's geometries and proportions in the classic architectural motif of a circle inscribed in a square.

in the woodwork and fireplace ornamentation—quite a few floral motifs are employed. Thistles, most likely a nod to Sir Walter Scott's Scottish heritage, are painted on the library ceiling; simple wreaths, a symbol of pride, praise, and scholarship, grace the stenciled canvas wall covering of Mrs. Babcock's sitting room. The shell pink sitting room is as graceful and spare as a piece of Wedgwood china.

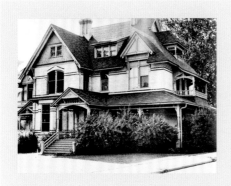

Hearthstone, another design by architect William Waters

Hearthstone

In Appleton, less than seven miles north of Havilah Babcock's home, another impressive residence, also designed by William Waters, was built in 1882 for paper mill investor Henry J. Rogers. Like the Babcock house, this Queen Anne has resplendent details such as inlaid wood flooring, distinctive stained glass, decorative fireplaces, and an overall feel of magnificence.

Rogers's home differs from Babcock's in the organization of its plan: a main north entry connects to the lesser south entry to create a strong central axis reception hall that symmetrically defines and divides the major elements of the first floor. In both the Babcock and the Rogers homes, a minor circulation hall splits off perpendicularly to the east to communicate to the support or porte cochere spaces.

New power sources were adapted to Victorian tastes through the development of "gasoliers," chandelierlike branching frames for gas jets, and later electric "electroliers." On September 30, 1882, Rogers's home became the first private dwelling in the United States to be lit by a nearby hydroelectric station that employed the "newly invented Thomas Edison System." Visitors to Rogers's residence—known today as the historic house museum Hearthstone—can see the original light switches and fixtures.

The paper industry came to this part of Wisconsin, not for the same pine forests that attracted lumbermen, but for the abundant waterpower that was necessary to turn the train-shipped cotton rag into paper. Once the industry was established here, the transition to using wood pulp was accompanied by another logical shift, the use of hydroelectric power. Soon paper mill magnates were running electrical lines from the mills to their homes—although in the case of Rogers's residence the dynamo was located on the river directly below his home.

Golden grapes on a burgundy background speak of good luck, kindness, and providence in the dining room's Lincrusta, a deeply embossed and hand-painted wall covering favored during this period. In adherence with Eastlake and his American counterpart, architect Henry Hudson Holly, the dining room was made as dark as possible so that candlelight reflected off the white damask tablecloth was the only source of illumination. Servants dressed in black would disappear from view, keeping the focus on the table and those around it. By day, the three bay windows could be covered with heavy drapery.

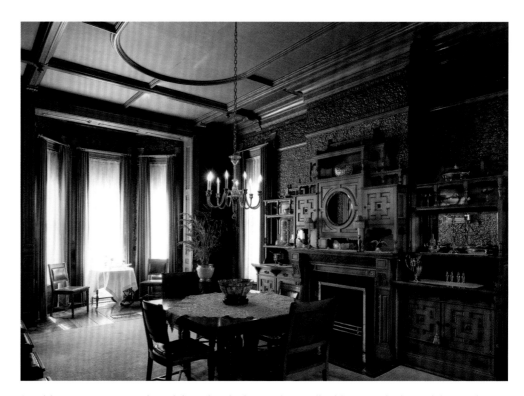

Breakfast was set out on the sideboard and taken at the small table set in the bow of the window. The sideboard allowed for the newly popular buffet-style serving.

BABCOCK HAD A REPUTATION of being a loving, concerned, and communicative father. When his children were back East at school, he wrote them weekly letters and expected the same in return. He took his role as head of household very seriously—and this responsibility is represented in the organization of the second floor. The master bedroom is not located at the front of the house, where the best views and most spacious rooms are; instead it's in the middle, at the top of the main stair and the base of the servants' stair. From this central location, Babcock could audibly keep track of the comings and goings of all of his children and the servants. His bedroom also had an interior door that opened directly into his sons' bedroom, so any late-night roughhousing or tomfoolery could be swiftly quieted.

The home for the family of seven was built with only one bathroom—a nearly unknown luxury at that time. Each of the six bedrooms had a sink in the room (common in wealthy households during this period), spacious closets, fireplaces with glazed tile surrounds and carved wood mantels with tall mirrors above, and canvas-covered walls decorated with floral friezes. The turret afforded the easternmost bedroom with a curved study illuminated by tall, thin windows. The boys' room was comfortable but more plainly furnished than their sisters' rooms.

Atypical of most Victorian homes, the Babcocks' second floor is almost as richly appointed with wood detailing, broadloom carpets, and decorative wall coverings as the first floor. While paper products made him fabulously wealthy, Babcock missed going to market and following the latest fashion trends. Decorating the home was his creative outlet. He enjoyed selecting fabrics, tiles, and wall coverings for every room.

In the days before air conditioning, sleeping porches provided refuge from the summer heat. Some grand homes in the 1890s used the staircase as a vent chimney, outletting the heat through an operable skylight. The Babcock home used this same principle through the attic and also included a sleeping porch spanning the width of the house on the second floor's south side. The porch was added in the early twentieth century, in response to the advice that fresh-air sleeping was a good preventive measure against such diseases as consumption. Below the sleeping porch is a screened-in porch located off the kitchen, which had lovely views of Nell Babcock's flower garden with her prized peonies.

William Waters's original drawings show a different front porch than the one that exists today. His was a one-story, Victorian-style porch that covered the entire facade and extended east around the turret, with a separate side porch for the porte cochere. It was rich with Queen Anne details: thin, round spindle wood columns with incised decorative scrollwork, curved paired brackets, and a low narrow wood rail created a light, open effect. The front and carriage entries were punctuated by highly pitched gables; the rest of the porch was covered by a low shed roof. The front porch gable emphasized the center point of

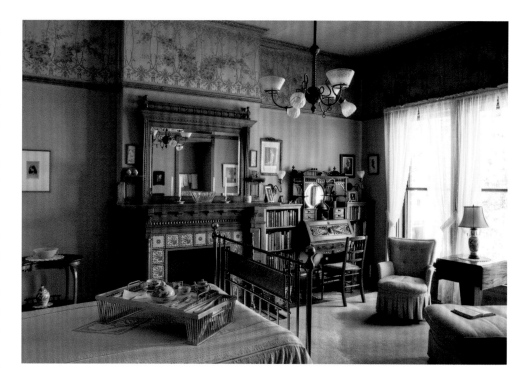

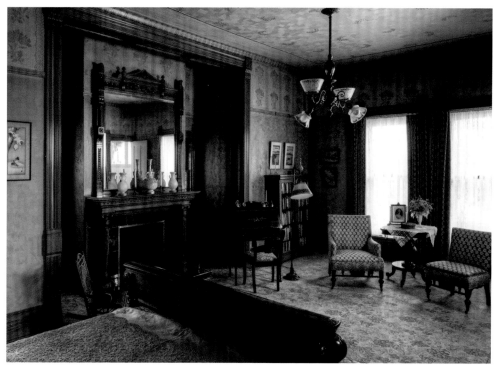

TOP AND BOTTOM: Babcock's daughters' bedrooms—known to this day as the "Aunts' rooms"—are feminine but not childish. The rooms are still furnished and appointed as he originally directed.

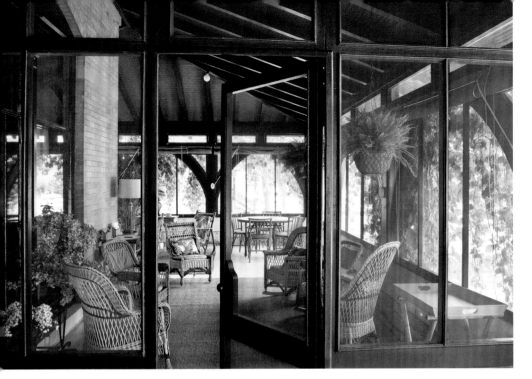

ABOVE: Suzanne Hart O'Regan wrote *Ghosts in Sunlight: A Remembrance of Things Past* about the social life and customs in nineteenth-century Neenah. Some remembrances took place on this porch. OPPOSITE: The green tones in the library ceiling and the walls' warm orange tones are repeated in the dining room, serving to visually marry the two rooms.

the home's asymmetrical elevation, announcing the front entry in grand fashion.

The second iteration of the front porch is a combination of Arts & Crafts and Romanesque styles. In comparison to the original, this more massive and masculine porch solidly marries the house to the ground. The rusticated stone base is topped by a thick stone cap and two staunch stone columns that affirm the authority of the substantial structure. The heavy timber arches are more in keeping with the half-timbering details on the second floor than Waters's slender spindles were. The three-story brick tower now rises from a stone base as a geometric solid, rather than as a decorative element weakly popping out from the shed roof. Eliminating the porch roof from the home's eastern side freed Mrs. Babcock's sitting room from dark shadows.

The Arts & Crafts porch extends farther to the west than Waters's original design; the result is a generous screened outdoor room, well suited to lounging and dining. Overall, the embellishments are restrained and geometric, and they appear more integral to the structure than the incised decorative scrollwork of Waters's first porch.

THE BABCOCK HOME is still lived in by a direct descendant of Havilah Babcock. After World War II, Nell and Bess, who lived in the house their entire adult lives, other than their school years at Elmira College in upstate New York and Mount Vernon Seminary in Washington, D.C., thought about selling the house and moving into a smaller one. These plans were abandoned when they learned that a potential buyer was planning to convert the home into apartments. They withdrew the house from the market. It pained them to think anyone would even consider altering their father's creation.

LEFT: The home soon after its completion in 1883. The family moved in that year despite the fact that the interior still was not finished. RIGHT: The Babcocks replaced the original Victorian wood porch with a limestone one in 1905.

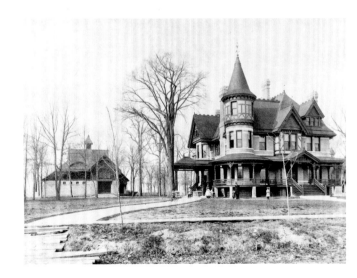

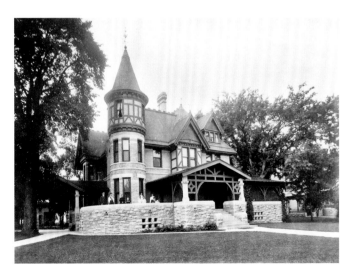

Today the house is in such perfect condition that Havilah could walk up the stone front steps, open the heavy oak doors with stained-glass panels, hang up his coat opposite the reception hall's oak mantel, pass into his library, light a fire in the fireplace, reach for a favorite book, and settle down into his extralong couch, unaware that several generations of his descendants had lived in the house as their own.

The hand-painted ceilings throughout the first-floor rooms are still luminous; the woodwork gleams; and the portieres at the doorways are intact. Many of the rugs and floor coverings are original as are the light fixtures and much of the plumbing fixtures. Most of the furnishings are original—well used and obviously well built since they have lasted for several generations. The house, while not a public museum, is remarkable as a period piece. Guests do not have to use their imaginations to experience how the original Babcock family lived.

With the house and all its contents long held in a protective family trust, Babcock's heirs understand the importance of their home to the state. They enjoy sharing the house, the sum of myriad details—for which they give complete credit to Havilah and his admiration of Charles Eastlake.

Havilah Babcock was a self-made man who adapted to changing times and tastes. Babcock, with his eye for fashion, truly enjoyed the dry goods business, but his role in the paper business was a managerial one. While he was an attentive and a responsible businessman, the work did not provide the artistic outlet he desired. He poured his creative energy into the design and decoration of his home. Babcock's quest for quality in everything he did is evidenced by the fact that his descendants have not altered the integrity of what was truly his life's work. •

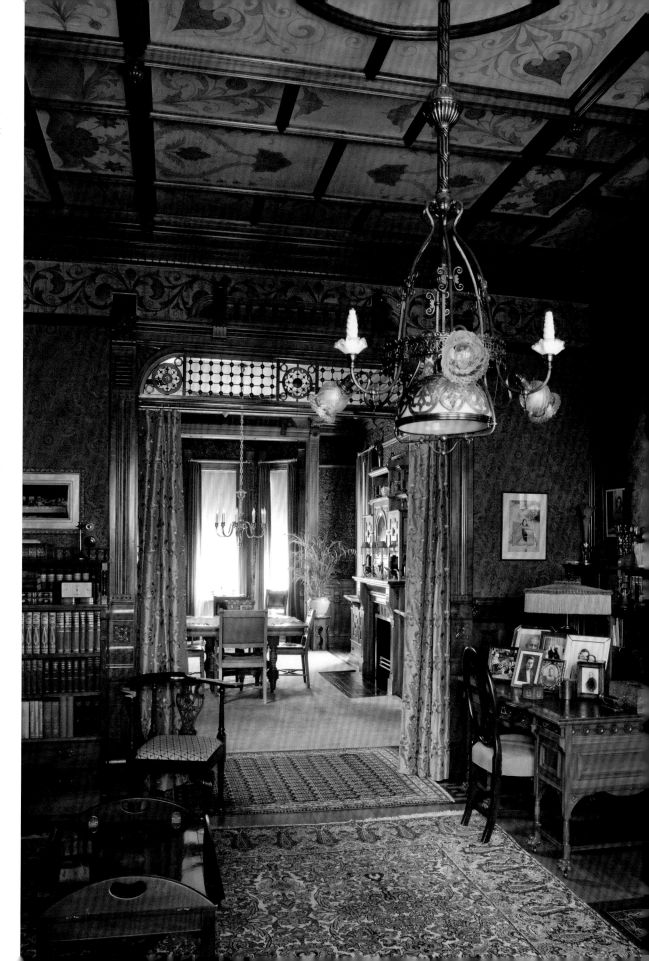

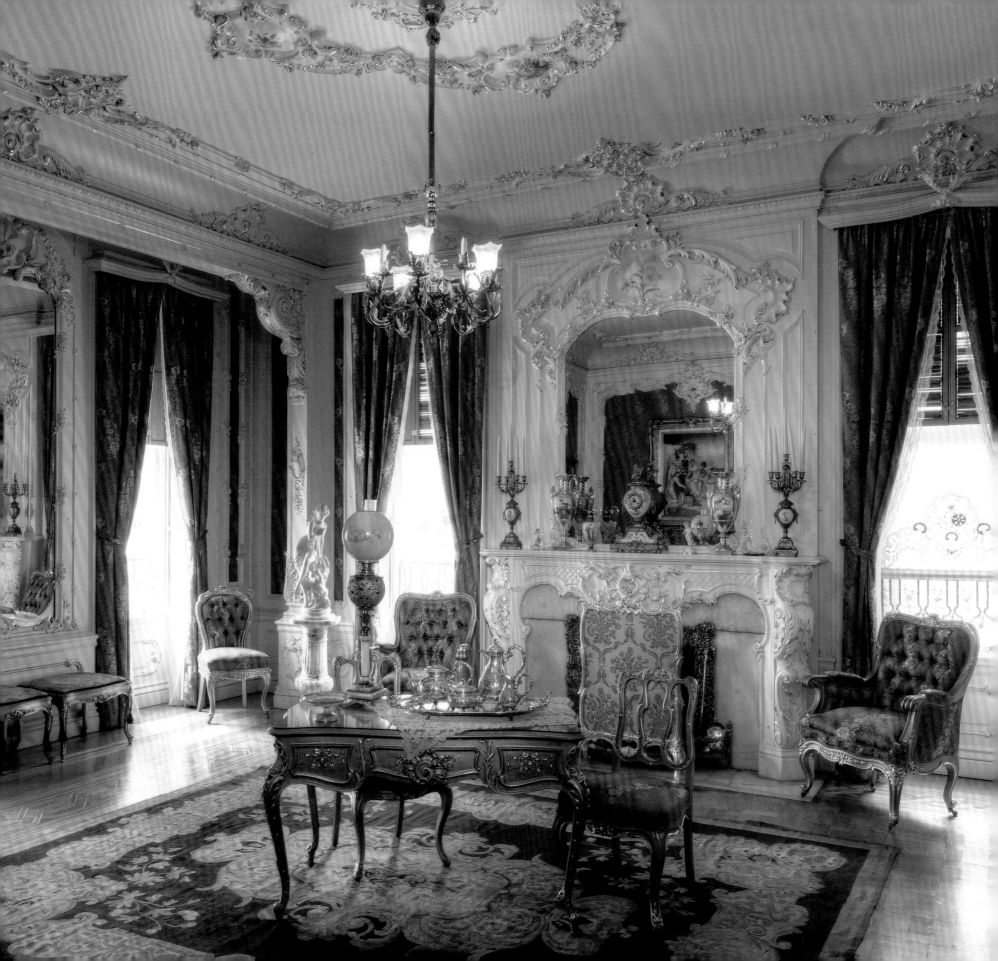

Captain Frederick Pabst Mansion | Milwaukee 1892

OPPOSITE: The furniture in Mrs. Pabst's parlor is original to the house. Many gentlewomen favored painted woodwork and lighter-colored materials such as white onyx, gilt trim, and rose upholstery and drapery for their sitting rooms.

MILWAUKEE IS KNOWN as the City of Neighborhoods. Where people choose to live in the city speaks volumes about them, their ethnicity, their income, and their political leanings; this was as true in the 1890s as it is in the twenty-first century. Frederick Pabst, known as the Captain, made a statement when he built his Flemish Renaissance Revival mansion on Grand Avenue.

The Pabst mansion is set in an evolving neighborhood—one with ever-changing street names. Until 1876 Grand Avenue had been known as Spring Street; it was renamed to more aptly reflect the changing character of the neighborhood, which was rapidly developing as an avenue of mansions for members of high society: bankers, industrialists, sausage and meatpacking kings, and beer barons like Pabst. It became Wisconsin Avenue in 1926. To the east, across the Milwaukee River, was Prospect Avenue, a rival affluent neighborhood where mansions on tight urban lots were rising rapidly. In comparison, Grand Avenue was almost a pastoral setting: the homes were placed in their spacious properties like fine jewelry in velvet-lined boxes, the green lawns shaded by arching elms.

Alexander Mitchell, a Scottish financier and railroad developer, started the building boom on Spring Street in 1859. Mitchell added onto a small cottage numerous times until the architect E. Townsend Mix transformed the various additions into a rambling

The Pabst Building in downtown Milwaukee, 1903

Second Empire mansion surrounded by gardens, ponds, and a wrought-iron fence. In 1870 another railroad man, Sherburn S. Merrill, built an exuberant Victorian home on West Spring and Thirty-third streets. It was a street of fine homes as well as magnificent religious architecture, its Episcopal, Congregational, and Presbyterian churches serving as important attractions for those investing in a neighborhood to rival the allure of the prestigious lakeside Prospect Avenue neighborhood.

Highland Avenue, located several blocks north of Grand, was so heavily populated by wealthy businessmen and industrialists of German descent—heads of tanning factories, breweries, and meatpacking concerns—that it was affectionately called "Sauerkraut Row" in the 1890s. Pabst, a first-generation German American, chose to build among like-minded business associates on Grand rather than in a homogeneous ethnic enclave. Being German was important to Pabst, but being successful was more important. He was the head of the largest brewing company in the world and his house needed to reflect his prominence within and outside of Milwaukee.

FREDERICK PABST was not born to wealth and power. His parents immigrated to Milwaukee in 1848 from a rural town in Saxony, Germany, when he was twelve. They were among 1.5 million other Germans who came to the United States between 1845 and 1860. In 1844 an estimated one thousand Germans a week were immigrating to Milwaukee, the majority of whom continued westward after a short stay. Milwaukee had a reputation for accepting liberal and free thinkers, which, at the time, Germany did not. Almost immediately after arriving in Milwaukee, the Pabsts settled in Chicago, along with large numbers of German immigrants seeking employment opportunities.

Frederick Pabst went to work in hotels and restaurants as a busboy. At age fourteen he signed on as a cabin boy on a Great Lakes steamer, a large cargo ship outfitted with passenger cabins and staterooms that sailed between Two Rivers, Manitowoc, Sheboygan, Milwaukee, and Chicago. In just seven years Pabst worked his way up to captain, a title earned when he obtained his maritime pilot's license. Pabst was twenty-four when a frequent passenger, Phillip Best, president of the Phillip Best Brewing Company, introduced his eldest daughter, Maria, to Frederick. The couple married in 1862.

Phillip Best was a second-generation Milwaukee brewer; his father, Jacob, started the company in 1844. The Bests emigrated from Rhineland, Germany, where the family had a well-established winery. Germany was in a period of revolution, upheaval, and economic stress. The Best family did not come as poor immigrants seeking their fortune in a new world, but as canny businessmen, seeking to become even more prosperous. Jacob was attracted to cheap land close to Milwaukee that was suited to growing hops and barley, had low taxes and good transportation routes, and offered a high standard of living at a low cost. By the 1850s Milwaukee was considered America's "German Athens." The influence of German culture created a lively social environment rich with music, dancing, literature, painting, sculpture, and beer gardens. The Bests were quickly recognized as leaders in Milwaukee's German community.

Following his marriage to Maria Best, Captain Pabst continued to pilot Great Lakes steamers, until December 1863, when a storm ran his vessel, *Seabird,* aground on the shores of Whitefish Bay, just north of Milwaukee. A family decision was made that Pabst would join his father-in-law and learn the brewing business, which was safer and more lucrative than commanding lake steamers. In 1864 Pabst purchased a half interest in the brewery, and two years later Phillip Best's new son-in-law, Emil Schandein, bought the remaining half interest, enabling Best to retire. Pabst was now the president of a company in which he had two years of on-the-job experience in the industry. Still called the Phillip Best Brewing Company, the business grew under the new leadership.

Schandein was a born salesman, Pabst understood logistics, and they both understood business. Their goal was to take their beer nationwide; unfortunately, Schandein died in 1888, right before the brewery's heady national success in the 1890s. Schandein also did not live to see the completion of his Grand Avenue home—described by George Yenowine in the monthly magazine *The Cosmopolitan* as "one of, if not the very finest private residence in the West. . . . a modernized castle"—four blocks west of the site of Pabst's future home. His wife, Maria Pabst's sister, the former Lisette Best, became the first vice president of the Phillip Best Brewing Company after her husband's death. In 1889 the name of the brewery was changed to the Pabst Brewing Company to denote Captain Frederick Pabst's sole ownership.

BY THE 1890s MILWAUKEE WAS KNOWN nationally and internationally as the locus of world beer production due to the exceptional efforts of immigrant German brewers, with Captain Frederick Pabst at the forefront. Schlitz, Miller, and Pabst bought or built drinking establishments, beer garden saloons, and restaurants in major American cities. In Chicago alone, Schlitz owned more than sixty properties to assist in the distribution and consumption of his beer, and Pabst owned more than six hundred taverns across the country.

During this period Pabst was as busy developing real estate projects as he was brewing beer—and not just in Milwaukee. Pabst, who had worked with architects on the designs for his brewery buildings, continued his role as a patron of architecture by hiring architects to design restaurants, beer gardens, and hotels throughout the boroughs of New York. These were not corner taverns; they were among the largest restaurants and hotels in the United States, places where international and American tourists as well as native New Yorkers had opportunities to sample Pabst beer while being inundated with his advertising. Pabst also developed hotels and restaurants in San Francisco, Minneapolis, and Chicago. Clearly, Pabst retained valuable lessons about hospitality from his days as a busboy in Chicago hotels.

Pabst did not cater to only one class of clientele. Betting that everyone liked beer with his or her entertainment, Pabst hired architects to design an outdoor beer garden in Whitefish Bay and numerous taverns throughout the Milwaukee area.

A great booster of the arts and business community in Milwaukee, Pabst retained architect Otto Strack to design the Pabst Theater to replace *Das Neue Deutsche Stadt*

The Pabst Park beer garden in Milwaukee, circa 1902

Theater destroyed by fire in 1895. He commissioned Chicago architect Solon Spencer Beman to design Milwaukee's tallest building; in 1891 the sixteen-story Pabst Building rose at the corner of Water and Wisconsin streets to house Pabst offices and office space leased to other concerns. Ever the astute businessman, Pabst created the Pabst Heat, Light, and Electric Company to supply utilities to Pabst-owned buildings downtown.

WHILE ALL THESE large-scale real estate, utility, and financial investments (Pabst was elected the first president of the Wisconsin National Bank in 1892) were occurring, the Pabst family was still living in the brick Italianate home designed by Henry C. Koch that they had built next to their brewery just west of downtown. But by 1891, their impressive Grand Avenue home was almost complete. By the time Frederick and Maria moved in the following year, they had been married for thirty years and were the parents of ten children, five of whom survived to adulthood. While the children would live in the home on occasion—when the Pabsts moved in, their oldest child was twenty-seven and the youngest was twenty-one—this was a thirty-seven-room house built primarily for Captain and Mrs. Pabst. However, after their oldest daughter died following the birth of her daughter, Emma Marie, the Pabsts adopted their granddaughter as their own (her father, Otto van Ernst, was a panorama painter and interior decorator for the Pabst home who returned to his native Germany upon his wife's death), renaming her Elsbeth Pabst. Elsbeth was the only child to grow up in the mansion.

In 1890 Frederick Pabst had commissioned the recently established architecture firm of Ferry and Clas to design his new home. George Bowman Ferry, a Massachusetts Institute of Technology graduate who moved to Milwaukee in 1881, was a well-regarded society architect known for his Beaux-Arts education and his understanding of historical styles. Alfred C. Clas, an architect born in Sauk City, did not have a formal architectural educa-

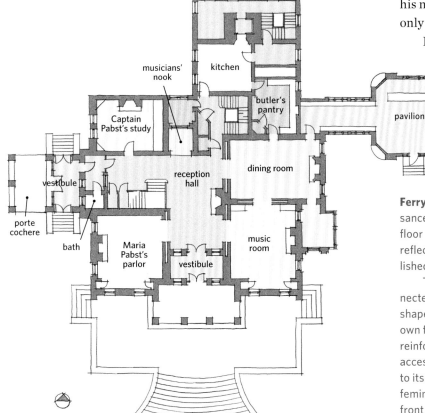

Ferry and Clas fashioned a Flemish Renaissance Revival design around a typical Victorian floor plan for the Pabst mansion. This layout reflects the specific needs of a mature, established couple.

Two entrances with vestibules are connected by a Victorian, multiuse corridor in an L shape. Sexes are separated and assigned their own functional zones in this Victorian plan, reinforcing the importance of both comfort and access: Captain Pabst's manly study is closest to its own porte cochere, while Mrs. Pabst's feminine French Rococo parlor relates to the front door.

At the intersection of the L is a visually dramatic stair that rises to a vent chimney. The music room was actually used for music: here the Captain was framed by ebony columns as he sang beside a piano. In a household where music was important, the architects also fashioned a nook at the intersection of the axis of circulation where musicians could entertain guests in the reception hall. Accessed via the dining area is the Otto Strack–designed pavilion originally built to display Pabst beer at the 1893 World's Columbian Exposition and moved here—replete with themed ornamentation of hop vines, beer steins, and barley.

tion but instead followed the then accepted path of serving apprenticeships under architects; he worked with architects in both Wisconsin and Stockton, California. Upon his return to Wisconsin he formed a partnership with James Douglas, a Scottish immigrant and builder who specialized in residential design, typically in the High Victorian Gothic style, and was popular among Milwaukee society families. Ferry and Clas joined forces in 1890 and later became one of the most powerful architecture firms in the state, with such impressive projects as the Central Milwaukee Public Library, the Wisconsin Historical Society building in Madison, and Milwaukee's Northwestern National Insurance Building. One of their first residential commissions as partners was the Pabst home. Many of Milwaukee's next best generation of architects, Peter R. Brust and Richard Philipp among them, worked for Ferry and Clas at some point.

German immigrants in Milwaukee exhibited a preference for working with German-born or German-trained architects such as Henry C. Koch, Otto Strack, and Eugene Liebert, each of whom was well established in the 1890s. These men understood the aesthetic of northern Europe and what it symbolized to Milwaukee's German elite. As one of the richest men in Milwaukee, Frederick Pabst could have his pick of architects. Pabst showed his independence—especially considering his neighbor was going to be architect Henry C. Koch—when he selected Ferry and Clas, a new local firm with little experience working together.

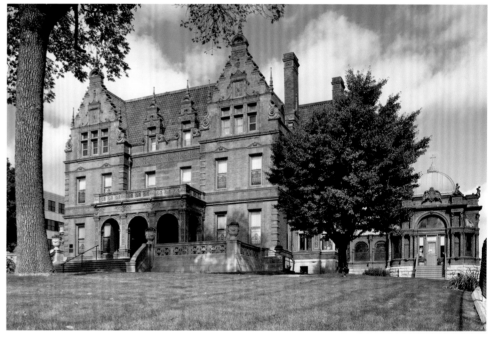

The beer pavilion, initially used as a company display at the 1893 World's Columbian Exposition, was brought back and attached to Pabst's home for use as a conservatory (at right). It was later converted to a chapel during the tenure of the Milwaukee Roman Catholic Archdiocese.

Without a paper trail, there is only speculation as to why Pabst chose this firm. Perhaps Koch was too busy with his drawings for Milwaukee's German Renaissance–style city hall to design a house, no matter how grand or for how grand a patron. Perhaps Pabst admired Ferry's Beaux-Arts education and Clas's Milwaukee portfolio, which included two mansions on Grand Avenue—one for George Markham and one for Maria's brother, Charles Best—as well as a significant late Victorian home on Prospect Avenue for Emanuel Adler. Perhaps it was as simple as friends referring an architect with whom they enjoyed working. Or Pabst may have enjoyed giving a new firm a chance to show its mettle. Whatever the reason, the ambitious firm received the residential commission of its lifetime—and proved it was equal to the task.

Pabst had bought land on Grand Avenue years earlier. The assembled lot was a stunning 2.1 acres—an extensive parcel considering it was only a few miles from both the brewery and the Pabst Building. Clas, who was involved in the development of the fledgling Milwaukee County Parks system, brought on Warren Manning as the site designer for the Pabst home. Manning was a young landscape designer in Frederick Law Olmsted's Brookline, Massachusetts, office until 1896. Manning had worked on the planting designs for the 1893 World's Columbian Exposition in Chicago and also prepared many of the planting plans for Lake, Washington, and Humboldt parks in Milwaukee.

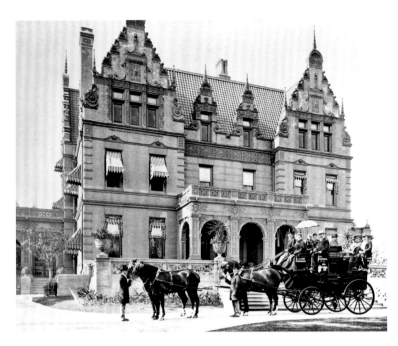

Captain and Mrs. Pabst prepare for an outing with friends, 1896.

Manning's design for Captain Pabst's mansion was never executed, however. His proposal, which he estimated would cost $4,050, contained fees for demolishing the original landscaping, including a circular drive, a lawn, and a picturesque planting of more than forty trees, and replacing those elements with a sunken Italian garden that featured a fountain and pergola, a croquet field, a large vegetable garden, and blanket yards for the stables. John Eastberg, senior historian for the Captain Frederick Pabst Mansion, postulates that perhaps the plan was not executed because the family spent most of every summer abroad and so would not have been around to enjoy such seasonal landscape amenities. The Pabsts maintained close connections with Germany, and their summer travels—including a cruise down the Nile, an activity popular with many wealthy families in the late 1800s—usually culminated in a visit to Wiesbaden, Germany, known for curative spa treatments.

The mansion building boom on Grand Avenue took place between 1876 and 1905. By a conservative estimate, sixty mansions lined the avenue, the most popular style being a variation of a Victorian, ornamented with gingerbread, towers, and turrets. While Flemish Renaissance Revival and its German Renaissance Revival counterpart are considered, by virtue of the time frame, to be Victorian substyles, both are, by comparison to other Victorian styles, restrained: stepped Flemish gables replace towering turrets; low-relief, terra-cotta ornamentation is substituted for a variety of shingle shapes; and the subdued monochromatic color palette of the terra-cotta and brick stands in contrast to the more colorful stick-style Victorians. Other key elements of Flemish Renaissance Revival are symmetry, soaring chimneys, slate or clay tile roofs, and arcaded porches. The architectural vocabulary of the Pabst mansion looks to the Leipzig Old City Hall, built in 1557, from the arched stone portico and stepped dormers to the pantile orange roof.

While a home's location was an indication of status, building materials and colors also were chosen to discreetly convey power and wealth. Expensive brick was often employed on the primary elevation and transitioned to a less costly type on the side and back elevations of the home. The Pabst mansion features the same sable-toned pressed brown brick on all elevations. Pressed brick was not warmly

Style: Flemish Renaissance Revival

The Queen Anne style was followed by a mix of period revivals that reinterpreted classic styles. Add to this those emboldened by their financial success who yearned to express where they came from and the result was the rise of national architectural movements such as the Flemish Renaissance Revival style.

Flemish Renaissance Revival was highly popular in Milwaukee in the last decade of the nineteenth century. The expressions of nationalist fervor in the Amsterdam Stock Exchange, the rebuilding of the Hamburg Rathaus, and Stockholm's Statshuset provided dynamic examples for Milwaukee patrons. Outstanding Milwaukee examples of this style included the city hall, the Pabst Building (no longer standing), the Germania building, and the Pabst mansion. Interestingly, the first examples of this

style in this country were fire stations built in 1880s New York City.

This style's major hallmark is Flemish gables that translated the roof pitch into a series of stepped geometric forms—in the Pabst mansion accentuated with ornamental masonry brackets—that often extend perpendicularly from a building's major volume to maximize its street presence. Like their Amsterdam precedents, roofs of Flemish Renaissance Revival–style buildings are clay tile, with abundant, exuberant decorative masonry bands or ornaments that punctuate the roof terminations at dormers and cross gables.

The 1975 National Register nomination refers to the Pabst mansion as Baroque Revival, and many historians see little distinction between German Renaissance Revival and Flemish Renaissance Revival. John Eastberg, the acknowledged expert on the Pabst mansion and the Pabst family, states that the appropriate style distinction for the Pabst mansion is Flemish Renaissance Revival.

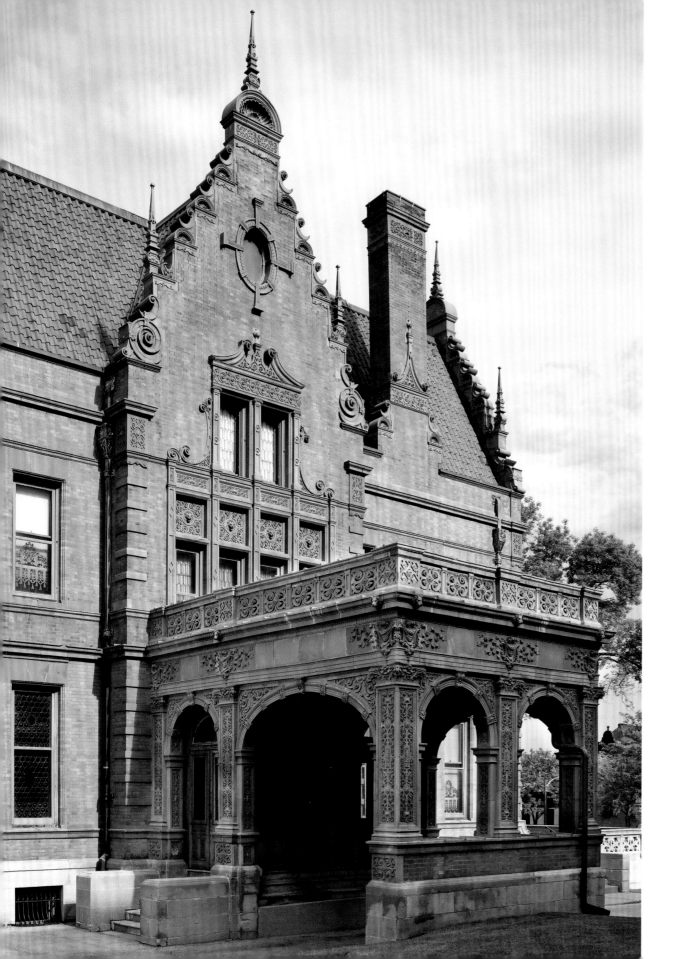

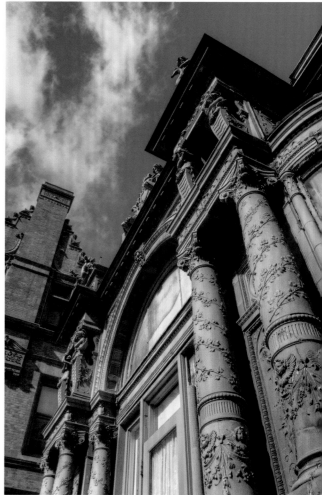

LEFT: The terra-cotta strap work—the S- or C-shaped segments that follow the outer edges of the top of the gable— is of particular interest. The motif was borrowed from seventeenth-century Eliza-bethan and Jacobean archi-tecture. ABOVE: Hops tendrils encircle the pavilion's columns.

Captain Frederick Pabst Mansion | 145

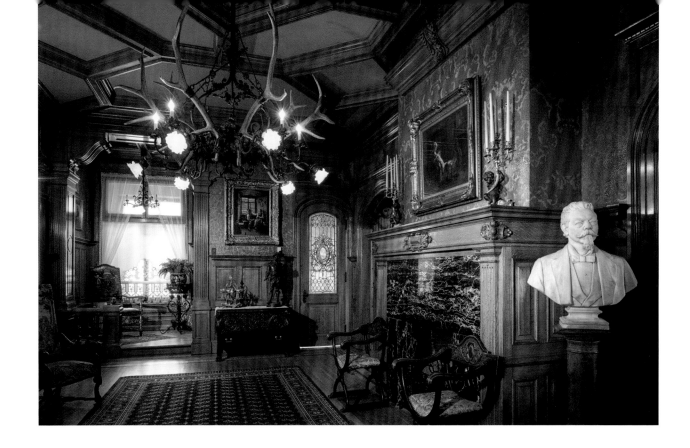

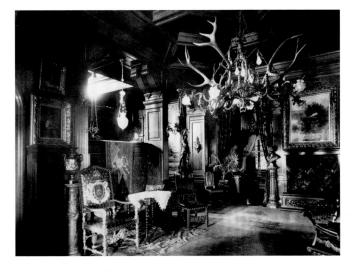

received when it was introduced in the 1870s; it was considered an inexpensive alternative to cut stone. By the 1880s, however, it was widely accepted as a material that guaranteed uniform shape and color and kept costs down.

Terra-cotta embellishment was a hallmark of the Flemish Renaissance style and the Pabst mansion has it in abundance—on all four elevations and, originally, on the three-story carriage house that is no longer extant. Before the Great Chicago Fire of 1871, manufactured terra-cotta was looked down on because it was mass produced; not surprisingly, the most vociferous opponents were the stonemasons and the wood-carvers. By the 1890s there were more than one hundred terra-cotta companies in the United States. Architects liked the material because it was less expensive than stone; it was fireproof; they could design their own motifs or select from a catalog; and production time was typically three weeks. Stonemasons found it hard to compete. Terra-cotta gracing the Pabst mansion's stepped gables, the piers, the porch balustrades, the porte cochere, the window pediments, and the chimneys is embroidered with lions' heads, gorgons, putti, birds, vines, shields, caryatids, crests, and geometric designs.

RECEIVING AN INVITATION to tea with Mrs. Pabst or cigars with Captain Pabst or to an evening of musical entertainment was filled with the promise of unsurpassed hospitality in one of, if not the most, sumptuous homes ever built in Milwaukee. The moment the quarter-sawn oak front doors open, the splendor comes alive in the burnished oak-paneled reception hall. Above the paneling, the walls are cloaked in earthy green and sepia-toned Tynecastle tapestry. (This color palette continues throughout the hallways.)

Opposite the double entry doors is an elevated niche scaled for a trio of musicians, who played as guests arrived for social gatherings.

Once guests' eyes adjusted to the reception hall's low light level, they were dazzled by the oak-and-antler-tipped chandelier, where electric lights emanated from glass-blossomed, wrought-iron stems. The Pabst home—an example of Old World craftsmanship meeting modern technology—was both wired for electricity and piped for gas. In the 1890s even forward-looking people like the Pabsts were not quite sure that electricity, then considered an alternative energy source, was not a passing fad. The reception hall's elaborate carved and coffered quarter-sawn oak is testimony to the craftsmanship of the Matthews Brothers, a long-established Milwaukee firm that also designed woodwork for Frank Lloyd Wright's Wingspread, the Cyrus C. Yawkey residence in Wausau, and many other significant homes throughout Wisconsin for more than a century. Today, the reception hall remains a showcase for some of the original tapestries, paintings, furniture, and artifacts that the Pabsts gathered on their travels, both abroad and around the country.

Mrs. Pabst was described as an elegant and pretty woman; those adjectives provide an apt description of the aesthetic of her French Rococo parlor. With its gold, ivory, and pink color scheme, it's an architectural equivalent of a strawberry Schaum torte. An oversized mirror doubles the opulence typical of Mrs. Pabst's social milieu. The white onyx fireplace facing was favored for feminine rooms in the late 1890s.

Captain Pabst was an impressive and imposing figure of a man. His somber-toned, oak-paneled study is the most masculine room in the home. Animal carvings, antlers, a massive oak-paneled door, tooled leather furniture, and ornate metal door hinges create a den worthy of cold winters, intelligent discussions, and the haze of cigar smoke. Captain Pabst was fond of incorporating uplifting mottoes in German into the decoration. Milwaukee-born artist Louis Mayer wove several examples into the painted ceiling. In the kitchen, mottoes were integrated into the stained-glass design, and furnishings are inscribed with Pabst's initials or some of his favorite mottoes, such as the one over the fireplace, the translation of which is "Learn."

The music room with its twisting, faux-finished ebony columns framing tall, slender windows and large mirror over the green marble fireplace front was the center of the Pabsts' family life. The room's sedate atmosphere of antique gold, green, and red jewel tones along with that of Captain Pabst's study are in sharp contrast to Mrs. Pabst's delicate parlor and the vibrant dining room that is also decorated in the French Rococo style. Ceiling decoration, which is important throughout the home, is showcased in the painted dining room ceiling's imagery proclaiming Mrs. Pabst's love of flowers and Captain Pabst's love of musical instruments. Unlike many dark-paneled Victorian dining rooms

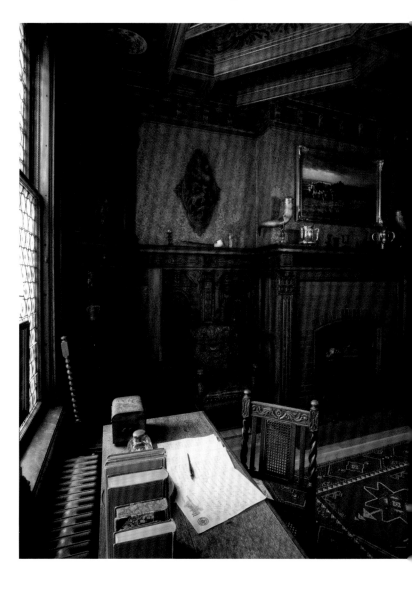

LEFT: The ornate cabinetry in Captain Frederick Pabst's study, 1897, contains fourteen hidden compartments as well as a large cigar humidor behind a door on the eastern wall. BELOW: Pabst's study faces west, with the light diffused through the thick, blown-glass window. Late in the day, the rich tones of the oak and walnut cabinetry, paneling, and coffered ceiling beams glow.

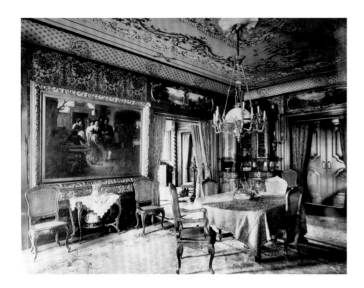

ABOVE: The dining room, 1897: The table—which when expanded could seat up to twenty-two—typically maintained a four-person place setting during the Pabst family's time in their mansion. BELOW: Like Mrs. Pabst's parlor, the dining room is decorated with original furnishings, in the same French Rococo style.

of the 1890s, this glittering gold, yellow, white, and pink dining room sparkles. Standing in the doorway one can almost hear the brilliant conversation, bursts of laughter, and clinking of glass and silverware.

THE MANSION'S FOURTEEN OPULENT and varied fireplaces were faced with white onyx, verde marble, pink marble, glazed tile, and glazed brick, whereas in the basement the latest mechanical heating controls were all of shiny brass, uniform in size and shape, and lined up with military precision. The interior decorations required the artistry of painters, wall covering hangers, ironmongers, stained-glass artists, and muralists. Gilding; faux painting; stenciling; silk and Lincrusta wall coverings; carved plaster motifs of festoons, borders, and scrollwork; and polychromed ceilings all demanded the skills of the best craftsmen of the region.

Stonemasons and wood-carvers may have lamented the use of terra-cotta and pressed brick on the exterior, but they must have celebrated when they bid on the Pabst mansion's interior. *Extravagant* would be a modest descriptor for the variety, intricacy, and level of detail of the interior finishes. Coffered ceilings, paneling, mantels, balusters, columns, moldings, entablatures, interior shutters, cabinetry, and doors are all constructed of the finest oak, mahogany, birch, maple, cherry, walnut, and wood inlay—invoking the exuberance of wealth and luxury at every turn.

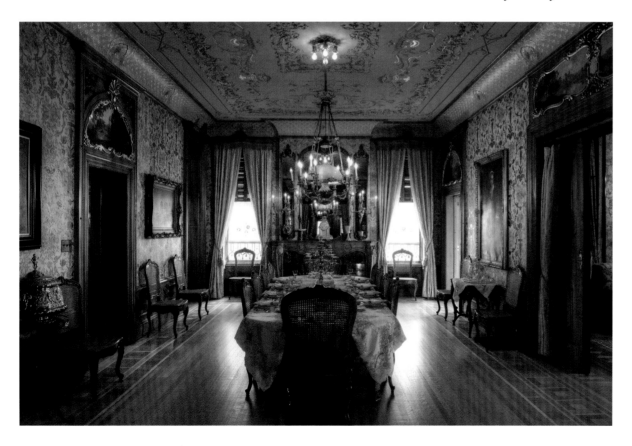

Architectural hints as to the origins of the Pabst fortune are evident in the bas-relief terra-cotta hop vines circling exterior columns and in a carved hops bud topping the newel post of the Jacobean-style staircase. (The Jacobean woodwork style consisted of Renaissance details as filtered through Germany and Flemish carvers, as opposed to Italian artisans.) Referred to as one the most stunning staircases in the United States due to the quality of the quarter-sawn oak strapwork design of the panels and balustrade, the interlaced bands or relief ornamentation are suggestive of arabesques, braiding, and scrollwork punctuated by circular or oval holes. The glowing oak is daylit by a dazzling stained-glass skylight ornamented with heraldic crests. The skylight opens to provide fresh air ventilation.

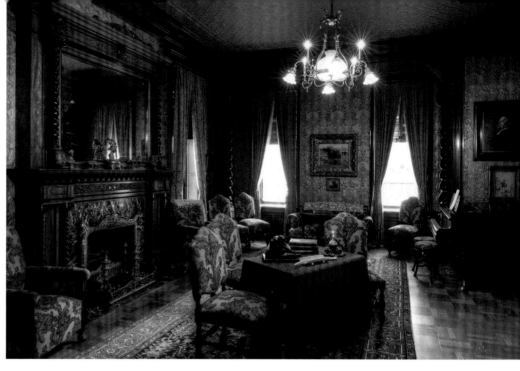

The staircase rises to the third floor. Three family bedrooms and a sitting room on the second floor are centered around a spacious foyer with a simple brick-faced, wood-burning fireplace. Two stained-glass doors and transoms create a privacy screen to Elsbeth's bathroom while allowing light to shine onto the foyer from the south windows. Emma, the Pabsts' youngest daughter, also lived at the mansion on occasion, in a bedroom with a late-Regency motif. Gilded swags and Neoclassical references abound in the relief on the fireplace front, the ceiling, and wall coverings as well as the bedstead and chairs.

The Pabsts shared a master bedroom, which was unusual for the time. Their beds were on opposite walls, so they could sit in bed and have a face-to-face conversation. They insisted that their suite be simple and comfortable, not showy and formal. Mrs. Pabst's adjoining sitting room was well suited to casual visits with close acquaintances. She always had some sewing and mending to tend to while company called.

Upstairs, the southern part of the third floor was outfitted to accommodate the Pabsts' adult children and their spouses on the occasions when they stayed overnight.

The Pabsts' love of music played an important role in their family life. The richly ornamented music room with its lacquered twisted columns, Italian marble firebox, and oriental rugs evokes the feeling of a Renaissance salon.

Technological Innovations

Wisconsin's Own is a story of dynamic men and women who succeeded through hard work, creativity, and innovation. When these early settlers built their homes—whether as emblems of their success or simply to enjoy the fruits of their extensive labors—they were receptive to or demanding of the latest innovation or technological development. Such open-mindedness made Wisconsin fertile

Pabst's home was built by artisans, but it was heated with the most modern mechanical system and monitored by these basement gauges.

—————

Warren Johnson was a professor of penmanship at the State Normal School in Whitewater in 1876. As was typical of the time, the janitor would make hourly rounds of each classroom to check temperature and then return to the basement boiler room to manually adjust each room's damper accordingly. A multitalented and inventive sort who was miffed by the frequent interruptions, Johnson created electric "thermostats" for each room that would indicate to the janitor below the room's condition as warm or cold, thereby alleviating the interruption and streamlining the mechanical adjustment process. The science of mechanical controls has grown from this and other developments and inventions by Johnson and the Milwaukee-based company he later founded that is known today as Johnson Controls.

The Pabst mansion contained myriad mechanical innovations: a vent chimney at the stair tower

ground for further innovation and established a demand for such technological advances.

used natural heat convection to recapture the home's heat in winter and maximize its cooling in summer; the original boiler room was separate from the main house to alleviate the noise and mess of combustion energy; and a unique indirect steam radiation system. Using Warren Johnson's invention, these technical innovations could be controlled for the first time by the owner via a series of pneumatic climate switches set in each room. The switches were powered by a battery similar to today's low-voltage controls, and they pneumatically closed and opened dampers to regulate the heat supply. Johnson Controls records show that the first residential installation of these climate switches was in Frederick Pabst's sister-in-law Lisette Schandein's mansion and that a similar system was installed in Andrew Carnegie's New York City home (now the Cooper Hewitt Museum of American Design).

Just as homeowners today seek out the most energy-efficient heating, cooling, and lighting systems, so did homeowners at the turn of the twentieth century—especially those who were in the forefront of embracing new technologies in their own industries.

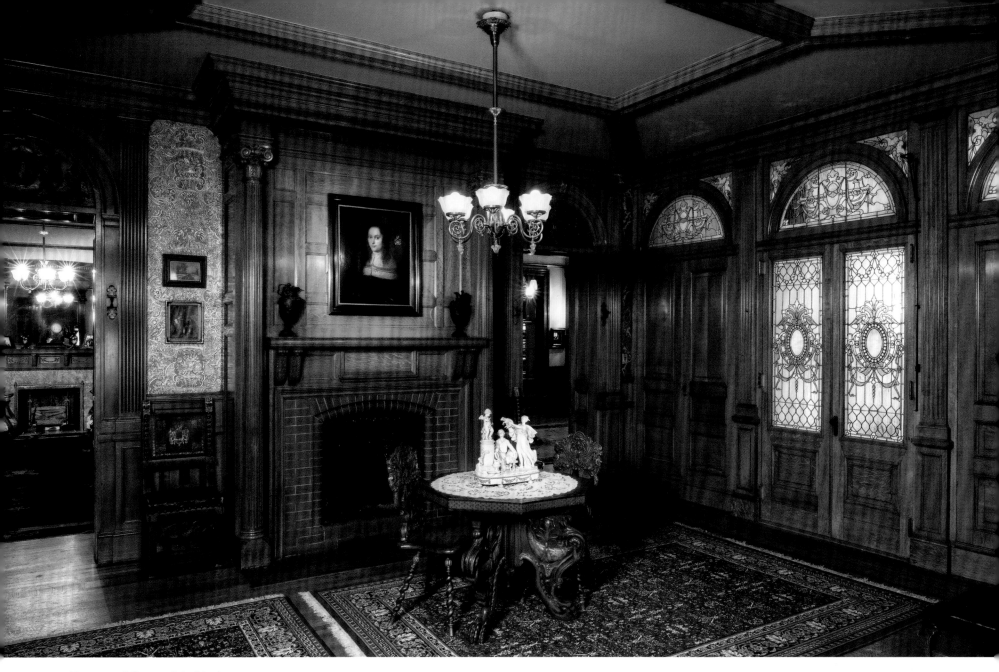

The second-floor stair hall is the equivalent of a contemporary family room; family would gather around the fireplace to read or play games. Behind the stained-glass door is a bathroom, linen closet, and storage.

The floor's northern wing was occupied by staff quarters and storage. An elevator located in the servants' stair hall was installed during one of Captain Pabst's illnesses. It travels between the first and third floors.

CAPTAIN PABST ENJOYED HIS HOME for a decade; the last two years of his life, while in ill health, he traveled to Europe and Southern California for spa treatments and warmer climates. By the time of his death in 1904 and Maria Pabst's death two years later, Grand Avenue was in decline as a residential neighborhood: streetcars and automobiles brought the noise, congestion, and construction of the downtown to the doorsteps of the Pabsts and their neighbors. The very wealthy families were either moving north of the city or

building along Lake Drive, Wahl Avenue, and Terrace Avenue on Milwaukee's east side.

In 1908, after the home was on the market for three years, heirs Gustave and Frederick Pabst Jr. sold it to the Milwaukee Roman Catholic Archdiocese. The Catholic Church was one of the few groups interested in large homes during this period. The house became home to the archbishop and chancery offices, and the famed pavilion was transformed into a chapel. The church did little in terms of redecorating, so many of the outstanding features of the house were left otherwise undisturbed under coats of white paint.

In the 1970s the archdiocese wanted to sell. But even fewer buyers were interested than in 1908, and the house was almost demolished for a parking lot. One man, John Conlan, bought the house to stop the travesty. Many of the grand Wisconsin Avenue mansions built between 1880 and 1890 had already fallen to the wrecking ball to make way for commercial and institutional development. In 1978, Wisconsin Heritages Inc., a fledgling preservation group, cobbled together a financial package of a state grant, private money, and twenty-three mortgages to save the main house from slated destruction. The land that the carriage house occupied was sold to an adjacent hotel for a parking lot, and the carriage house was demolished. The funds from this sale went toward the purchase of the mansion.

The Captain Frederick Pabst Mansion opened to the public later that year as a historic house museum. Visitors could imagine what a magnificent home it had been since some of the

Daughter Emma's bedroom is being restored back to the late-Regency style. Ormolu—gilt decoration made from finely ground, high-karat gold over metals—was a favorite for embellishing walls, furniture, and objets d'art during the Victorian period.

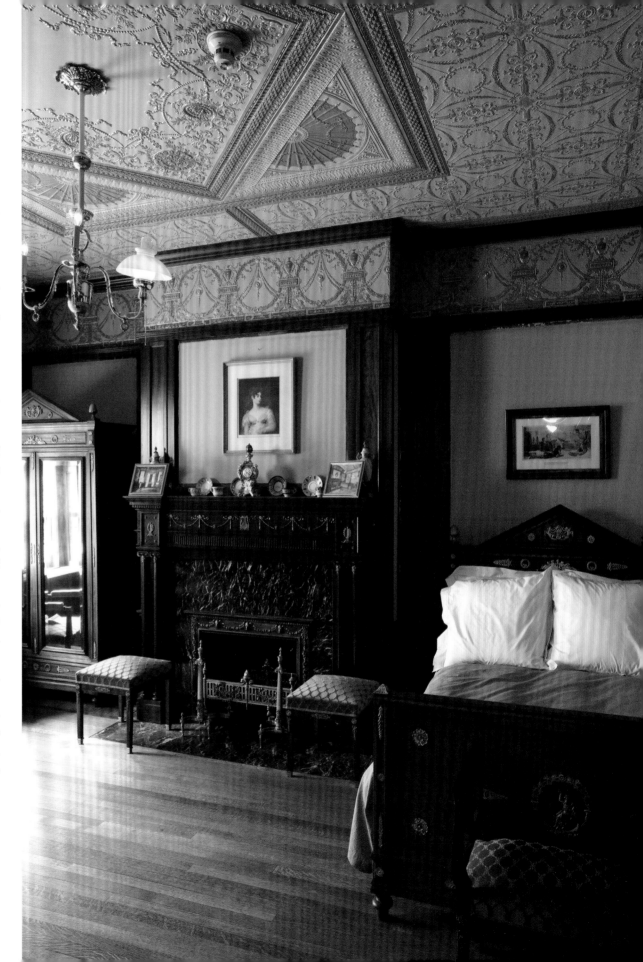

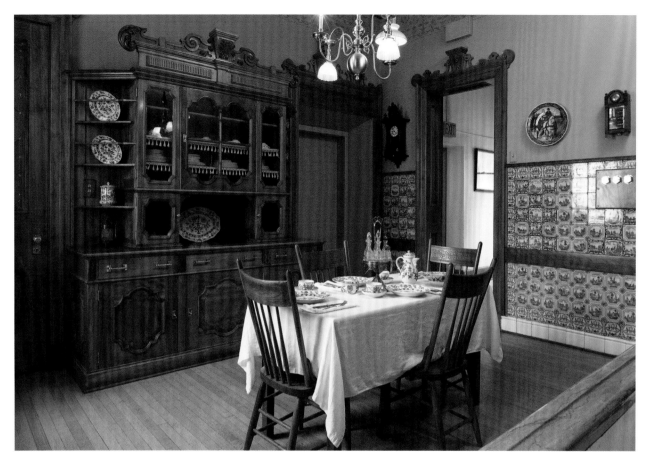

The kitchen and servants' dining room were bright and cheery rooms outfitted with Delft tiles, stained-glass windows, birch cabinetry detailed with nickel fittings, and granite countertops. Pabst recognized that quality work deserved a quality workspace, both in his home and in his brewery.

original furnishings remained and some of the first-floor woodwork had not been painted over. The restoration, which began with the dining room in 1984, continued in earnest in 1989 with the music room. Every effort was made to re-create its 1897 appearance, from the ceiling and wall coverings to the furniture's upholstery. The entire first floor of the main house is now restored and future plans involve the restoration of the pavilion. Large numbers of family photographs continue to assist the curators in their restoration efforts.

As part of the ongoing restoration of the second floor, the Captain Frederick Pabst Mansion continues its drive to reassemble art from the Pabsts' collection, much of it purchased by Pabst on his European visits. It had been difficult to locate the pieces, but hopes were raised when eighteen paintings previously owned by the Pabsts were at auction at Sotheby's in 2005, including "Lisa." Pabst commissioned this work from Austrian painter Eugen von Blaas in 1895; the nearly eight-foot-tall painting of a winsome young peasant woman once hung in the staircase. Pabst also collected the work of other nineteenth-century Academic painters: Germans Karl von Eckenbrecher and Adolf Schreyer, Adolphe William Bougereau of the French school, Belgian artist Eugene Verboeckhoven, and American Daniel Ridgway Knight. As funds allow, and as paintings appear at auction, the collection is being brought back home.

The grand house on Grand Avenue stands as a legacy of a poor immigrant who came to Milwaukee with nothing but native intelligence. Today, visitors continue to pay their respects to Frederick Pabst as they have made the mansion one of Milwaukee's most popular tourist sites. Under Senior Historian John Eastberg's capable direction, new scholarship about the Pabst family, their home, and their place in Milwaukee's history continues to unfold. Ongoing special events such as beer tastings in the mansion, a Grand Avenue Christmas, fund-raising events, and lectures on beer barons, Victorian architecture, and servant life at Pabst's mansion make the home come alive for contemporary visitors. For all intents and purposes, the present is the past. •

The Matthews Brothers of Milwaukee crafted the three-story stair hall from quarter-sawn oak. The stained-glass ceiling window opens to allow hot air to escape and cool air to enter the home.

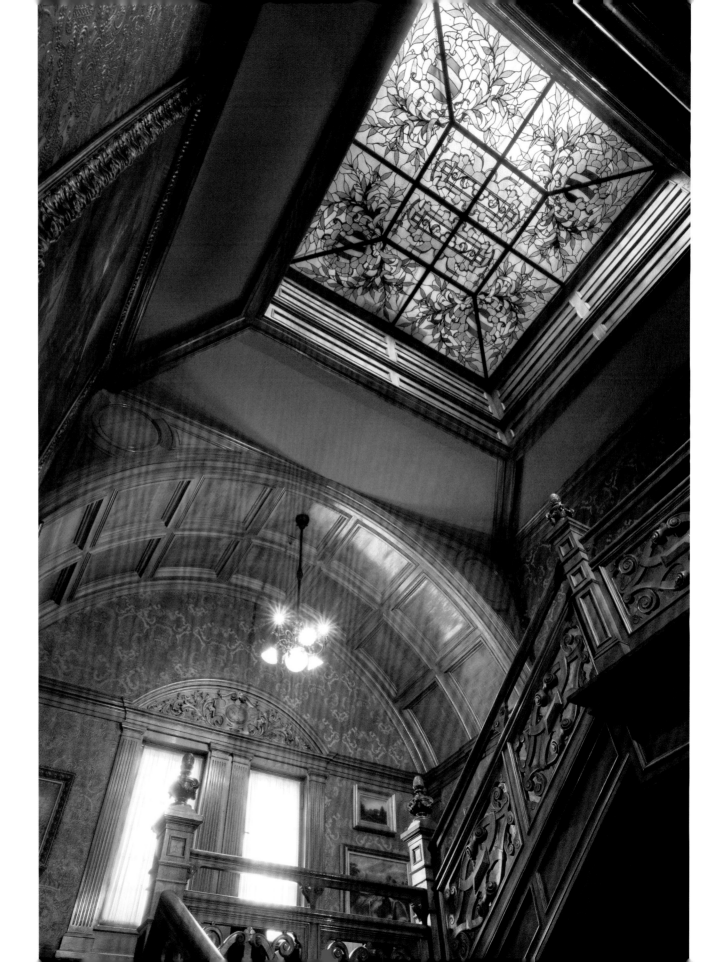

Henry A. Salzer House

OPPOSITE: Windows and doors were designed with Prairie elements Mr. Salzer enjoyed. The living room's white-painted beams and the white-painted wood fireplace surround reflect the Colonial Revival style more today than during the Salzers' residency.

THIS CRISP, SHARPLY GEOMETRIC HOME on King Street in La Crosse is one of 287 buildings listed on the Cass and King Street Residential Historic District of architecturally significant late-nineteenth- and early-twentieth-century structures. Queen Anne and Romanesque styles reigned here in the 1890s; the Prairie style's influence is seen in homes dating to between 1910 and 1930; and Colonial and Tudor Revivals marched in between 1900 and 1940. These houses were built by lumbermen, financiers, brewers, and merchants who comprised the middle class and were inclined to hire architects to design their homes. Percy Dwight Bentley and his partner Otto Merman's architecture firm was in great demand. Bentley received the commission for Henry Salzer's Prairie-style residence when he was just twenty-seven years old.

Salzer was a first-generation American businessman whose father, John Adam Salzer, was a German immigrant and itinerant Methodist minister who arrived in Wisconsin in 1846 with religious zeal, a love of flowers, and not a penny to his name. Late in life, Salzer would build his fortune by creating a virtual garden of Eden in La Crosse, producing flower and vegetable seeds. Upon his death in 1892, his son Henry succeeded him as president of the Salzer Seed Company. How fitting that a fortune made from seeds would result in a house based on the principles of organic architecture.

The Salzer Seed Company conducted most of its business through mail orders. This 1922 full-color cover was typical of the bold images used in Salzer's catalogs.

THE SALZER FAMILY FORTUNE did not come easily. The family first came to La Crosse in 1866, when John Adam Salzer's church sent him to serve a three-year ministry. Salzer and his family had spent twenty years traveling from congregation to congregation in Illinois, Iowa, and Wisconsin. They suffered from financial and personal hardships, often lacking enough to eat or a decent place to live. Upon arriving in La Crosse, Salzer found that the natural beauty of the area's deep ravines, steep valleys, tall bluffs, unique geologic formations, and rich soil awoke his desire to plant and grow flowers and vegetables. He had learned to plant and propagate trees from his father, a nurseryman in Germany. But he loved growing flowers most of all.

During the final year of his ministry assignment, Salzer bought some land in La Crosse and built a greenhouse to grow food and flowers, initially to feed his family and satisfy his desire for beauty. He literally planted the seeds that grew the family's fortune. After his retirement from the ministry Salzer continued to buy more land and build more greenhouses. In 1886 his Salzer Seed Company sent out its first mail-order seed catalog; two years later the company had 4,300 square feet cultivated in greenhouses. The Salzer Seed Company eventually grew to employ two hundred people in peak season and reaped $1 million in annual sales by 1892.

John Adam Salzer was well respected both as a minister and as a plants man. In his obituary in the *Minnesota Horticulturist,* his company is credited with being the largest commercial florist and seed business in the northwest. When Salzer died in 1892, his sons Henry and John assumed ownership of the business. At the time, the company owned 5,000 acres in Wisconsin, Minnesota, and the Dakotas, and the mail-order department filled six thousand orders a day, worldwide, and distributed more than half a million catalogs a year. The Salzers also managed an apiary of eighty stands of Italian bees in moveable hive frames to pollinate the flowers. The company sold the bonus three thousand to four thousand pounds of honey the bees produced annually.

The Salzer Seed Company was sold in the mid-1940s to a Chicago businessman. The plots were allowed to go fallow in the late 1950s, and by 1968 the majority of the buildings associated with the Salzer Seed Company had been razed. La Crosse's first airport, Salzer Field, was built in 1926 on 80 acres that had been owned by the Salzer Seed Company. Salzer catalogs and seed packets are still in demand today among those interested in heirloom tomatoes, potatoes, beans, and flowers.

IN 1911 HENRY AND CLARA SALZER lived on West Avenue South, a busy thoroughfare in La Crosse. Henry had been president of the Salzer Seed Company for almost twenty years and was enjoying the wealth the company had generated. He decided it was time to move to the same quiet leafy neighborhood that his brother, John, called home. He took Clara to see examples of Percy Dwight Bentley's completed residential projects. Henry admired the designs for their similarity to the work of Frank Lloyd Wright. Bentley and Salzer were close in age and their fathers had been friends through their in-

volvement with the Methodist Episcopal Church and the administration of the YMCA. With these social connections and aesthetic agreement, Bentley was the logical choice as Salzer's architect.

One sticking point in the design process was that Clara expressed her desire for a Colonial Revival–style home. This husband-and-wife stylistic conflict was so common at the time that women's magazines addressed the issue with regularity. The magazines, in particular *The House Beautiful, House and Garden,* and *Ladies' Home Journal,* were instrumental in forming the popular aesthetic and understanding of residential design by educating readers about the basics of architectural design. Black-and-white photographs, extensive floor plans, well-drawn construction details, and notated structural diagrams complemented the articles.

Well-known architects authored articles for the popular magazines in an attempt to curry the favor of those women who were involved in determining the design of their homes. *House and Garden* featured an ongoing monthly series with such titles as "What Period Styles Really Are," "Real Meaning and Use of Architectural Details," "How to Read an Architectural Drawing," "The Meaning of a Floor Plan," "The Service of an Architect," and other articles on such technical subjects as heating, plumbing, and sewage systems. These thoughtful articles were more educational than inspirational. A telling serialized topic was "Homes Architects Have Built for Themselves." Revival styles such Colonial and Mediterranean were featured from 1911 to 1914. The message women were getting was that traditional designs were what people of quality were seeking.

Ladies' Home Journal was one of the few magazines that touted the Prairie style. Frank Lloyd Wright wrote two articles for the magazine, in 1900 and 1907. He was hired and dismissed by both Chicago industrialist Harold McCormick and Detroit automobile magnate Henry Ford when their wives decided that Italian villas and English manor homes designed by East Coast architects were more appropriate to their social standing than the work of Midwestern Prairie School architects. While the very wealthy Midwesterners looked to the East Coast and Europe for design precedent, successful middle-class businessmen, such as Henry Salzer, made up the majority of Prairie-style architects' clientele.

Salzer agreed to a compromise between his desire for a Prairie-style home and Clara's for a Colonial Revival. He handed over mediation responsibility to their architect, Percy Dwight Bentley. At this juncture, Bentley brought interior designer George Mann Niedecken into the project. Niedecken had worked with Frank Lloyd Wright on the interiors of the Dana, Coonley, and Robie houses before establishing his Milwaukee interior design office, Niedecken-Wallbridge, in 1907. Niedecken understood Prairie architecture, but he also understood the desire of many female clients to create homes that suited their family heirlooms and were more like their friends' classic, revival-style homes. With Niedecken on board, the schism between Clara's and Henry's aesthetic tastes would be bridged in a compatible mode.

"The Suburban House," an article by Robert C. Spencer Jr. in the October 1908 issue of *The House Beautiful,* featured an Illinois residence with a striking resemblance to the Salzer home.

This House Beautiful

There were notable exceptions to the conservative trend in housing styles showcased in popular women's magazines at the turn of the twentieth century. Robert C. Spencer Jr., one of the original Steinway Hall group, wrote more than twenty magazine articles extolling the virtues of the Prairie School architects and their designs in the Chicago-based *House Beautiful.*

Spencer, who was born in Milwaukee, worked for the architecture firm Shepley, Rutan & Coolidge in Boston and Chicago prior to starting his own architectural practice in 1895 in the Dankmar Adler and Louis Sullivan–designed Schiller building (also known as the Garrick Theater) next door to Frank Lloyd Wright's own office. In 1900 Spencer wrote the first major article about Wright in *Architecture Review,* a generalist professional periodical.

After the *House Beautiful* headquarters was relocated to New York City in 1910, interest in publishing articles about the Prairie School diminished. Chicago's identity was changing from experimental western frontier to established center, and the Midwest looked to the eastern architectural establishment and social milieu for aesthetic guides. Edward Bok, a Progressive who believed in modernizing the American home and who served as the editor of *Ladies' Home Journal* from 1889 to 1919, continued to champion the style, particularly Wright's work, by commissioning such articles as "A Home in a Prairie Town."

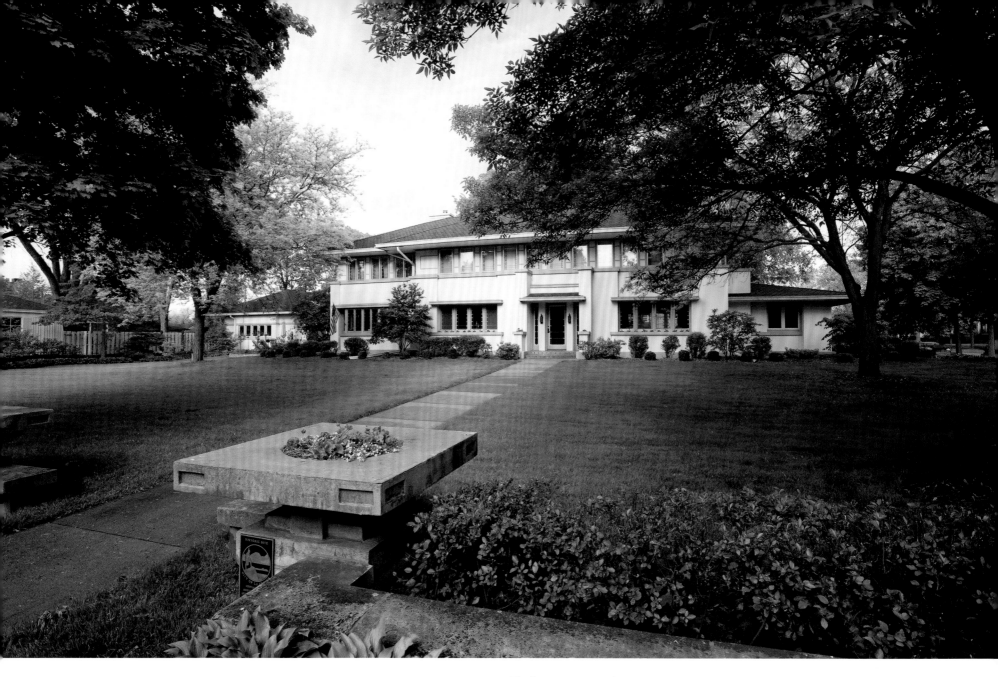

ABOVE AND LEFT: The home, 2009 and circa 1920

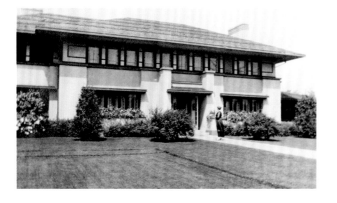

BENTLEY WAS BORN IN 1885 in La Crosse. He was eighteen years younger than Frank Lloyd Wright and almost thirty years younger than Louis Sullivan. Bentley, who graduated from Ohio Wesleyan University in 1907, began but did not finish a program of architectural studies at Armour Institute of Technology in Chicago (the present-day Illinois Institute of Technology). Before the state of Wisconsin had a school of architecture, Armour was a stepping-stone for many Wisconsin students wishing to matriculate in an architectural program. As part of its program, some courses were offered at the Art Institute of Chicago's decorative arts galleries.

Like most young architecture students in Chicago, Bentley was aware of the reputation and work of those architects known as the Steinway Hall group, which was based across from the Art Institute. The original group consisted of Dwight H. Perkins, Robert C. Spencer Jr., Myron Hunt—all of whom were Massachusetts Institute of Technology graduates—and Frank Lloyd Wright, who obtained most of his architectural education working in the offices of Joseph L. Silsbee and Louis Sullivan. The group eventually numbered eighteen and included such architects as Walter Burley Griffin, brothers Irving K. Pond and Allen Bartlit Pond, Hugh Garden, and Arthur Heun, all of whom came to be known as members of the Prairie School. This serendipitous gathering of architects created a pool of talent that still creates architectural waves. Bentley was among the younger generation of architects who felt the pull of the tide.

The Chicago School and Prairie School labels were bestowed by critics writing about the works of architects, not by the architects themselves. Originally, the Chicago School referred to Chicago architects, like Louis Sullivan and William Le Baron Jennings, and Holabird and Root, who boldly embraced steel construction technology in the design of tall commercial buildings in the 1890s. In *The Prairie School,* H. Allen Brooks credits two articles written in 1905 and 1908 with coining the term *Chicago School*—only then the term referenced residential architecture and residential architects, such as Frank Lloyd Wright, George W. Maher, and Arthur Heun.

The origin of the term *Prairie School* is less specific aesthetically, geographically, and genealogically. Frank Lloyd Wright attempted to crown himself the king of the New School of Middle West, an appellation that never caught on. Wright believed in a formal vocabulary and strict adherence to that vocabulary under his leadership. Architects who worked for Sullivan and Wright have not, until recently, been allowed by architectural historians to fully claim their spot in the limelight. As for those who designed in the Prairie style in cities other than Chicago, they are just beginning to come out from behind the curtains to accept their bow. The Prairie School had a broad geographic and aesthetic mantle, with followers throughout the world, including Australia and India.

This postcard of Main Street in La Crosse, circa 1913, shows a thriving business and commercial district.

IN 1900 LA CROSSE was one of Wisconsin's largest cities, with a population of almost thirty thousand. Like many other successful Wisconsin cities, La Crosse got its start from the fur and lumber traders who traveled along the La Crosse and Black rivers down the Mississippi to Prairie du Chien and beyond. Its sustained growth came from lumber and flour mills, banks, breweries, merchants, manufacturing, and river and rail transportation. The railroad first crossed the Mississippi at La Crosse in 1858, opening up trade routes to the Plains states.

Bentley returned to La Crosse in 1908 for an apprenticeship in the architectural office of Wells E. Bennett. Bennett had been the architect for the Batavia Bank building, where Bentley's father was president. That year, La Crosse was beginning to gain recognition as a regional medical center. By 1910, La Crosse was still one of Wisconsin's largest cities, but business development had begun to level off. This lack of growth and development was inauspicious for a young man just starting out as an architect. But Bentley was a local boy. Like many architects he would depend on social and business connections for references.

In 1910, following his two-year apprenticeship, Bentley opened his own practice with a commission for the residence of Edward C. Bartl, president of the Bartl Brewery. The home, still extant in the Cass and King neighborhood, is a two-story, wood-and-stucco Prairie-style home. The stylistic homage to Wright—strong horizontal lines, a brick chimney rising from the center of the broad overhanging roof, and corner windows—is obvious. But Bentley fearlessly inserted some new vocabulary into the Prairie lexicon, employing square, rather than vertical, windows and designing a prominent prow-shaped stair hall projection—his twist on Wright's breaking out of the box mantra. This type of projection became a favorite of Bentley. He did borrow heavily from other architects' design language, but he was not a mimic. His buildings often responded more to the wishes of his clients than to the dictates of a style.

La Crosse native Otto Merman started out as Bentley's draughtsman and went on to become his partner. The two worked together from 1910 to 1919, designing Prairie-style homes in La Crosse, Tomah, Fountain City, and Richland Center. Not all of their work was in the Prairie style, though. For example, they designed a Nordic-influenced Arts & Crafts–style vacation cottage on Barron Island in the Mississippi River for the Gundersen family. The Argyle Scott house, located a block from the Salzer house, was the last home Bentley designed in La Crosse. It is a conventional Colonial Revival, one without Prairie overtones.

The exterior's angular geometry and understated ornamentation belie the fact that the home is almost one hundred years old.

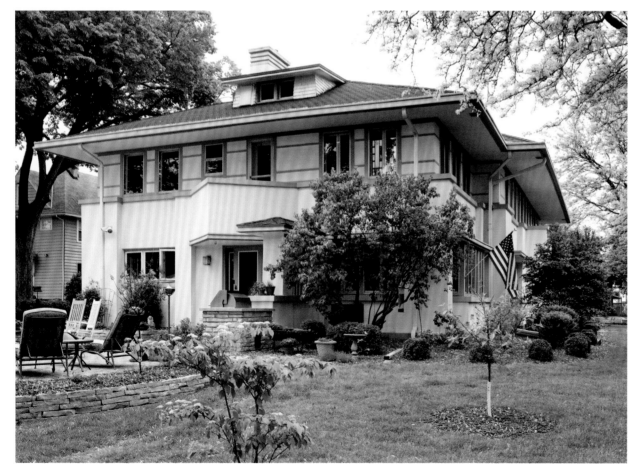

WHILE THE EXTERIOR OF THE SALZER HOUSE is designated as Prairie style, it does not contain all the style's hallmarks. It was architect Percy Dwight Bentley's habit to deviate in significant ways from the pure vocabulary of Frank Lloyd Wright without diminishing the architectural integrity of the design. Bentley never worked for any of the Prairie School architects recognized as being part of either the Chicago School or the Prairie School, but while he may have lacked professional experience in their offices, he was an ideological follower of Louis Sullivan and Wright. Bentley adopted (and adapted) Prairie School architect Irving K. Pond's list of Prairie hallmarks:

- horizontal lines
- low, long hipped gable roof
- horizontal banding of windows
- belt course
- broad, forward set foundation
- short, vertical accents or piers
- clear, precise, angular geometry
- judicious use of ornaments
- textural expression of material
- leaded or zinc strip window mullions
- combination of brick or stucco and woods

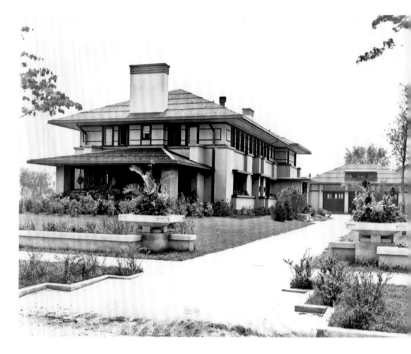

From the curb, the Salzer home's broad hipped roof, horizontal lines, leaded casement windows, and spare geometry expressed in stucco says Prairie. But on close inspection there are several hints in the elevations that the Prairie house has a Colonial Revival interior floor plan. The first sign is the tall chimney on the north elevation. Most classic Prairie houses employ the hearth as the central organizing and visually dominant element of the floor plan; a central chimney hints that the major living rooms radiate around the fireplace. In most instances a Prairie chimney rises from the center of the roof and is not a dominant exterior vertical element.

Another broad hint that the floor plan reflects the Colonial Revival style is the symmetry created by the centered glass front door with sidelights. The symmetry of the main (or east) elevation of the Salzer home is typical of the Colonial Revival style, but the entryway's Prairie influence is indicated by the abstracted pilasters extending above the minimal covered entry and the geometric design of the glass front door and sidelights. Neither an elaborate Colonial-style fanlight nor a paneled door graces this entry. Colonial Revival windows, which are often shuttered, are typically double-hungs with divided lights arranged in pairs on the first floor and individually on the second floor. The windows in the Salzer house are vertical casements grouped in multiples that create the Prairie School effect of a band of windows spanning every elevation.

The accepted open plan of the Prairie style mandates an asymmetrical entry with a minor reception hall that allows for the free flow of visual and physical movement among

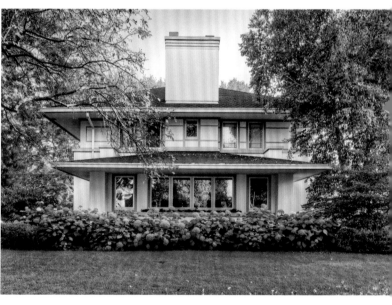

TOP: The Salzers' Prairie-style home was originally outfitted with moss green shingles and painted a deep tan with a brown string course and trim. Today's color palette is softer. BOTTOM: The combination of the broad overhanging eaves and horizontal wood trim patterning creates an illusion that the second floor has a much lower ceiling height than the first floor.

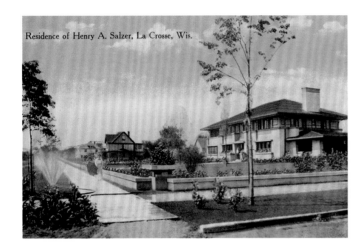

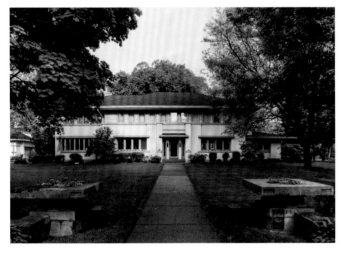

TOP: Edged with a planting wall and Prairie School urns, the Salzers' large corner lot allowed for impressive landscaping. This colorized postcard from 1921 shows the young trees, now fully mature. BOTTOM: The Salzer house embraces and occupies a corner site without overpowering it. House and garden are one— a true hallmark of the Prairie style.

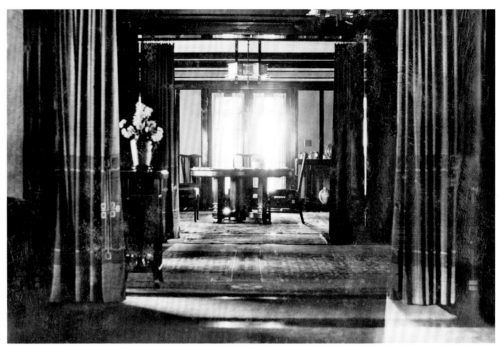

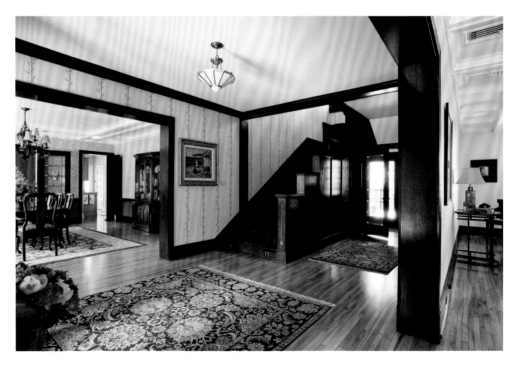

TOP: Early view of the dining room. The ceiling beams were not originally painted white. BOTTOM: The wood floors originally were covered in carpet designed by interior architect George Mann Niedecken. Presently, shiny hardwood floors and oriental carpets reflect more of the home's Colonial Revival style than its Prairie elements.

the major living rooms. In a typical Colonial Revival plan discrete living spaces are disposed to either side of an entry hall. In lieu of the hearth typically found in a Prairie home, the generous Salzer hall is more reminiscent of a Victorian grand hall punctuated with a visually dominant stair. Prairie staircases are typically shielded from view by wood screens or staggered plaster walls. But the Salzer home's dark mahogany stair with golden oak inlay accents in the broad risers and a staggered mahogany balustrade is more similar to the Victorian staircase at Villa Louis than the Prairie stair in the Bradley house. Also as in Villa Louis, the back door of the Salzer house is visible from the front door—a plan configuration not found in Wright's Prairie homes. The well-resolved rear exterior acknowledges that the family would arrive at the house by automobile.

The stair landing's cushioned window seat is framed by four leaded, clear glass, vertical windows framing the view of sky and trees. The overall effect from the base of the stair is a real-time, seasonally changing landscape painting—a modern take on the stained-glass windows found in Victorian and Arts & Crafts homes.

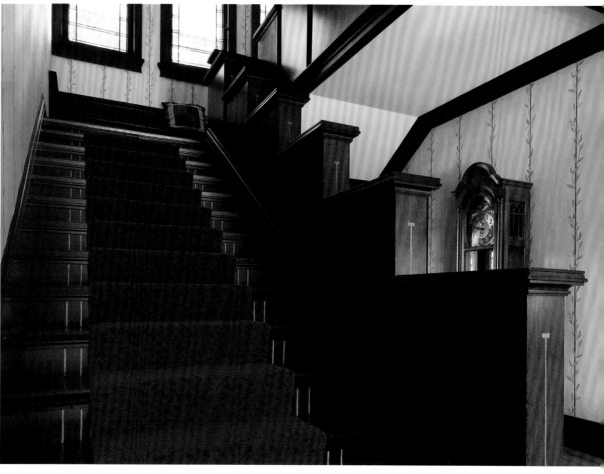

The golden oak inlay of the stair and banister are reminders of the importance of both lumbering and craftsmen at the beginning of the twentieth century.

WHILE A PURIST MIGHT NOT AGREE, there are worse things than inserting a Colonial Revival floor plan into a Prairie envelope. One can only imagine how surprised current owners Kim and David Pretasky were when they stepped into the Prairie-style home with a real estate agent in 2000 and found a 1960s decorative motif: geometric wall paintings, a primary color scheme, and shag carpeting—and not just on the floor. The interior was no longer Colonial or Prairie. Whatever it was, it was completely divorced from Percy Dwight Bentley and George Mann Niedecken's original intent.

Niedecken had been asked by Bentley to design the Salzer home's movable furniture, a large living room rug, light fixtures, and radiator covers; the crystal chandeliers he designed were crafted in Austria. Drawings by Niedecken for the Salzer home—drawings of the couch, chairs, and table, as well as preliminary drawings and wool samples for the rugs—are in the Niedecken archives at the Milwaukee Art Museum. In spite of the fact the Niedecken enhancements were no longer in evidence, the Pretaskys could still sense the home's architectural integrity. A childhood connection to the historically designated neighborhood sealed the deal.

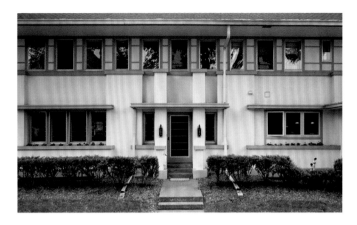

Every house has windows. But in the Salzer home, the windows are integral to the design of the elevation. Through repetition and alternation, the home's Prairie-style elevation is read as a seamless sculptural wall.

Changes large and small were made to the original Bentley plan over the past ninety-eight years by the home's various owners. All three porches in the original design have been modified for four-season living. The living room fireplace is now double-sided to accommodate a den in what was the northern porch. A home office on the southeast corner was created out of what was once a porch adjacent to the dining room. The second-floor sleeping porch, also on the southeast corner, was enclosed as a guest bedroom. An outdoor swimming pool was built west of the original three-car garage. These additions reinterpret the inside-outside connection of the original design, but the massing of the building is true to the original plans.

The current owners spent several years removing any trace of the 1960s decoration, updating the kitchen and bathrooms, and creating a spacious master suite by combining a small bedroom, a sewing room, and a bedroom. They have maintained the integrity of the Prairie exterior and Colonial Revival interior with Prairie accents, retaining or replicating many of the details of the original interior including wood moldings. They replastered and painted the walls and refinished the woodwork, much of it a now-rare

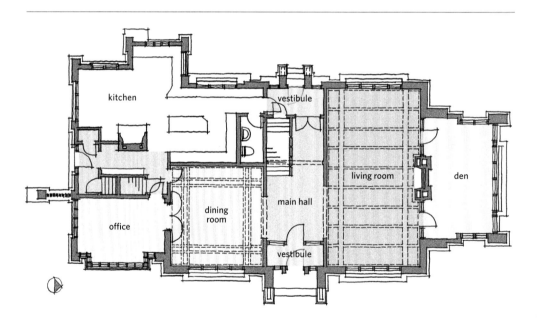

This handsome home displays all the hallmarks of the Prairie School—except that the floor plan is Colonial Revival in its organization.

Like a true Colonial Revival, the first-floor design is bifurcated by two symmetrical entries at the east and west, with a formal staircase at the home's heart. This defining center element is functionally balanced to the north with the living area and to the south with the dining room and kitchen. The office and den were, on the original plan, bookend porches to the south and north that further reinforced the symmetrical layout. The dotted lines in this drawing represent the pattern of the coffered ceiling.

The kitchen was recently reconfigured to reflect the current owners' needs while remaining sensitive to the home's original "bone structure."

Philippine mahogany. The color range from dark brown to red to purple was its major attraction; its smooth texture gleams under polish. On the second floor many of the doors; door hardware; leaded, hand-cut crystal doorknobs; and geometric Prairie-style ceiling light fixtures are original to the house. The first floor is a melding of Colonial Revival elements with some original Prairie details (which occur mainly as decorative, not spatial elements), the best examples of which are in the simple geometric designs of the vertical casement windows and the brass radiator covers.

The basement recreation room is the most Prairie-looking room in the house. A massive, double-arched, Roman brick, floor-to-ceiling fireplace dominates the northern wall. The walls around the room are faced with the same brick to chair-rail height and then plastered to the ceiling. The deep and broad fireproof concrete beams create a very masculine coffered ceiling. The doorway to the recreation room is surrounded by Roman brick, with expressed brick pilasters flanking the opening. This dark brick gives the impression that Niedecken-designed Prairie furniture would be right at home in this male retreat from the light and airy Colonial Revival living room with its elegant, white-painted wood fireplace surround, its deep hearth bounded by two piers. The living room's cross beams and the dining room's framing beams were painted white as a nod to the Colonial Revival style.

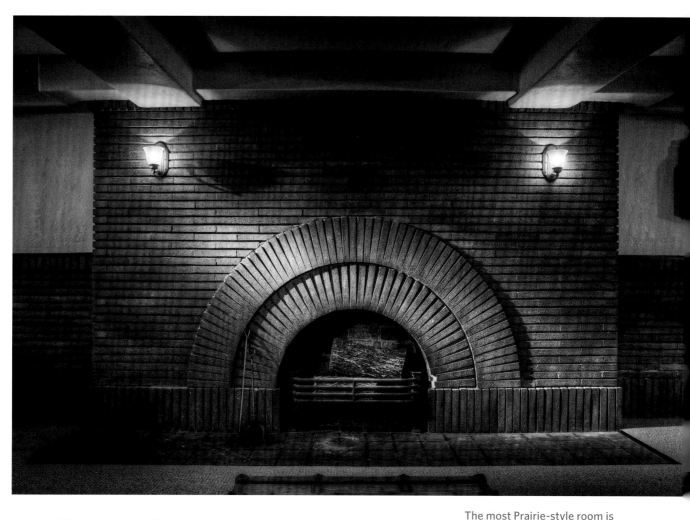

The most Prairie-style room is the basement recreation room. The bold, double-arched brick fireplace dominates the entire wall. Concrete ceiling beams highlight the home's fireproof construction.

THE SALZER HOME, built almost a century ago, still attracts attention from passersby—not because it is a charming, quaint, old house reflecting a bygone era or a house museum open to the public but because it is still a vital family home and part of a distinctive neighborhood. The harmony of proportions, the elegance of restrained ornamentation, and the manner in which the home still commands the corner with grace shows the respect and value all of the owners have shown to the Salzers for putting down roots and flourishing in La Crosse—and building a home worth maintaining. •

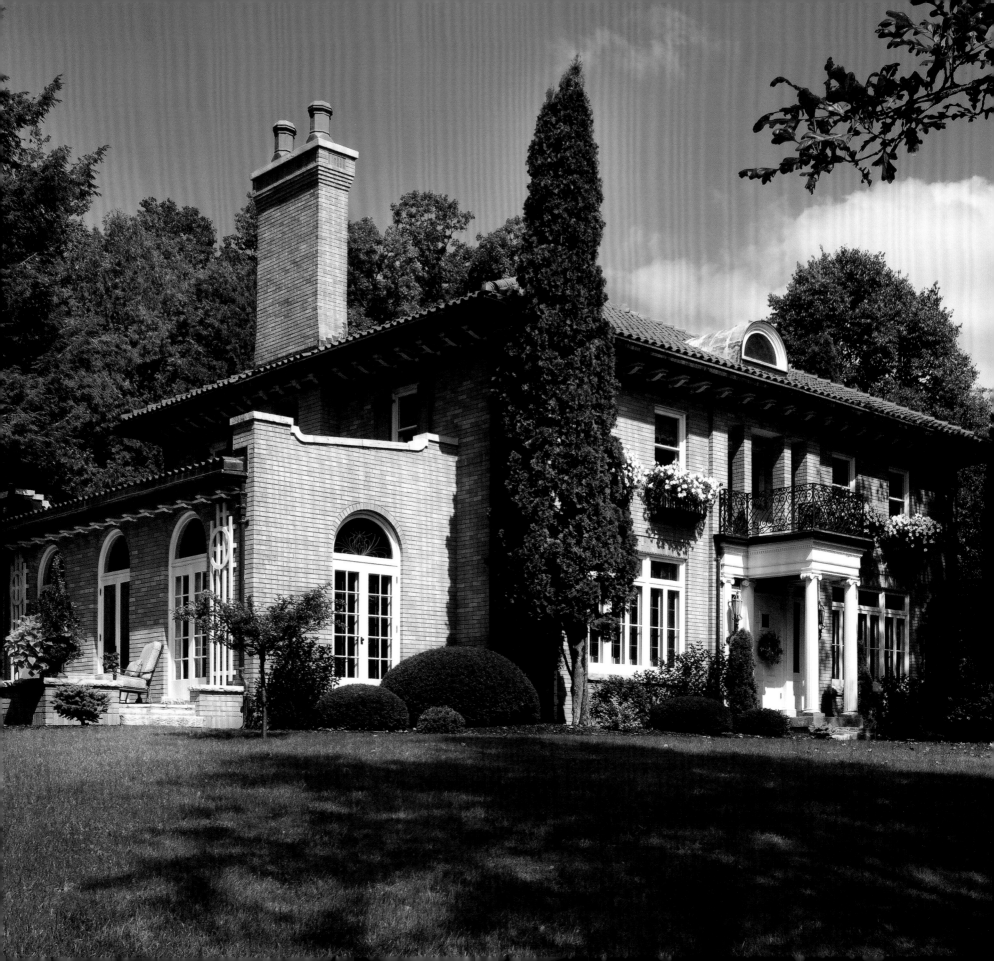

Walter and Mabel Fromm House

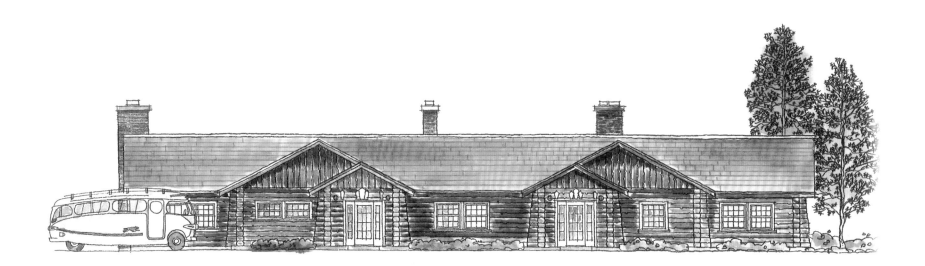

OPPOSITE: Walter and Mabel Fromm built a four-bedroom Mediterranean Revival home set on a slight rise east of his family's original farmstead. The southern rooms offer long views of the countryside the Fromm brothers spent their childhood exploring. ABOVE: The elevation of the clubhouse at the Fromm Brothers Fur and Ginseng Farm Complex.

WHAT COULD FOUR POOR BROTHERS growing up in the early 1900s in rural Wisconsin have in common with John Jacob Astor, the first multimillionaire in the United States?

If they were the Fromm brothers from Hamburg, Wisconsin, the answers would be humble origins, plowing profits from ginseng into the fur trade, and thinking big.

The four brothers turned a childhood dream into a company that became the world's largest breeder of silver foxes. The brothers may have personally labored harder than Astor to amass their fortune, but ginseng and furs earned millions for both parties. Astor had learned of ginseng when trading furs with the Iroquois in Canada. After a Jesuit priest told of how the Chinese revered ginseng for its medicinal properties, Astor gathered wild American ginseng from his fur traders in New York, Canada, and Wisconsin to send to China in 1792 with his usual shipment of furs. It took three years for the ship and Astor's money to come back, but the ginseng had netted Astor $1 million.

THE IMPROBABLE STORY of how four farm boys became leaders in the ginseng and fur worlds could have been written by Horatio Alger Jr. Walter, Edward, John, and Henry were the four younger sons of Alwina and Frederick Fromm; the boys also had two older brothers and three sisters. Both Alwina's and Frederick's parents immigrated to

JOHN & EDWARD FROMM

A Chicago buyer tried to steal some Scotch.

into their nostrils a quarter-ounce of carbon tetrachloride.

The four Fromms all live at the Hamburg ranch, John, the lone bachelor, quartering himself in the warehouse. U. S.-born of German parentage, the brothers still speak German in the family circle. President Edward makes monthly trips to New York. The walls of his office are covered with family portraits and photostats of certified checks (largest, $1,-300,000 from New York Auction Co. in 1929). On the dashboard of his Lincoln is a radio remote-control gadget which opens & closes his garage door and turns the lights in the garage on & off. None of the brothers smoke or drink. Each takes only $5,000 a year out of the business as salary.

This picture of John and Edward Fromm accompanied the 1936 *Time* magazine article "Furs from Fromms."

Wisconsin from Germany. Alwina's parents arrived in 1848, settling near present-day Hamburg in Marathon County. Frederick's parents came first to Milwaukee and then settled near West Bend at about the same time. Upon the couple's marriage in 1883, Alwina's parents gave them 160 acres of land in Hamburg as her dowry. The era of logging the great white pines was nearing its end, and farming was being touted by the state as the best use for the land that had been clear-cut by lumber companies. Families attempted to transform the cutover land, littered with stumps, into farms, from Marathon County north to Lake Superior.

Hamburg is twenty miles northwest of Wausau and about the same distance southeast of Merrill. Even today, the Fromm farm is remote from development. The rolling hills, misting valleys, and distant vistas likely appear much as they did in the early 1900s when "the Wolves," as the younger Fromm boys called themselves, roamed the countryside exploring, observing nature, trapping wild game, and dreaming about their future. Although the four boys did almost everything together, they had distinct personalities: Walter, the eldest among them, was born in 1888 and had an interest in ginseng; Edward, born in 1890, was known for his way with words; John, born in 1892, was a naturalist; and Henry, born in 1893, was obsessed with foxes—bright silver foxes, in particular. Silver foxes are the result of a naturally occurring, but rare, mutation found in red fox litters. Introduced to the United States by the British settlers in the 1700s, red foxes have adapted very well to marshy areas adjacent to meadows where they hunt their food of choice: field mice.

As in every great rags-to-riches story, there is a seminal moment when the course of history changes. For the Fromms, this moment came as one of the older brothers read an article by candlelight from the *Hunter-Trapper-Trader* magazine to the others. Upon hearing that a single silver fox pelt had sold for the grand sum of $1,200, the boys, ranging in age from eight to thirteen, made a pact to earn their fortune by raising silver foxes. On that night in 1901 the four could not have imagined the journey this agreement would take them on.

Life on a farm, with a large family, was exhausting and pocket money was scarce. If the brothers wanted to buy an expensive silver fox they were going to have to work hard and use their ingenuity to come up with the capital.

One of the Fromms' neighbors raised ginseng and bragged about turning a nice profit. The brothers realized this could be the cash crop they were looking for to finance their business. The boys scoured the woods for wild plants. When they asked their father for land to plant their ginseng, he made them clear a field where stones had been stockpiled for years. In 1904, the boys attempted their first crop.

The brothers learned, by trial and error, that ginseng was a difficult species to transplant: it would take five to seven years before the roots would be big enough to be an attractive and lucrative product. The boys' horticultural education consisted of eavesdropping on adult farmers, reading, and most of all experimentation. At the ages of sixteen, fourteen, twelve, and eleven, the boys cast their die, changing their name from the Wolves to

"the Company." Edward was elected president; Henry, vice president; Walter, treasurer; and John, secretary. The Fromm brothers kept these positions their entire working lives.

The complete story of the Fromms' slow and steady climb to success is delightfully told in the 1947 book *Bright with Silver* by Kathrene Pinkerton, who outlines the extent of Alwina Fromm's belief in her sons' vision of their future. In 1913, knowing she held the deed to the farm, the boys asked for her help. She agreed to mortgage the farm so they could purchase a breeding pair of silver foxes from a breeder on Prince Edward Island in Canada. Until 1910, the silver fox fur trade had been tightly controlled by a group of six breeders on the island. When one of the six broke ranks and sold a breeding pair outside of the group, the monopoly was broken and the silver fox breeding industry quickly expanded. In 1910, 10,000 pelts were harvested in the United States; by 1942, 101,439 pelts were harvested in Wisconsin alone.

The company's fortune also grew rapidly. In four years they had successfully bred fifty mating pairs and, in 1917, were able to repay their debt to their mother. By 1919 the Fromm brothers were also the country's top producers of ginseng, a unique position for four brothers all but one under thirty years of age operating out of their family farm in rural Wisconsin. Ginseng, which had provided the start-up capital for their fox endeavor, continued to be profitable. In 1923 the ginseng brought in $45,000; the following year, earnings were $115,000. In 1925 the Fromms' fur company earned almost half a million dollars; in 1926 the number was three quarters of a million dollars; and in 1929, as the country's economy was crash-

ing, Fromm Bros. received a check for $1.3 million in a single sale. The brothers, except Walter, were all under forty.

The fur company's headquarters was resolutely located in Hamburg. Walter traveled to New York City monthly to check on operations there; originally, all the sewing of the pelts into collars, cuffs, coats, and scarves was done on Seventh Avenue, the heart of the garment district. The company hired famous movie and stage actresses of the day to model their wares in national advertisements. None of the brothers had the slightest desire to leave Wisconsin, but they understood the necessity of a national advertising campaign.

HOW TO CARE FOR YOUR

FROMM PEDIGREED SILVER

FOX SCARF

C OMMON sense is the leading consideration in caring for your Fromm Pedigreed Silver Fox scarf. Treat your scarf with the respect that its great beauty and great value deserve. There are, however, a few specific points that you should observe in order to get the maximum service from your scarf.

Attached to every Fromm Bros. garment was a metal tag that could be removed and sent to the company; in return, the customer would receive a booklet outlining the particular fox's pedigree.

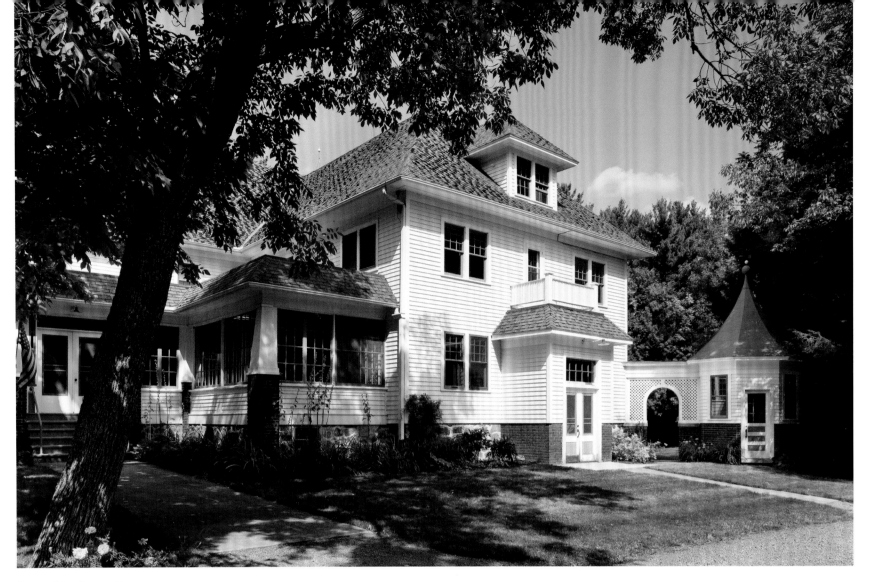

Some of the Fromm Bros. workers ate, bathed, and slept in the boarding house's dormitories. Cleanliness was strictly enforced: the male workers entered the basement bathroom from the side door before entering the dining hall.

Over time, the original 160-acre farm grew to holdings of 12,000 acres around Hamburg and 5,000 acres in the Mequon and Cedarburg area. Fortuitously, the land Alwina's family settled provided an environment that satisfied the needs and requirements for both ginseng production and fox breeding. Ginseng grows in association with sugar maples, basswood, and walnut trees, preferring north-facing slopes and shaded ravines. Cold temperatures over a period of several weeks are needed for dormancy as is well-drained, deep, loamy soil. Foxes require room to roam and access to fruits, berries, and rodents, and they prefer scrub woodland—which the cutover provided in abundance. Today 90 to 95 percent of all gingseng harvested in Wisconsin—which is most of the country's crop—is grown in Marathon County.

THE FROMMS WERE A FRUGAL, hardworking, close-knit family who spoke German at home. They built structures as needed, without great concern about making an architectural statement. Quality of construction, durability, and functionality were the primary criteria. As the business grew, the family farm buildings were adapted to the needs of the

fox farm and to the large number of employees needed for the labor-intensive ginseng and fox-raising operations. At the peak of production, the Fromms employed five hundred seasonal and full-time workers.

The first building visible from the road on the Fromm property is a prairie dairy barn built in 1922, identifiable by its commanding gambrel roof under which was a cavernous hayloft. The cheery yellow-and-white wood barn housed horses and cows—the horses hauled sleighs and wagons and the cows provided milk for the workers—and was in proximity to the boarding house. Sliding doors, fish-scale shingled dormers, and divided light windows embellished the simple aesthetic of the barn.

A gravel drive leads past the barn to the boarding house built in 1926 for the numerous workers. A fieldstone foundation provides the base for the frame structure painted the same palette as the barn. Entrance is through the comfortable screened-in porch to the open living room/dining hall. The interior is plain yet serviceable, easy to clean, and large enough to accommodate a crowd. The first floor is comprised of an institutional kitchen where meals were prepared and served in the clear-span dining room, a simple scroll cornice wrapping the room its only embellishment. One can easily conjure up the image of workers eating in short shifts and getting back to work without undue ceremony. Since many of the Fromm employees' children attended the nearby Maple Grove School, hot lunches were sent from the boarding house to students and teachers there.

The boarding house was added onto twice after the original construction: in 1929, the bathrooms, offices, and three bedrooms were added; the kitchen addition came later. The second floor had a large dormitory for the male borders and several small bedrooms for visitors. There were also two bunkhouses on the property to accommodate seasonal workers.

Cleanliness was obviously a priority for workers who were in close contact with valuable animals and herbs, for any threat of disease or blight could cause ruin that had a multiyear impact. In contrast to the homely living and dining space the boarding house's bathrooms are decorated with bold and playful tile work. Green, red, gray, and white snowflake patterns are created out of six-sided tiles, bordered by a continuous bent decorative line. The men's bathroom is a story and half in height and lit by daylight. Another unusual condition is that the men's room can be accessed three ways: from inside the boarding house, from off the enclosed porch, and from the outside. This tripart traffic pattern suggests that this facility was expected to experience heavy traffic. The women's bathroom, located on the second floor, included nine sinks. The same snowflake tile pattern is employed, in a slightly different color scheme. Many of the workers came from nearby farms and small townships; these may have been the nicest bathroom facilities they had ever seen outside of schools or churches.

THE YEAR 1928 WAS A NOTABLE ONE: each of the brothers earned $72,000, and each had a family house on the property, with the exception of John, who remained single. He lived in a suite of rooms in the main warehouse, where the fur auctions were later held. His artistry can still be seen in the hand-painted floral motifs on the columns, walls, and kitchen

The women's bathroom was on the boarding house's second floor. The tile work throughout all the bathrooms in the boarding house, the clubhouse, and Walter and Mabel Fromm's home is artfully crafted. The snowflake pattern appears in different color palettes.

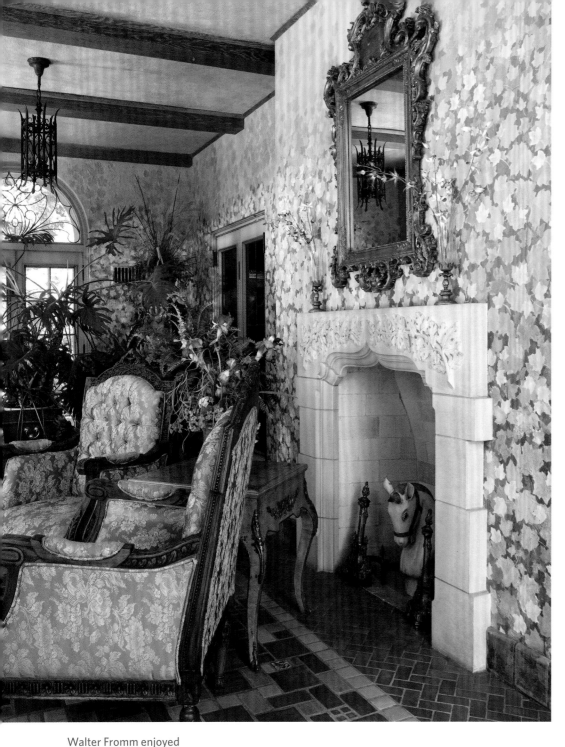

Walter Fromm enjoyed gardening and learning about plants. Most of the decorative painting and carving in his home represents plant material in a realistic style. Even the leading in the solarium windows is an abstracted flower motif.

cupboards of his rooms. Henry and his wife, Mamie, converted what had been the family's syrup shack into their home; he added a lap pool, rathskellar, and conservatory with tile work matching the expert craftsmanship found in the other buildings. Edward and his wife, Alice, took possession of the main family home; it had undergone several additions over the years while the boys were growing up.

The same year, Walter and his wife, Mabel, built one of the finest homes in the region—but not so fine as to be considered ostentatious. Their home was built just down the road from the farm property, on a separate 7-acre parcel.

They'd married in Wisconsin but honeymooned in Cuba and frequently vacationed in Florida in the winter months. They were intrigued by the Mediterranean Revival– and Hispanic-style architecture they encountered on those trips. In the 1920s the Mediterranean Revival style was all the rage. Its popularity was based partly on representing a lifestyle of the warm and exotic Mediterranean culture found in the architecture of California and Florida. The style was also popular in the movies of the day. The Fromm house incorporates many of the hallmarks of the Mediterranean Revival style: symmetry, a low-pitched hip roof clad in red clay tiles, arched doorways and windows, and wrought-iron details expressed in both the grillwork and balcony rails.

Curtis and Yale, a Wausau door, sash, and general house finishing company; German master Friedrich Estenfelder, a decorative painter living in Milwaukee; and local contractor Theodore Kohl are credited with the design of the home and the interior finishes. Those interior finishes are what make this house truly significant. Estenfelder, along with an assistant, spent nine months painting, gilding, and stenciling the beams, ceilings, trim molding, and walls throughout the house—including the walls of the utility rooms. And as in all the Fromm properties, the home's bathrooms are impressive, both for the pastel tile work and for the plumbing: the showers have multiple heads, for steam as well as hot and cold water.

Walter had taught school in rural Marathon County as a young man and never lost his love of learning new things. He was an avid reader—his library, just off the solarium, was where he spent his evenings—and many of his ideas for decoration came from travel essays and *National Geographic* magazine. Of particular decorative note are the solar-

ium and the lower-level recreation room. The solarium walls are painted with swirling yellow, bronze, and orange sugar maple leaves; the effect is so realistic that it is almost dizzying. The lower level is a spacious barrel-vaulted room with a massive stone fireplace at the far end. The walls are divided into framed panels with hollyhocks, insects, and clouds painted in glorious romantic detail.

Walter and Mabel were a private pair who worked long hours and enjoyed spending quiet time at home. They celebrated holidays with family in their home and invited nieces and nephews to stay with them for a week or so in the summer. Activities were centered on gardening, berry picking, and nature, not on grand parties or entertaining strangers.

Hollyhocks bloomed around the clubhouse in the summer and year-round in Walter and Mabel's basement recreation room.

Wisconsin's Own at the World's Fairs

The technical advances, immediacy of communication, and launch of innovation that we associate with the World Wide Web found their precedents in nineteenth-century World's Fairs.

World's Fairs provided a setting for the dissemination of new ideas, inventions, and styles. Manufacturers could introduce new products to interested markets while sharing and borrowing ideas. Municipalities and countries used the fair platform to further positive exchange and understanding while establishing credibility on a world stage. Visitors saw the new and exotic and brought these experiences and ideas home. All of this was realized in entertaining architectural settings laden with meaning and aspiration that, like cinema, called for a certain suspension of disbelief.

The World's Fairs of the nineteenth century were born of conflict and trade embargoes. Embargoes by the English prevented Napoleonic France from selling and transporting its goods. A European fair was inaugurated by the French in 1802 to entice visitors from across the continent to travel to Paris to see demonstrations of French ingenuity, science, and manufacturing prowess. Every eleven years the French would mount extensive trade fairs reinforced with displays of science and discovery that drew ever-larger crowds. As the scale of audience and offerings increased, certain characteristics of the contemporary World's Fair emerged. Scale and traffic dictated how the fairs would be designed and laid out.

In 1851, under the leadership of Prince Albert, the English made the fair a Victorian England undertaking. Prince Albert intended to lessen international hostilities by demonstrating the similarity of world interests and improving the quality of manufacturing through the comparison of work with others. Six million attended.

Landscape gardener Joseph Paxton's design for the 1,848-foot-long Crystal Palace, which was based on the structural system of the underside of a water lily, was spectacularly realized in three hundred thousand panes of 49-by-10-inch glass supported on prefabricated iron columns without scaffolding. This was considered one of the earliest examples of an industrialized building.

Prodded by publisher Horace Greeley, New York City built its own version of the Crystal Palace in 1853 in what is now Bryant Park. Gas lights shone from within the great glass-and-iron structure, delighting

Edward Fromm budgeted $40,000 for the company's "Bright with Silver" display at the 1933–34 Chicago Century of Progress Exposition. His brother Henry's design—which included an extravagant revolving stage featuring stuffed foxes in their "natural" habitat and garments made of fox pelts—exceeded this amount by $60,000 and garnered them an award for their booth.

the crowd, and illuminating the vast display of works by artisans from across the globe. This exhibition's displays and exhibits were expanded, at the urging of the fair's president, P. T. Barnum, to include amusements, and Elisha Otis dramatically demonstrated his invention of the steam-powered safety elevator.

In 1855 and 1867 the pendulum swung back to the French who saw these fairs as a way to establish their technical superiority. Ever-taller built heights and clear spans showed off the country's engineering and architectural prowess. Young engineer Gustave Eiffel oversaw the construction of the 1867 fair's elliptically shaped exhibit building. Aluminum, the distillation of petroleum, and the ice-cream soda were first introduced at this fair.

The 1876 Centennial Exposition at Fairmont Park in Philadelphia was the first to commemorate

an event: the centennial of the United States. Here Westinghouse displayed the air brake; Edison, the duplex telegraph; and Bell, the telephone. At the annex to the women's buildings, Frank Lloyd Wright's mother discovered Froebel blocks. Rosalind Blakesley, in *The Arts and Crafts Movement,* cites a Shaker exhibit as a formative influence on Gustav Stickley. Bartholdi's magic lantern was France's first installment of the Statue of Liberty, with a structural armature engineered by Eiffel. Each of the four founders of Kimberly, Clark and Co. attended this fair with their families, taking turns staffing their company's exhibit. Havilah Babcock saw interior ornaments and brocades that he would repeat in his Neenah home. Other state products were displayed in the Wisconsin Building designed by William Waters.

At the 1878 Paris World's Fair the phonograph,

typewriter, rubber tires, and the first electric light were introduced. The dominant icon of the 1889 Paris Exposition was Eiffel's tower, with a design that borrowed from the Sawyer observatory design proposed for the 1876 Philadelphia fair.

The 1893 World's Columbian Exposition in Chicago was realized in a "White City" on a site plan designed by Frederick Law Olmsted. This eclectic design of Venetian gothic with canals and romanticism captured the visitor's imagination, and introduced the public to the "City Beautiful." But Frank Lloyd Wright felt that, with the exception of Louis Sullivan's transportation building, this fair set modern architecture back fifty years. Technical innovations included the two-hundred-foot-tall wheel by George Washington Gale Ferris of Galesburg, Illinois, a roller coaster speeding on refrigerated rails, and a moving walkway. Dvorak introduced the "New World Symphony." Cream of Wheat, Aunt Jemima Syrup, Juicy Fruit gum, and Cracker Jack were all introduced here. Exhibits by J. I. Case of Racine, Kimberly, Clark and Co., and Edward P. Allis Company enjoyed a positive reception. Pabst exhibited a $100,000 gold-plated model of his brewery and won honors for brewing excellence. At the fair's end, Pabst moved his pavilion from the large Manufacturers and Liberal Arts Building to the grounds of his Milwaukee mansion.

The 1900 Paris International introduced the world to Art Nouveau, including Hector Guimard's metro stop design. The 1901 Buffalo Pan American Exposition was eclipsed by the assassination of President McKinley.

In 1904 St. Louis celebrated the Louisiana Purchase by hosting a World's Fair and welcoming nearly twenty million visitors, among them Frank Lloyd Wright. Warren Johnson demonstrated his floral clock. Iced tea and the ice-cream cone were introduced.

At the height of the Great Depression and without any tax assistance, 1933–34 Chicago hosted its Century of Progress. Thirty-nine million people attended. The theories of Howard Scott, an acolyte of Thorstein Veblen, helped establish the underpinnings of this streamline decade that would be realized by proponents of the new profession of industrial design: Norman Bel Geddes, Raymond Loewy, and Brooks Stevens. This was the fair of the zigzag; the Sky Ride; and the House of Tomorrow by Watertown-born Keck and Keck. Kohler Co., Kimberly-Clark Company, and Johnson Controls all had exhibits here—and the Fromm brothers won first place for their exhibit booth: a snowy scene to showcase their furs.

World's Fairs enlarged the visitor's view of the world and, by capturing the imagination of homeowners, architects, and landscape architects represented in *Wisconsin's Own*, influenced the design of many of the featured homes.

A niece recalls that the front door was never used; to this day there is not a paved walkway to the front door. Prior to the addition of a porch on the home's north side, everyone entered the house through the kitchen. It was a typical family home. Company entertaining took place at the log clubhouse on the farm property.

TOP: Snow covers the Fromm clubhouse during the winter of 1945. BOTTOM: Mabel and Walter Fromm (third and fourth from the left, respectively) raise their glasses outside the newly completed clubhouse in the 1930s.

AFTER THE ROUND of house building and remodeling was complete, the brothers continued to grow their business. The dream of owning one silver fox had morphed into a diversified worldwide operation involving agricultural and garment workers, union bosses, bankers, traders, scientists, nutritionists, and inventors. It is little wonder the brothers appreciated the quiet beauty of Marathon County. After winning the Best in Show award for their booth at the 1933–34 Chicago Century of Progress Exposition, they decided they could entice fur buyers to come to Wisconsin. In 1935 they built a rustic-style clubhouse. What better way to impress international fur buyers and those from big American cities than to entertain them in a log cabin?

The rustic style was an architectural design popular in resort settings on the East and West Coasts. Tourism was on the rise in Wisconsin, and the rugged "Up North" experience appealed to visitors looking for something authentic. Snowstorms and minus-thirty-degree weather is about as authentic of a Wisconsin experience as one can get—and that is exactly what the fur buyers got when they came to Hamburg in February 1936 for a fur auction. The buyers stayed in the Hotel Wausau and were ferried by bus between Wausau and the Fromm farm. Kosher food and additional waitstaff was brought in from Milwaukee. Resortlike accommodations and catered food helped create the idealized North Woods attraction amid expected comforts.

From 1936 through 1940 auctions were held three times a year in Hamburg; auctions took place in the warehouse, with the exception of the spring 1936 auction, which was held

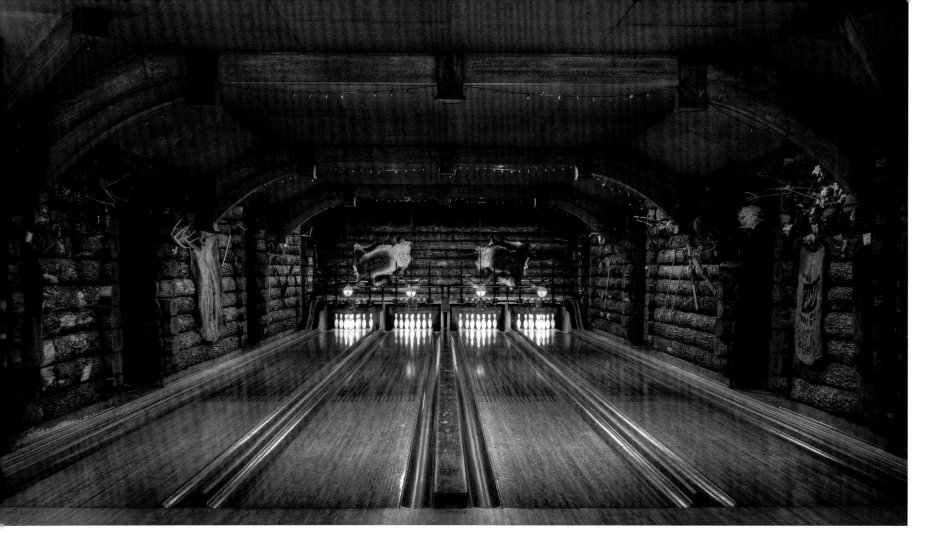

ABOVE AND OPPOSITE: Hamburg is an isolated community, so the Fromms needed to create their own entertainment. Employees, as well as fur buyers from the East Coast, enjoyed socializing and bowling at the rustic clubhouse. BELOW: All their lives, the frugal Fromm brothers expanded only with money in hand. Their company's symmetrical log clubhouse was built in two stages: first the office wing and then, when funds permitted, the recreation hall.

in the boarding house. In 1946 Edward led a mink auction at New York City's Waldorf-Astoria Hotel. That year the company opened a factory in Merrill, which was a real economic boon to the midsized town. Furs were shipped directly from Merrill to seventy-five select stores nationwide.

The clubhouse was the one building built to impress outsiders, and its authentic log cabin construction, down to its round saddle notches at the interior and exterior wall intersections, did. The single-story structure was set in a field, away from the other buildings. Today, tall white spruce and deciduous trees provide a sylvan backdrop, with birds calling back and forth in the trees. In the summer, hollyhocks, like the painted ones on the walls of Walter and Mabel's recreation room, frame the doorways.

Dozens of buildings still on the property tell, in detail, the workings of a fur farm, from feed to slaughter. The other working buildings on the farm were built with the idea that function came first; form was secondary. The clubhouse, with its four-lane bowling alley, was built for fun and fellowship. In fact it was not just for use when visiting buyers were in town; employees formed bowling leagues, and office celebrations were held there. Bowling was a popular sport, especially after the repeal of Prohibition in 1933, which cut across many social lines.

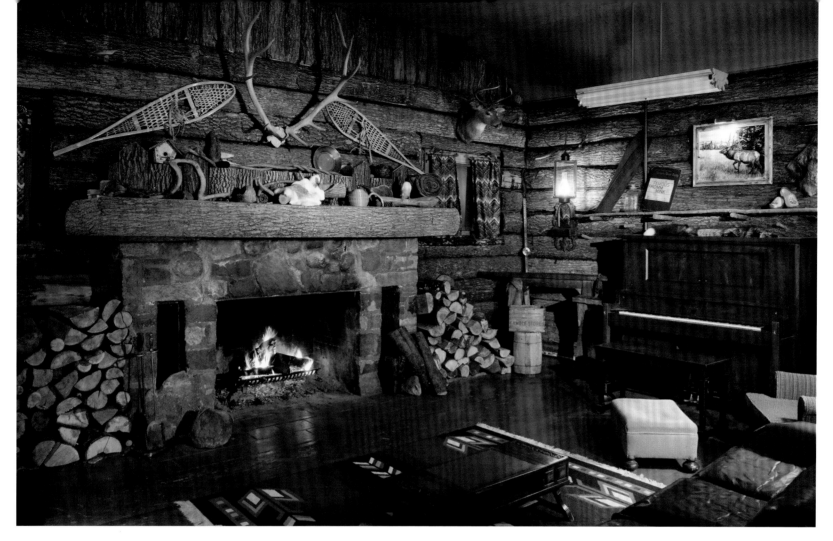

Arched beams span the four shining wood lanes—the white pins were and still are hand set. Bark-backed bleachers provide seating for the scorekeepers and those waiting to have a turn at the lanes. There's an alcove with seating around a rock-faced fireplace sporting a massive log incorporated as a mantle. Large lanterns cast a honeyed glow. And even though the four brothers were teetotalers and nonsmokers, they were accommodating hosts: a well-stocked bar outfitted with barrel tables and chairs was positioned between the bowling alley and the office. Large men's and women's restrooms are nicely tiled, if less ornate than the boarding house bathrooms. The office was really more like a salon. Pelts of silver foxes are draped here and there.

THE FROMM BROTHERS' LEGACY is much more than a collection of rustic and romantic rural buildings in an isolated setting. John and Henry only had eighth-grade educations, but they were students of the natural world. John was an expert in matching breeding animals for specific colors, and Henry was interested in animal nutrition. Edward, the only one with a four-year degree, had taught various grades in Marathon County in the early years to earn money to buy ginseng and save up for foxes, as did Walter. Edward traveled the world, serving as the face of the Fromms' fur company, but his community meant a lot

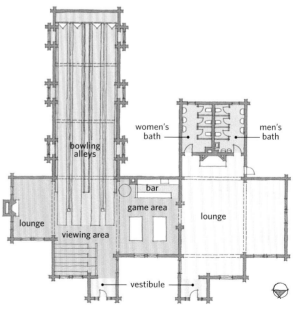

The clubhouse's floor plan

to him. He took volunteer positions with many civic organizations, the state and Marathon County historical societies, and the Wausau Free Public Library. He was president of the Merrill Public Schools and was involved in environmental concerns.

While some may think it ironic, animal welfare was one of the company's greatest legacies. The brothers never took very large salaries, instead plowing most of their money back into the company. Three dollars from every pelt was designated for research expenses, including the company's scientific research on animal nutrition and diseases. Dr. Robert Green, a scientist from the University of Minnesota, worked on-site (the fox farm, due to the number of animals, was a lab in itself), and the Fromms built a lab in Grafton, Wisconsin. During his thirty years with the Fromms, Green developed a distemper vaccine, which, while no longer given to dogs, is still used today to vaccinate ferrets and pandas. Animal nutrition (first for fox and mink; they later developed a specialty dog food) was another area the brothers explored.

Ginseng remained important to the Fromms, especially to Walter and Edward, who are credited with being the motivating force behind the invention of the ginseng root washing machine and a root digger. Ginseng harvesting is labor intensive and these inventions greatly reduced the number of hours involved. The four brothers had learned early on that diversification was a good business model.

But by the end of World War II the silver fox fascination was waning. The exuberant full-length fox coat was considered old-fashioned; mink was sleeker and appealed to younger women. Henry always had some mink as a hobby, so when the fashion-forward wanted mink, he was ready. He had been experimenting with color mutation in silver foxes and he translated his know-how to mink. The company went on to become the largest mink farm in the world and continued to sell pelts to clothing manufacturers until the Fromms' last mink was sold in the 1960s; fashion and the times had changed from the company's early days. The brothers passed the businesses—ginseng, mink breeding, and dog food manufacturing—down to the next generation.

Upon retirement, Walter and Mabel Fromm moved to Florida, where they built a modest one-story, one-bedroom house on the shores of Lake Wales. Walter continued to garden, learning about tropical plants and enjoying the longer growing season. The successive owners of their Hamburg residence have respected their home's artistry and craftsmanship. Even the kitchen is in its original 1928 condition. Remarkably, the painted surfaces and tiled walls and floors remain vibrant today.

While the Fromm properties in Hamburg have all passed on to other owners—a family is in Mabel and Walter's home, and the clubhouse and boarding house at the fur farm site are now part of a corporate retreat center—the Fromms remain an important chapter in the history of Marathon County, as citizens, employers, and friends. Their shadow is cast so long that the current owners are faithfully restoring the buildings the Fromms lived and worked in to be able to tell the remarkable story of the Fromm family through the buildings they left behind. •

Opposite: The current owner recently implemented a new landscape design. Most of the home's interior is in the original condition, as the Fromms built and decorated it, including the original wall murals and decorative ceiling painting.

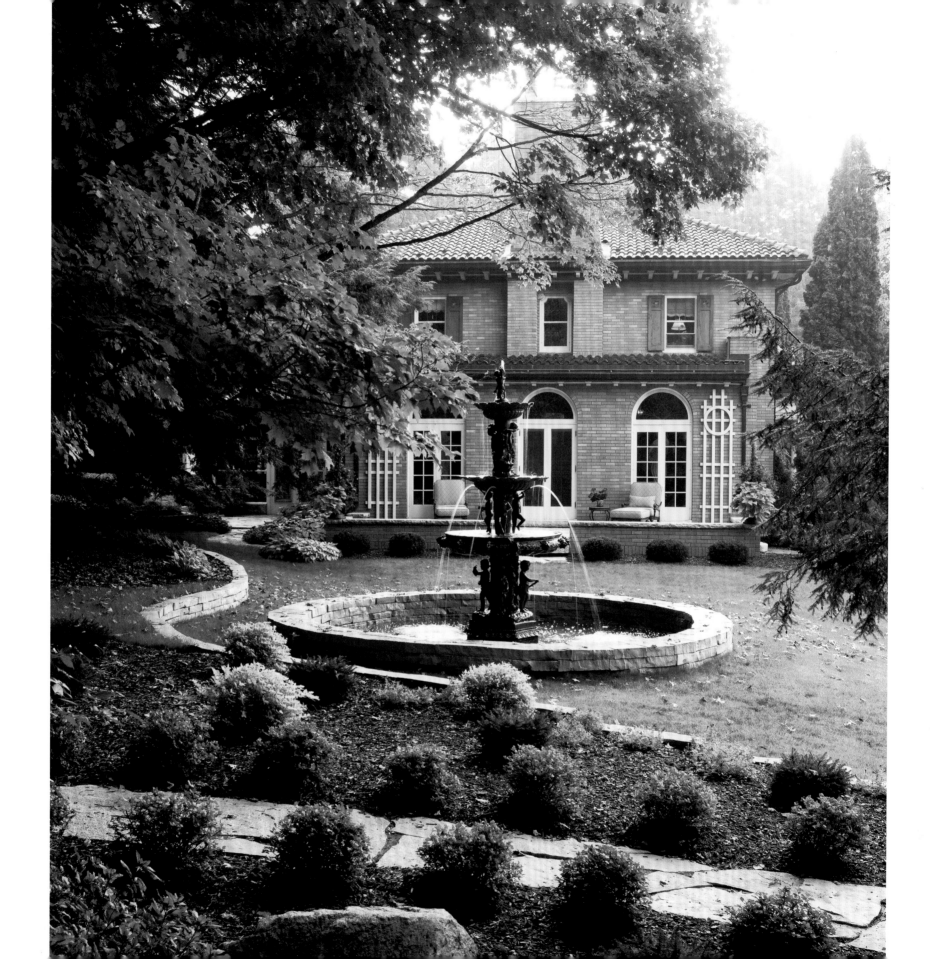

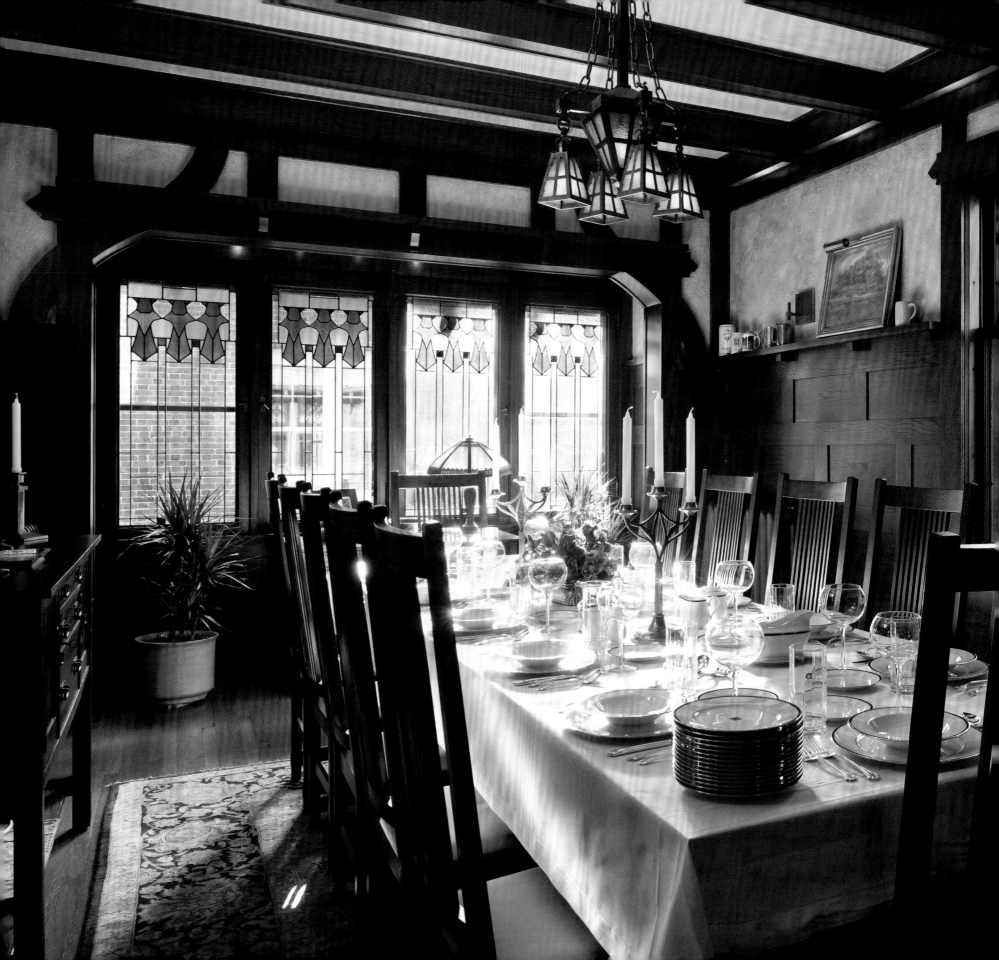

SETTING THE STAGE

TOURING A HISTORIC HOME is much like attending a play or watching a film. The aspirations and actions of a play are silhouetted against a creative stage set known as architecture.

English Romantic poet Samuel Taylor Coleridge coined the phrase "willing suspension of disbelief" in his *Biographia Literaria* in 1817. Since then, authors, playwrights, script writers, and architects have all latched onto the phrase as a way to explain the willingness of their audience or clients to overlook the limitations of the medium in exchange for entertainment.

The styles of the houses in this section—the House of Seven Gables in Baraboo, the Allyn Mansion in Delavan, the Adam J. Mayer house in Milwaukee, and the Brooks Stevens home in Fox Point—run the gamut from Gothic Revival to Art Moderne. The original owners were a banker, a farmer, a shoe manufacturer, and an industrial designer. Each created a home that defined his inner life—dwellings that, for three of them, were more romantic, expressive, and tactile than their stalwart professions. Stevens had the luxury of incorporating craft and art into both his work and home lives.

Before World War I, clients typically deferred to their architect as the expert for accepted styles for certain classes. Their style preferences were influenced by the literature they read and what they had seen on their travels, and they brought these ideas to their architects. After World War I, both clients and architects became more blatant about deliberately designing homes as a backdrop for the role the homeowner wished to play in front of his or her guests, friends, family, and neighbors.

If the setting is convincing—even if oak is faux-painted to resemble pine or if flat walls are transformed with paint into seemingly three dimensions—the audience is delighted and eager to become part of the unfolding narrative. The more convincing the setting, the more the audience participates in the "willing suspension of disbelief" that makes historic homes so rewarding, refreshing, and invigorating.

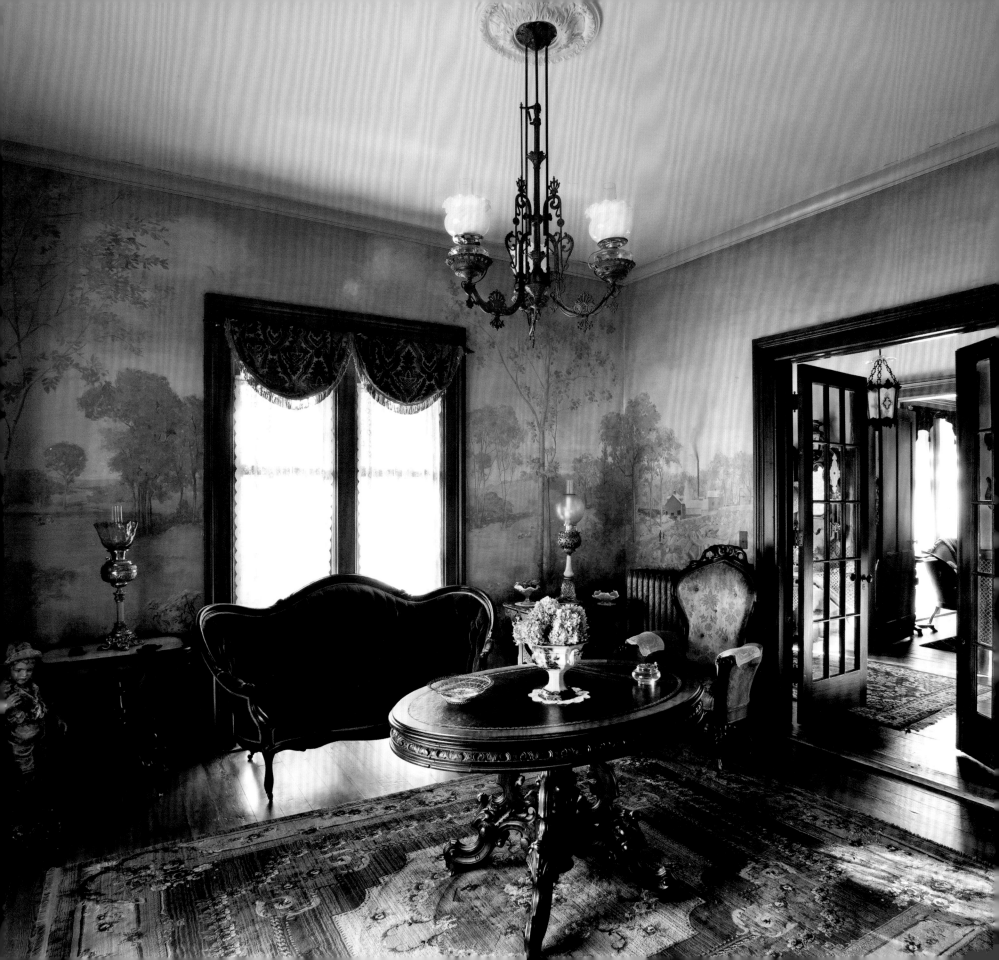

House of Seven Gables

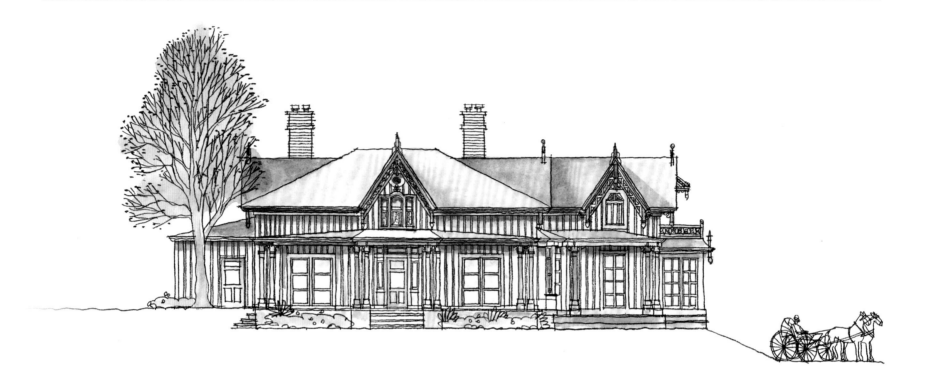

OPPOSITE: Baraboo's House of Seven Gables may look like a museum but it has been the Krainiks' family home for more than forty years.

THE SCRIPT UNFOLDS, telling the story of two newlyweds—a newly minted lawyer and his nursing student bride—who settle in a Wisconsin river town and stumble upon their dream house, a Gothic Revival cottage. The first act plays like a light romantic comedy. When the second act reveals a leaky roof on a sunny summer day, backup sewage in the basement, bad wiring, and haywire plumbing, the audience wonders if it's in for an evening of drama filled with plot twists.

The current production at Baraboo's House of Seven Gables has had a successful run for more than forty years under the direction of Pam and Ralph Krainik. The plot and action have been revised over the seasons to fit a changing cast, from young couple to young family, to bed-and-breakfast hosts, to empty nest, to in-laws living in, and back to empty nest.

An experienced playwright would advise a neophyte to avoid exposition because what happened to the characters before the curtain rises has little bearing on the plot. But when the protagonist is 150 years old, the back story shapes the unfolding of the action. The house is known as the House of Seven Gables for the obvious reason: the Gothic Revival cottage has seven steeply pitched gable ends that animate the roof of the wood board-and-batten-sided house. When the cottage was built in 1860, it was known as the Terrell Thomas House, after its owner.

Pattern Plan Books

More than two thousand years ago, Vitruvius wrote the first architectural "pattern" book, *Ten Books of Architecture.* Early nineteenth-century American books by Minard Lafever and Asher Benjamin further established the pattern book by presenting cogent principles with clear technical illustrations of the various architectural parts upon which classical architecture was derived. Skilled craftsmen referring to these patterns could create popular classical examples.

The architectural advice books of Alexander Jackson Davis and Andrew Jackson Downing extended the reach of the pattern book to landscape and lifestyle, not just for craftsmen but for the everyday American as well. Davis produced an early multicolored illustrated pattern book that showed examples of the home's plan and perspective. Nineteenth-century pattern books were far more popular and influential in the United States than anywhere else or at any other time for a uniquely American reason: the art and craft of building had been a personal pursuit of the familiar, handed down from neighbor craftsman or from father to son. As the United States and its opportunities expanded to the west, second sons struck out into unfamiliar terrain with few skilled craftsmen or relatives to rely on.

Pioneers could build their own homes with the assistance of these do-it-yourself books. Downing's tragically short life made way for other plan books by Vaux, Sloan, and Wheeler. Architects since the nineteenth century have produced portfolio pattern books as a way of extending their architectural practice and of advertising inexpensive package plans available through the mail or even via the Sears catalog.

Gothic Revival houses are admired for their romantic full-width porches with whimsical scroll-saw embellishment.

OHIO NATIVE TERRELL THOMAS had had a variety of work experiences before settling down, from working in the dry goods business in Ohio and Maryland to packing pork for his father in Ohio. In 1854 he moved to Madison to serve as a bank cashier. Thomas arrived in Baraboo in 1857 at age thirty-one to take a job as a cashier at the Sauk County Bank. That year, he married Sarah Williams, whom he met in Ohio. Sarah's brother, Charles Henry Williams, had moved to Wisconsin to manage the extensive Milwaukee real estate holdings that he had inherited from his father. Enthusiastic about the area's natural beauty and the business opportunities of the growing town of Baraboo, Charles had encouraged his sister and his brother-in-law to join him in Sauk County.

Thomas was named bank president in 1864 and three years later was responsible for hiring E. Townsend Mix to design a new building for the bank. He was also involved in real estate, a lumber mill, and hops and cranberry growing. Years later Thomas sold his interest in the bank and invested in water power, manufacturing, and railroads. His lasting contribution to Baraboo is the house he built in 1860 on heavily wooded land on Sixth Street, within walking distance of the town square.

Charles Henry Williams shared an interest in the future location of the La Crosse and Milwaukee Railroad with Col. Stephen Van Renssalaer Ableman. Thomas purchased six lots in town and contracted with Ableman—who supplied carpentry and joinery for various buildings, including several in Milwaukee—to build his new home. Either Ableman or Thomas, or both, were likely to have owned a copy of Andrew Jackson Downing's *Cottage Residences,* published in 1842, or *The Architecture of Country Houses,* published in 1850. Thomas's home is strikingly similar to cottage designs illustrated in these books, in particular Alexander Jackson Davis's Design II, "A Cottage in the English or Rural Gothic Style," in *Cottage Residences.*

Downing, known widely as a tastemaker, published his first book, *A Treatise on the Theory and Practice of Landscape Gardening, As Adapted to North America,* in 1841 at age twenty-six. Downing collaborated with New York architect Alexander Jackson Davis on a series of pattern books that illustrated residential designs in various styles: English Country, Gothic, French, Italian, and Elizabethan. Perspec-

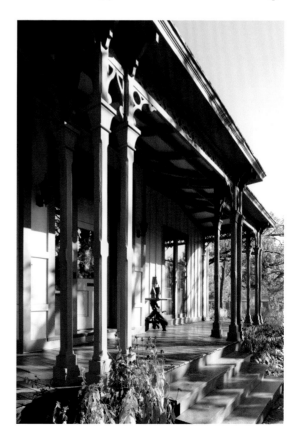

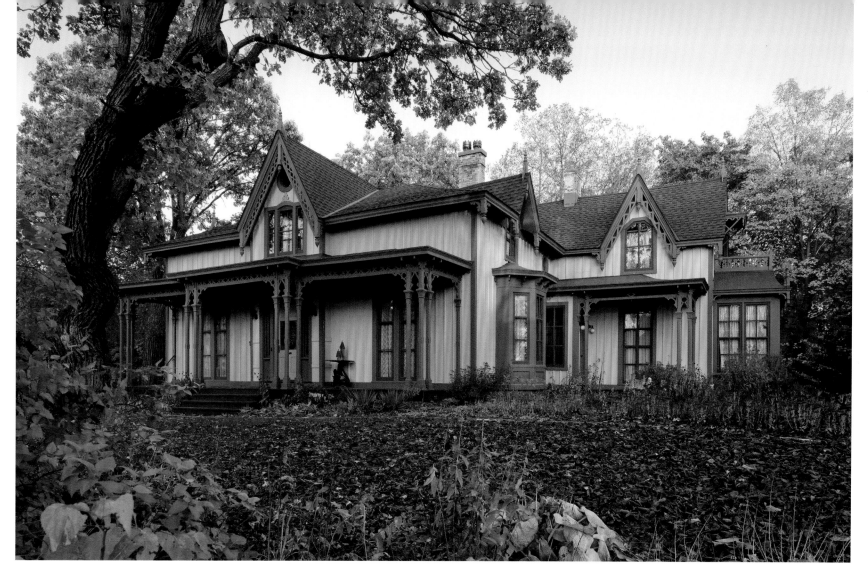

An unusual feature of this Gothic Revival cottage is that it does not employ pointed-arch Gothic Revival windows. The Palladian window topped by an oculus in the center bedroom is atypical.

tives, rendered by Davis, gave the reader an image of how the completed home would appear in a landscaped setting. The perspectives were paired with a floor plan that showed the design's organization and the room sizes. An accompanying description explained why these homes were tasteful and warned prospective builders against possible blunders in design that were to be avoided.

Downing and Davis even went so far as to provide an estimate of final costs. Detail drawings of window sections, water closets, porch brackets, finials, and chimney pots point out appropriate scale and materials. Downing offered advice on interior finishes, wallpaper, paint color, wood trim, and furniture as well as heating, ventilating, and sanitation systems. Downing, a horticulturist by training, included illustrated suggestions for garden arrangements and specific plant lists. As he wrote in the preface to *Cottage Residences:* "The relation between a country house and its 'surroundings' has led me to consider, under the term residences, both architectural and the gardening designs." The books were wildly popular with a middle-class audience looking for guidance on how to build a home that reflected culture and refinement at a reasonable cost.

ABOVE: Judge Bohn constructing the retaining wall. Area residents would let him know when they found deposits of local red stone. BELOW: Clara Bohn reads to her daughters, Carol and Joanne, on the Seven Gables lawn, circa 1931. The Bohn family gave the house its literary name.

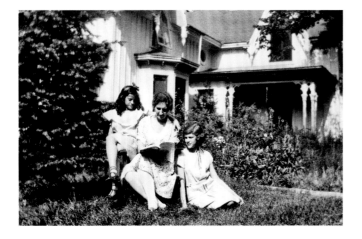

IN THE COURSE OF THEIR RESEARCH into the house history, current owners Pam and Ralph Krainik compiled a list of the people, owners, and tenants who lived in the Gothic Revival cottage since 1860. The list includes more than fifty names. Terrell and Sarah Thomas lived in the house with their daughter from 1860 until Terrell's death in 1888. At this time, Sarah sold a portion of the six lots, and from 1891 to 1901 she took in boarders. She moved to California in 1901 and sold the home in 1911 to John T. Durward, a retired priest who lived in the home for seven years. Judge Henry J. Bohn and his wife, Clara, bought the home in 1921. The Bohns converted part of the house into an apartment that they rented to tenants. The Bohns were a well-respected Baraboo family, and the home is still referred to as Judge Bohn's House by some longtime residents. He had been reluctant to buy the house due to its neglected state. However, he grew to love the house and enthusiastically preserved it from further decline.

But time and wear and tear had taken its toll on the residence. Judge Bohn sold the house in 1962 to a couple who quickly put it back on the market without making improvements. When the Krainiks bought the house in 1966, Clara Bohn's prize flower gardens were overgrown with volunteer trees, bushes, and vines. The empty house had been vandalized, its striped metal awnings sagged, and the altered interiors bore little resemblance to Downing's exhortation for "Fitness and Truthfulness": plywood covered the bookshelves that had been built in the hall for Bohn's law books; floor tile had been glued over the second floor's pine flooring; three layers of linoleum covered other floors; ceilings had been lowered; and a bathroom had been sandwiched into the main hall on the first floor. Only one original light fixture, which hangs in the front hall today, remained.

During the early years when the Krainiks were busy with practicing law and nursing and raising two small children, their restoration efforts were focused on maintenance and stopping further deterioration from structural failure and weathering. Over the years they became quite accomplished at carpentry, painting, plastering, and reading faint clues about the original house. Ralph has become an expert at faux-finish painting, a technique popular in the mid-1800s. His ability to mimic pine, oak, and walnut wood grains is on display throughout the home.

As the Krainiks stabilized the house, they continued to learn more about its history, its past tenants, and the Gothic Revival style. Downing's description of exterior hallmarks of the Gothic style as illustrated in Design II, "A Cottage in the English or Rural Gothic Style" sounded familiar: tall gables ornamented by handsome verge boards and finials, neat or fanciful chimney tops, steep shingled roofs, balconies, verandas, and a window in the front gable. While Downing's stated preference for veneer was for brick and cement colored to imitate stone, the Krainiks' Baraboo cottage is stick construction sheathed in board-and-batten siding. The siding on the house today is original. In the 1860s straight, true, and clear, or knot free, lumber was plentiful in Wisconsin.

For the interior plan of a Gothic-style cottage's first floor, Downing proposed an entry centered in the middle of the long veranda. He suggested that on one side of the center hall a parlor and a bedroom be placed; on the other the library and a room called a hall, which

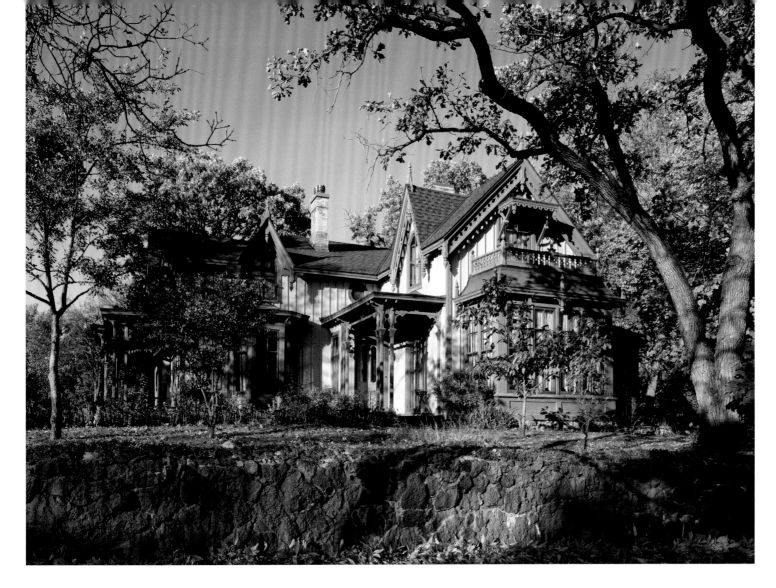

LEFT: Baraboo's House of Seven Gables was constructed on a rise above street level. The front door faced away from the street, providing scenic views and privacy for the family. BELOW: Thanks to the Krainiks' careful restoration, the home's exterior looks much as it did in 1929 when friends of the Bohn family posed for this snapshot.

he stated should be large enough to serve as a dining room. The kitchen would be located at the end of the center hall. These descriptions are very similar to the plan of Baraboo's House of Seven Gables. Downing also prescribed bay windows and large windows; rooms with little windows were deemed "common." His proposal for the second floor included four bedrooms of varying sizes.

The Baraboo cottage incorporates a significant number of Downing's prescribed Victorian Gothic hallmarks. At present, the home has seventeen rooms. The first floor has a center hall, a bedroom, a sitting room, and a dining room—all of which were part of the home's original design. Known structural changes and early additions to the home include: an office, a sunporch, an enclosed porch, a utility room, a second-floor bedroom, a half bath, and a full bathroom. The second floor is a warren of winding hallways and bedrooms with charming angled ceilings expressing the individual character of each of the seven gables. The home has a full basement with a stone foundation. A retaining wall of local red quartzite built by Judge Bohn serves as a picturesque base that sets the house apart from the street level. The front entry faces west, away from the street.

EVERY SUCCESSFUL PLAY counts on its audience to suspend disbelief. Some of the alterations made during the Judge Bohn era were deliberately retained by the Krainiks, even though they are not true or do not fit with the Gothic Revival style. Judge Bohn used the sitting room, which is separated from the main hall by a pair of three-over-five divided light French doors, as his law office. The room receives western light through two tall windows that open onto the main porch for ventilation, and a triple bay window facing south. The late afternoon light washes over the cool green-and-blue-toned floor-to-ceiling

Style: Gothic Revival

Few residences enjoy as close a match to the accepted definitions of their style as Baraboo's House of Seven Gables does.

Alexander Jackson Davis executed the first documented and "fully developed" residential example of the Gothic Revival style in the United States in 1832. Davis and later Andrew Jackson Downing championed this style as ideally suited for the rural setting due to the picturesque character of its irregular outline created by tall ornamented gables ❶, upright chimneys, steep roofs, and decorated verge boards ❷.

Gothic architecture originated in the Isle de France in the twelfth century and flourished throughout Europe and Britain into the sixteenth century. It was an architecture of innovation and technical achievement aspiring to reach greater heights on ever-slender supports. This medieval quest to reach heaven was realized in *la voûte sur croisée d'ogives*, a slim framework of vaults of intersecting pointed arched stone ribs, which in turn supported thin stone wall panels punctured by willowy pointed Gothic arch openings. The

reduction in material thickness to achieve great vertical spans required flying buttresses, or ribs of half-Gothic arches, to transfer the load to the ground. Massive bearing walls were replaced by these ornate thin structures that in many ways anticipated today's "curtain walls."

Gothic Revival translated the Gothic style into a Victorian sensibility. Gothic Revival hallmarks include a steeply pitched roof with an intersecting central gable and flanking smaller dormers of similar design. Gable ends are trimmed with jigsaw-scrolled verge boards punctuated with distinctive finials and drip or drop pendants that are vertical, often tear-shaped elements that project below the verge board and help "shed a tear" (and water). Windows extend beyond the low knee walls into the dormers and gable ends. Most Gothic Revivals, including the House of Seven Gables, have a full-width, lean-to porch ❸. Also typical is the board-and-batten siding ❹ that creates a strong graphic of vertical shaded accents.

While an excellent example of the Gothic Revival, the House of Seven Gables does differ from the style in that it has neither true Gothic windows nor Gothic arches. Instead, the home has a Palladian-inspired window at the entry ❺ and distinctive, "Gothicized" angled top windows at the smaller dormers.

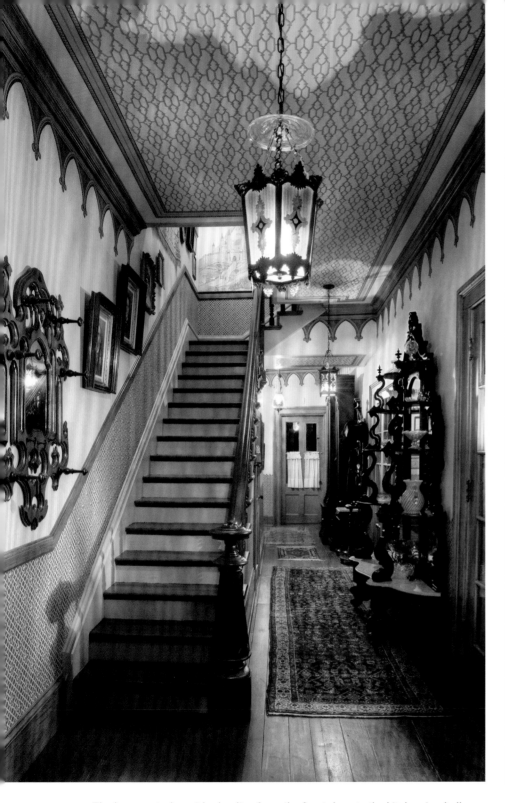

The long central corridor leading from the front door to the kitchen is a hallmark of the Gothic Revival style. During Judge Bohn's ownership, the hallway was lined with his law books.

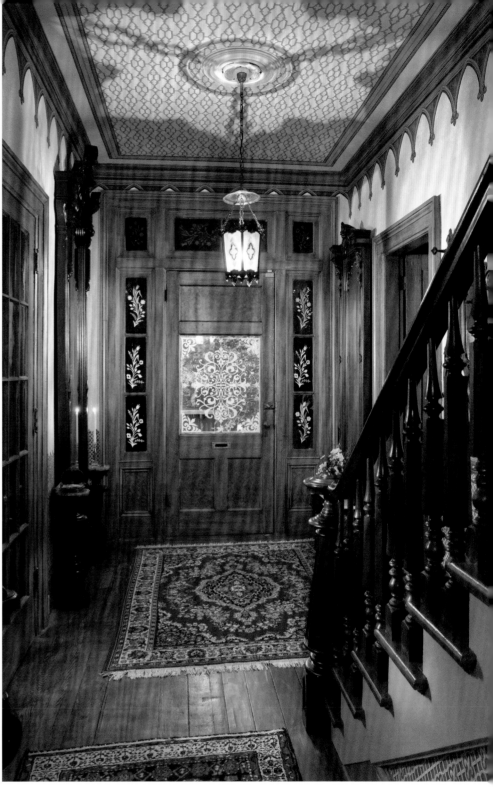

Only a couple of the original cranberry front-door glass sidelights had to be replaced during the Krainiks' restoration of the home. The stair has been rebuilt and reconfigured, but the floorboards are original.

The sitting room's murals depicting Judge Bohn's childhood memories of his father's sawmill were painted in the 1930s by a local artist.

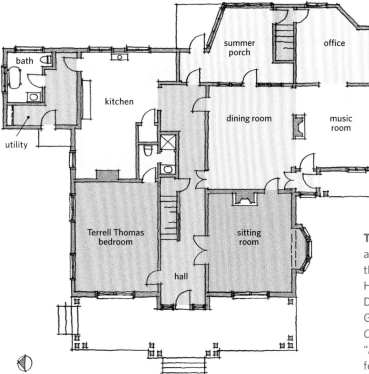

murals that Bohn commissioned local artist Mrs. R. S. Ferris to paint in 1932. The oil murals realistically, but dreamily, depict scenes from Bohn's childhood: landscape images of the lumber mill that his father owned at Lime Ridge and the countryside that surrounded his childhood home.

When the Krainiks moved in, the murals were obscured by multiple layers of cracked and yellowed shellac. After a number of careful experiments they hit on a gentle application of denatured alcohol as a method to remove the shellac without damaging the paint beneath. Ralph and Pam spent many long nights carefully removing the shellac inch by inch, slowly revealing the murals; the dollar value of their labor is incalculable.

In 1976 a violent windstorm caused many of the old oaks to come crashing down. As the Krainiks contemplated the loss of the trees and the cost of repairs, they came to realize that they were seriously committed to restoring the house to the spirit of its original 1860 time period rather than just maintaining an old house. They decided it was time to set about identifying the changes made over time that detracted from the home's Gothic Revival style. After an antiques-gathering trip to Natchez, Mississippi, in 1980, the couple began to plot out a long-term plan—almost as though they were designing a stage set for a production set in the 1860–80 period.

The Krainiks use the adjectives *haunting* and *spooky* to describe their first impression of the house, not because of ghost stories but because the landscape of oaks and shrubbery was so neglected and overgrown. Tree branches scratching (and falling in on) the roof and exterior for years had taken their toll. In 1980 the couple started a five-year odyssey to repair and rebuild the exterior. They repaired the edges of the old metal porch roofs, missing gingerbread trim, and rotted or missing roof finials. To get down to the bare wood to make the repairs to the boards, the soffits, the sills, and the divided lights, Ralph first had to remove 120 years of built-up paint without further damaging the original wood. Once the repairs were made, the difficult decision of choosing an appropriate color scheme began in earnest.

The fingerprints of Alexander Jackson Davis and Andrew Jackson Downing are all over this plan. Strong similarities to Baraboo's House of Seven Gables layout can be found in Design II, "A Cottage in the English or Rural Gothic Style" featured in Downing's popular *Cottage Residences* (1842), and Design XXIV, "A Cottage Villa in the Rural Gothic Style," featured in his influential *The Architecture of Country Houses* (1850). The current owners of the House of Seven Gables have noted an even closer connection between their home's plan and that of the Nichols McKim cottage that Davis designed in Llewellyn Park, New Jersey, in 1859.

In the House of Seven Gables plan, a porch fronting the entry facade leads to a center hall that symmetrically divides the plan into four principal quadrants, including a first-floor bedroom and a kitchen at the end of the hall. In Baraboo, the original plan and its functions largely remain and have been sensitively embraced by additions and structural changes throughout the years.

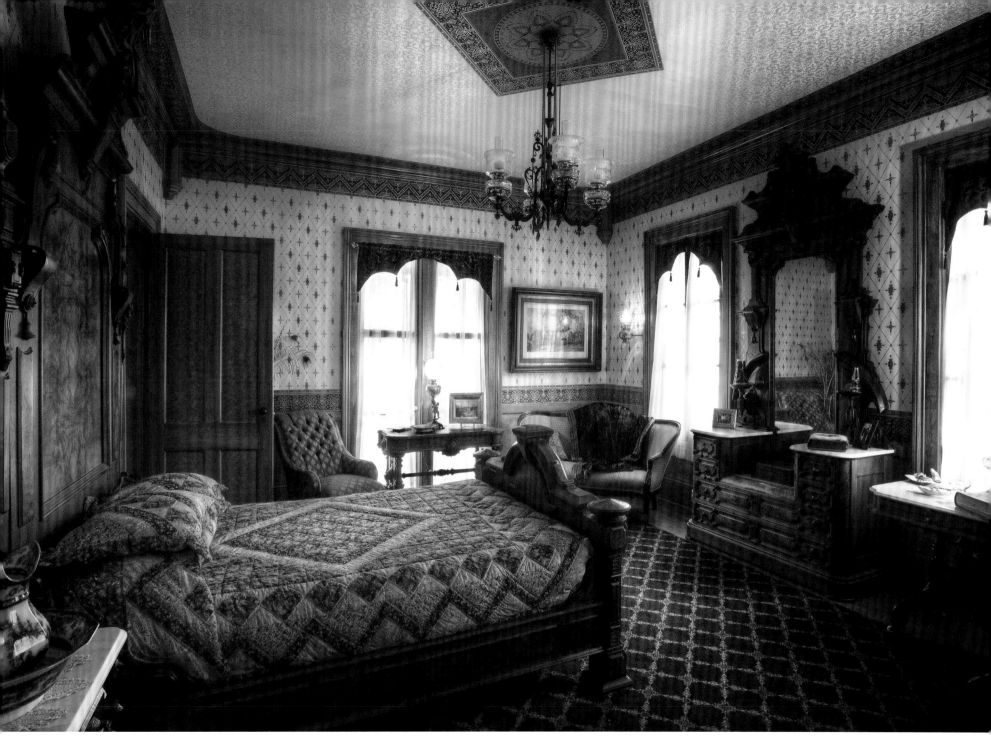

Ralph and Pamela Krainik became experts at hanging wallpaper throughout the process of restoring their Gothic Revival–cottage to the style of the 1860s to 1880s.

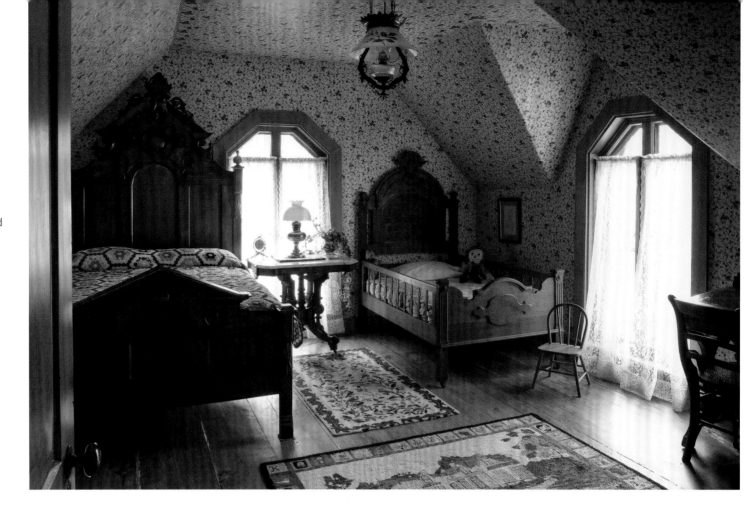

The second-floor bedroom windows are uniquely shaped to fit under the highpoint of the roof's peak. The southern windows are actually French doors that lead to a balcony over the sunroom.

Pam Krainik hooked this rug of her home—when she was not applying fresh paint or scraping old paint or stripping old wallpaper or floorboards.

The Bohns had painted the cottage white with black trim, roofed it with red asphalt shingles, and the next owners applied red-and-white-striped metal awnings over many of the windows—not a color scheme Downing would have favored. In *Cottage Residences,* he proclaimed: "There is one color, however, frequently employed by house painters, which we feel bound to protest against most heartily, as entirely unsuitable and in bad taste. This is *white*.... The glaring nature of this color, when seen in contrast with the soft green of foliage, renders it extremely unpleasant to an eye attuned to harmony of coloring." Downing recommended six colors as highly suitable for cottages: three were shades of gray and three were shades of drab or fawn color, which are light yellowish-brown colors. The Krainiks visited the 1846 Roseland-Bowen Gothic Revival Cottage in Connecticut, which is described as an excellent example of the writings and principles of Andrew Jackson Downing. It was painted in a salmon pink with chocolate brown trim—close to the Krainiks' first consideration for a palette.

Ralph backed away from the salmon, however, and began painting their cottage a cream color. Upon finishing an entire side of the house, he reconsidered his original impulse for a deeper hue. He worked with a local paint store to mix various colors and came up with a color he named Krainik Peach.

In 2006, when color analysis became more affordable and available to the general public, the Krainiks had the Conrad Schmitt Studios of Milwaukee, an internationally rec-

ognized decorative arts studio, execute a color analysis for their home. The couple had discovered that a previous owner had used original siding as a subfloor in the parlor; original paint fragments still clung to the boards. The studio's analysis determined that the exterior's original colors were brown, yellow, and cream. Today the home is painted in Renwick Beige, Rookwood Brown, and Rookwood Dark Brown with Renwick Rose Beige and Downing Straw as accent colors.

ONCE THE EXTERIOR WAS STABILIZED, the K
rainiks turned their efforts to the interior. During the 1990s the couple tackled the main hallway. The hallway is critical to setting the stage, for it is the organizing element of the first-floor plan. Standing in the hall today, the clarity of the Downing plan unfolds before your eyes. But what the Krainiks saw in the 1990s was a low false ceiling, a Colonial-style balustrade adorning an ill-conceived stair renovation, and

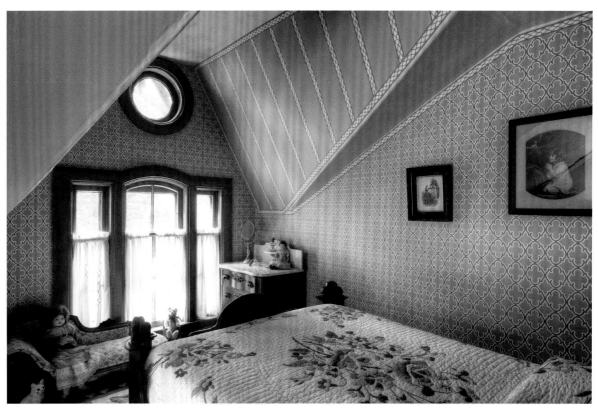

The interiors are as picturesque as the exteriors.

Federal and State Rehabilitation Tax Credits for Historic Preservation

In 1966, the year the Krainiks bought their home, the National Historic Preservation Act was passed. This act established a national framework for historic preservation by creating the National Register of Historic Places, providing expertise through new State Historic Preservation Offices and creating federal preservation standards. The act ensured that participation by owners would be voluntary and would not interfere with private ownership rights.

The Tax Reform Act of 1976 has proven to be one of the most beneficial and successful means of encouraging the rehabilitation and restoration of residential and commercial buildings and landscapes. This law provides tax credit incentives that have been of benefit to those who have restored and improved the face of our architectural and cultural landscape.

In Wisconsin this program provides a 20 percent federal plus 5 percent state income tax credit for income-producing commercial projects. Because federal tax laws do not cover non-income-producing residential properties such as homes, states like Wisconsin have a statute that covers residential property. Wisconsin administers a program that allows a 25 percent tax credit applied to state income tax only. Though independent of the federal program, the state statute requires compliance to the secretary of the interior's guidelines, with submissions made directly to the state.

The process begins with writing a Part 1 report that establishes the historic significance of the building, site, or amenity. This significance can be established if the building is architecturally important, is associated with a noteworthy historic event that took place on the site, or is connected with a notable person. Historic districts usually represent a collection of buildings or places that collectively share one of the above criteria.

Part 2 describes the existing architectural conditions and anticipated method of work necessary to rehabilitate or restore in compliance with the guidelines for this work as established by the secretary of the interior.

Part 3 documents that the work described in Part 2 was completed according to the methods and procedures outlined therein.

Much of the effort and documentation involved in ushering a project through this three-stage process can be applied to the process for having the property listed on the National Register of Historic Places.

battered and worn pine floors. By this time the Krainiks were ace wallpaper hangers; they expanded their technique and prowess with each hallway and room they tackled.

Downing was forward thinking in his exhortations to consider plumbing, heating, and ventilating as integral to the design and enjoyment of the house. The Krainiks put interior renovations on hold when they updated the boiler and water heater and once again reroofed the house. When time and money allowed, they began again on interior plastering, painting, and papering.

Renovating an old house guarantees that you will find as many mysteries as you solve. In their many projects the couple has found original wood shingles under layers of roofing, an 1867 newspaper, shards of early wallpapers, and original faux-wood grain painting in the bedrooms. When old floors were pulled up, the couple found "ghost" locations of walls removed long ago. Judge Bohn modernized some of the interiors to more of a Craftsman style in the 1930s: he covered pine floors with oak, removed the Gothic Revival–style fireplace surround and mantle, and opened up the walls of what had been Thomas's banking office and is now the dining room. Eighty years later the Krainiks are continuing their efforts to return the house to its picturesque Gothic Revival roots.

Shortly after the Krainiks bought the house in 1966 they began seriously collecting Victorian furniture. The first-floor northwest bedroom, which is dedicated to the memory of Terrell Thomas, contains one such treasure: a bed by Berkey & Gay of Grand Rapids. Such beds were referred to as "Medieval Battleships."

With each passing year the House of Seven Gables shows its age—in stunning glory. The Krainiks were pioneers in the historic preservation movement and throughout all of their discoveries and intense labor they retained their sense of wonder and curiosity. While the couple has truly re-created the period of the 1860s to 1880s, their insistence on quality and thoroughness ensure that their home will live on as a classic example of Gothic Revival architecture into its third century. •

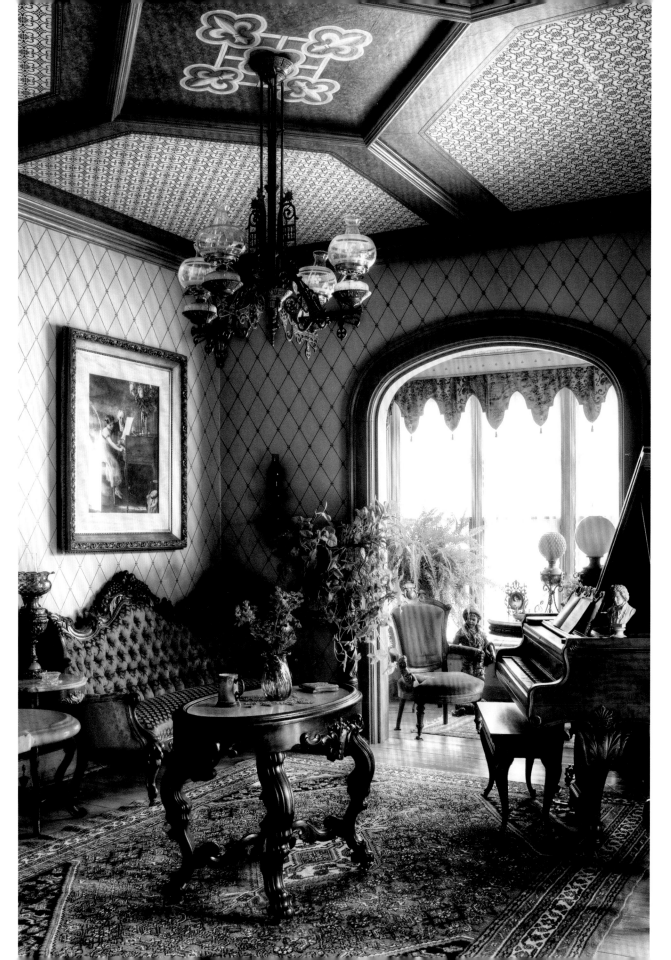

Ceilings were paid a great deal of attention in the late 1880s. The current owners became students of Andrew Jackson Downing's writings to guide their choices in color, patterns, and appropriate wood molding and ceiling beams.

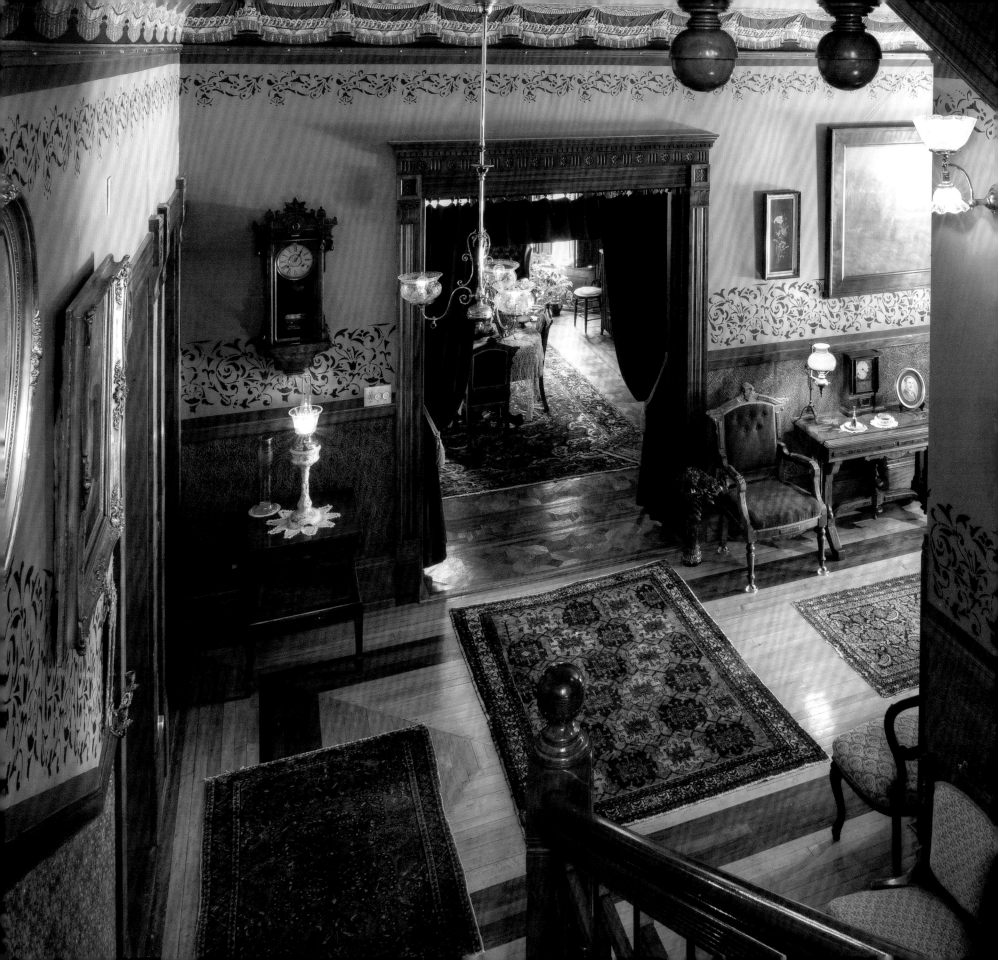

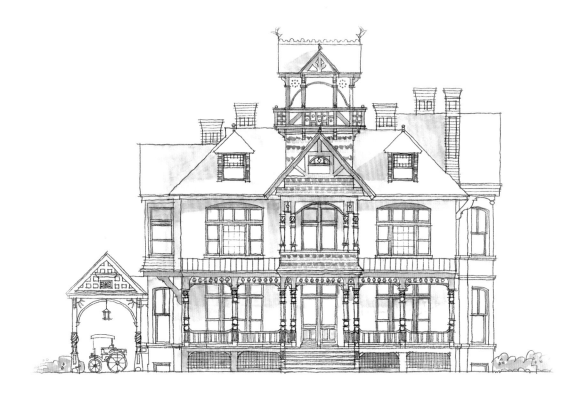

DELAVAN WAS SETTLED IN THE 1830S by followers of the Temperance Movement. The city—with its location on the rail line, abundant farmland, pure springs, and the scenic Lake Delavan—attracted an eclectic mix of people during the nineteenth century: Yankees, teachers and students at the School for the Deaf, summer people from Chicago. Hundreds of wintering circus performers from twenty-six circuses, including P. T. Barnum, lived in and around Delavan between 1847 and 1894. The large barns, fresh water, and ample feed outweighed the disadvantages of the Wisconsin winters. Another who eventually made his way to Delavan was Alexander Hamilton Allyn, the original owner of the twenty-three room, 9,500-square-foot Queen Anne mansion prominently located on Delavan's main street.

While Allyn was aware of the showmanship and costumes of the circus, when he chose architect E. Townsend Mix to design his home he pursued the drama of the socially scripted Victorian era. The elaborate wood-shingled and brick house towers over the main street, rising from an English basement of rusticated stone. Five Cream City–brick chimneys punctuate the roof surrounding the third-story balconied tower topped with cresting and pinnacles. The interior is equally theatrical. A dramatic back-paneled walnut staircase winds its way up the three stories, walls are covered in glazed Anaglypta,

and hand-stenciled floral wall and ceiling decorations rival the finest painted stage backdrops. Stained, cut, leaded, beveled, and etched interior and exterior glass windows dramatically reflect light. Today, the restored mansion looks as though it were frozen in time, like a play that is revived year after year.

ALEXANDER HAMILTON ALLYN arrived in Walworth County in 1859, at the age of twenty-three. A descendant of the Pratt, Mather, and Wadsworth families—all prominent names in Colonial America—Allyn had left his family home in Connecticut at age sixteen to seek his fortune in the West. He made his way to Chicago in 1852 via the Erie Canal and the Great Lakes. After two years at the dry goods store Cooley, Wadsworth & Company, Allyn moved to Milwaukee. Grain was king in the Upper Midwest in the 1850s and Milwaukee was one of the earliest cities to establish itself as a center for grain exchange. There were abundant employment opportunities for young men like Allyn, who took a job with Bell, Courtney & Company, a large grain warehouse business.

Mrs. Allyn had the front balcony enclosed and awnings added sometime around 1914.

By 1859 Allyn was able to purchase 184 acres of farmland outside Delavan, fifty miles southwest of Milwaukee, with the intention of growing wheat. He had great success with wheat initially, but after his crop failed, victim to the statewide infestation of chinch bugs in the 1860s, Allyn, like other farmers, turned to dairy farming. He became well known as a breeder of Brown Swiss dairy cattle.

Allyn married twice and had seven children. His first wife, Elizabeth Humphrey Martin, whom he married in Hartford, Connecticut, in 1861, also came from Connecticut. One of the three children they had together died in 1869; Elizabeth passed away the following year. In May 1870 Allyn married Mary Elizabeth Doolittle, who had lived in Delavan since relocating from New York state as a child. The couple had four children, including twins born in 1874. One of the twins and a daughter died in 1879. During this time before immunizations, children succumbed to the measles and whooping cough, as well as waterborne diseases such as typhoid and cholera. Their last child, Joseph Pratt, was born in 1883, the year the Allyn family left the farm and moved into town. Allyn's financial success as a breeder allowed him to hand over the day-to-day farming operations to his employees and concentrate on the business end of the operation as well as community service.

Allyn commissioned Milwaukee architect E. Townsend Mix, who had worked with architect William W. Boyington in Chicago for a time, to design his city home. Between 1860 and 1886 the Connecticut-born Mix was a favorite of Milwaukee's business elite—particularly the Yankee families. In the 1860s Yankees tended to form business alliances with other Yankees as Germans did with Germans. Mix's work was widely published in the professional journals of the time, and he was sought after as a trend-setting architect who was up to date on all the latest styles in residential design. He was known for his flex-

ibility, both in interpreting various architectural styles and for bending to the will of his socially prominent clients.

Mix's practice was not limited to Milwaukee. His other notable designs include the Italianate Villa Louis in Prairie du Chien; Montauk, an imposing red-brick Italianate home in Clermont, Iowa; and Fair Oaks, a magnificent Gothic Revival mansion in Minneapolis, Minnesota. Many of his early designs were in the Italianate style and were realized in Milwaukee's Cream City brick. Later, as industrialization made wood a more interesting decorative material—the scroll saw allowed carpenters to more easily and quickly turn out a wider variety of patterns and shapes—Mix incorporated wood details into a number of his Queen Anne–style homes, including the Allyn mansion.

During his lifetime, Mix's reputation was secured when he received national notoriety for his design of Fair Oaks. The house was among 93 homes built in the 1880s that were featured in George William Sheldon's *Artistic Country-Seats* (1886). The majority of the book's homes were built for wealthy Northeasterners by such well-known architects as McKim, Mead & White and Richard Morris Hunt. Mix's Fair Oaks stood out, in part, due to its location west of the Mississippi River—a world away from the East Coast architectural critics.

Allyn would have been aware of Mix not only for his residential work but also for his design of Milwaukee's five-story Grain Exchange Building, built in 1879 and also known at the time as the Chamber of Commerce Building. With its High Victorian sandstone-trimmed exterior clad in granite and limestone and an interior heavily adorned with frescoes, stained glass, and bas-relief, this building may well be Milwaukee's most elaborately embellished commercial building. As a former grain merchant, Allyn must have been impressed by the building—and its architect.

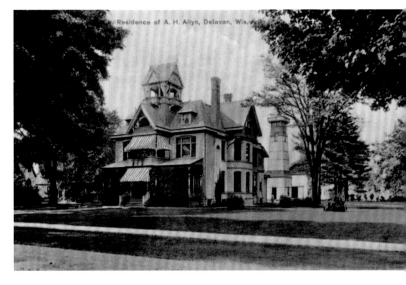

ABOVE: The backyard windmill, seen in this 1914 postcard, pumped water into a third-floor holding tank. Gravity then pulled the water through lead pipes into the kitchen and two bathrooms on the lower floors. BELOW: Victorian mansions lined Delavan's Walworth Avenue around the turn of the century. Parcels of the formerly large lots have since been subdivided, and today commercial and institutional buildings flank the Allyn mansion, shown at far left.

THE AMOUNT AND VARIETY of textures and details in the Allyn home are almost dizzying. Upon its completion in 1885, Mix's Queen Anne home for the Allyns was described in the local newspaper as "a commodious dwelling and handsome, one of the most desirable residences in the county." There are five walnut double pocket doors, one set of which has panels of etched art glass imported from France and is surrounded by elaborate Eastlake wood moldings of dentils and carved rosettes. Various woods—walnut, maple, oak— in intricate parquet and inlaid patterns constitute the flooring. Embossed wall coverings and other wallpapers grace the rooms. It is possible that Mix actually ordered many of these items from catalogs—or, more likely, had the moldings and decorative pieces custom-made in factories in Milwaukee or Chicago and then contracted with craftsmen to fit them in place. The mass production of building materials during the Industrial Revolution and the advance of railway shipping brought down costs of items previously made by local craftsmen.

The Queen Anne style of Allyn's home is the most recognizable of the various Victorian styles, due to its enduring popularity and wide geographic distribution. Although it was not developed during the reign of Queen Anne, the queen of Scotland, Ireland, and England from 1702 to 1714, the style initially drew its aesthetic influences from the architecture of the Elizabethan and Jacobean eras that preceded her reign. When the Queen

Victorian Ingenuity

The Allyn mansion is representative of the evolving technologies of an inventive age.

The balloon frame employed in the Allyn mansion was developed in Chicago as an improvement over the labor-intensive and expensive mortise-and-tenon construction. The mansion's high ceilings were made possible by longer machine-sawn studs of original-growth lumber. Standard sizes and the technical efficiencies of automated machinery maximized lengths and made sections uniform.

The Victorians gave the porch—the outdoor room—distinct social functions. In a seemingly private society, it provided a safe transition from public to private zone where pleasantries could be exchanged and fresh air enjoyed. The introduction of screens after the Civil War made this outdoor room an ever-more utilized space and allowed for the option of sleeping porches in the floors above.

Developments in the production of power and millwork equipment like the lathe made the turning of ornate columns and spindlework both uniform and affordable. Powered equipment made the cutting of individual molding and wood window sections standard and consistent, though these elements still required hand assembly. The scroll saw made the cutting and fabrication of gingerbread wood ornament like the medallions on the porte cochere possible.

The colors we see on the Allyn mansion are a direct product of nineteenth-century invention. While in the first half of the 1800s bright yellows, reds, Prussian and cerulean blues, Brunswick greens, and alizarin crimsons were developed using oil paints with zinc-based pigments, these paints were expensive and not readily available. By 1880 the Sherwin-Williams Company had perfected a formula in which fine paint particles would remain suspended in linseed oil, resulting in a paint far superior in durability than others. A wide range of paint colors supplied in large tin cans was made available. Technology enabled the Victorians to personalize their architecture with color.

Beneath the home's entry foyer is a large basement chamber where a built-in-place furnace (now gone) once supplied convection heat to the floors above via tin-lined wooden ducts. Even Victorians hedged their bets, though: in the Allyn mansion, a complementary system of nine carved polished granite, heat-producing Rumford fireplaces—all a different decorative design except for those in the back parlor and reception room—were also incorporated into the design. This duplication of systems was probably intended to supplement the furnace and to assist in ventilating both heat systems while introducing fresh air and a means to expel the smoke of the gas lighting system through the chimneys. The stair tower's roof hatch did double duty as a chimney to further vent gases, let out rising summer heat, collect cool summer evening air, and recirculate air.

Illumination by gas provided consistency at the cost of flexibility. Kerosene lamps could be moved anywhere, but the fixed gas jets were typically placed in the ceiling in the middle of the room, thereby dictating the centered placement of furniture to take advantage of the light.

The early conversion of gasoliers to electrified electroliers provided more light coverage, but proximity to the available light source still dictated room arrangement. When the Allyn mansion's built-in furnace was abandoned, the fireplaces were updated with gas heating inserts and vented as before. Contemporary radiators were added in 1952.

Anne style arrived in the United States, its influence became less medieval and more eclectic. Its hallmarks included Tudor elements such as towers and half-timbering; decorative gables and porches; corbeled chimneys; highly decorative windows, entry doors, and bay windows; and a dominant front gable.

Victorian homes were designed with the firm belief that the home was a refuge from the outside world. Each room in a Victorian home was assigned both a function and a hierarchy that delineated the division of public and private spaces. While the rooms in a Victorian house each had a discrete function, the wide stairs, hallways, and expansive portals allowed for visual flow of space from one room to another. Tall, sliding double pocket doors were rarely completely closed; instead, they were usually partially pulled out—more to show off the high-quality woodwork and the beauty of the wood than for privacy. These doors were often faced with two different woods, with one species chosen for the hallway and another chosen to match the decor of the interior room. On the first floor of the Allyn mansion the original walnut woodwork is intact, including five eight-foot-tall double pocket doors.

In *The Theory of the Leisure Class,* published in 1899, Thorstein Veblen described *conspicuous consumption* as the practice of spending lavishly on visible goods to prove to others how prosperous one was. In Victorian homes the rooms for receiving outsiders—the hall, dining room, main parlor, and reception room—were invariably more opulently furnished and decorated than the private family rooms. Alabaster and gold leaf were employed as decorative elements. High ceilings, rectangular rooms, and bay windows were desirable features. The floors in the family parlor and in Mrs. Allyn's parlor, where the room height rose to thirteen-foot-high coved ceilings, was an intricate parquet. But the most sumptuous room in the house was the dining room, where most of the entertaining took place.

The complementary colors of green and red create a stabilizing background for the mansion's patterns and prints. From parquet floors to ceiling stenciling, the eye never rests in a Victorian house.

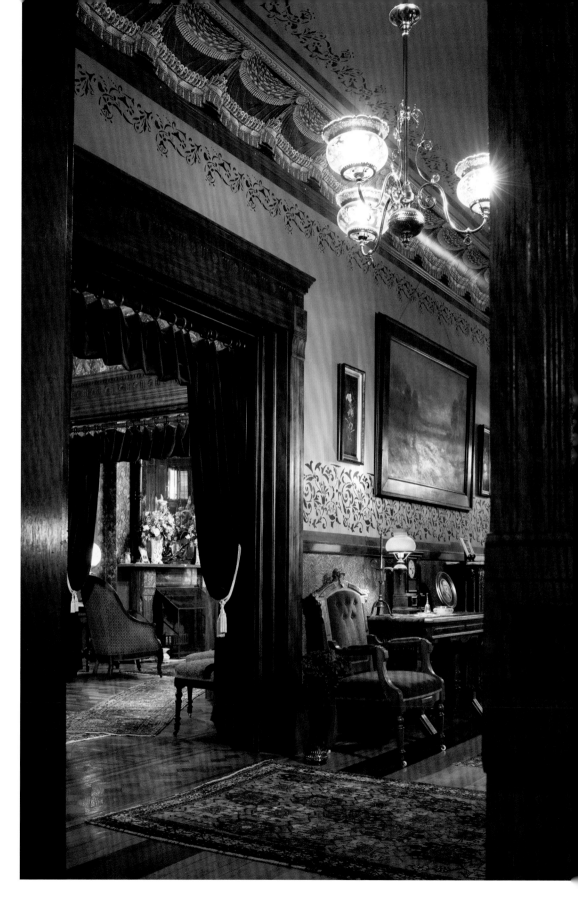

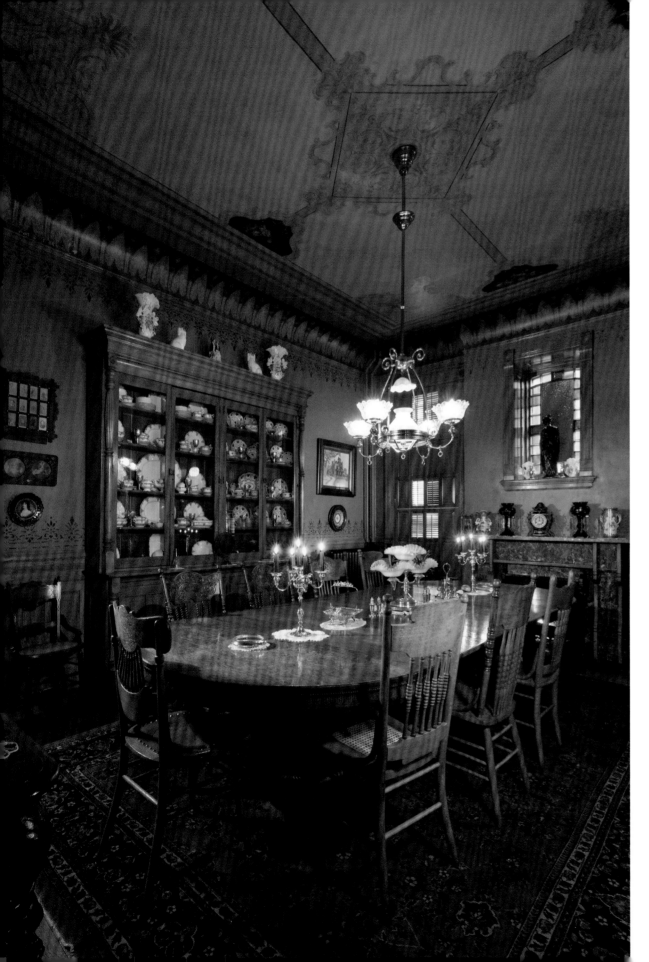

The dining room as well as the library were considered masculine spaces; these rooms were typically decorated in woods with rich coloring such as the smooth-grained, reddish brown French walnut in the Allyn mansion and employed a somber palette, preferably crimson or dark green. A tall, well-proportioned, distortionless mirror over the fireplace was a highly prized decorative artifact. Equally desirable was a sideboard covering an entire wall where silver and glass serving pieces—symbols of gentility and hospitality—were prominently displayed.

The Allyn mansion has eleven bedrooms. Bedrooms were intentionally plainer and more sparely furnished than formal rooms, in part to keep dirt, dust, and bedbugs to a minimum. Gas or wood-burning fireplaces and coal stoves supplied heat but contributed to grime as well. Laundry was an arduous task, especially during Wisconsin winters, so keeping bedroom furnishings to a minimum made them much easier to keep clean. It was understood that good hygiene was a step toward reduced illness and death, very important concerns in the late 1800s before vaccines were available and communicable illnesses were prevalent.

Privacy was as important to Victorian families as was the outward show of wealth, which created a strange dichotomy: adorning the elevation of a house with numerous and varied windows (new manufacturing techniques made a wide array of window shapes and sizes available for those who could afford them) served as a status symbol, yet the Victorians did not want anyone to see into their homes. Alexander Allyn wanted his house to be seen as a physical manifestation of his financial success, but he also wanted to safeguard his family from public display.

The Allyn home was in full view of everyone coming and going through town. During this era windows were often outfitted with interior wooden shutters as well as layers of curtains—shears or lace and heavy-weight velvet, wool, or brocade draperies—not only to keep people from looking in but also to filter the household's views of strangers on the public sidewalk and street. In addition to providing privacy, the shutters provided sunlight and temperature control. Heavy window coverings also prevented sunlight from damaging artwork and impermanent organic dyes in the carpets, and from bleaching the wood floors. Stained glass was held in high regard for it created an aesthetic gesture while simultaneously providing privacy. In some cases in the Allyn home, stained glass was incorporated only on the upper half of exterior windows. Richly colored cast light was an added decorative benefit.

The need for a variety of types of rooms to accommodate different social activities often meant that as the number of rooms increased, their dimensions became smaller on each successive floor. This, however, is not true in the Allyn mansion, where even the third-floor rooms are generous in size and height. The distinctions between the

OPPOSITE: The deeply inset stained-glass window over the dining room fireplace is a quirky detail. Traditionally, a mantel-to-ceiling mirror or a large painting would grace such a space. TOP: The room's light color palette, shirred full bed canopy, and low seating all indicate that this was decorated as a woman's bedroom in the 1890s. The authentic staging is one reason the mansion was so popular as a bed and breakfast. BOTTOM: Many of the ceilings in the four third-floor bedrooms are sloped, but each of the spacious rooms has at least an eight-foot-high ceiling and most have an in-room sink.

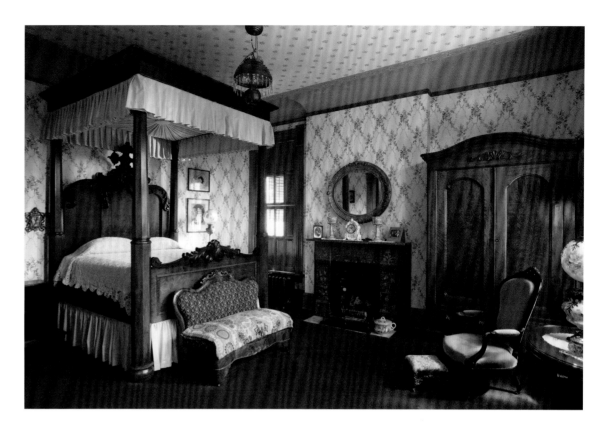

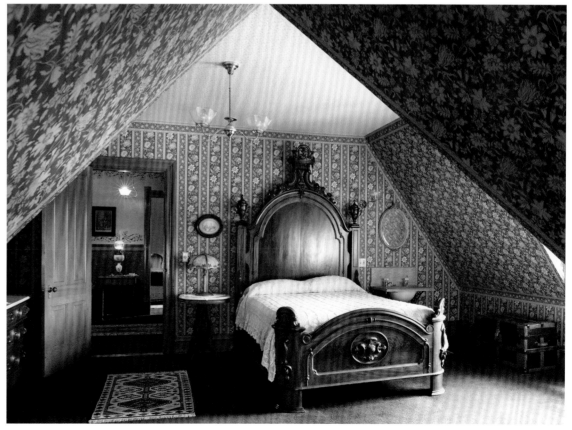

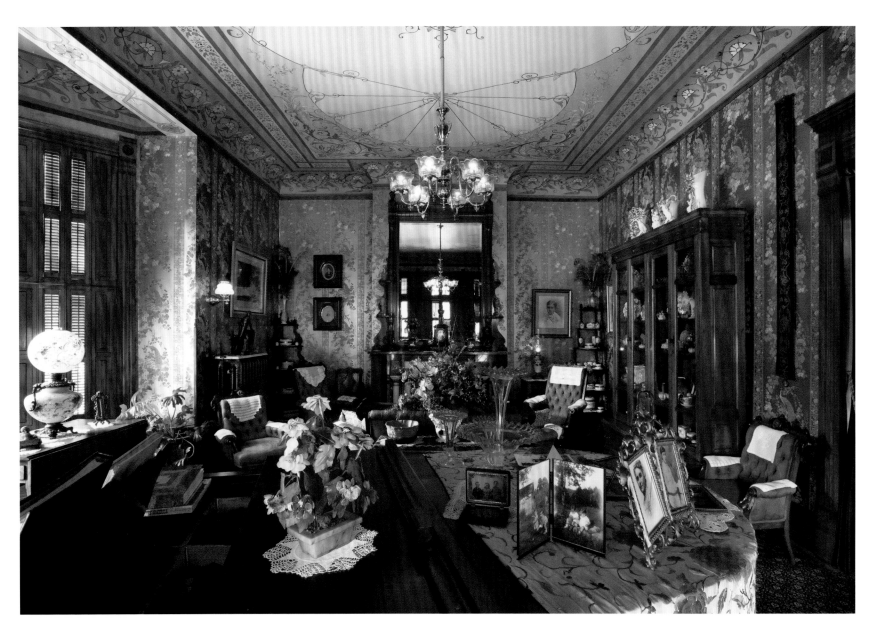

third-floor rooms are telling: the children's bedrooms had heat vents and finished woodwork while the woodwork in the servants' rooms, which had no heat source, was simply painted.

THE ALLYNS HAD THREE RESIDENCES: the mansion in Delavan; a home on 8 acres on Lake Delavan, about three miles outside the city; and a winter home in Los Angeles. After Mr. Allyn died in 1913, Mrs. Allyn remained in the house until her death in 1939; her step-daughter, Esther, lived there until 1948. The house then fell into disrepair and the mainte-nance decisions of Esther's daughter, Ruth Peterson, did not enhance the property. Many of the wonderful Victorian elements—the tower, the porte cochere, and the porch—were demolished rather than repaired.

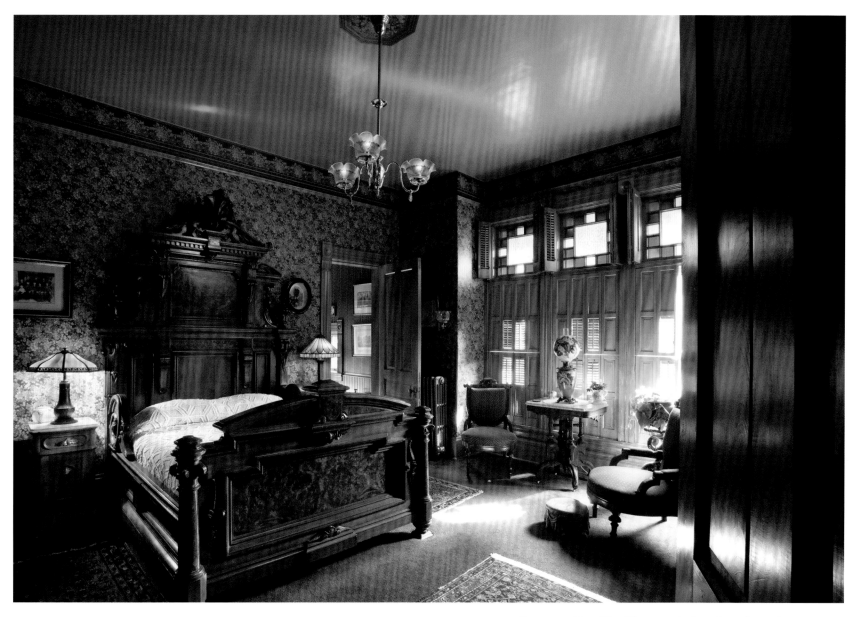

Mrs. Allyn's heirs sold the home to the City of Delavan in 1950. Two years later the city decided that the building did not suit its needs and sold it to a nursing home concern. (Part of the appeal was the elevator Mrs. Allyn added in 1929.) The integrity of the Victorian mansion was compromised during its fifteen years as a nursing home: bathrooms were remodeled; a fire escape was added; the side garden, which had originally included an elaborate gazebo and fountain, had been abandoned; and a parking lot for staff and visitors was added out front. After the nursing home closed in 1966, the mansion stood empty for three years until the property was purchased and converted into a furniture store that operated until 1983. Changes made to the house at this time were mostly cosmetic.

The mansion again was vacant until Joe Johnson and Ron Markwell, whose shared hobby was restoring Victorian homes, purchased the Queen Anne in 1984 with the in-

OPPOSITE TOP: The Allyn mansion's main parlor embraces many Victorian hallmarks: hand-painted ceilings; patterned wallpaper; a tall mirror over the fireplace; full-window, wood interior shutters; a piano for entertainment; and myriad personal mementos on display. OPPOSITE BOTTOM: Joe Johnson and Ron Markwell's rediscovery of the original main parlor ceiling's decorative painting. ABOVE: The square stained-glass panes surrounding a clear pane is a signature of the Queen Anne style. The current owner's collection of authentic period furniture came from all over the United States.

As Joe Johnson peeled back the dining room wallpaper hung during the period the mansion was a nursing home, detailed stencil work was discovered and later restored.

The Allyn mansion as it looked when Joe Johnson and Ron Markwell purchased it in the 1980s. Stripped of the porte cochere, tower, and front porch, it possessed only a faint semblance of its former grandeur.

OPPOSITE LEFT: Even during the formal Victorian era, family members entered their homes from a side door. The porte cochere provided cover from the elements for those arriving by carriage. A side location was convenient to the stable. OPPOSITE RIGHT: For 125 years the Allyn mansion quietly stood by and watched over the citizens of Delavan. The out-of-style Queen Anne was snubbed and fell into disrepair. Now faithfully restored, it is impossible to ignore.

tention of restoring it. Based on previous experience, they thought the restoration would take eight years. It took eighteen.

Gallon upon gallon of paint obscured the hand-painted ceilings, woodwork, and wallpaper. Wall-to-wall shag carpeting hid the inlaid, parquet, and hardwood plank flooring. All that remained visible of the original glory were the nine fireplaces on the first floor and in the second-floor bedrooms, six original gasoliers, two grand over-mantle mirrors, decorative floor and wall registers, ornamental brass hinges, and door and window hardware. Otherwise the stage had been stripped bare.

There was no way for Johnson and Markwell to know what, if anything, was salvageable under cover of all the "improvements." They stripped paint, refinished woodwork, tore down all the walls that weren't original to the home, and hired an artist to restore the main parlor's floral-patterned, hand-painted ceiling. The partners went the extra marathon miles and rebuilt the tower, the porte cochere, and the porch to their original specifications. Original drawings by Mix of exterior details found in the Allyn mansion's basement safe enabled Johnson and Markwell to rebuild those missing exterior elements accurately. At this point, the men realized they were no longer hobbyists. They had become serious preservationists. Serious preservation means serious economic investment. Johnson and Markwell decided to open a bed and breakfast in 1986 to help finance their project.

Successful restoration projects focus on a particular time period. The partners chose to restore the Allyn mansion to the mid-1880s period, to show it as Allyn would have originally lived in the home. No records have been found documenting the original furnishings, but the two were able to purchase a few original pieces back from local residents who appreciated their restoration efforts.

Johnson and Markwell chose the Eastlake style as the dominant choice in replacement furnishings because they had a major collection of the furniture and it also was appropriate to the chosen time frame. Charles Locke Eastlake was a British architect and writer who greatly influenced late-nineteenth-century attitudes toward home decorating. Prior to Eastlake's influence it was common for a home to include a ladies' parlor in the French style and a man's library furnished in the Gothic Revival style. Eastlake's goal was to inspire homeowners to outfit their rooms in a unified style of furniture rather than decorating each in a different fashion. His designs relied on incised lines, geometric ornaments and molding, and flat surfaces, which he promoted as aesthetically pleasing, easier to clean, and more tasteful than heavily carved furniture.

All of the furnishings in the Allyn mansion are American Victorian pieces purchased by Johnson and Markwell, who often traveled great distances to retrieve them. Some replacement pieces such as the interior wood shutters and bookcases were made expressly for the house.

In 1985, one hundred years after its construction, Johnson and Markwell wrote the nomination papers to recommend their home for placement on the National Register of Historic Places. It received that designation, and, in 1992, the National Trust for Historic Preservation awarded Johnson and Markwell the Great American Home Award grand

prize for their "meticulous and thorough restoration" of the Allyn mansion. While saving an architectural treasure, the couple made lifelong friends with guests at their B&B—essentially a whole network of like-minded people who shared and traded information about good resources for furnishings and recommended craftspeople—who were impressed by Johnson and Markwell's devotion to Alexander Hamilton Allyn's home.

A few years back, when asked how they learned to do all they needed to know to restore the Allyn mansion so faithfully, Johnson and Markwell's simple response was, "Trial and error." Like great actors and set designers, they believed the overall effect of the setting is all the more amazing when it is ageless and appears effortless. Entering the Allyn mansion today, it feels as if the curtain has just gone up on a magnificently staged play set in the Victorian era. •

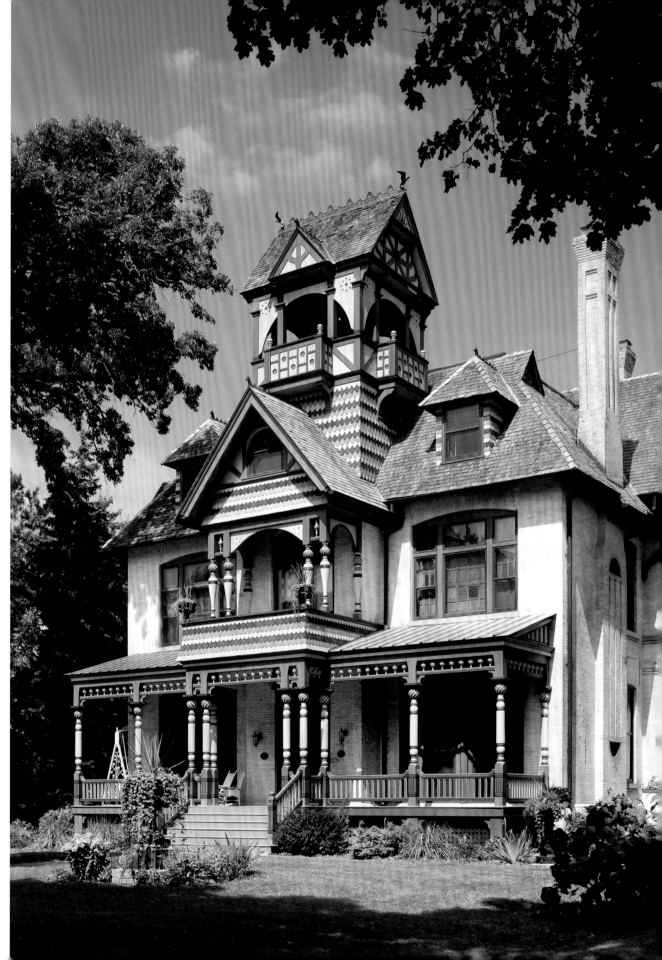

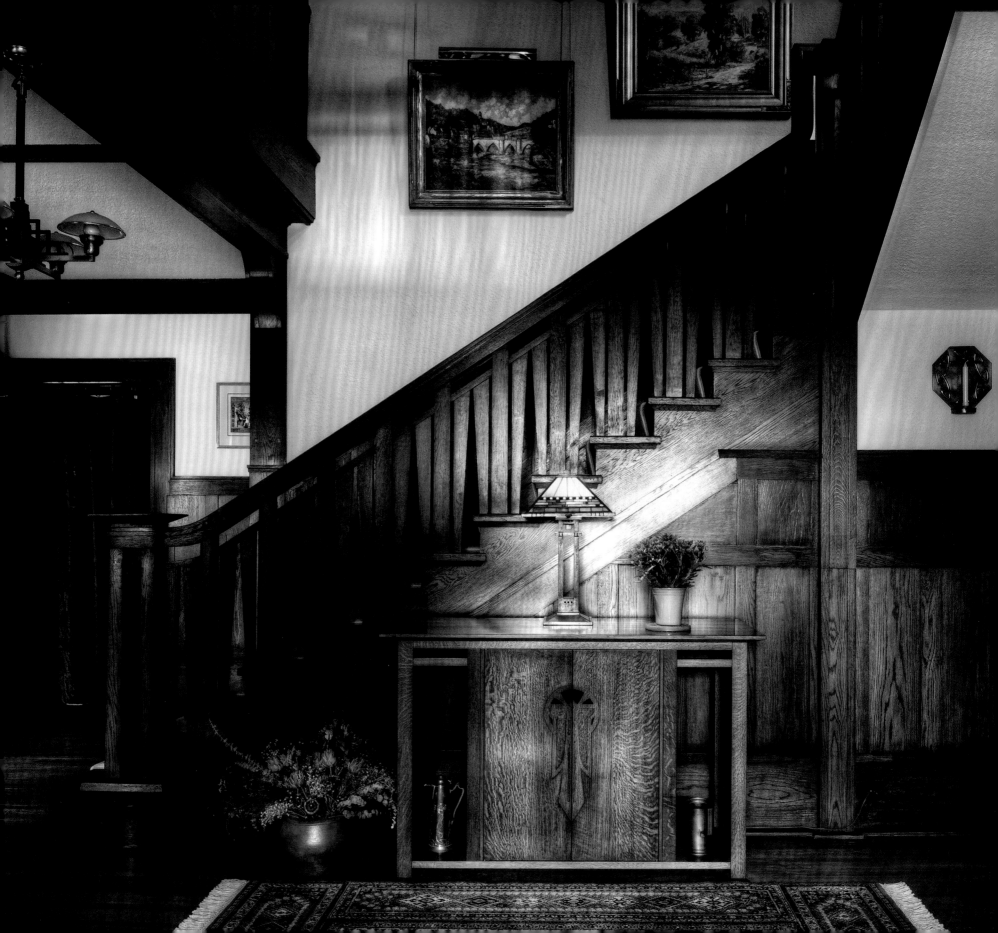

Adam J. Mayer House

OPPOSITE: The dove-tailed, white oak balustrade was built exactly as outlined by architect Henry G. Lotter in his forty-one typed pages of specifications—detailed instructions that described every detail of construction—for the Adam J. Mayer house. ABOVE: The home's south elevation

EVERY STREET IN MILWAUKEE tells a tale within the full saga of the city's history. If one lets his or her imagination flow, then each street can be viewed as the scenery or backdrop to a play where apparitions from the past come forward and in sotto voce tell their version of the story. The abundance of historic homes lining the leafy streets of Milwaukee's east side provide the perfect stage for the heroes, villains, directors, and producers of the city's past. Behind the front doors of these stately homes the more personal stories unfold, the stage is more intimate, and the props more personal. One such home, that of shoe manufacturer Adam J. Mayer, may have had the public persona of a tough-as-cobbler's-nails businessman. But its interior, designed in large part by interior architect George Mann Niedecken, projects the rich, warm, tactile quality of a devoted family man with an appreciation for aesthetics.

THE DEVELOPMENT OF LAKE PARK in 1890 spurred interest in the building lots west of the park and north of the Water Tower, an area now referred to as the North Point North neighborhood. These homes were built by architects for their own families and by doctors, businessmen, and industrial and beer baron Milwaukee families, such as the Pabsts, Blatzes, and Galluns.

Men's Dry-Sox Shoes

The unusual construction of this shoe makes it the biggest selling specialty in the shoe business

Solid Oak Tanned Counter

½ Bellows Tongue

Solid Oak Tanned Insole

Full Leather Vamp

Solid Oak Tanned Heel

Best Quality of Upper Leather

Oil Slicker Lining

Animal Parchment

Inside Cork Filling

Solid Oak Tanned Out Sole

Choke Seam Welt sewed in with Leather Welt, makes the shoe as waterproof as it is possible to get it

Animal Parchment (Pig's Bladder) over entire bottom of shoe

[15]

This page from a Mayer catalog notes that the "unusual construction of this shoe makes it the biggest selling specialty in the shoe business."

In 1900 ten homes had been built; by 1910 a total of eighty-five houses were built; and by 1930 all of the lots had been sold. The census for this neighborhood during these thirty years reads like a page from Milwaukee's social register: Pabst, Gallun, Falk, Nunnemacher, Trostel, Blatz, Harnischfeger, and Smith. Alexander C. Eschweiler, a versatile architect whose projects ranged from pagoda-shaped gas stations to brick buildings on the Downer College campus, was the favored architect, but other prominent architects—Peacock and Frank, Beumming and Dick, Armin Frank, Leenhouts and Guthrie, Eugene Liebert, Ferry and Clas, Fitzhugh Scott, and David Adler—were well represented. English Arts & Crafts, Tudor Revival, Norman or French Provincial Revival, Colonial Revival, and Shingle were the preferred architectural styles. Revival styles were favored by the East Coast architectural critics and featured in popular publications of the period.

One of the early landowners and homeowners was Adam J. Mayer, treasurer of the Fred J. Mayer Boot and Shoe Company, a business started by his father, Frederick J. Mayer Sr. Frederick was born in Germany, where he served in the army and was a shoemaker's apprentice and journeyman. In 1851, at age twenty-eight, he immigrated to Milwaukee, which was then an important center for leather tanning. The first tannery had been started in 1848 by two cousins from Germany; by 1872 the city was home to thirteen major tanneries, and leather was the third largest manufactured product. Mayer employed six shoemakers in a small shop, the motto of which was "Honorbilt." His fortunes rose quickly due to the quality of his merchandise.

By 1880 Mayer's company moved into the wholesale business, producing fifty pairs of shoes a day. Output grew to 500 and then 1,500 pairs of shoes daily from 1880 to 1893 and increased to 12,500 pairs by 1921. During World War I the company had a government contract for boots. The company enlarged eleven times in fifty-one years, making shoes in its brick factory with a castellated cornice, now known as the Fortress, in the Brewers Hill neighborhood in Milwaukee as well as in factories in Seattle, Washington, and Luddington, Michigan—cities with good shipping to Cuba, Mexico, South Africa, and Alaska. Three of Mayer's sons assumed control of the company in 1906, with George as president, Frederick Jr. as vice president, and Adam as treasurer. (Another son, Chester, was an artist who attended the Art Institute of Chicago.) The Mayers believed in investing in the latest in equipment and held their workers to the highest standards in quality control.

The Mayers were a close-knit family who built a successful business and shared a love of outdoor activities and the arts. George was a lifelong member of the Milwaukee Art Student's League, Adam attended many of the lectures given there, and Chester became a sculptor. Frederick Jr. enjoyed gardening and hiking. Their uncle, Louis Mayer, was a nationally acclaimed artist, first as a painter and then as a sculptor of bas-reliefs and busts of historical figures, like the one of his friend Albert Schweitzer. His painting "Woman in Black" (1900) is in the Milwaukee Art Museum's permanent collection.

In 1895 George, Frederick, and Adam jointly bought a parcel of land on Pine Lake in northern Wisconsin near Ironwood. The brothers built three substantial Shingle-style homes, a boathouse, and an ornate observation tower. Other families who summered on

Pine Lake at that time would be their future Milwaukee neighbors: the Wahls, Nunnenmachers, Vogels, and Brumders among others, including the Niedeckens, whose son, George Mann, would play a major role in shaping the interiors of Adam Mayer's future home.

Adam Mayer purchased a lot on Wahl Avenue for a home for his wife, the former Pauline Anstedt, and their five children; his brother George bought a lot on Terrace Avenue behind his. The curving avenue commands sweeping views of Lake Michigan and Lake Park, which boasted numerous amenities: pedestrian walkways, streets for carriage drives, rustic bridges, and dirt paths that made exploration of the deep wooded ravines an option and provided ready access to the newly constructed swimmers' beach. (Lincoln Memorial Drive was proposed in 1905 but was not built until 1927.) Concerts took place in the Ferry and Clas–designed pavilion, golfers enjoyed a six-hole golf course, and children romped around the playground. Lake Park was an urban amenity for the fitness-minded Adam Mayer, who enjoyed incorporating the natural environment into his daily routine. His grandchildren still remember how they loved to tag along with him to get ice cream at the pavilion on his near-daily walks through the park.

The half-timbering on the exterior is reflected in the wood detailing of both the library and the dining room. Adam J. Mayer chose his address so he could cross the street and take long walks in Milwaukee's Lake Park overlooking Lake Michigan.

THE END OF THE NINETEENTH CENTURY saw a boom in mansion construction, and the early twentieth century was kind to the middle class. President Theodore Roosevelt's enthusiasm for Progressive reform and strong foreign policy created an era of optimism among the business community. Automobile sales soared and the middle class built homes that reflected their commitment to a growing consumer class. Residential construction had a banner year in 1905. In spite of the Progressive political atmosphere, residential housing styles still favored established revival styles.

Mayer contracted with Milwaukee architect Henry G. Lotter to design his home in the Tudor Revival style, a style that reflected the gentlemanliness of the English suburb. It was solid but not stodgy, impressive but not excessive. The home's Tudor Revival attributes include a steeply pitched roof, stucco and brick wall cladding, side and front half-timbered gables, a massive chimney, numerous multipaned windows, and a front porch.

Style: Arts & Crafts

Many consider the Arts & Crafts movement one of the precursors of the twentieth-century modern movement because it replaced the elaborate design and ornament of the Victorian era with a modern decoration stripped of its historic precedents. The Arts & Crafts style was reflected in architecture, interiors, furniture, textiles, ceramics, and book design and shared principles with contemporary painters, authors, and poets. Nineteenth-century essayist, poet, and artist John Ruskin and artist, textile designer, and furniture designer William Morris were the leading proponents of the style in England. The style's popularity in the United States can be traced to Wisconsin-native Gustav Stickley's *The Craftsman* magazine, which popularized both Arts & Crafts architecture and furniture. To this creative mix were added the many Eastern European immigrants who brought their own interpretations of the Arts & Crafts and Vienna Secession styles.

Hallmarks of Arts & Crafts interior design emphasize the quality of "handcraft," functional design, and the appreciation and use of local materials. Everyday uses could be realized in simply detailed, solid, and straight forms, while more formal functions called for sophisticated proportions and intricate enhancements including sinuous, organic shapes derived from nature. Although the movement's English founders sought to elevate and celebrate the artistry of simple craftsmanship, the commercial success of the Arts & Crafts style stemmed from the easy and relatively inexpensive reproduction of these simple shapes by industrial machines.

An oak and leather Gustav Stickley Morris chair, model #2342

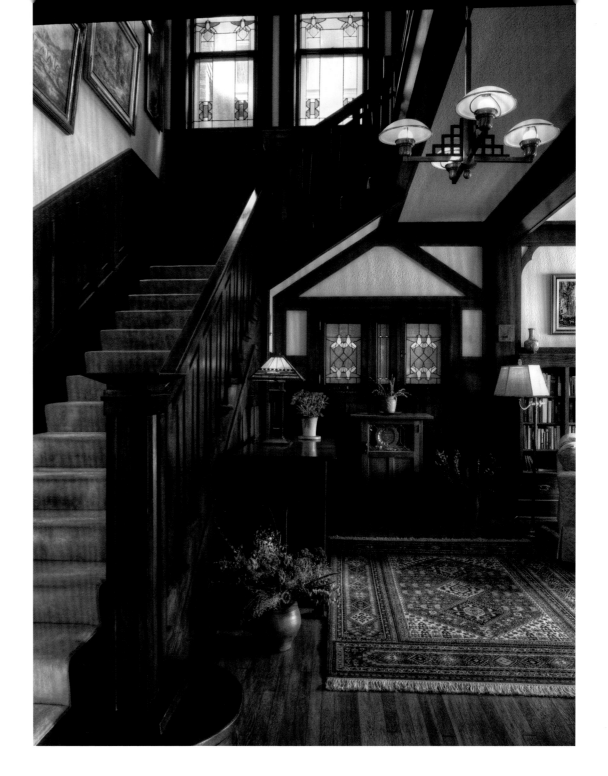

One out-of-character element—a tower—was removed after it was struck by lightning and burned. The roof was, and is today, shingled in wood.

The reputation of the Mayer house was built on the work of its interior designer, Milwaukee native George Mann Niedecken. The house was designed by Lotter in 1905, with the Niedecken interiors completed in 1907. This sequence has created some confusion

concerning design authorship and style attribution; it may be that the two collaborated early on in the process.

Many of the interior wood details—the mantels, the bracketing, the staircase and banister, picture moldings, timbered ceilings, doors, and wainscoting—were designed and detailed by Lotter. The present owners have in their possession Lotter's original blueprints, complete with detailed interior elevations and very precisely written construction specifications. Lotter specified the woods: maple for the upper floors and white oak for the first floor, with the exception of birch flooring in the living room. Bookcases in the library were to be white oak, as were the inside finishes in the main stair hall, vestibule, library, dining room, and butler's pantry. The living room, per Lotter's specification,

OPPOSITE: The stair hall was an actively used gathering room during Adam Mayer's lifetime. Holidays and birthday celebrations filled the open space. The stair was a viewing stand for grandchildren too short to see over the adults. BELOW: The window frames throughout the home are of clear pine; the dining room, library, and main hall floors are white oak; the living room is birch. All the rooms and halls except the kitchen and attic had wood picture-rail moldings.

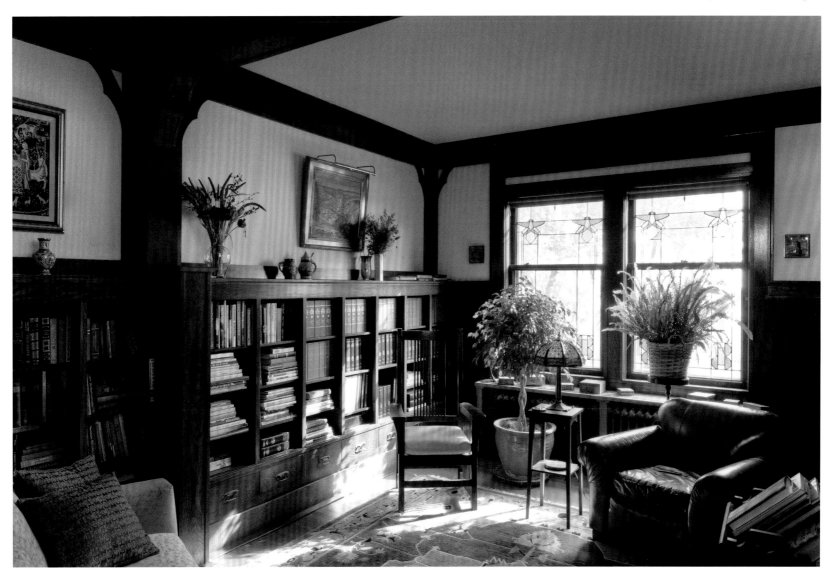

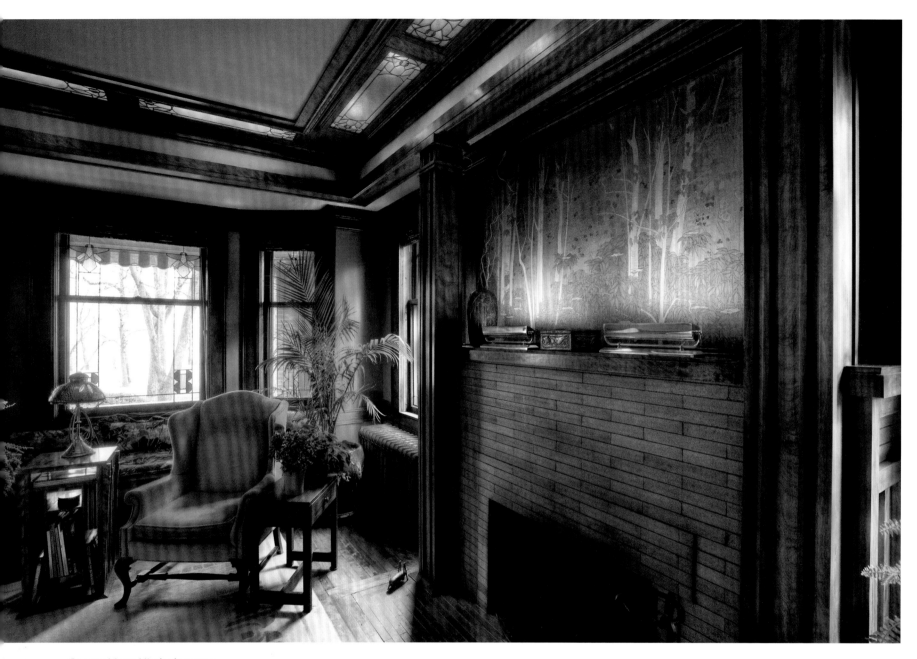

George Mann Niedecken was an accomplished fine artist as well as an interior architect. He painted the birch grove mural specifically for the Mayer living room. The mural's color palette was repeated in the original Niedecken-designed carpet.

was to be of "first quality red curly birch." The staircase also received special attention: "build all stairs per plans and sections, in the best and most substantial manner, as per detailed drawings . . . all of which must be wrought from the most thoroughly seasoned materials of every kind."

Lotter and Niedecken's combined contributions result in a Tudor Revival house on the exterior with an Arts & Crafts interior. Each made a significant contribution to the quality and character of the home. Lotter proposed a tile surround for the living room fireplace topped by a wood shelf and panel. Niedecken's design substitutes a subtly variegated brown Roman brick that he would have been familiar with from his work with

Frank Lloyd Wright, Herman Von Holst, Percy Dwight Bentley, George Elmslie, and other Prairie architects. Niedecken replaced Lotter's proposed wood paneling with a sumptuous autumnal mural. This mural—abstracted birch trees whose golden leaves shimmer at twilight, the white trunks are nestled in a bower of soft gray-green ferns—set the stage for the color scheme throughout the first floor. It has been suggested that the imagery came from the shores of Pine Lake, an evocative landscape for both the Mayers and Niedecken.

Lotter was best known in Milwaukee as the architect of flamboyantly designed movie theaters during the city's golden era of theaters from 1912 to 1923. His 1,150-seat Butterfly Theatre sported a twenty-foot-tall terra-cotta butterfly on the exterior that was illuminated by one thousand lightbulbs welcoming patrons to the red velvet– and gold-leaf-decorated theater. He was not the only architect of society homes to design movie theaters, although he was in the first wave. Lotter's movie theater background likely influenced his drawings of cove lighting in the Mayer home's living and dining room ceilings; Niedecken designed the stained-glass ceiling panels. The living room cove is lit with forty-one standard-size bulbs; its tin-cast finish enhances the light's reflectivity.

While Lotter marked the drawings for the library, dining room, and reception room windows "L.G." for leaded glass, Niedecken designed a highly abstracted insect motif that some think looks like bees while others say it represents the lightning bugs illuminating Lake Park on summer evenings. Abstracted frog and bird images are found in other interior and exterior windows. The interior windows are backlit to give the impression of daylight. Natural daylight to the windows on the north elevation was blocked when a large house was built on the property line. At the time, it was common practice to have a distance of only six feet between buildings.

IN ADDITION TO THE MAYER RESIDENCE, Niedecken is responsible for two other outstanding residential interiors in the North Point North neighborhood: the Frederick C. Bogk and Mrs. Emma Demmer homes, which he worked on in collaboration with the respective architects, Frank Lloyd Wright and Beumming and Dick. Niedecken's interest in design began early. In 1890, twelve-year-old Niedecken started art classes at the Wisconsin Art Institute in Milwaukee, where he received a well-rounded course of studies in figure, still life, and landscape drawing and painting. Niedecken proved a keen observer of Wisconsin's native trees, shrubs, and plants and excelled at landscape painting. His art education continued at the Art Institute of Chicago, where he would study with Louis Millet, an École des Beaux-Arts graduate, who had founded a new department: Decorative Design. Millet's curriculum encouraged students to think in a cross-disciplinary and holistic manner, one in which architecture, landscape, interior furnishings, and finishes were to be integrated into one big design idea. Millet exposed his students to the writings of English architect Owen Jones, whose thirty-seven propositions for "General principles in the arrangement of form and color, in Architecture and the Decorative Arts" became the credo for a new generation of designers known as interior designers, or, as Niedecken

A reproduction of an original George Mann Niedecken lamp designed for the Mayer home

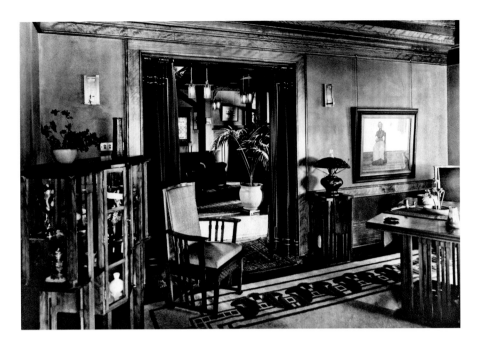

Niedecken designed the majority of the interior furnishings, including the reception room rug in this circa 1907 image. Its color palette was chosen to match Niedecken's fireplace mural. When closed, the thick portieres blocked the draft from the eastern front hall.

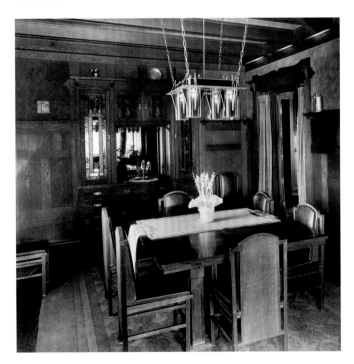

Stained-glass embellishment was a signature design element of Niedecken. He favored geometric abstractions of insects over the period's more typical stained-glass depictions of florals and landscapes.

preferred to be called, interior architects. Proposition 1 was "The Decorative Arts arise from, and should be properly attendant upon, Architecture." This strict approach was a strong reaction against the riotous mixing and matching of the lavishly eclectic Victorian era and the lack of restraint of the overfurnished and overdecorated interiors of the Gilded Age.

In the late 1890s most interior design was the provenance of architects and their retinue of upholsterers and painters. This changed in 1897 when Edith Wharton and Ogden Codman Jr. wrote *The Decoration of Houses,* their wildly popular book that caused a tidal wave of interest in interior design as a discipline distinct from, yet in collaboration with, architecture. Frank Alvah Parsons began a professional course of study in interior design at the New York School of Fine and Applied Arts in 1904, which later became known as Parsons The New School for Design. Elsie de Wolfe, the self-proclaimed first professional interior designer, got her start with architect Stanford White in 1905. And then there was Frank Lloyd Wright, who was well known for his innovative and unified interiors, many of which were actually collaborations with George Mann Niedecken.

As a member of the Chicago Architectural Club—a collection of architects, draftsmen, artists, and manufacturer's representatives who were interested in freehand sketching and rendering—Niedecken met some of the architects with whom he later worked professionally: Dwight Perkins, Robert C. Spencer Jr., and Myron Hunt. They admired his skill with perspective renderings and watercolors and his understanding of architecture.

After two years in Chicago, Niedecken went to Europe, where he was exposed to the work of Austrian architects Koloman Moser, Josef Maria Olbrich, and Otto Wagner—architects who also designed furniture, glassware, toys, graphics, textiles, bookbindings, jewelry, and flatware. As members of the group of artists known as the Vienna Secession, their work included clean lines and repeated motifs based on abstraction of pure form—elements that struck a chord with Niedecken. In their work he saw Millet's philosophy of integrated allied arts become a reality.

Upon his return to Milwaukee in 1902, Niedecken and other former Wisconsin Art Institute students formed the Society of Milwaukee Artists. He also taught courses on interior design—illustration, decorative arts, interior architecture, and furniture—at the newly formed Milwaukee Art Students League. After his marriage to Mary Thayer, Niedecken joined his brother-in-law John Wallbridge to form Niedecken-Wallbridge, an interior decoration studio, in 1907.

Niedecken's personal philosophy was that "eccentricity rarely makes for good art" and concluded that a professional interior designer is one who is an artist at heart, understands the fundamentals of architecture, and wants to achieve the harmony of a building with its environment. These principles can be seen in his work at the Mayer home. Niedecken's notes on the back of his photographs clearly show how intentional he was about

the integration of interior and exterior design elements, color coordination, and placement of furniture designed for a specific location, like the dining room table, chairs, and its built-in china cabinet. These notes are a boon to the current owners in their efforts to faithfully re-create Niedecken's design intent in the first-floor reception areas.

Today, the first-floor plan is almost exactly as it was when the Mayer family lived in the home, with the exception of the library/sitting room. The original floor plans show the first-floor northeast room as a library that was one step up from the main hall and separated by a half wall—a subtle way to demarcate the room from the hall without blocking the view to the park and Lake Michigan from the staircase. At some point the floor was made level with the other rooms.

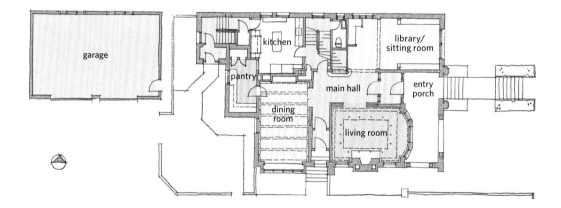

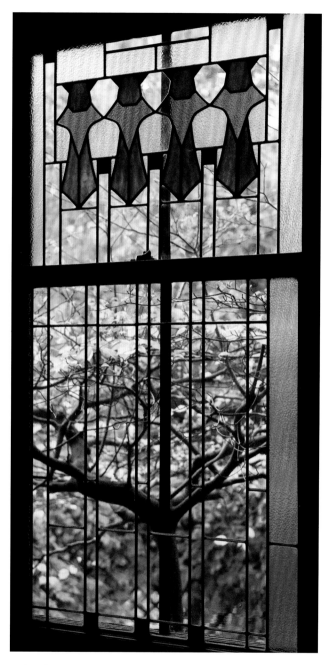

A detail of Niedecken's glass in the dining room

This Tudor Revival overlooking Lake Michigan envelops an extraordinary example of an Arts & Crafts interior. Because of the chronology of styles, this coexistence is not unusual and follows English precedents.

The Adam J. Mayer home's central east-west entry axis and north-south minor axis organize this tightly sited plan. Additional entries at the south and west respond to auto and service access needs. Later construction of the neighbor to the north diminished the home's daylighting.

Not unlike its Victorian precedents, the vestibule plays into a hall and decorated stair from which all the public spaces are accessed. To the south is the living room or parlor with its museum-quality Arts & Crafts space including interior architect George Mann Niedecken's mural. Dotted lines in this plan indicate the home's original recessed light soffit of connected horizontal Prairie-style lines.

To the north of the entry, the library, originally separated by a level change and stub walls, has been folded into one unified space defined on the west by the imposing stair volume. Dotted lines here denote ceiling drops and portals. Continuing west, the visitor enters Niedecken's richly crafted dining room with its Arts & Crafts composition of wood, glass, furniture, and casework; coffered ceiling beams are represented by the dotted lines. To the northwest is the home's utility quadrant with a sensitively updated kitchen, a pantry, and rear vestibule.

Until recently the third floor was used as an office and storage space. The current owners took advantage of the full-height ceilings to create guest rooms, a billiards room, a media center, and a full bath.

WITH ITS FOUR FULL FLOORS of living space, the Mayers' Tudor Revival was built for family gatherings. Bette Drought, a granddaughter who lived in the home in the 1950s, remembers that a typical Sunday dinner would include ten to twenty family members and that each Christmas the holiday tree filled the alcove at the base of the front staircase while its peak reached past the second-floor stair landing. Half the attic was a full-height ballroom that the children and grandchildren played in; the maids' rooms and their bath occupied the other half. A large billiards room in the basement was daylit by ample windows, and there was direct access to the small backyard. Window seats in eastern rooms provided quiet places from which to enjoy the ever-changing views over the park to the lake.

After Pauline Mayer's death in 1947, her son Fred and his family moved in to care for Adam. The Mayer family sold the home in 1971, eleven years after Adam's death, with most of the furniture in situ because Niedecken designed the furniture specifically for the house. At some point the second owner removed the furniture from the house; some was sold and some was stored. Fortunately a number of the original pieces—including the hall clock, the reception room tabouret, and armchairs—are now in the Milwaukee Art Museum's decorative arts collection.

David Stowe and Gene Webb are the fourth owners; they purchased the home in 2001 from two college professors whose major contribution was the design of an outdoor patio. Stowe and Webb have remodeled the kitchen as well as the two upper floors. The second floor has a library and a master suite that is comprised of the family chambers now serving as individual but interconnected rooms for sitting, sleeping, and dressing; maids were once called to the family bedrooms via a buzzer/enunciator system. The third floor

Gustav Stickley

Wisconsin-born Gustav Stickley stands as the central figure in America's Arts & Crafts movement.

This movement began in mid-nineteenth-century England as a reaction to the deleterious effects of industrialization. Factory goods were seen as cheaply produced and of lesser quality, with ornament often used to mask inferior fabrication or materials. Working conditions were seen as inhumane. William Morris led a revival of past handicrafts married to simple designs. In his magazine *The Craftsman,* Stickley advocated his own democratic "Craftsman idea" for furniture, ironwork, textiles, and housing design.

Gustav Stickley was born in Osceola, Wisconsin, in 1858 to a farming family. In 1876 he discovered his calling while working in Pennsylvania at his uncle's furniture factory. In 1884, with his siblings,

Gustav formed Stickley Brothers Company. Unable to afford sophisticated equipment or many power tools, they created Shaker-, Colonial-, and Windsor-style chairs mostly with demanding handwork. By 1888 Stickley was in partnership with Elgin Simonds and his brother Leopold, producing Chippendale, Hepplewhite, and Empire style furniture for Colonial Revival tastes in their Syracuse, New York, factory.

By the end of Stickley's second decade of furniture making he had prospered by providing for the American demand for traditional styles. But his reading of Emerson as well as English Arts & Crafts proponents John Ruskin and William Morris was leading him elsewhere. He and Leopold formed the Gustav Stickley Company in 1898. That year Stickley was starting to experiment with Arts & Crafts designs and, by 1901, inspired by Buffalo-native Charles Rohlfs and European examples, Stickley was showing strong and confident Arts & Crafts designs. Stickley started *The Craftsman*

magazine to publicize his work and to extol his Arts & Crafts ideals.

Stickley's Craftsman idea as applied to his furniture, interior design, metalwork, textiles, and house design was derived from established Arts & Crafts principles: the ideal of honesty of materials, solidity of construction, utility, adaptability to place, and aesthetic effect. Honesty of materials meant that the function of the furniture or design should be apparent; the designer and artisan therefore needed to appreciate the nature of the materials and express that nature in the end product. Solidity of construction relied on a boldly visible means of assembly to provide added visual interest. Utility called for functional products for daily use, the durability of which may also explain their long-lasting appeal. Stickley's enduring achievement was popularizing the Arts & Crafts style in the United States with affordable, designed items for the middle-class consumer—the iconic Stickley furniture designs coveted by collectors today.

Light streams through the numerous third-floor windows of the Mayer home, the tallest house on the block.

(which over time has been a ballroom, game room, and office) is now an entertainment center and billiards room, and the former maids' rooms are guest rooms.

Stowe and Webb admit that they bought the house for the neighborhood and its proximity to Lake Park—the same things that spoke to Adam Mayer when he purchased the lot for his future home. It was only after the couple was living in the house for a while that they actively began educating themselves about Niedecken and the Arts & Crafts movement. Slowly, they are returning Niedecken to the home in replicas of his designs. Following the Arts & Crafts tradition, they commissioned pieces from a Milwaukee woodworker who obtained permission from the Milwaukee Art Museum, which holds the Niedecken archives, to reference the original Niedecken drawings.

Until recently George Mann Niedecken was treated like an understudy for the star architects with whom he collaborated. But Niedecken and the architects he worked with understood the difference between mere interior decoration and equal design collaboration. For too long the myth of one genius dominated the study of architecture. Today the chorus of supporting actors is gathering a fan base and the history of architecture is becoming all the richer for the harmony that blends with the melody. The Adam J. Mayer house is a superb example of Niedecken's artistry thanks to the generations of owners who chose not to renovate the main living spaces. Niedecken's legacy endures in the current owners' dedication to a long-term plan to furnish the home, piece by piece, with reproductions of Niedecken's original creations. •

Brooks Stevens House

Fox Point
1939

OPPOSITE: The current owners remodeled a series of service rooms into a guest suite and family room (pictured). The latter's geometry and patterning evoke the Hiawatha passenger car Brooks Stevens designed for the Milwaukee Road.

THE 1930S WERE, for most Americans, a time of economic insecurity. Many people striving to be part of the middle class possessed a strong desire to fit in, to not stand out, to associate with people like themselves, and to adjust their individuality to match the era of standardization, mass production, and corporate culture. This was the era of the Yes Man, one who went along to get along. And then there was Brooks Stevens, the industrial designer who broke the mold, many times over. Stevens's Village of Fox Point home was (and still is) a light and modern residence in a suburban neighborhood of stone and brick revival homes. His irreverent house is not irrelevant: its Art Moderne lines boldly suggest optimism for a brighter and better future—one in which the suburb would play a major role.

FOX POINT WAS NAMED by surveyors in the late 1880s who observed that the shoreline along this section of Lake Michigan resembled a fox's head. The surveyors had chosen the rail route through Fox Point in 1870, cutting travel time between Fox Point and Milwaukee from five hours by ox cart to half an hour by train. While the railroad's location did not greatly change the character of the farming community, it would play a more significant role in later real estate development.

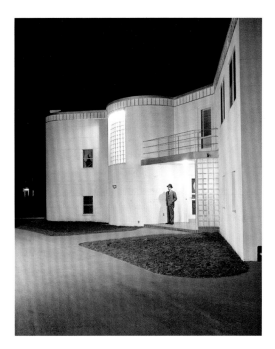

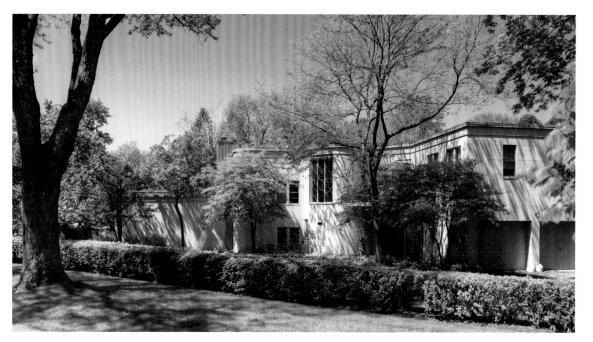

LEFT: Brooks Stevens at the entrance of his newly completed home, circa 1945. RIGHT: When the Brooks Stevens house was built, its stark, white geometric shape stood out in a neighborhood of Tudor and Colonial Revivals. Today, the curving geometries meld into a veil of cast shadows.

After the two great simultaneous fires of Chicago and Peshtigo on October 8, 1871, people quickly cut down trees in Fox Point to cash in on the high prices that could be charged for the suddenly scarce lumber: Chicago needed wood to rebuild and Peshtigo's lumber operation was shut down. By the 1890s most of Fox Point was deforested or deserted farmland, and its early settlers had moved south to Milwaukee or farther north.

Residential growth in Fox Point, stemmed by the financial panic of 1893, eventually came in 1898 in the form of the nine-hole Fox Point Club. Golf was a recreational rage storming the country, and well-to-do Milwaukee families built summer homes near the new golf course.

Real change came to Fox Point in the 1920s, when the summer residents realized that with the improved roads and the automobile they could live there year-round. In 1920 Fox Point's population was only two hundred, but properties were selling quickly. Whitefish Bay, a village just to the south, was eager to annex part of Fox Point. This proposed action propelled property owners in Fox Point to band together to incorporate the village in 1926 to avoid higher taxes they would incur if absorbed by Whitefish Bay. When the property boundaries were drawn, the area of the Village of Fox Point was 2.8 square miles, with two and a half miles of spectacular Lake Michigan frontage.

In 1927 a park commission and a village plan commission were organized to take a long-range look at how the community—a first-tier, post–World War I suburb of Milwaukee, or the first ring of suburbs around an urban center—would grow. Town planning, driven by East Coast architects and landscape architects, was booming.

There are earlier notable Midwestern examples of planned communities: Riverside, Illinois, which was planned by Olmsted and Vaux in 1869; and, in Wisconsin, John Nolen's proposed 1908 design for Madison, the Olmsted Brothers' 1924 Village of Kohler plan (although this was directed not by a civic committee but by private interest), and the 1917

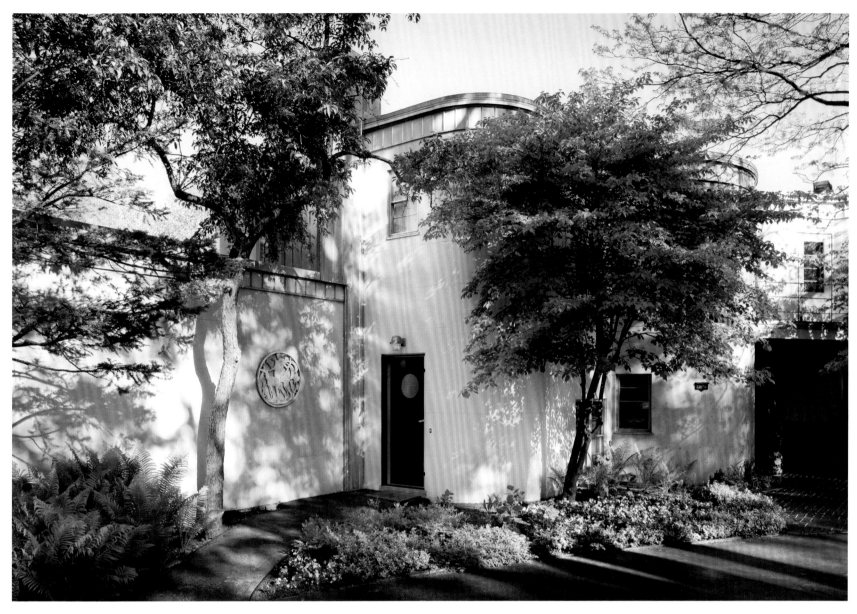

Werner Hegemann plan for the Washington Highlands in Wauwatosa. Unlike the others, the Village of Fox Point did not retain a nationally known planning firm. Instead, it formed a commission of local residents, including Charles Whitney, an internationally respected engineer and architect, and Hugh Guthrie of Leenhouts and Guthrie architects. The commission, looking to follow Kohler's lead, proposed a village styled on the popular Garden City movement in England, one in which all of the architecture in Fox Point would be of the English garden village style, with brick and stone houses that would be at home in the Cotswolds built on winding, tree-lined streets. But the planners faced resistance due to costs and the preference for Colonial and other revival styles.

The village was divided into three categories of lot size; some lots overlooked the lake, others were wooded. "A" lots, the largest, were located east of Lake Drive. "B" lots, a third

ABOVE AND RIGHT: Until the 1960s many suburban households had daily help and milk and grocery deliveries. Few service entrances, though, are as discreet—or Art Moderne—as this porthole door flanked by a medallion of a god and his greyhound.

The Wienermobile, 1958

Innovations of Brook Stevens

Plastic laminate was a serendipitous byproduct of Westinghouse experimentation in wire insulation, a result of the incorporation of glued laminations of craft paper and plastic coating. In 1955 Brooks Stevens was enlisted by the Formica Corporation to generate a new line of patterns for its ubiquitous Formica plastic laminate line. Around this time, Stevens was also creating a four-pointed amoeba-like trademark for the Frederick Miller Brewing Company. The evolution to a three-pointed series of repeated overlapping boomerangs for Formica was both pleasing and popular. While Stevens's fellow industrial designer Raymond Loewy is credited with tweaking this design, authorship for this plastic postwar icon goes to Stevens. And boomerangs do indeed come back, with Stevens's patterns enjoying periodic reissue.

Another Stevens icon still going strong is the Oscar Mayer Wienermobile—along with the plastic Wienermobile whistle souvenirs still handed out by its drivers.

the size of "A" lots, were west of Lake Drive and east of the railroad tracks. And "C" lots were west of the railroad tracks and half the size of "B" lots. The village hired Eschweiler and Eschweiler—a prominent Milwaukee architecture firm, known for revival-style homes on Milwaukee's east side and buildings at Downer College—to design a civic center in a vaguely European village style, with gable ends, pitched roofs, an arcaded ground floor, and a corner clock tower. But the need for a school for Fox Point's rapidly growing population of school-age children was more pressing, and the civic center was never built. Eschweiler and Eschweiler was once again brought in, this time to build the school that opened in 1935.

Milwaukee-born Brooks Stevens studied architecture at Cornell University from 1929 to 1933 and spent those summers working for Eschweiler and Eschweiler. His father, William Clifford Stevens, vice president of engineering for Cutler Hammer, suggested that the Great Depression was a difficult time to become an architect, so Stevens returned to Milwaukee in 1933 without a degree. Two years later, with help from his father's business contacts, Stevens opened his first office on North Milwaukee Street in downtown Milwaukee. The country was still deep in the throes of economic collapse, but Milwaukee had a strong manufacturing base and there were opportunities for those with specific skills and the right contacts. At the age of twenty-four Brooks Stevens was head of Brooks Stevens Design, an industrial design studio.

Industrial design was a young profession developed in response to industry's need for a new look for products suited to the modern age. It married the previously separate jobs of product development and aesthetic design. The term *industrial designer* had first entered usage in a 1913 patent office reference to "art in industry." Industrial designers were an amalgam of engineer, architect, sculptor, and graphic designer. Because there were no schools of industrial design at this time, people learned on the job, often as consultants to large manufacturers, utilizing their various professional backgrounds to design new, or new looking, products.

Stevens's office was known for its product design of steam irons, motorboat engines, clothes dryers, lawn mowers, vacuum cleaners, refrigerators, golf carts, toasters, a peanut butter jar, and the "boomerang" Formica design that is still a ubiquitous countertop pattern in kitchens, bathrooms, laundry rooms, and restaurants across the United States. Stevens was considered a natural-born salesman who enjoyed aligning himself on the side of corporate culture. His fame came equally from his truly distinctive designs— the Excaliber, the Zephyr Land Yacht for William Woods Plankinton, the Johnson Wax Research vehicle, the Western Printing van, and the world-famous Oscar Mayer Wienermobile—and his self-promotion. A skillful presenter, he was as sought after as a speaker. His most infamous contribution to the profession of industrial design was his appropriation and popularization of the phrase *planned obsolescence* in a 1954 speech in Minneapolis.

The phrase was commonly known among advertising and marketing types— Bernard London, the New York real estate broker who had coined the phrase, had self-

published a pamphlet in 1932 entitled "Ending the Depression through Planned Obsolescence"—but Stevens used it to his great advantage on his lecture circuit, and executives liked his thinking. Stevens's definition of *planned obsolescence* was "instilling in the buyer the desire to own something a little newer, a little better, a little sooner than is necessary."

Throughout Stevens's career, Milwaukee connections were important to his success. In large part, he worked for and hired people whom he knew from childhood. He had attended the Milwaukee Country Day School and was a classmate of the sons of Milwaukee's business and manufacturing elite. This secure platform launched a confident young man ready to compete in a brave new world. Brooks Stevens and other notables like Raymond Loewy, Henry Dreyfuss, and Walter Dorwin Teague are recognized as the first industrial designers in the United States. In 1944 when the Society of Industrial Designers was organized, Stevens was the only one of the ten charter members whose firm was not located on the East Coast.

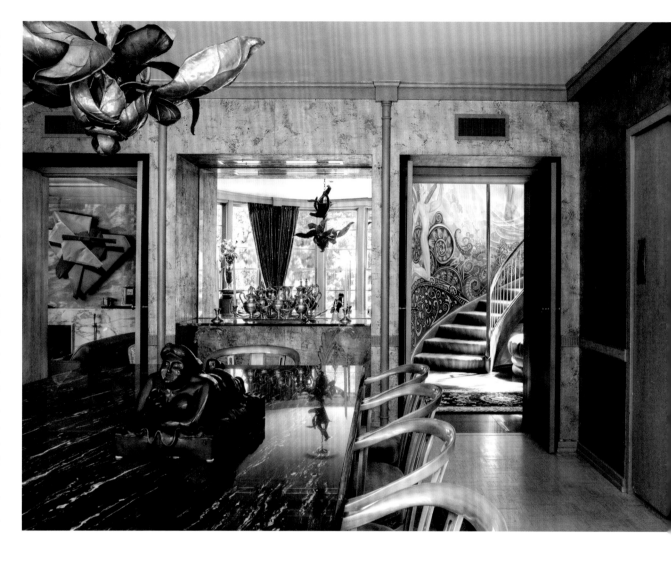

In 1937 Brooks Stevens married Alice Kopmeier, the granddaughter of the Joseph Schlitz Brewing Co. president Henry Uihlien. Two years after their marriage, Mr. and Mrs. Stevens built a home in the Village of Fox Point. It was the perfect location for the couple, both of whom came from socially prominent Milwaukee families.

Their home is considered Stevens's most complete architectural project. His collaboration with Fitzhugh Scott Jr. was quite logical as they were similar in age and background. Fitzhugh Scott Sr. was one of Fox Point's early planners.

The design for the home in architecturally conservative Fox Point was possibly a little too new and a little too soon. In the late 1930s the Stevenses' neighbors were building sprawling Colonials, majestic English manor houses, and charming French country villas. Stevens, with architect Fitzhugh Scott Jr., designed a concrete, flat-roofed, two-story Art Moderne home. The crisp, curvy, bright, white, contemporary home with a swimming

ABOVE AND LEFT: The dining room, circa 1945, and today. The current owners added a wall mirror to borrow a view of the landscape.

ABOVE AND RIGHT: Brooks Stevens designed the dining room's sculptural glass-and-Lucite buffet.

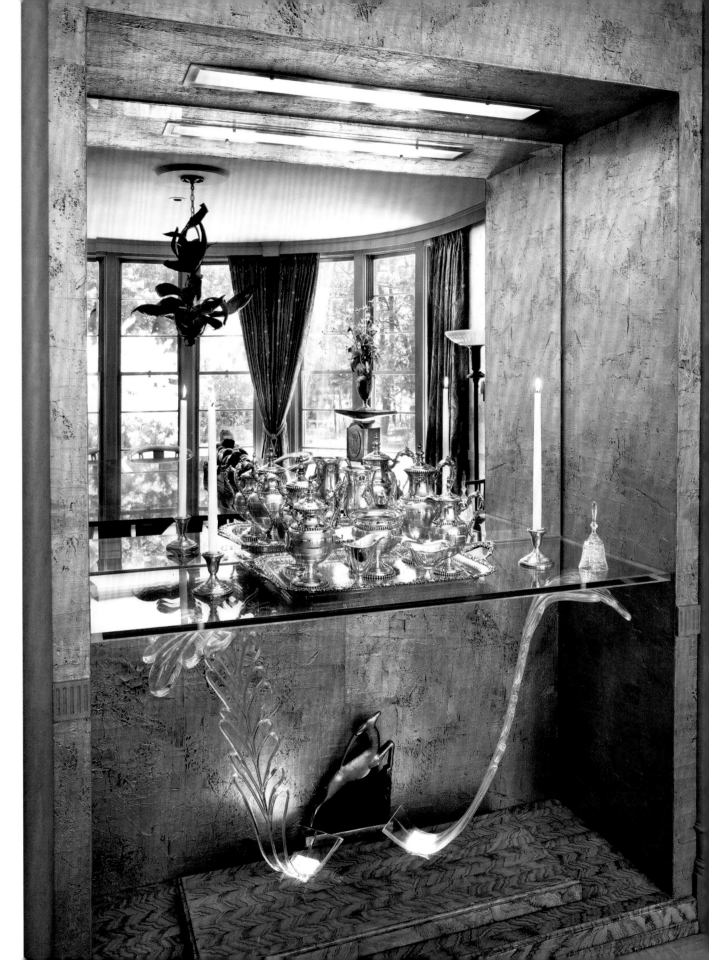

pool, tennis courts, and a stunning garden was the perfect stage for a man who could have come straight from central casting as the dashing, successful modern man. The house employs the five basic tenets of modernism: simplicity, unbroken lines, use of pure color, contrasts in light and shadow, and honesty in materials.

Moderne, modernistic, Depression Modern, or, more precisely, Art Moderne was a new, uniquely American architectural style derived from the industrial designs for airplanes, automobiles, trains, and oceanliners (round windows were suggestive of portholes). Art Moderne hallmarks are smooth walls of stucco or concrete topped with flat roofs. Horizontal roof copings are visually reinforced with railings and horizontal construction-joint-like reveals or bands in the walls. Corners projecting from the main building are often rounded; deeply inset, circular accent windows are common; and glass block is frequently used. It was the perfect architectural choice for the Brooks Stevens home. This style derived its expression from efficiency of form. Like the image of America in the 1930s, the style was spare and straightforward. It complemented the machine age, while it coexisted stylistically with the International or Modern style. Americans employed more technology (such as air conditioning) in their designs, which gave them more flexibility in volume and form than their European counterparts, who still depended on natural light and ventilation. In the Milwaukee area the Art Moderne style was more often associated with businesses than single-family homes.

The Stevenses purchased two parcels of land; the site, even for "A" lots in the Village of Fox Point is sizable. Their Art Moderne home's undulating sculptural facade gives few clues to the interior plan organization. Tucked between two curved walls, the front door is only revealed on approach, making the house as private as possible. A second-floor bedroom balcony doubles as the entrance canopy.

Rounded Art Moderne forms seen here help erode the traditional "box." The visitor is admitted to an entry hall—dramatized by the circular stair—affording views and access to public spaces of living and dining. Modern sensibilities employed this entry point, with sunlit connecting corridors, in lieu of a great hall. Daylighting's healthful and economic benefits in the workplace were translated here to major residential spaces that maximized natural light.

This home's access point, which is unusually close to its southeastern property line, was probably sited there for privacy. This siting also maximizes views of the expansive grounds and landscape development to the west and north—although it's at the expense of optimum solar orientation.

Early on, the northwest porch was weatherized for year-round use, while the southwest wing was added for support staff. In keeping with contemporary socializing, sensitive recent revisions—much in the original spirit and detailing—have further opened the kitchen area to the visitor.

The Art Moderne porthole window offers a glimpse of the more traditional architectural housing styles favored by the Stevenses' neighbors.

The first floor was designed with entertainment in mind: the rooms flow one into the other, but each is designed for opportunities to see and to be seen. One can almost imagine the men standing at the bar at the base of the stair watching the women parading down the spiral staircase in their party gowns. The vestibule—the only space on the first floor with four right angles—acts as a locus point to gather one's bearings. From there, guests sweep into the dining room, where a curved, floor-to-ceiling window wall composed of glass and steel affords views of the landscape beyond. Suddenly one has left the suburbs and encounters the countryside. The dining room has two formal doorways: one leads a step down to the living room; the other leads to the entry hall, framing the view of the circular staircase with its chrome handrail and faceted stained-glass window. Current owners Jodi Peck and Les Weil commissioned an Art Deco–style mural of dancers in vibrant secondary colors on the staircase wall.

The living room is the most muted space. Indirect lighting focuses on the planes of the tiered ceiling, and the furniture appears to be in silhouette. It is a moody and seductive room. Just off the living room, the sunroom is more casual: the two walls of glass windows lend the room a resort ambience. Direct light, reflected light, indirect light, and shadows are used to artful effect, with major residential spaces laid out to maximize natural light.

Designing and driving cars was a passion Stevens first shared with his father and later with his sons. Throughout his design career there are brilliant examples of his automotive styling, from the first Jeep Wagoner to the Gremlin. He designed for the Auburn Company and Studebaker in Indiana; Kaiser-Frazer in Michigan; Alfa Romeo in Italy; and a number of independent car manufacturers. Early black-and-white photos show Brooks Stevens–designed cars parked on the semicircular driveway in front of the house—its simple, white backdrop a good foil for the dark, sleek automobiles. Stevens built a large garage screened by evergreen shrubs at the west end of the yard. His sons enjoyed working on and building cars in the backyard.

The grounds are a well-kept secret. A combination of a grand arborvitae hedge, mature trees, and a tall, unassuming grape-stake picket fence surround the property like a screen, providing Peck and Weil more privacy from the street view. Before the vegetation was mature, the home appeared starker; today, the cast shadows of leaves and branches float a decorative filigree over the concrete walls.

Twenty-two drawings of the landscape plan and construction details covering the years 1937 to 1972 are in the Harvard University Loeb Library. The landscape architecture firm was Shurcliff, Merrill & Footit, a prestigious Boston, Massachusetts, firm. (Sidney Shurcliff, once a member of Frederick Law Olmsted's firm, later assisted him in founding the Harvard School of Landscape Architecture, the country's oldest school of landscape architecture.) The sculptural quality of the ground plane Shurcliff designed results in a graceful layering of space throughout the landscape.

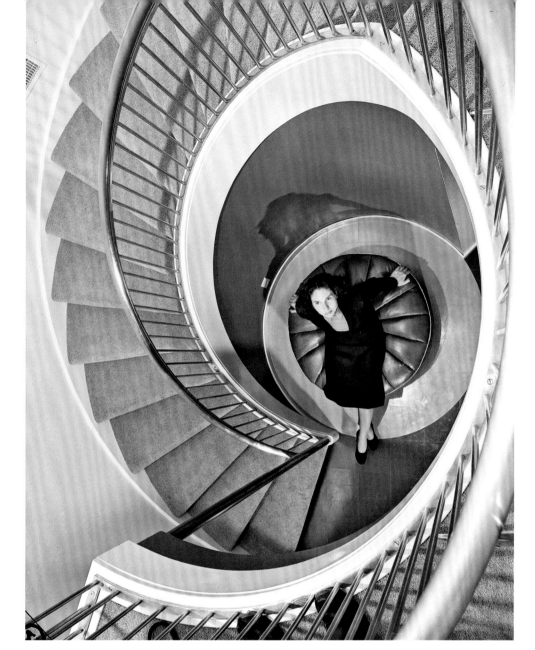

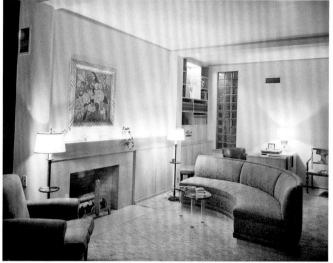

LEFT: Alice Stevens gazes up from the epicenter of the spiral staircase. The Stevenses enjoyed the drama of staging photographs in their controversial home. ABOVE: The living room, circa 1945

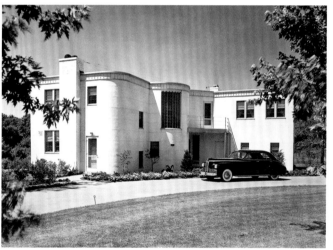

Note the original glass block windows in this photograph from 1940.

The character of the grounds is well suited to the house and to the style of entertaining favored by the Stevenses and the present owners. Home entertaining was a large part of doing business in Milwaukee during the 1940s and '50s.

Alice was an accomplished gardener and tennis player. Brooks, who had polio as a child, enjoyed swimming as therapeutic exercise. Today, the tennis courts have been removed and a smaller pool, closer to the house, replaces the original. Peck and Weil kept the unique lanai—a curving wall-less outdoor living room, its structure incorporating pipe columns as roof drains and roof vents that provide natural air cooling on sticky days—and Alice's extensive rock garden has been redesigned as an undulating lawn.

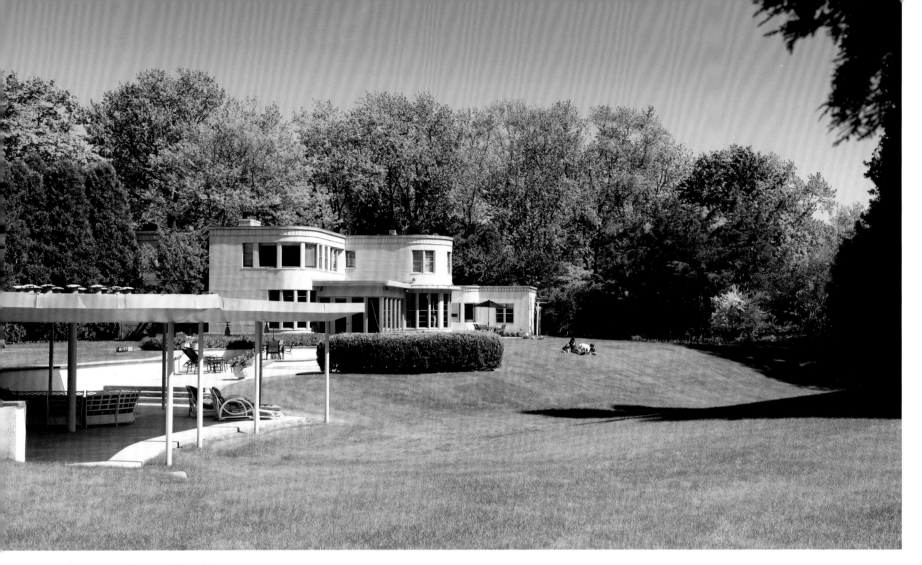

ABOVE AND RIGHT: The original landscape, circa 1945, was designed by the Boston firm of Shurcliff, Merrill & Footit. A rock garden and tennis courts were incorporated for Alice Stevens, an avid gardener and tennis player. Current owners Jodi Peck and Les Weil are more peripatetic; their lifestyle is more suited to a static sculpture garden than an intensive perennial garden.

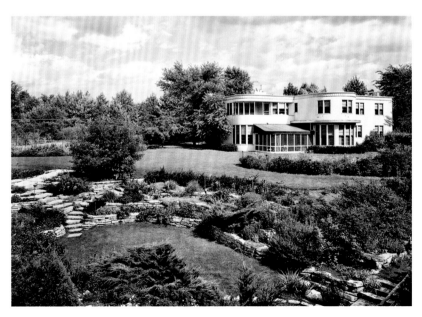

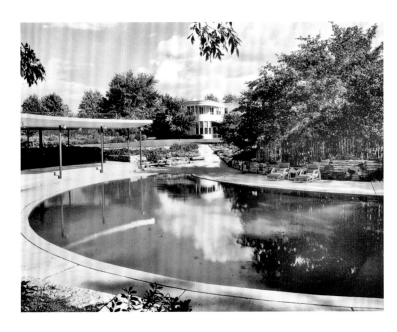

LEFT AND BELOW: The current owners downsized and relocated the swimming pool and removed the tennis courts, using the double lot to showcase their sculpture collection.

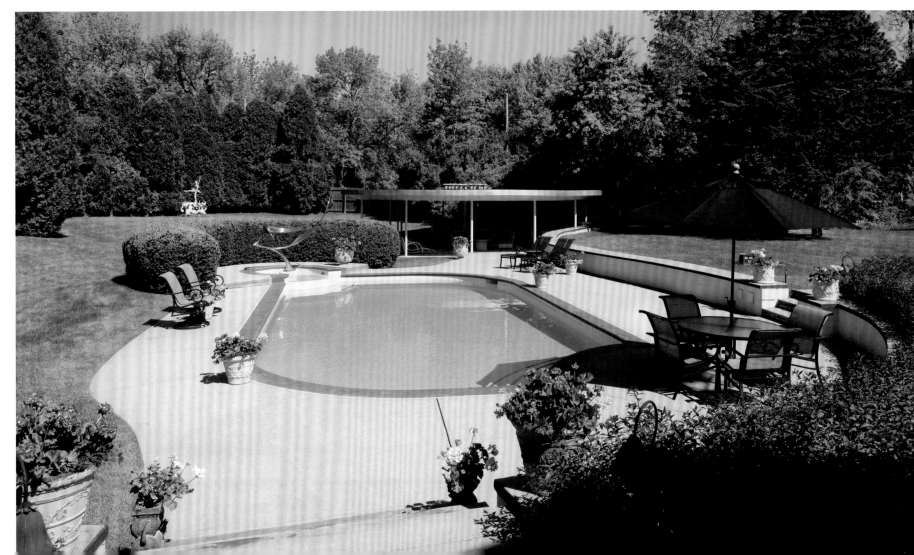

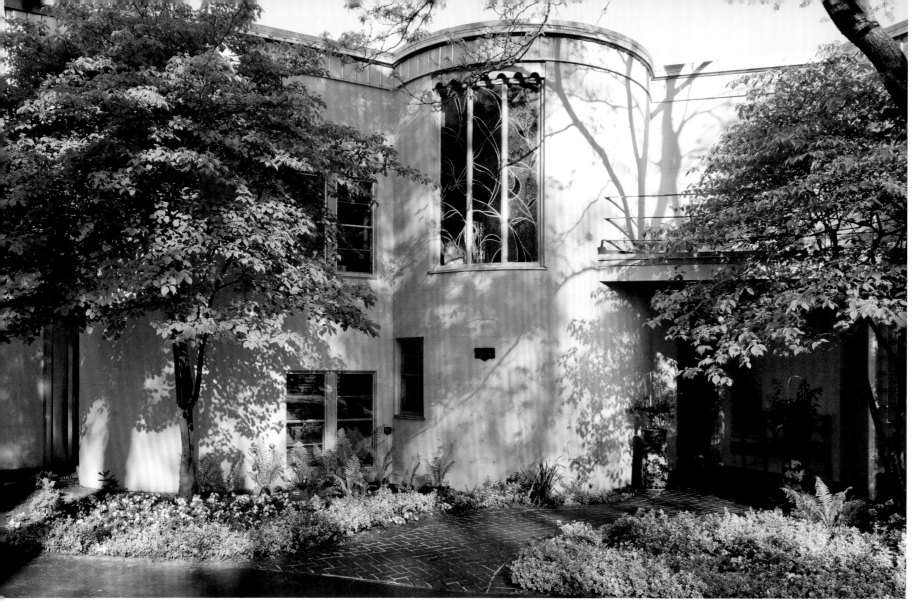

The effect of the facade's stark geometry has been softened over time as the evolving landscaping softens the look of the home.

The changes to the home and grounds, both large and small, are in keeping with Stevens's adherence to the theory of planned obsolescence. Alice slowly went about making her own changes to Brooks's design. She convinced him to replace the original glass block stairwell window in the main stairway with stained glass in an abstract leaf design. The home was originally furnished with Dunbar hand-crafted wood, steel, and tailored-upholstery furniture. The style was Modern; the target audience was those whose taste was less austere than the International-style furniture favored by architects. After an appropriate interval, Mrs. Stevens prevailed upon her husband to replace the Modern furnishings with French Provincial.

In 1951 a service addition was built on the west, its form and medallion wall decoration in keeping with the 1930s design. Several of the windows were enlarged, opening the front elevation. The second-floor master bedroom porch was enclosed, providing more usable interior space and reducing weathering problems caused by rain, snow, and wind. Tweaking and styling were all part of Stevens's image.

THE STEVENSES LIVED in the home until the 1980s. Peck and Weil, who knew the home was architecturally distinctive and had a fantastic private yard, bought the house from Stevens in 1985 and have continued to tweak and style while maintaining the integrity of the original design. The kitchen and service wing was redesigned as a kitchen and entertainment center. The terrazzo floors in the new kitchen and the "observation car" entertainment center—so called because of its tiered ceiling mural depicting floating Art Deco gods, goddesses, and gazelles—give an affectionate wink and a nod to Brooks Stevens's era, while avoiding imitation.

Brooks Stevens was a brilliant designer and an even more brilliant salesman who knew that setting the stage was as important as the object on the stage. He knew exciting was better than bland, desire was more powerful than acceptance, standardization was less invigorating than experimentation, improvement was more valued than stasis, and feeding the ego was not such a bad thing if it encouraged self-confidence. That idea, made manifest in his Village of Fox Point home, still appears modern today. Stevens designed a home that showcased his uncanny ability to fit in and stand out at the same time. •

Brooks Stevens collected cars; the current owners collect art. The simple geometries of the rooms perform as galleries for their collection. The sunroom, originally a screened-in porch, was made into a four-season room by the Stevenses.

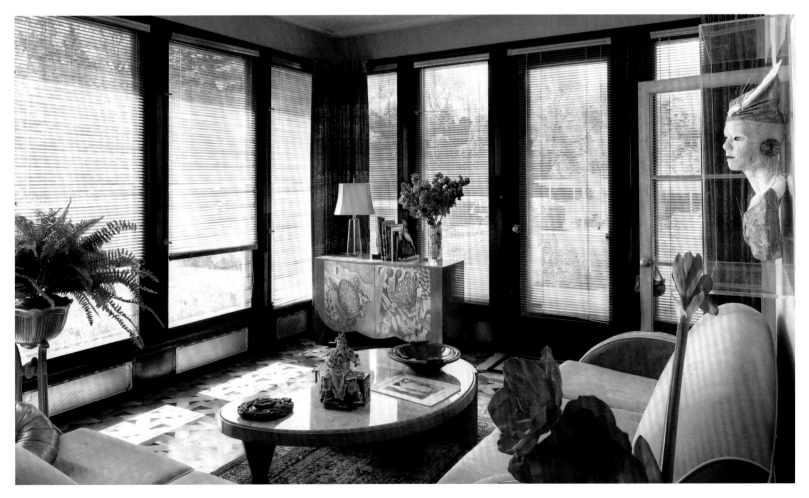

GETAWAYS

THE EXPERIENCE OF RETURNING TO THE SAME LAND YEAR AFTER YEAR, season after season, generation after generation has great appeal. The literary, sentimental, or romantic names of getaways are part of the tradition. Names such as Wadsworth Hall, Ten Chimneys, Fort Eagle, and the Island of Happy Days have the power to stir the imagination and the anticipation of pleasure into motion. Naming a getaway endows the place with a mantle of protection from everyday life.

A getaway need not be far away. Part of the appeal is being able to disappear easily from society and reappear quickly. The development of railroads, reliable paved roads, plumbing, and electricity increased the desirability of getting away from it all without having to do without any of the necessities, or even the luxuries. After the Wisconsin logging boom left thousands of acres of depleted land, the state realized that, with reforestation, scenery and tourism that celebrates the beauty and abundance of our natural resources could become important industries and a major financial boon to the state.

Wisconsin has acres of inland lakes and its topography varies from the bluffs of the Driftless Area along the Mississippi River to ridges and lowlands near Lake Michigan to pine forests in the center and rolling highlands near Lake Superior. As a result of the action of the glaciers, soil conditions change rapidly and create transitions in vegetation that enhance the sense of traveling afar even if the distance is in reality only a hundred miles.

The four getaways in this chapter were built by men of financial means. Three are remote and one is in a resort community. Three are on water and one is landlocked. Each had suffered from neglect or abandonment. These four homes were returned to their former glory by their inspired owners, who had the vision and the means to breathe new life into them while retaining the magic and historic significance that sets these extraordinary getaways apart.

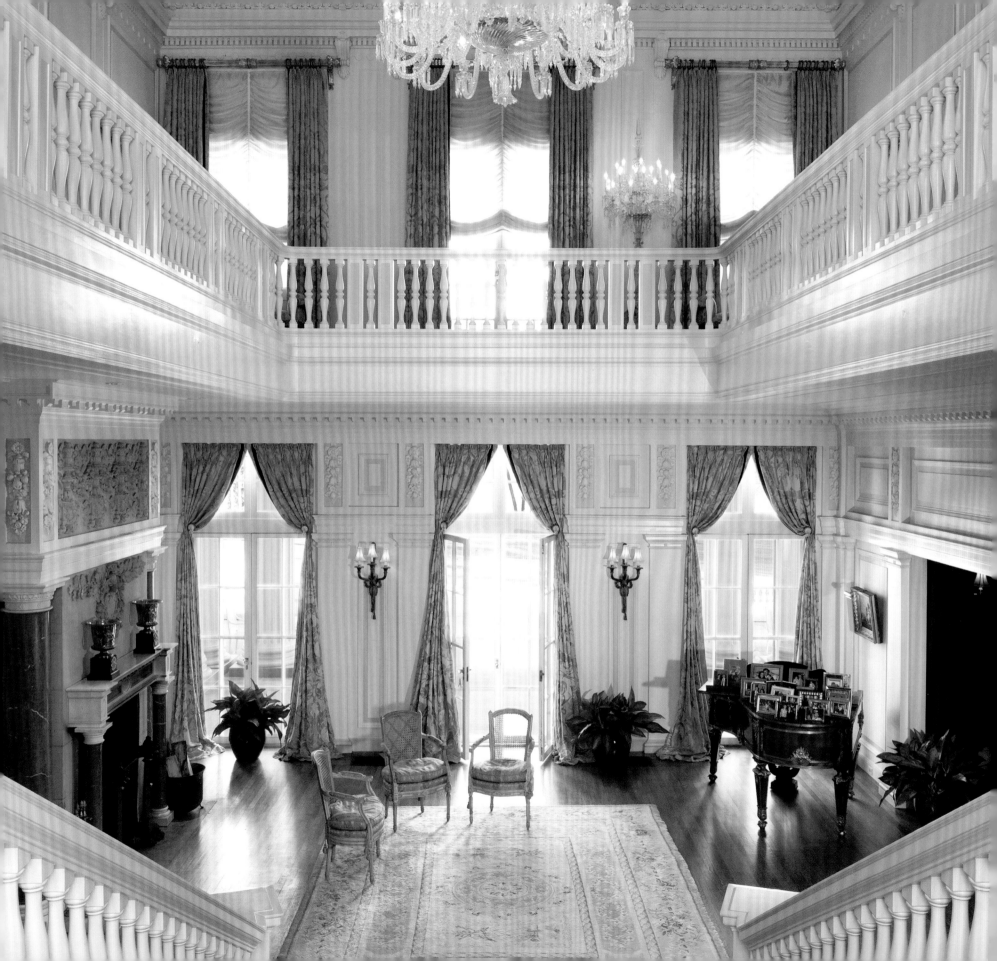

Wadsworth Hall | Lake Geneva 1905

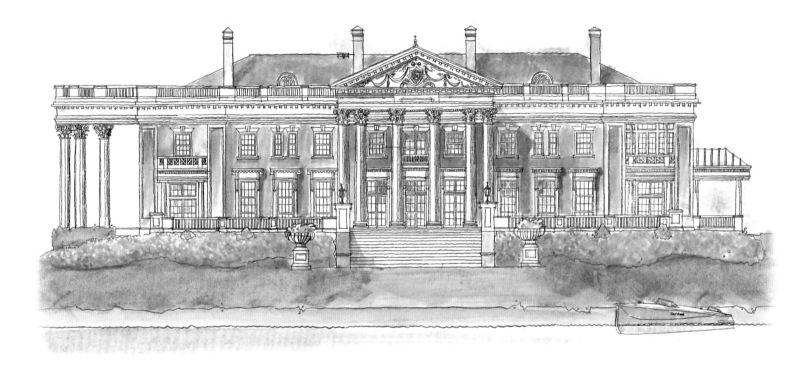

OPPOSITE: Three sets of French doors open out to the terrace that wraps around the east and west entries. The home's free-flowing circulation pattern complements Richard Driehaus's expansive entertainment style.

DURING THE LATE 1800s AND EARLY 1900s, many who made their fortunes in urban areas felt strongly the nostalgia for an idealized American rural life. New York industrialists built summer homes on the shores of the Atlantic, along the Hudson River, or in the mountains upstate. Bostonians went to the rugged coast of Maine, the sandy shores of Cape Cod, or the mountains in western Massachusetts. Milwaukeeans gathered around Delavan and Oconomowoc lakes in southeastern Wisconsin or headed Up North. About seventy-five miles from Chicago, the banks of Geneva Lake in Walworth County, with the distant views of verdant rolling hills, became a prize Wisconsin summer colony for the city's elite seeking to escape the summer heat and humidity.

Lake Geneva earned the title of "Newport of the West" because of the lavish houses built by these members of Illinois and Wisconsin high society. Chicago's hog butcher to the world, Sam Allerton of the Union Stockyards, built a summer home in Lake Geneva as did Oscar Mayer and Arctic explorer and dairy magnate John Borden. Retailers such as Montgomery Ward and Levi Leiter (Marshall Field's partner) were joined by manufacturers F. L. Maytag, Phillip K. Wrigley, Ignatz Schwinn, and plumbing magnate Charles R. Crane. Brewers Conrad Siepp and Edward Uihlein sailed with industrialists Orrin Potter of Union Steel and Martin Ryerson of Ryerson Lumber. And no early-twentieth-

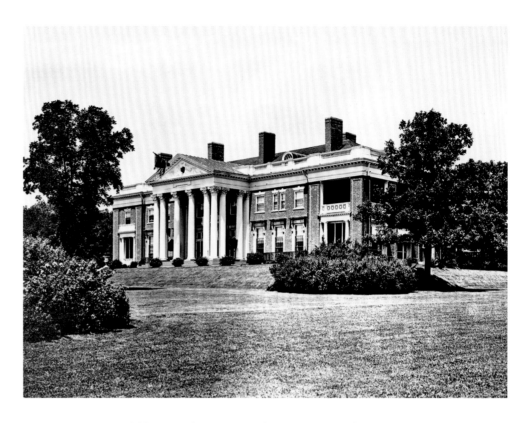

Wadsworth Hall, circa 1910: this and the other historical images of the home that follow were included in a small album created around 1910 to showcase the country residence of Norman Wait Harris.

Wadsworth Hall's formal gardens

century resort would be complete without bankers. Two of Lake Geneva's most prominent banker-residents were Sheldon Sturges of Northwestern Bank of Chicago (arriving in 1870, he was one of the first summer residents) and Norman Wait Harris of Harris Bank, who built his fourteen-bedroom Georgian Revival mansion, Wadsworth Hall, in 1905. At the time of construction, his summer residence was considered one of the crown jewels of the lakeshore estates. And the same is true today following its complete restoration and transformation into the Lake Geneva Family Estate.

SERENDIPITOUSLY, TWO EVENTS that stimulated the building boom around Geneva Lake occurred simultaneously in 1871: a rail link between Chicago and Lake Geneva was reestablished and the Great Chicago Fire destroyed many of the homes and office buildings of the Chicago elite. Concerned for the safety and comfort of their wives and children, the men decided to remodel summer cottages along Geneva Lake into year-round homes or to build extravagant new estates. Building was only one of the activities that spurred competition among the residents; an entire social scene developed around these vacationers.

At the turn of the twentieth century competitive sailing—in both summer and winter—was a popular pastime. Geneva Lake is one of the deepest inland lakes in Wisconsin; its vast expanse—it's seven and a half miles long and two miles wide—makes it one of the state's largest inland lakes. Sailing regattas were held and sailors from other Wisconsin resort communities would compete against the Lake Geneva Yacht Club crews. As soon

as children were old enough, they learned to handle a sailboat. Swimming beaches, public and private, were popular places to spend the day, and women as well as men held cross-lake swimming competitions. Since paved roads were rare, the easiest way to get a foursome to the golf course was to sail.

In addition to sports, the residents entertained themselves with musical events; some performed for their own pleasure, while others hired members of the Chicago symphony for entertainment. Astronomy (the University of Chicago dedicated its Yerkes Observatory on the western end of the lake in 1897) and nature-related activities such as birding and plant identification were fashionable pastimes.

Lake Geneva was a sentimental favorite location for holding family weddings and for honeymooners. Friends in adjoining estates would take in overflow guests for a long weekend or a week. The social season lasted from May to early fall, with some families returning to celebrate Christmas. Fireworks were a must on the Fourth of July, and the midsummer fair was much anticipated. Guests would be met at the train and sailed up, down, or across the lake to their hosts, arriving with trunks full of clothing suitable to various activities from boating to ballroom. However large the estate, the lake was recognized as the front door: piers dotted the shoreline as front porches line residential streets.

Postcard of a Lake Geneva
steamboat landing, circa 1905

Fertile soil was another amenity the area offered. Many of the estates, some of which encompassed more than 1,000 acres, were large enough to be working farms outfitted with large animal barns, horse stables, and greenhouses that provided the means for a great number of people to be fed in the course of operations at a grand country estate. Gentlemen farmers claimed the blue ribbons for prize hogs, cows, chickens, sheep, flowers, dairy, vegetables, and fruit at the annual Lake Geneva midsummer fair. It was the local help, however, who performed the lion's share of the work, serving as farm managers, horse trainers, and gardeners. These were good jobs with steady incomes, and staff was often provided with room and board. Housekeepers, cooks, maids, butlers, and chauffeurs were considered essential at a time when eighty-five guests for dinner was not unheard of. Properties on Geneva Lake changed hands frequently as owners traded up or downsized. Often the staff would be asked to remain; property owners understood the value of good help who knew the peculiarities of the property.

Many of the families who enjoyed Geneva Lake were well aware of their privileged status, and they sought to give back to their community. Some provided scholarships for local children or created trusts for local schools, and area churches were the recipients of donated funds for building additions or pipe organs. The local YMCA was a favored organization for philanthropic gifts. The Williams Bay Library received donations of money

and books, land was purchased for public parks, art and fountains were donated to the parks, a community center was built, the lake was stocked with fish, and bird and wild-flower habitats were protected by summer residents. Several owners deeded their lands as nature sanctuaries or church camps in their wills. Women organized and provided funds for summer school and domestic science classes for young local children to occupy them while their parents cleaned, cooked, and sewed at the grand homes.

ECLECTICISM, in various Gothic Revival and Queen Anne permutations, was the prevailing architectural style of the Lake Geneva mansions built in the late 1800s. Follies such as Levi Leiter's six-story working windmill with forty-foot arms and the half-timbered French château house George Sturges built in 1882 with a five-and-a-half-story witch's-hat tower were two of the more exotic examples. One friendly form of competition and expression was the relocation of exotic buildings from the 1893 World's Columbian Exposition in Chicago to the grounds of the private estates. C. K. G. Billings brought the Norwegian building to his Green Gables estate. The Ceylon Court Building was transported to the F. R. Chandler estate in twenty-six train boxcars.

In the early 1900s there was an aesthetic shift away from cobbled-together, rambling wood summer cottages to more formal architectural expressions of the American Country Place era. During the late nineteenth century the trend among wealthy families was to keep a home in the city and to build a large residence in the country. The popular styles for the new century were built of brick or stone, with impressive columns or half-timbering.

Rosalie Sturges Carpenter, whose parents' Lake Geneva home was a wood Queen Anne, built, with her husband, Hubbard, a brick Tudor Revival–style farmhouse just east of Snug Harbor, her parents' home. The Carpenters' architect was Chicagoan Howard Van Doren Shaw, whose other area designs ranged from the Mediterranean Revival Villa Hortensia for E. F. Swift and the Classical Revival Aloha Lodge for Tracy Drake to the House in the Woods, a strikingly modern for the times home for hardware millionaire A. C. Bartlett. Jarvis Hunt, the society architect who designed Cyrus McCormick's estate and several estates for the Morton Salt family on the shores of Geneva Lake, designed the thirty buildings in the Arts & Crafts style that comprised Loramoor, James Hobart Moore's estate. Perhaps the most stately and sumptuous of all is Wadsworth Hall, a Georgian Revival home built in 1905 on 32 acres for Norman Wait Harris.

Harris's ancestors emigrated from England to Charlestown, Massachusetts, in 1630. He was born in Becket, Massachusetts, in 1846. Upon his graduation from the Westfield Academy, Harris entered the insurance business at age eighteen. By thirty-four, his own insurance company, the Union Central Life Insurance Company in Ohio, was the second largest in the western United States. Ill health, however, forced him to step down from the company and, as was often prescribed, take an extended European trip to regain his health.

In 1881, restored and ready for a new challenge, Harris settled in Chicago, where he formed the Harris Trust and Savings Bank, with branches in Chicago, Boston, and New York City. Harris was well respected and admired for his philanthropic endeavors: he was

a staunch supporter of the YMCA, was involved in the Methodist Church, was a generous donor to Northwestern University, and is well remembered for his $250,000 gift to the Chicago Field Museum of Natural History to fund its Harris Public School Extension.

The twice-widowed Harris married Emma Gale in 1879; together they had five children. The couple retained the Boston firm of Shepley, Rutan & Coolidge, successor to the firm of H. H. Richardson, to design their Georgian Revival mansion, named for Henry Wadsworth Longfellow, a distant relative of Emma's. Shepley and Coolidge had been associates of Richardson's when he died. After Richardson's death, the Boston firm was awarded so many significant Chicago commissions—the World's Congress Auxiliary Building at the World's Columbian Exposition, now the Art Institute of Chicago; the Chicago Public Library, currently the Chicago Cultural Center; and more than fifteen buildings on the campus of the University of Chicago—that they established a branch office in

NEXT PAGES: Distant vistas, diversity, and water are the perfect components of a picturesque landscape. Wadsworth Hall's original landscape architects were the Olmsted Brothers. Contemporary landscape architects continue the tradition of excellence.

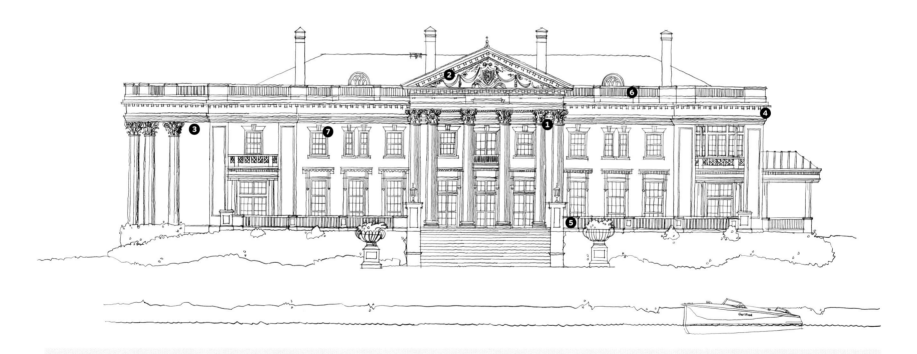

Style: Georgian Revival

Wadsworth Hall, built in 1905, with its elevation dominated by a full-height portico of Corinthian columns ❶, shares the basic hallmarks of the Neoclassical and Colonial Revival styles. Colonial Revival examples are derived from Dutch, Colonial, and, as exemplified here, Georgian precedents.

A full-height entry porch with front gabled roof ❷ is supported by seventeen-foot-high Corinthian columns that anchor a mostly symmetrical facade set off by a curved portico ❸ extension to the west. Additional style hallmarks popularized in the United States by the published works of eighteenth-century Scottish-born architect Robert Adam are seen here in the boxed eaves with small overhangs ❹ running across the entire elevation as well as the low stone balustrade ❺ defining the grade-level open veranda. The balustrade is repeated at the roofline ❻. Exaggerated broken keystones ❼ crown the second-story windows. Vertical surface accents and wall bumpouts emphasize the side and wing porch areas while breaking up the overall elevation size to lend scale to the composition. Original plans and elevations indicate little change has been made to this elevation except for the enclosure of east and west porches for year-round use.

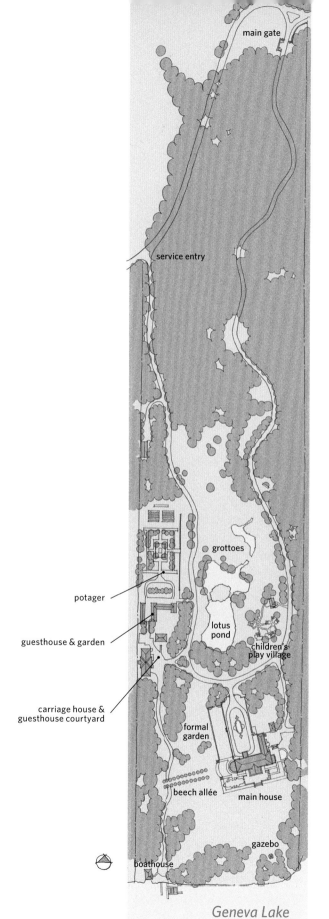

Geneva Lake

Chicago. While Richardson's firm was known for the Romanesque style, Shepley, Rutan & Coolidge designed in a variety of styles. (Coolidge had collaborated with Frederick Law Olmsted on the design of the Chicago fairgrounds, and the firm could trace its origins to the illustrious architect Charles Bulfinch.)

The Olmsted Brothers, the successor to Frederick Law Olmsted's firm after his death in 1903, provided the master plan for Harris's estate. They proposed the location of major landscape elements such as the large fruit and vegetable garden, a lotus pond, and major tree plantings. The realization of the master plan took various professionals years to execute, and the vast landscape required time to mature. During the Harrises' ownership, a network of carriage roads and horse and pedestrian paths connected neighboring estates. These paths were accessible only to property holders; the public was discouraged from roaming around the elite estates. Today many of the estates are visually accessible from a twenty-one-mile path that encircles the lake.

Harris was almost sixty years old when he built Wadsworth Hall. His daughter Pearl was married in the home in 1910, five years after the family started summering there. Harris died in Lake Geneva in 1916; four years later Emma sold the estate to Walden W. Shaw, John Hertz's partner in the Yellow Cab Company. Wadsworth Hall was renamed The Stenning, after Shaw's grandfather's home in England. He willed his estate to his daughter Bessie, who had three daughters with husband Daniel Peterkin, heir to the Morton Salt fortune. After Bessie's death in 1997, her three daughters inherited the estate. Bessie had owned the estate since 1929. In the later years it was increasingly difficult to maintain such a grand house and grounds; just the expense of full-time staff was daunting. The landscape became overgrown and the house suffered from deferred maintenance. The estate was in need of a caretaker, on many levels.

Wadsworth Hall's site stretches almost three thousand lineal feet from its northern auto access at Snake Road down to Geneva Lake. The topography and approach road gradually slope south, providing views of the home, site, and lake. The original Olmsted landscape plan maintains its structure with quality enhancements.

Visitors by car approach from the northeast past a gatehouse and through wrought-iron gates. Verdant foliage frames the meandering drive to theatrically shape the view, suddenly revealing impressive formal entry gardens and a porte cochere still scaled for carriage drop-off. The formality of the home is contrasted dramatically against the natural setting of a lake created by prehistoric glaciers.

Guests transported across the lake on yachts and boats cross the picturesque English lawn up to the residence's south entry.

To the north a playful sequence of ponds under spreading trees leads to a series of water-nourished grottoes. Farther south is a Midwestern version of Le Hameau, Marie Antoinette's play village at Versailles. To the west are the original support buildings. Appropriately scaled additions by the current owners include a potager, or kitchen garden, to the northwest and a swimming pool and pool house adjacent to the east porch.

Through the expert weaving of the landscape events, outdoor rooms, and vistas, this property yields a pleasing palatial feel beyond its actual acreage.

In 1998 RICHARD DRIEHAUS, founder and chief executive of Driehaus Capital Management, philanthropist, and historic architecture benefactor, was looking for a getaway property where he and his daughters, other family, and friends could get to quickly from Chicago for short visits. When he first saw Wadsworth Hall, the house had only been empty for a year, but it suffered from years of deferred maintenance. The grounds designed by the Olmsted Brothers were in need of attention and the exterior required extensive restoration. Driehaus took one look at the decaying mansion and decided that he would throw a grand party in the house in December 1999 to celebrate the turning of the millennium. He returned to Chicago, already planning how to transform the weary Wadsworth Hall into his Lake Geneva Family Estate—and in the process resurrect an aging relic, making it once again a stunning example of Georgian Revival country place residential architecture.

Architecture and historic preservation are among Driehaus's passions. In 2008 he was awarded the Restore America Hero Award from the National Trust for Historic Preservation. He, along with a forty-person team of experts, spent five years meticulously renovating Chicago entrepreneur Samuel Mayo Nickerson's 1883 home, which local writers of the day nicknamed the Marble Palace for its abundant varieties of marble, onyx, and alabaster. The 24,000-square-foot Neo-Renaissance stone townhouse, which opened in 2008 as the Richard H. Driehaus Museum, is a showcase for his collection of nineteenth- and twentieth-century pieces. Driehaus's offices are across the street in yet another of his restoration projects: the 1886 limestone Victorian Ransom Cable House, a Richardsonian-style mansion designed by Harry Ives Cobb and Charles S. Frost.

Unlike past undertakings, the renovation of Wadsworth Hall could not wait twenty or even five years. The first order of business was to assemble a team that could get the job done on time and to Driehaus's vision and exacting standards. While he put together

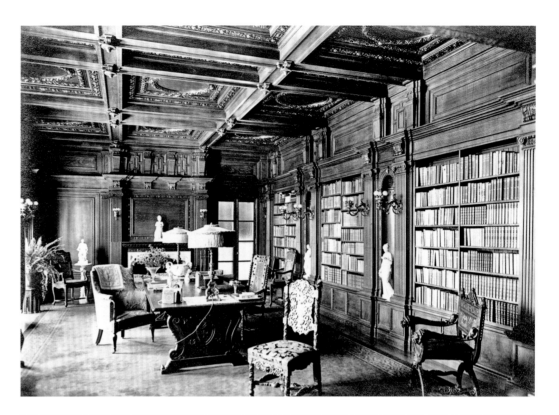

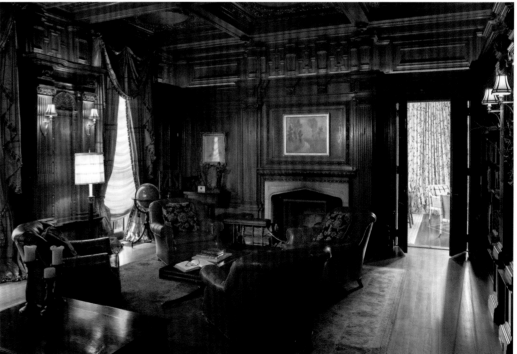

TOP: The Harris family library, circa 1910. BOTTOM: Lighting is an important aspect of the renovation of this home. Light levels, technology, and aesthetics of both the fixtures and use of light are employed to create atmosphere—especially in the dark, wood-paneled library.

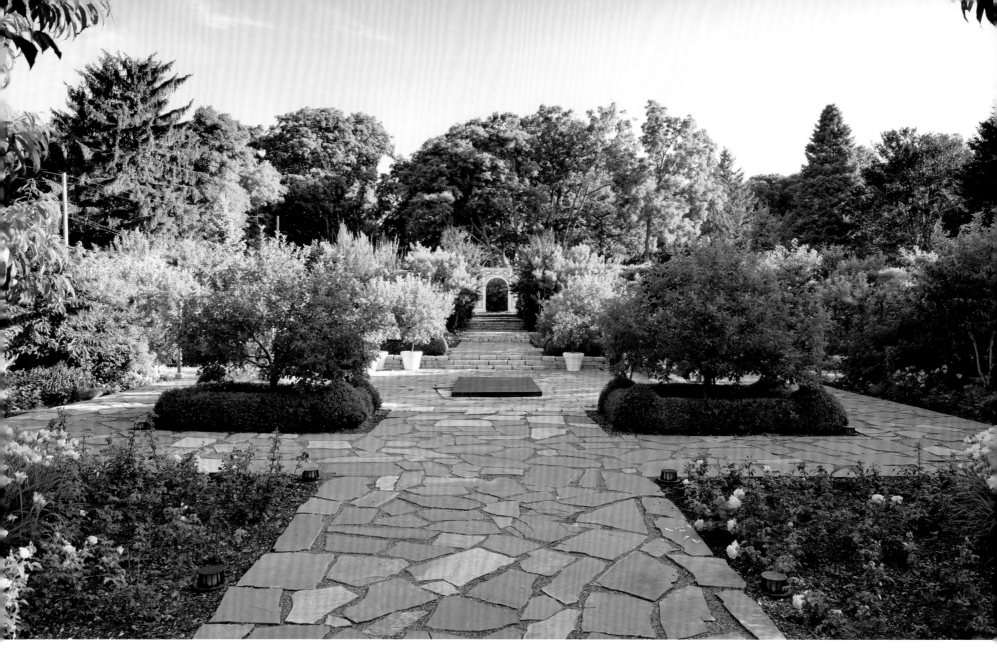

Revitalizing the potager, or ornamental fruit and vegetable garden, is one of the current owner's latest projects. The Olmsted Brothers included one in the original plan, but it had gone into decline over the years.

a dynamic force of twenty firms, from architects (including the firm of Environ Inc. and Harley Ellis Devereaux) to lawyers, and as many as one hundred tradesmen and craftsmen working on-site at a time, he made the final decisions, often flying up from Chicago by helicopter to fully understand the situation at hand.

The home was ninety-three years old when Driehaus acquired it, and unlike many other Lake Geneva mansions, it had not been excessively remodeled, added to, or rebuilt after a fire. The imposing mansion needed rescue from further decline, and to be livable, it had to be brought into the twenty-first century in terms of electricity, heating and cooling, plumbing, and security while preserving the aesthetic inherent in its twentieth-century origins. The home is outfitted with a state-of-the-art mechanical system; energy efficiency and sustainability considerations were factored into the renovation.

The mansion was structurally sound but needed work at every level, from replacing the missing roof balustrade, roof shingles, and copper roofing to rebuilding the entry steps. Scores of restoration experts collaborated on the project, from tuck-pointing the brick facade to replacing decaying capitals and columns as well as the decorative exterior plasterwork on the capitals, cornices, and garlands in the south portico's tympanum.

While massive restoration, painting, plastering, wood refinishing, and decorative work was under way on the mansion's exterior and interior, Terry Guen Associates of Chicago conducted a full landscape and ecological assessment of the grounds. Landscapes are dynamic, and the plantings from the Olmsted Brothers master plan had long ago reached climax and were well into decline. Many of the features, such as the extensive potager filled with fruiting trees and vegetables, were reconstructed in the same location as the Olmsted plan. But since only fragments of the plan exist and Driehaus has his own vision for the garden, he embellished the existing landscape framework. He calls the new walled potager the Secret Garden; it is really more like stepping into Eden. The site's design is still evolving to incorporate Driehaus's vision for additional water features, grottoes, and ponds filled with flowering lotus blossoms. Framing views to and from the home with landscape elements is very important to Driehaus, and the magnificent lake is always integrated into the sight lines from the house.

WHILE DRIEHAUS IS SERIOUS about preservation, he did purchase the estate as a fun and relaxing getaway for his family—a place they can enjoy with their extended family and friends. His elaborately themed birthday parties, including a circus with live elephants and a reincarnation of Route 66, with classic cars, have become legend in less than a decade. Continuing with a Lake Geneva tradition, Driehaus is exceedingly generous in opening his home for charitable events. A new terrace with swimming pool off the breakfast room allows for easy circulation from the east side of the house. It's also a perfect setting for the Driehaus daughters to swim with their friends and to view the lake.

When Wadsworth Hall was built, cars were not an important design consideration; paved roads did not come to Lake Geneva until 1910. Service vehicles arrived at the house via dirt roads but guests usually came via boat or carriages. A major redesign for the property was the reconfiguration of the arrival sequence and car drop-off. A new main gate was designed and along with it a revised entry road alignment that provides sweeping views of the series of newly constructed ponds, waterfalls, and grottoes as well as the potager; the play village with its child-scaled elements, from a sweet ice-cream parlor to a rustic stockade; and two guest and staff houses before the main house and the glorious lake behind it are revealed.

Richard Driehaus created a children's village for his daughters and their friends, complete with play forts and an ice-cream parlor. Both of the girls have their own cottage.

ABOVE: The west porch originally offered a relaxing place for the Harris family to take in views of the lake. RIGHT: This west porch, once enclosed with unsympathetic sliding glass doors, is now a four-season room. The French doors match the south entry.

A new forecourt parking court provides space for guests' cars and valet parking, while ensuring the vehicles do not block the view of the main house. Seasonal plantings in the forecourt create a seasonally changing outdoor room and direct line of sight to the double front doors under the porte cochere, which was enlarged to accommodate limousines. The forecourt fountain's arcs of water cross each other while a vertical jet rises to the three-story height of the western porch's restored Corinthian columns.

Inside, the most surprising aspect of the grand mansion is that the visual flow from one room to another belies the scale of the rooms and imparts an immediate impression of hospitality rather than intimidation. The Driehaus family and their close friends enter their house through a side entrance, with the front doors reserved for formally greeting guests. This east entry opens to a hall with stairs down to the basement and a service stair up to the second floor, where the bedrooms are located. First-floor guest rooms and a powder room are down the hall to the north. A comfy family room just south of the service stair is adjacent to the fully equipped French manor house–style kitchen that opens onto a sunny breakfast room. During the Harris era, the current breakfast room was a colonnaded open porch topped by a sleeping porch. The former sleeping porch is now an enclosed suite of guest rooms and baths. These casual though gracious rooms can be closed off from the formal dining room with heavy doors. Servers slip in and out of two doorways to serve formal meals without revealing views of the kitchen.

The dining room's plaster ceiling is one of the most exquisitely crafted ceilings in the state. It is ornamented with piping, garlands, and leaves that appear as though they are sculpted of buttercream frosting by a pastry chef; glossy white damask silk wall coverings complete the wedding-cake look. Twin crystal chandeliers cast dancing light over the ivory white surfaces, and their images are dazzlingly doubled in the mirror above the fireplace.

Guests arrive either by water, the lake path, or car (and the occasional helicopter). Those coming by car exit at the coffered porte cochere, where they are welcomed at the front door with leaded-glass sidelights and a transom atop the doorway; two oversized brass lanterns from Driehaus's collection of antiques grace each side of the sidelights. The door opens onto an entry hall with a marble floor incised with a black marble "D." The Harris family coat of arms is carved into the woodwork of the fireplace in the reception hall.

Those disembarking at the boat dock or arriving from the lake path stroll across the manicured lawn, past boxwood hedges and reflecting pools. The house is set on a grassy plinth, about six feet above the lawn; broad stone steps lead visitors to the lakefront doors. During the renovation these steps were expanded to the full width of the six columns; in the Harris's time the steps were centered on the two middle columns.

French doors on the western side of the terraced porch open onto the sitting room; the south or lakeside doors open onto the double-height reception room that contains little furniture—it is meant to be filled by people, who mingle or dance, or gather on the cascading steps and around the mezzanine banister for a better vantage point from which to

As in most homes, the front door is reserved for company. The foyer's marble floor introduces guests to the exquisite attention to detail throughout the entire residence.

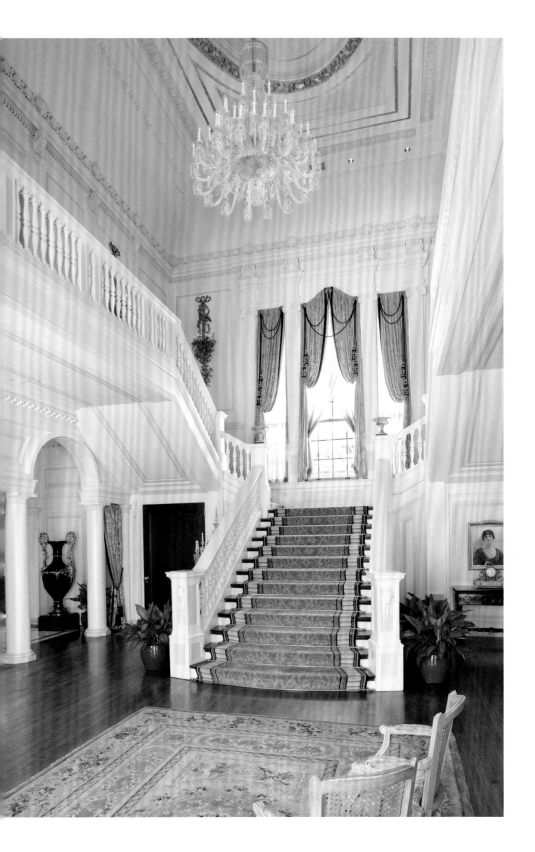

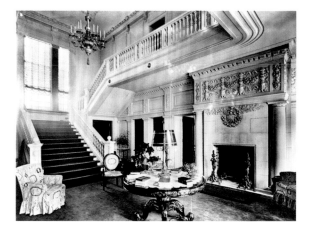

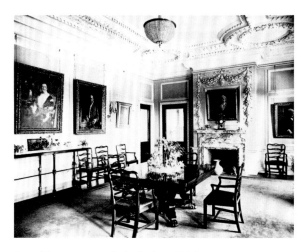

TOP: The ornate main hall, circa 1907. BOTTOM AND RIGHT: The dining room, 1907 and 2009. When the current owner purchased the home, the room's elaborately decorative plaster ceiling was sagging. Rather than take it down and rebuild it, his architects devised a way for the contractors to secure it from above. LEFT: Symmetry is important on the interior of a Georgian Revival as well as the exterior. The ornate white plaster moldings and wood details reflect light in a room of grand proportions.

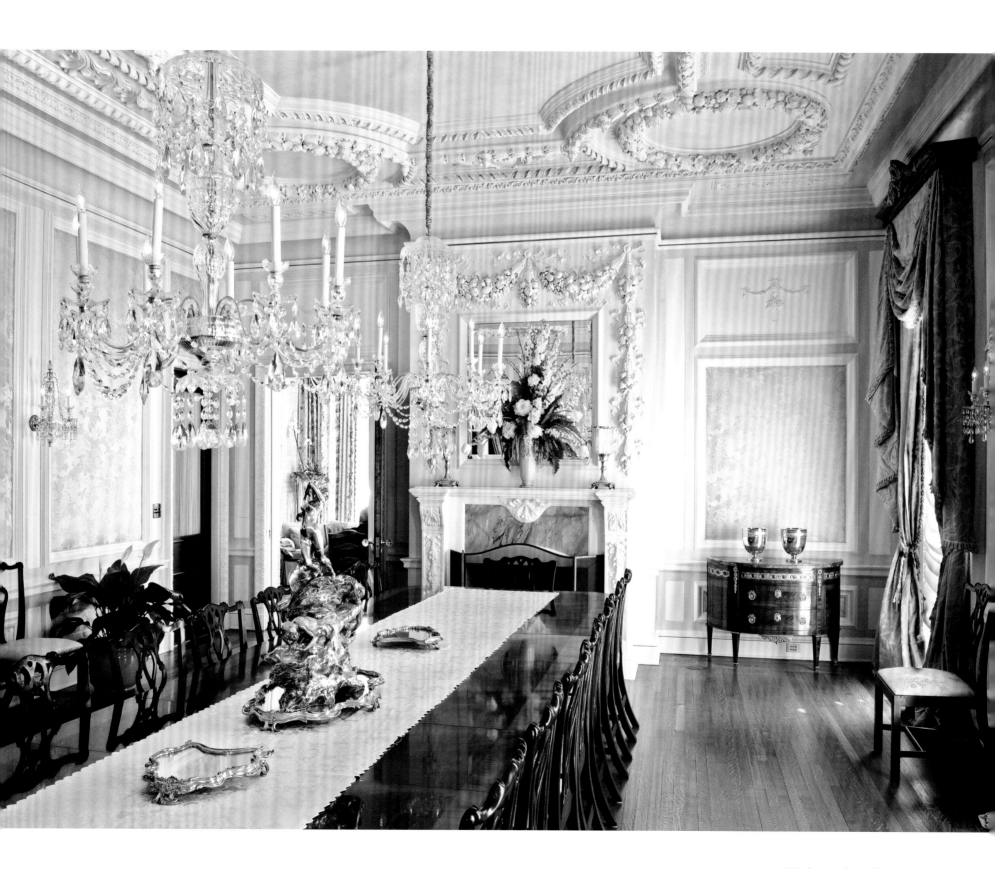

watch the gala below. From the mezzanine one can enjoy the tongue-in-cheek ceiling mural, which incorporates cheerful images of family members. Wall murals with images of the family are woven throughout the home.

From the reception hall guests are directed to either the dining room or the library, with its walnut-paneled walls and ceiling as richly detailed as the embossed leather bookbindings. The ceiling coffers are painted with a brushed, bronze-leaf finish. The room glows from within, its warmth enhanced by light sparkling off the lake. Other first-floor rooms include a study and powder rooms. The lower level, originally a service floor, now has a clublike atmosphere: a billiards room with a bar, a wine cellar, and a catering kitchen.

Upstairs, on either side of the grand staircase, are the family wing and a guest wing with chandeliers and fireplaces gracing each bedroom. The family wing includes the master bedroom and bath, both of which are lit with skylights uncovered during the renovation. Elegant ceiling moldings were added by Driehaus. The master suite occupies the entire western side of the house; its windows overlook a grand allée of beech trees that were transplanted at mature height.

Every room in the guest wing is decorated in a different style, offering guests a variety of getaways, from the Pompeii room with its mink trim to the Kew Gardens room with an original wood mantle from the Harris era. All the other rooms have marble-fronted fireplaces.

THE RESORT COMMUNITY of Lake Geneva is one of those rare getaway locations—one without the flash and glam typical of the frantic retail developments that surround many elite summer destinations—where people quietly create lavish estates that are the envy of many.

People often say they need a getaway to leave the city and all its ills behind, but when they return more than once to the same place the desire is really more of "getting to" than "getting away." True getaways are family homes that the family members look forward to returning to with great anticipation and appreciation, from generation to generation. In the case of Wadsworth Hall, now the Lake Geneva Family Estate, the estate passed to a new owner, one with the intelligence, grace, and ability to restore the home to its former splendor while making it comfortable for his family as a getaway. •

The Baccarat chandelier is attached to a mechanism in the attic that allows it to be lowered for cleaning and lightbulb changing.

Each pair of beech trees was planted closer together than the last to enhance the sense of perspective by creating the optical illusion of greater distance.

Island of Happy Days

OPPOSITE: To this day, the view is uninterrupted from the Island of Happy Days.

BY THE LATE 1800s Wisconsin's lumber concerns and railroad companies were working together, with the lumber companies providing railroad ties, bridge timbers, and other lumber the railroad needed. Railroad costs were higher than river transportation and sparks from the train were known to cause forest fires, but the railroad extended the lumbering season because it was not as weather dependent as the rivers. Railroads also made delivery of goods and food to the lumber camps less arduous than trekking in with pack animals on the narrow, rough tote roads.

The first railroad came to Barron County in 1878, and by 1900, the year Knapp, Stout & Company ceased its logging operation in the area, the railroad was no longer a working tool for the Stout family but rather a convenient way for them to come up from Chicago to their beloved rustic North Woods getaway, the Island of Happy Days. And to make sure it was convenient, Frank D. Stout, director of the Chicago, St. Paul, and Omaha Railroad, had a passing track for his private train car built off the main line between Balsam and Red Cedar lakes. The Stouts' stop was called The Narrows.

THE STORY OF THE ISLAND OF HAPPY DAYS and the Stout family fortune begins with the meeting of Captain William Wilson and John H. Knapp in Fort Madison, Iowa. They were at first glance an unlikely pairing. Wilson, who had earned the title of captain as a pilot

on the Mississippi River, was looking for a financial partner to back his dream of a large logging operation in the northern woods. He had heard the tales of an endless forest of white pine in the Wisconsin Territory. While exploring the Chippewa and Red Cedar rivers with an Indian guide in 1846, he met David Black, who was willing to sell him a half interest in a sawmill located near present-day Menomonie. But Wilson was deeply in debt due to a steamboat venture gone awry. He had no capital, could not get credit, and needed a partner to make his dream come true.

Knapp had a year of business education and some money but was anxious to make more. He was captivated by Wilson's prophecy of the riches they could make, so in 1846 the two became partners and bought that half interest. Two years later they owned all of it.

At the mill they met Andrew Tainter, who'd had a rough-and-tumble pioneer childhood; he worked on steamboats on the Mississippi and in sawmills on the Chippewa River. His plan, until he met Knapp and Wilson, had been to earn enough money to bankroll a trip west to the California gold rush. But instead of investing in gold, he invested in wood, purchasing a third interest in Knapp and Wilson's sawmill. The three then courted Henry L. Stout, a descendant of one of the oldest New Jersey families (his grandfather emigrated from England in the 1700s). One of the wealthiest men in Iowa, Stout had experience with lumber mills in Dubuque. But his most attractive quality was that he was a capitalist—and in order to buy huge tracts of land to log, the three partners needed capital. The four joined forces in 1853 and, after several name permutations, they formed Knapp, Stout & Company that year.

After the Homestead Act of 1862, the demand for building materials was so immediate that huge quantities of board feet of lumber were consumed as soon as they came out of the sawmills. Settlers in the Plains states were desperate for lumber to build homes, and pine had the attributes they were looking for: it is straight, free of knots, lightweight, and easy to work with, and when seasoned correctly it retains its dimensions and resists rot. The wood from four good trees could supply enough lumber to build a proper home.

A Nordic dragon carving at the south entryway

Knapp, Stout & Company had mills and land in nine different townships, most of it in the Red Cedar Valley, the area from Red Cedar Lake at Mikana in the north to the Chippewa River south of Menomonie. By the 1880s the company owned more than half a million acres of pine land in the Red Cedar Valley. Tainter managed the logging and mill activities at Chippewa Falls, and Stout remained based in Dubuque. A large part of the company's success was due to its control of the logging as well as the retail and wholesale sales, banking (the company had its own currency), food production, housing, and steamboat operations.

Frank, Henry Stout's middle child and second son, did not play an active role in the lumber company. But Henry had business concerns that went beyond lumbering. Frank's shared financial interests with his father lay in banking and development. He was at different times the director, vice president, and president of the Iowa Trust and Savings Bank, and he invested in hotels, streetcars, street lighting, power companies, and horses. With his father, he developed the Highland Stock Farm and a racetrack in Dubuque for breed-

ing and racing harness-trotting horses. They named the nationally recognized racetrack Nutwood Park after their most famous horse, Nutwood, which had earned $650,000 for the Stouts before its death in 1896. It was no coincidence that Frank's electric car company ran cars out to the track.

After Henry Stout's death in 1900 and the closing of the Dubuque branch of Knapp, Stout & Company, Frank moved to Chicago in 1902 with his wife, Clara Wales Stout of Dubuque, whom he'd married in 1889. He sold most of his Iowa investments by 1916 and made only one return visit to Dubuque.

Frank and Clara lived on North Lake Shore Drive in Chicago, in what is now the Lincoln Park neighborhood. Frank was a member of the Chicago Athletic Club and the Chicago Club. Clara was a trustee of the Chicago Historical Society and a generous donor to the Art Institute of Chicago. Stout served as a bank president and as an executive for several lumber companies in the south and west; he was also involved in the directorship or presidency of various railroads, invested in oil, and continued his interest in investing in hotels. At the time of his death his obituary stated that he was one of the ten wealthiest men in Chicago.

BEGINNING IN 1903, Frank Stout used millions from his inheritance to transform a horse-head-shaped island in the middle of Red Cedar Lake, just north of Mikana, Wisconsin, into a private, rustic Adirondack-style pleasure camp for his family. He and Clara and their children Harry, Katherine, Calista, Eleanor, and Allison would come up from Chicago to spend the summer and winter holidays, walking the three miles from their private train to the island's boat dock. The idyllic images in family photographs of gatherings, picnics, and games in all seasons give credence to their getaway's name: the Island of Happy Days.

TOP LEFT: Practicing their putting skills was a favored pastime of the Stout family during summer visits to their island. TOP RIGHT: "The chute" near the boathouse was a source of lakeside fun, circa 1904.

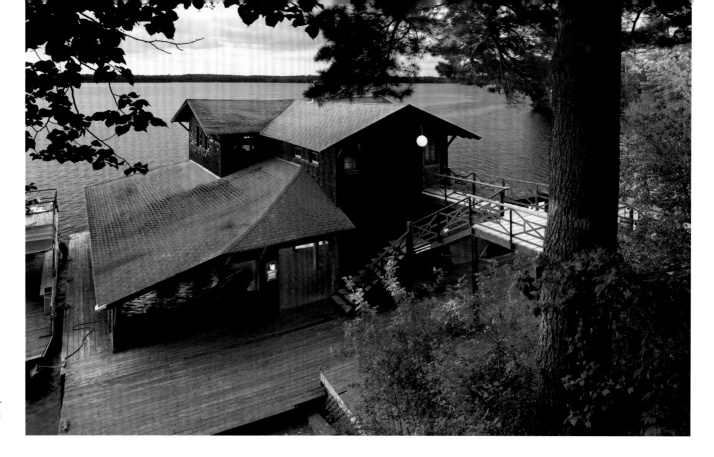

RIGHT: Frank D. Stout had lake views from his second-floor office in the boathouse. BELOW: The Adirondack-style boathouse, 1918, accommodated the many family and friends who arrived by boat.

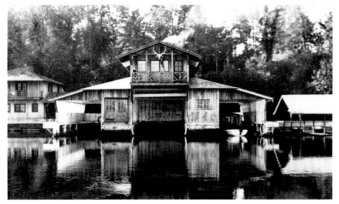

John Knapp had purchased the island's original homestead claim in 1868 for the grand sum of one dollar and sixty-eight cents. Over the years the island was sold twice. Several rude buildings were built on-site, including a one-room cabin where Mr. and Mrs. Hopwood lived for about three years when the island was known as Hopwood Island. In 1897 Frank Stout and William Wilson's grandson Thomas Wilson Jr. jointly purchased the island from the Hopwoods for use as a men's primitive hunting and fishing camp. They also bought whole sections of land around Balsam and Red Cedar lakes. In the early days the men camped in the Hopwood cabin, but when more friends wanted to bring their families, they built a log lodge.

In 1903 Stout bought out Wilson's share and began acquiring other parcels on the south and east side of Red Cedar Lake. He purchased an inn due west of the island in order to control both the view and the noise level. The Stouts established Lone Pine Farm on the site, and architect Arthur Heun designed a large farmhouse for staff. Poultry and vegetables were raised to feed the family and their guests for the entire summer, and a herd of Guernsey provided fresh milk. The farm was so productive that excess goods were sold. It was not a hobby farm; just as Knapp, Stout & Company understood that it needed to establish farms to feed its loggers before the logging camps were built, Frank Stout understood that support buildings off the island would give him the luxury of the isolation and privacy he desired without being deprived of good and plentiful food to serve his family and guests. The food could suddenly appear—completing the fantasy of playing at "roughing it." During the years of farm construction, carpenters were making the island's rough lodge more livable.

At one point there were four thousand sheep on the Stout property, large numbers of angora goats, and six hundred head of Hereford and Durham cows joining the prize Guernseys. But large-scale animal husbandry did not work out as well as Stout had anticipated due to the animals' inability to thrive in severe winters.

On the east side of Red Cedar Lake, the land known as "the Range" was transformed into Stout's private golf club, which he named Tagalong because his children always wanted to join him. Stout also built an airstrip for the golf course because by the 1920s many of his friends had traded in their chauffeurs for private pilots or flew the planes themselves.

IN 1903 FRANK STOUT had commissioned Chicago architect Arthur Heun, the architect responsible for his Chicago home, to design the farm buildings and to rebuild the family buildings on Stout's Island. Heun, a graduate of the University of Michigan whose Beaux-Arts training espoused the unity of building and site, was well regarded for his collaborations with landscape architects Jens Jensen and Ossian Cole Simonds on large-scale garden designs.

Heun was loosely associated with the Steinway Hall, a group of like-minded architects formed by Dwight Perkins that included Robert C. Spencer Jr., Myron Hunt, George Dean, Hugh Garden, and Frank Lloyd Wright, all of whom rented office space and shared staff on the top floors of Steinway Hall on North Michigan Avenue in Chicago. Heun designed several variations of the Chicago Arts Club, and while working on the Island of Happy Days he was also the architect for Lolita and J. Ogden Armour's 1,000-acre Mellody Farm in Lake Forest, Illinois, as well as the adjoining Arcady Farm, a model dairy farm, for Arthur Meeker. In 1918 Heun designed a farm for prize-winning livestock for Albert Loeb, president of Sears, Roebuck and Company, in a rustic style based on stone barns in northern France. During this American Country Place era, gentlemen's farms, on a large scale—such as Henry Francis du Pont's Winterthur Farms in Delaware and author Jack London's Beauty Farm in California—were favored by wealthy men of the time. These gentlemen did

Each of the sons had their own cabin. Harry's cabin, pictured, was on the east side of the island, near the schoolhouse and swimming dock.

not farm for profit; they farmed for a connection with the arcadian landscape, which, ironically, many of them had profited from with their lumbering and factories. Bragging rights for prize-winning animals or crops were a common bond among the wealthy, who enjoyed competition in industry as well as at their getaways.

Stout, who had not worked in the lumber camps, wanted to pass down a connection to the land and his family history to his five children who had been raised in the city. On Stout's Island, he had local builders construct a sprawling, three-hundred-foot-long main rustic lodge for the family and guests and separate log cabins for his two sons, Harry and Allison, in the Adirondack "roughing it in style" style that was popular with wealthy families in Maine and upstate New York. The twelve buildings, which include the maid's quarters and laundry, the carpenter and blacksmith shop, a woodshed, the gardener's house, the recreation hall, a gazebo, and a school built between 1909 and 1912, contribute to its 1995 National Register of Historic Places designation. The site also includes a romantic, gabled boathouse with tamarack supports.

When construction started on the original lodge and outbuildings in 1903, Stout directed that the bark be left on the exterior. Traditionally the exterior bark was also peeled, but Stout insisted on the more rustic look. This insistence was a dead giveaway

Style: Adirondack

By the time of the 1876 Centennial Exposition in Philadelphia, America's wilderness was considered tamed—a source of pastoral relaxation and a place to commune with nature and oneself. At this fair a Swedish school, a hunters' camp, and a New England kitchen were all realized as romanticized log cabins.

The hallmarks of the rustic or Adirondack style—which was developed in the Adirondack mountain area of upstate New York in the 1870s and remained popular into the Great Depression era—were massive and well-joined logs that supported shingled roofs extended beyond the enclosed footprint to enfold porches, exterior corridors, and expansive overhangs that fended off ice and snow. Massive native stone foundations protected the wood walls and structure from the damp ground; vertical split-log siding or rustic board-and-batten could complement these horizontal logs. Naturally shaped tree limbs and the roots, knots, and curves in wood were worked into architectural ornament to personalize porch railings, gable ends, expressed trusses, and decorative screening, as well as furniture. Kitchens and dining areas were separated from sleeping areas by deco-

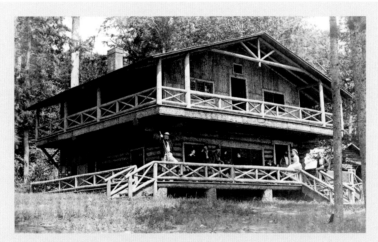

Camp Pine Knot, circa 1884, one of the Adirondacks' great camps, was designed by William West Durant for his father, railroad magnate Thomas Clark Durant.

rative covered walkways to protect residents from the threat of fire.

The romanticized rustic or Adirondack look of the Island of Happy Days comes from the use of wood and stone, allusions to pioneer building techniques and times, and, as was the original intent here, the employment of on-site materials and responsive site design to create a strong tie to the surrounding environment.

The rustic-style architecture at the Island of Happy Days can be traced to William West Durant, who was enlisted by his father, a vice president of the Union Pacific Railroad, to maximize the railroad's investment by encouraging tourism in the central Adirondacks. Durant drew from the 1876 Centennial Exposition, romantic writings such as W. H. H. Murray's popular *Adventures in the Wilderness,* and such publicized architectural examples as those by Andrew Jackson Downing and Calvert Vaux. He built rustic playgrounds that enclosed every conceivable amenity, fashioning primitive-looking compounds of massive native fieldstone chimneys and fireplaces that accented monolithic walls. Especially popular with the wealthy railroad-investor population, this style did achieve some economy from its use of local materials. The Adirondack style was further spread by railroad development and Americans' evolving interest in recreation and the outdoors.

that he had not been a hands-on member of the lumber company. In less than a decade, the bugs, worms, and moisture in the bark caused the logs to rot. In 1909 Stout told his architect to remake the buildings on the island; this time all logs were to be entirely peeled prior to delivery. Given that Wisconsin was logged of high-quality pine by 1909, Stout had to ship cedar logs of uniform size from Idaho for the reconstruction. He spent $1.5 million rebuilding his getaway complex.

Early stays on the island were "rustic," in that there were three outdoor toilets and no electricity. But the niceties of the upper class were not discarded for the summer: the Stouts usually arrived by train with their trunks filled with clothes and china, and accompanied by their servants—maids, cooks, and butler. Guests came prepared for parties, picnics, and playful competition. The island sported a clay tennis court and a croquet field, and swimming and boating were ready entertainment options.

FROM THE WOODED SHORELINE, the enclave of buildings is invisible and continues to be until guests climb the winding staircase from the boathouse. At the top of the stairs the main lodge comes into view. It is not the sheer size that charms but the amalgamation of small details: peak, gable, and shed wood-shingled roofs advance and recede; there's a variety of window types, from simple, two-over-two double-hungs to more complex six panes with true divided lights; a long screened porch connects the lodge's public areas—the entry, the dining room, and the lounge—to the private

The rustic decor of the main entry hall, made complete with mounted deer heads, was pleasing to the very wealthy who were getting away from their urban homes and the hectic social requirements of society.

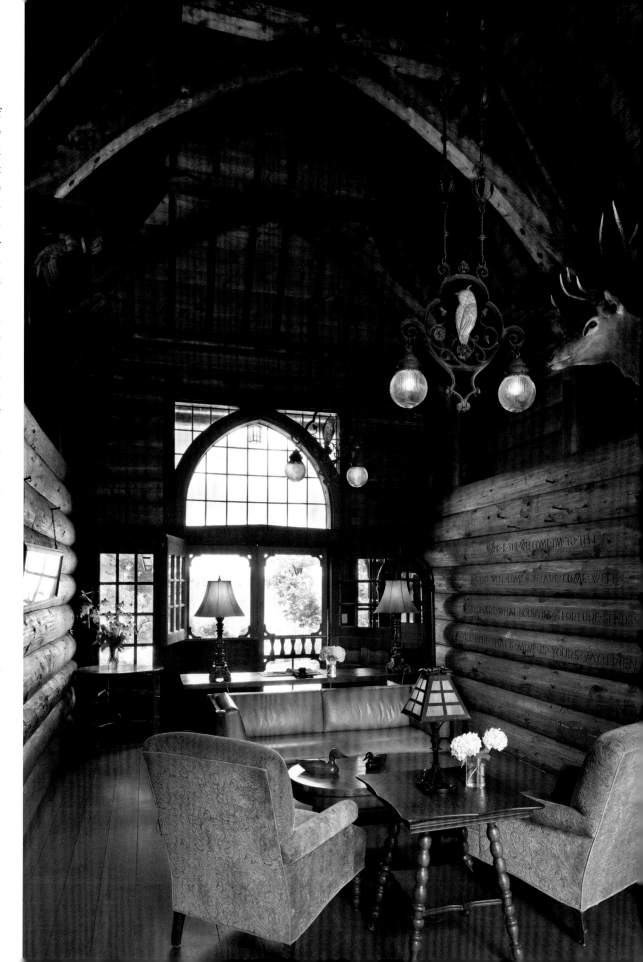

Log Cabins

The basic aedicule, or primitive hut, is the simplest and most important element in architecture and one that continues to captivate architects today.

Early French settlers to Wisconsin used *poteaux en terre,* or posts in the ground, to describe the palisaded enclosures they built of sharpened vertical logs driven into a dirt trench and caulked or "chinked" with straw and mud, then plastered with lime. Later log construction employed a horizontal timber sill or sole plate that rested above ground on stone or wood block foundations.

By the 1820s Yankee and Southern immigrants to Wisconsin were laying their logs horizontally, while the Welsh constructed dwellings of cut logs as if they were the stones they had always built with. The traditional German log cabin incorporated partially squared-off logs notched so they could be joined at the ends. Each of these log cabin approaches required that the horizontal joints of their logs be sealed with chinking to protect the logs from the elements. Some log cabin dwellings were updated with clapboard to fit new tastes and the need for better weatherproofing, but, for many settlers, log cabins were impermanent "starter" homes built quickly for shelter on the frontier.

In Finland and Sweden a more precise system of log construction with carefully fitted logs that did not need chinking had evolved in response to a more demanding climate akin to Wisconsin's. Immigrants from these Nordic countries relied on this form in their extensive farmsteads composed of farmhouses, stables, barns, root cellars, and even saunas. Settlers from forested northern Europe practiced their traditional methods on timber that was in abundance in Wisconsin, relying on chinking in their construction process. The examples of agricultural and residential buildings using log construction were well built and long lasting.

Traditional log cabin construction persisted into the mid-nineteenth century, but the advancement of technology and the call for more creature comforts were responsible for the replacement of most log dwellings with more conventional and comfortable construction. However, utilitarian log farm buildings that well served their intended function still dot Wisconsin's landscape.

The romanticism of Adirondack-style architecture was introduced by the railroad magnates to spur interest in and development of their own forested lands. Frank D. Stout built his own railroad line to help construct his romantic notion of a log refuge in the wilderness.

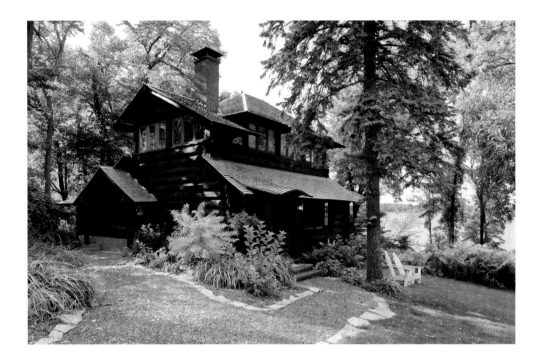

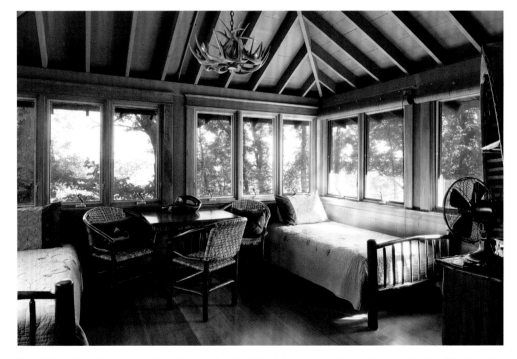

TOP: Allison's cabin was built on the west side of the island, near the boathouse. Both of the boys' cabins had fireplaces in their living rooms and sleeping quarters. Meals were taken in the family dining room. BOTTOM: The sleeping porch of Allison's cabin looks out over the lake through the treetops. The sound of loons and lapping water lulls guests to sleep.

bedrooms in the two-story wing to the west, which the Stouts built for their daughters and guests. The notched corner joints of the cedar logs are as architecturally decorative as quoins on a stone Renaissance palazzo.

Architect Arthur Heun devised a surprising rustic arch above the double-paneled doors that open onto the double-height foyer that sets the tone: mounted deer heads gaze intently at those who enter, a pair of cast-metal owls swing between two sets of globe lights, and the room smells like wood. Through the doors on the opposite side of the entry, Nordic dragon carvings and a stone dinner bell tower to call boaters, swimmers, and birders at mealtimes enliven the southern elevation. Heun was fond of incorporating

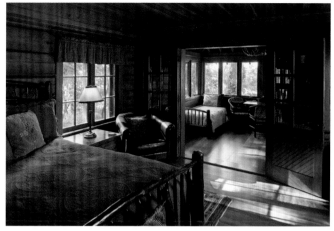

Today, Allison's cabin is privately owned but available for rental. The current owners have updated the cottage, maintaining the rustic appearance and mood.

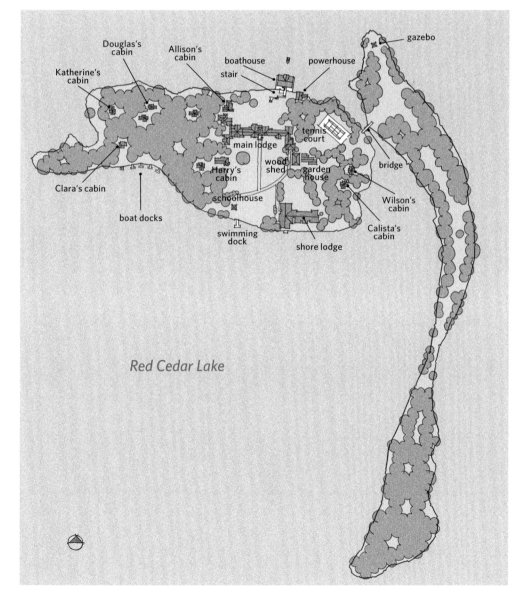

The Island of Happy Days consists of 26 verdant acres in the center of Red Cedar Lake. Today guests are met at the mainland boathouse by a scheduled boat launch and transported one hundred years away.

Visitors to the island disembark at the island's boathouse (generators contained in the adjacent powerhouse originally electrified this camp, which is now powered by buried cable) and ascend six winding flights to the island's rise where the three-hundred-foot-long main lodge is revealed like a magical Shangri-la. Off the center entry is a dining area to the east and a lounge to the west, which leads to lodge bedrooms on both floors.

To the south of the main lodge is a small school cabin originally used during Stout family vacations replete with tutors; a dock for connecting this getaway with the rest of the lake; and the shore lodge, where rainy weather and nighttime amusements such as board games, card games, and even bowling took place. To the east is a tennis court on the way to the nature trail that takes the visitor over another bridge to an east island with a north-south trail; a belvedere gazebo marks the peninsula's northern point. Meandering trails through the main island lead to the various cabins named for family members.

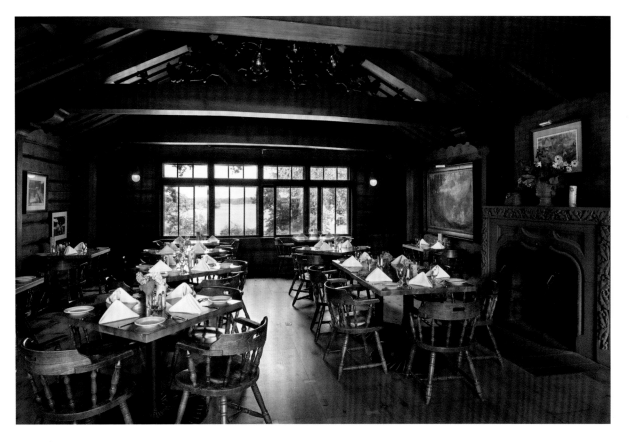

such towers in the country estates he designed. Looking south from the main lodge doorway, Red Cedar Lake appears to be a backdrop to the great stage of the sweeping lawn, with mature trees framing the view like velvet curtains. Not a building can be seen across the lake for miles.

Heun designed the structure, but he took full advantage of the log-notching, hand-carving, stone-splitting, and iron-mongering skills of local craftsmen, many of whom were Norwegian. The living room fireplace is constructed of pink granite rocks from Mount Hard-scrabble in the nearby Blue Hills; the dining room fireplace is carved Italian limestone. Throughout the complex, there are walls of cedar logs, exposed ceilings of white pine, fir floors, and California redwood paneling.

Clara Stout's bedroom, with its coffered plaster ceiling, painted plaster walls, and delicate scalloped wood trim pieces, is more delicate and feminine than all the other rooms in the complex. It is the only first-floor room that looks inward. In the other rooms the windows are grouped in threes and fours, achieving, in effect, a picture window, a blurring of the boundary between inside and outside. Clara's bedroom has four discrete windows whose purpose is to allow light and air into the room. The view is secondary while privacy is primary.

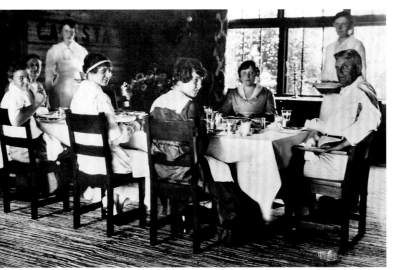

TOP: The dining room's beams were shipped from Germany, and the wide, bow-tie pegged floorboards were recycled when a local dam was dismantled. BOTTOM: The Stout family enjoys Sunday dinner at the Island of Happy Days, 1916.

FRANK STOUT COULD AFFORD TO GO ANYWHERE in the world in high style, and he did travel to Europe and the Middle East with his entire family. Until his death in 1928 he always came back to the Island of Happy Days, the place that meant more to him than any other. Following his death the family visited less frequently; the loss of son Harry four years earlier had been difficult for the family. Clara eventually remarried, and the Island of Happy Days ceased to be the center of family life.

From 1948 to 1990 the island had various owners but only one caretaker, Herman Hatfield, who is probably the unsung hero in this story due to his intimate knowledge of the construction and technology of the buildings. In 1990 John Rupp and Thomas Dow bought the island with the intention of creating a business retreat and resort. Today, after years of abandonment, guests can re-create the Stouts' experience at the Island of

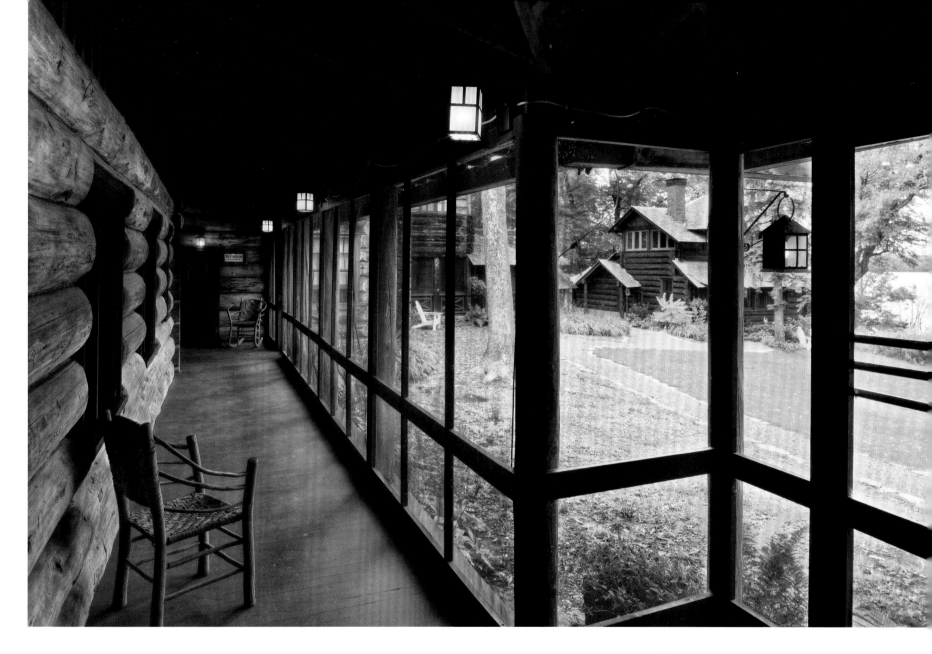

Happy Days. From May until October rooms and cabins at the resort known as Stout's Island Lodge, which is now owned by an association, are available for rental. The isolated and idyllic island has also been a setting for family reunions, weddings, and quiet retreats. There are plans afoot for making the lodge available and accessible for winter use as well. But until that happens, the only winter inhabitants of the Island of Happy Days are the black-and-white still images of Frank Stout's children laughing largely and playing in the snow. •

ABOVE: The amalgam of cottage pieces are joined together with screened porches that provide solitude when desired and protection from rain and insects. RIGHT: The Stouts may not have owned Red Cedar Lake, but it didn't stop them from damming and draining it when they wanted to annex a spit of land to the main island, now accessed via this bridge.

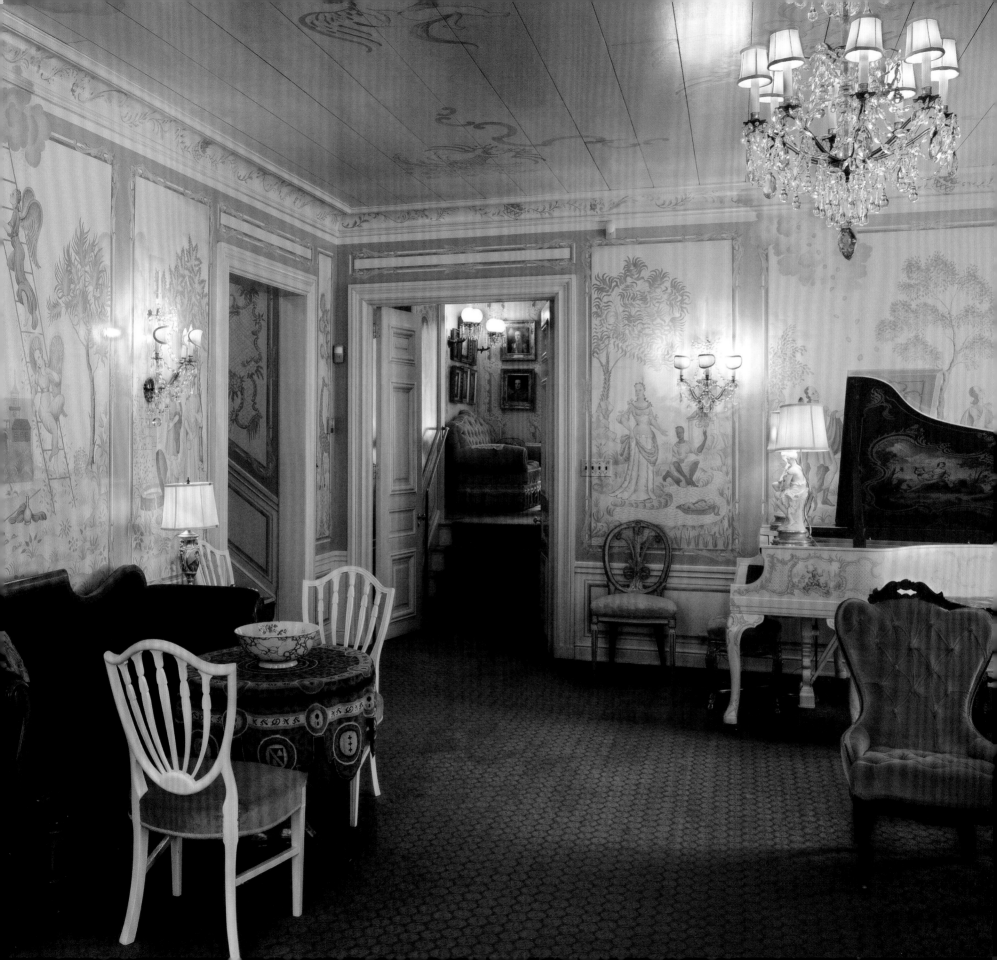

Ten Chimneys

OPPOSITE: Well-known scene painter and modernist artist Claggett Wilson lived at Ten Chimneys for two years while he executed the lighthearted murals throughout the main home. The living room murals, with a biblical theme, are his pièce de résistance.

ALFRED LUNT AND LYNN FONTANNE'S NAMES were rarely in print without being preceded by a superlative: fabulous, great, incomparable, aristocratic. The couple—who created a magical life on and off the stage for fifty-five years—was the most famous acting couple in American and English theater from the 1920s to the 1960s. Their contributions to Broadway were immortalized in 1958, when the New York Globe Theater was renamed the Lunt-Fontanne Theatre. Ten Chimneys, their sprawling compound at Genesee Depot in Waukesha County, proved an idyllic getaway for them, a refuge from their grueling performance schedule and hectic lives on tour.

As a young man Lunt had been torn between studying architecture, set design, and acting. In his creation of Ten Chimneys, he showed a mastery of all three disciplines. Although several architects and various craftsmen were involved in the process, Lunt was the inspiration behind the development of the Swedish-country-home-style getaway. He was capable of building scale models, doing drawings, and directing (when available) the construction process. Together with his wife, Lynn, he collected the furniture, carpets, and artwork that is still just as they left it. The couple acted as set designers, prop builders, and stage managers, and much of the cottage's interior decorative painting is by Lunt's hand. Their experience with the theater was invaluable to their vision for Ten Chimneys.

They understood that the power of suggestion was an important design element in creating a mood.

ALFRED LUNT'S FATHER, a successful and wealthy lumberman, died when Alfred was two years old. The family lived in Milwaukee on Grand Avenue (now Wisconsin Avenue), a few blocks east of the Pabst mansion and less than two miles from the Pabst Theater. Lunt's doting mother, Hattie, took her young son to performances at the Pabst and other Milwaukee and Chicago theaters. When she remarried, it was to Karl Sederholm, a Finnish-born doctor who also enjoyed the theater and musical performances.

Lunt was not content to just go to the theater. He and his neighbors the Conants created productions of their own that included set design, stage lighting, and acting in the various roles. This playacting had a great affect on Lunt. Presciently, young Alfred designated himself both head of his childhood endeavor, the Lunt Theatre Company, and manager. Throughout his career Lunt enjoyed the role of manager almost as much as he did being an actor. His desire to control any creative venture in which he was involved was evident in his long collaboration with architects in the creation of his Wisconsin getaway.

Alfred's mother rapidly depleted the inheritance Alfred's father had left her, so the family moved from the big house on Grand Avenue to the rural village of Genesee Depot, about thirty miles west of Milwaukee, to save face (and money). When their financial circumstances were further reduced, the family relocated to Finland, joining Sederholm's family at their Swedish colony near Helsinki. Even though he was far from his friends and all he was familiar with, Lunt truly enjoyed his Nordic summers. He felt Scandinavian and traveled to Scandinavia frequently throughout his lifetime. He learned to speak both Finnish and Swedish and absorbed the basics of Swedish design through his hobbies of photography and drawing.

Lunt returned to the Milwaukee area to attend Carroll College in Waukesha after his stepfather's death in 1909. At the end of his sophomore year he transferred to Emerson College in Boston and, shortly after arriving, landed an acting job at the Castle Square Theatre on Tremont Street. He decided to quit his studies and concentrate on professional acting.

In 1913 Lunt, upon turning twenty-one, received his inheritance from his father's estate. A year later he purchased 3 acres outside of Genesee Depot and set about building a two-story, wood-frame house in the style of a Nordic hunting lodge. It may seem odd that a young, single actor living in Boston with his eye on Broadway would take a portion of an inheritance and buy land in rural Wisconsin rather than spend it on acting lessons, rent, and food. But Lunt was earning an actor's salary, and establishing a home in Wisconsin was more important to him than living well on the East Coast. He felt an enormous emotional obligation to provide for his twice-widowed mother and his three young stepsiblings. Lunt also felt a deep connection to both Genesee Depot and Scandinavia, two places where he had been secure and happy. He wanted to create a home for his family in Wisconsin that recaptured the chapter of his childhood he loved.

The main house, circa 1938

Lunt left Boston for New York in 1916, and within two years his acting career flourished. During his third year there he met British actress Lynn Fontanne, who was slightly older and better known to theater audiences. After a tumultuous three-year courtship, they married in 1922. Lunt's stepsister, Karin, gave them a wedding present of 4 acres north of the 3 acres he owned. He continued acquiring land and eventually owned 140 acres.

In 1924 the couple acted together for the first time in a fabulously successful play, *The Guardsman.* Between 1923 and 1931 their professional lives kept them so busy that they had little time to devote to their beloved Genesee Depot retreat. The bulk of the construction, renovation, and decoration took place during the 1930s.

THE THREE MAIN STRUCTURES at Ten Chimneys—the main house, cottage, and studio—were designed to conjure the atmosphere of a Swedish rural farmstead. The siting of the buildings takes advantage of the rolling kettle moraine landscape and the natural screen provided by the forest of trees. The buildings and landscape rise and fall with the topography and the walk twists and turns, creating ever-changing views and the perception of a distance between structures greater than what is there.

The main house, the first building on the site, dates to 1914. This, the original family home, is not attributed to any architect but was likely built by local builders to Lunt's specifications. After their marriage, the Lunts, when visiting his family, stayed in a chicken coop they had converted into a cottage. By 1926, they relocated to the main house. His mother and half-sister took up residence in the cottage.

Extended family living was a cultural aspect of Scandinavia that Lunt enjoyed and respected. The cottage was designed to approximate a *stuga,* the simple red-with-white-trim rectangular structure with one major entrance. Most Swedes are apartment dwellers during the week but flock to their *stugas* on weekends and holidays. Lunt wanted to replicate this tradition remembered from visits to his Scandinavian relatives.

Originally a simple wood-frame building with bedrooms on the second floor and a first floor consisting of one great room that included a living room and kitchen, the main house was remodeled and expanded numerous times over twenty-eight years. Architects involved in the expansions were the Milwaukee firm of Eschweiler and Eschweiler (the firm was responsible for the living room wing added in 1934) and the Chicago firm

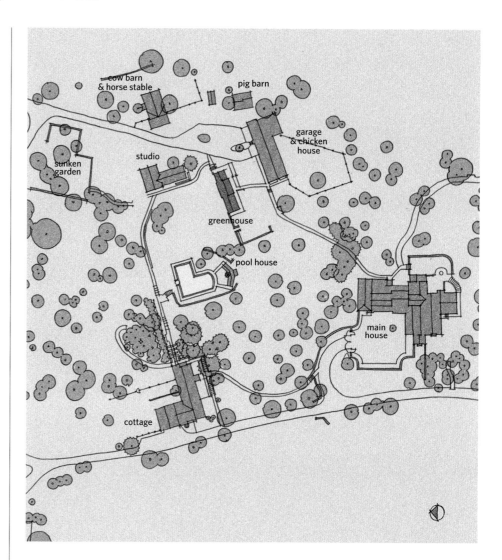

This site plan shows the impressive collection of buildings and outdoor spaces that Alfred Lunt and Lynn Fontanne assembled at the northern portion of their Ten Chimneys property. Borrowing design influences from Swedish and Finnish outdoor culture parks, this collection of buildings for life, work, and play are sited to afford maximum solar orientation, good views, and controlled vistas. Abundant plantings and effective use of the existing topography has been used to reinforce this design approach while establishing an incredible sequence of visual events or stage settings.

Lunt and Fontanne in the cottage's kitchen, 1933. Lunt, a graduate of Le Cordon Bleu in Paris, spent a great deal of time preparing meals when the couple was at Ten Chimneys.

The Lunts were always "on" at their home, which was as much getaway as stage set.

of Loebl, Schlossman and Demuth (the dining room and kitchen additions in 1938 were theirs). Charles Dornbusch was the project architect for the Chicago firm, which also prepared a master plan for the grounds and gardens that was completed in 1939. Lunt was involved in every detail of the design, including the kitchen, which was to be, according to his strict specifications, simple and efficient.

Curtains, draperies, canopies, and needlepoint cushions were designed and made by Fontanne, Lunt, his mother, and his sisters. Fontanne, who had grown up poor and learned to sew her own clothes, upholstered much of the furniture herself. The couple's master suite included a makeup room as well as a sewing room for Fontanne. The couple did have plenty of local help, but this home was a family home. They exulted in expressing themselves in their work.

Ten Chimneys was a working farm. While Fontanne loved to pose for photos as a farmer's maiden, Lunt was actively involved in the work of a gentleman farmer. When Lunt was at Ten Chimneys he was up at dawn and worked in the fields and gardens. Staff managed the farm in the couple's absence, raising corn, oats, alfalfa, clover, wheat, vegetables, and flowers as well as horses, cows, pigs, and two hundred chickens. Alfred consulted the University of Wisconsin Department of Agriculture about the latest scientific methods for raising chickens. Because they spent a large part of their life on tour, Lunt and Fontanne often stayed in apartment hotels, accompanied by a maid from Genesee Depot who cooked their meals and took care of their dachshunds. It was not unusual for their farm manager to send provisions of fresh vegetables by train to whatever city they were in. Lunt always insisted on good, fresh food as part of his health and fitness regimen.

Women's magazines—*Good Housekeeping, House Beautiful, Independent Woman, Colliers,* and *Vogue*—found Lunt and Fontanne's romantic and happy marriage to be good copy. *Ladies' Home Journal* even offered the couple a new kitchen for their Manhattan townhouse in exchange for photos and an interview. *The New Yorker, Look,* and *Time* also carried articles. The couple's quaint Wisconsin farmstead aroused interest as well; readers enjoyed the fact that the world-famous and sophisticated Lunts were also homebodies who enjoyed cooking, gardening, and sewing.

WITH ITS WHITE BOARD-AND-BATTEN wood and stucco exterior accented with Kelly green wooden shutters, the main house's exterior is simple. Six of the getaway's ten brick chimneys are here. (The other four are at the cottage, the studio, and the greenhouse.) In lieu of more elaborate clay chimney pots, these are plainly capped. The real drama unfolded inside.

Beyond a large arrival court, the main house's front door is tucked under an overhang and behind oversized columns, almost unannounced. The entry hall's fantastically hand-painted murals depict symbols of hospitality—namely serving girls offering refreshments. A small windowed garden room with a white brick Swedish fireplace is the only reception room on the first floor; the rest of the rooms are service rooms housing

the laundry, furnace, storage, garage, and caretaker's room, a setup that was similar to the typical ground floor of a European home. The second story, accessed via a winding white staircase with bold geometric balusters, was the entertainment floor. Many of the rooms are up and down a few stairs from one to the next—an effective device that lent a feeling of spaciousness and separation as well as the opportunity for theatrical entrances and exits. The drawing room had several seating areas and a white grand piano. If the conversation lagged, the biblically themed wall paintings were sure to provoke discussion.

The dining room and the flirtation room are the home's most audacious, with a riot of patterns, colors, and textures over the walls, floors, painted ceilings, furnishings, and objets d'art. Like most flirts, the flirtation room is coy, promising more than it delivers. It is a small anteroom at the top of the stair, a place where guests would gather closely before entering the living room, dining room, or hall to the guest suites. The luscious yellow-and-white dining room shimmers and glistens like a lemon meringue tart. Wall sconces, a crystal chandelier, and five pairs of casement windows fill the room with dancing light day or night. An elaborately painted ceiling casts family members in saucy roles. The carved wood window valences, painted white, and the Delft tile fireplace capture the essence of Romantic Nationalism, the period in Sweden when art and culture were considered patriotic. During this time, native handicrafts, architecture, and mural painting flourished.

Historically the Swedes had traveled far from their land in warring pursuits, returning with architectural ideas and ornamentation techniques from foreign countries, which they then incorporated into their own building. Four styles—Baroque, Rococo, Neoclassical, and Empire—were combined to create Swedish Romantic Nationalism, or the Gustavian style, named for Gustavus III, the King of Sweden from 1771 to 1792. Gustavus was an active playwright who also founded the Swedish Ballet, the Swedish Academy of Arts, and the Royal Dramatic Theatre. He was known as the Aes-

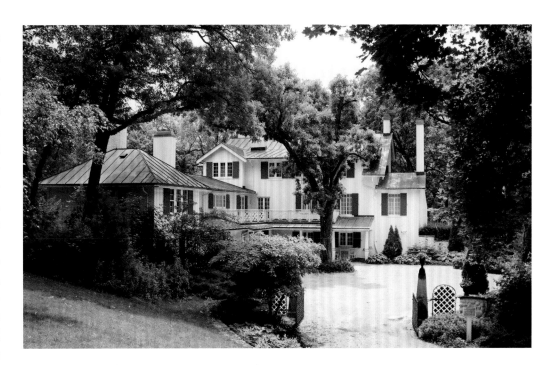

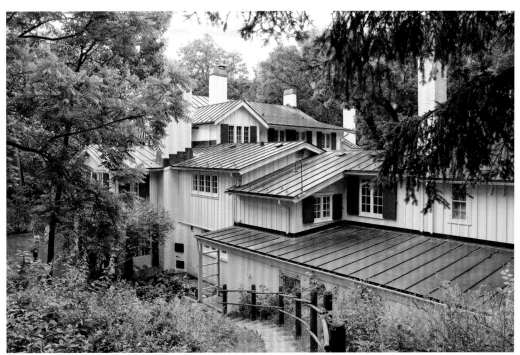

TOP AND BOTTOM: White board-and-batten siding, a silver metal standing-seam roof, and Kelly-green wood shutters are the simple materials of Alfred Lunt and Lynn Fontanne's Wisconsin getaway that was far removed from the glitz of Broadway.

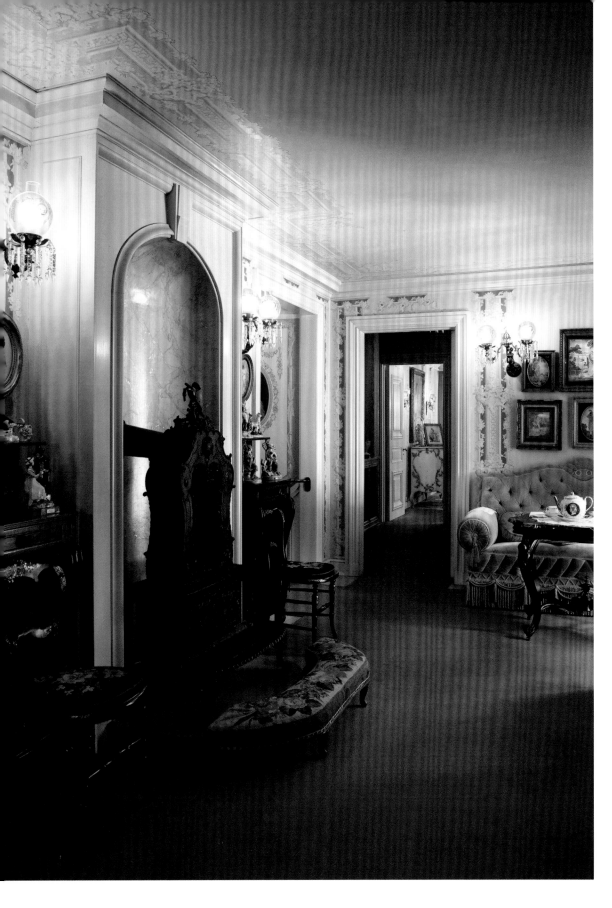

thete upon the Throne, an Enlightened Despot, and the Theater King. A small portrait of him hangs on the second floor of the main house at Ten Chimneys, visible from both the flirtation room and the living room, where he could quietly watch over the couple.

In contrast to the highly embellished rooms in the main house, the cozy, honey-hued, wood-paneled library with its comfortable armchairs, cushy couch, and many well-thumbed books is staid in comparison. The third floor houses the master bedroom and two guest bedrooms.

The simplest building on the site is the studio, built in 1932. The architects were Eschweiler and Eschweiler. The horizontal hewn logs were joined together in the traditional Scandinavian construction method of squared, double-notched corners. The studio was used primarily for practicing plays or as a quiet retreat for guests to get away from other guests. The double-height room with a balcony reached by a series of bent iron rails has a two-story-tall corner fireplace. The result feels very much like a playhouse for adults.

Corner stoves, or *kakelugn,* were a must in Swedish homes. These wood-burning stoves are exceedingly efficient and designed in brick or glazed tile. Fire was a concern in wood structures, but these stoves are tiled inside and out; they release their heat slowly, thereby reducing the threat of fire. There is a wide variety of porcelain and brick stoves throughout the buildings as well as an ornate cast-iron one in the flirtation room.

The use of material subterfuge is a time-honored Swedish tradition—a lesson not lost on Lunt, who enjoyed integrating numerous such techniques into the decoration at Ten Chimneys. Sweden's relative poverty (the Lunts were successful but not fantastically wealthy) and the harshness of

The "molding" in the flirtation room is actually cut-out wallpaper glued to the ceiling and the walls. Lunt appropriated set-design techniques to create illusions of grandeur in his home.

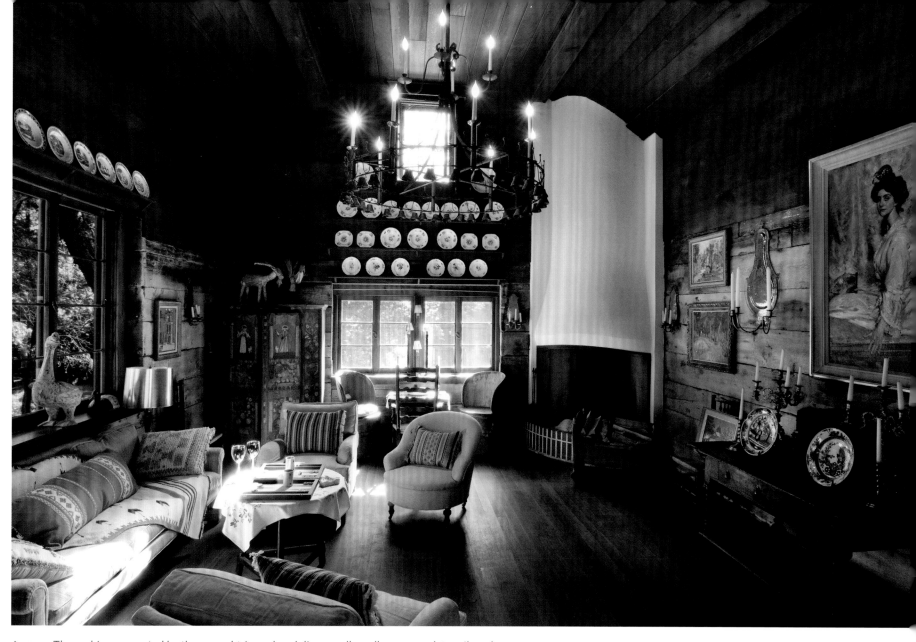

ABOVE: The ambience created by the wrought-iron chandelier, candle wall sconces, plate rail, and corner fireplace made the studio a favored escape from the main house. The couple liked to read scripts here with visiting actors. RIGHT: The two-story studio is attached to the wagon shed; both structures are formed from hewn, notched logs. These buildings were constructed in 1932.

the climate (much like Wisconsin's) required clever substitutions for the luxurious materials such as stone and ceramic tile better suited to rich patrons and more temperate climates. Swedish decorators were very clever, as was Lunt, in their use of thin and ephemeral materials to create the illusion of sumptuous and expensive interiors. The range and possibility of faux painting was widely explored. Exterior plaster was painted to look like stone; wood floors were painted to resemble tile; interior walls were made to appear to be marble; and trompe l'oeil painting enhanced perspective, depth, and even provided some humor to the interiors.

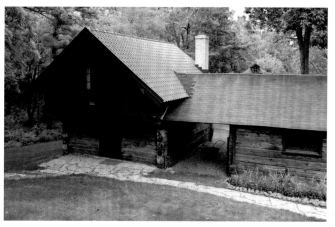

Style: Nordic Arts & Crafts

While Alfred Lunt would attribute his foreign architectural influences to his Nordic forebears and formative visits to Helsinki, his own estate was clearly influenced by the organization of Swedish farms and building technology.

At the beginning of the twentieth century, Sweden and Finland enjoyed a nationalism that was both politically and aesthetically fruitful. Established in the early 1900s, Skansen and Linnamaki were cultural parks where each country's folk traditions, costumes, and history were portrayed against a stage set of historic farmsteads and villages transported to the sites. The Swedish capitol designed by Ragnar Östberg and others in 1908 and Helsinki's train station designed by Eliel Saarinen in 1909 and opened in 1919 successfully blended accepted folk or nationalist forms with modernist style to achieve a distinctly Nordic approach to architecture. These award-winning examples of public architecture contributed to a positive reappraisal of the area's historic vernacular architectural forms. The published and built work of Carl Larsson further popularized this Nordic Arts & Crafts approach. Like its American counterpart, the style emphasized "honesty of materials, solidity of construction, utility, adaptability to place, and aesthetic effect." This was the environment and the aesthetic example that helped mold Lunt's views on architecture.

Energy-efficient site design, daylighting, and the use of local materials are part of today's sustainable architectural practices and can be traced back to many of the vernacular and Arts & Crafts approaches. Lunt was prescient in his use of the elegant but durable style of his Nordic ancestors in giving form to the landscape and the collection of buildings at Ten Chimneys more than eighty years ago.

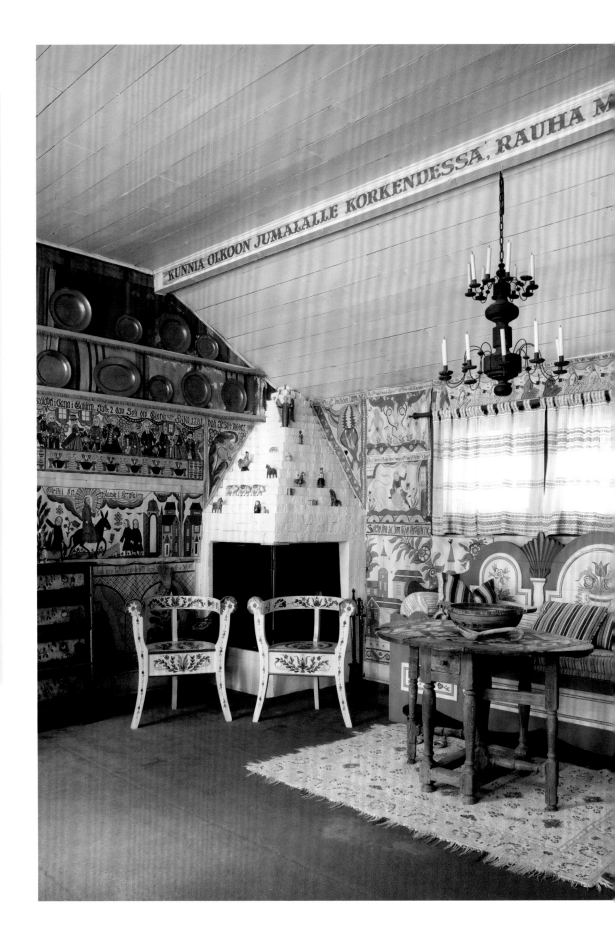

The cottage at Ten Chimneys abounds with traditional Scandinavian decorative painting and corner stoves with stepped masonry for the display of carved wooden horses, figures, and roosters.

Kurbits, or traditional Scandinavian folk art painting depicting floral and biblical motifs, abound in the cottage—many of them hand painted on canvas panels by Lunt while he was on tour. (The easily transportable panels were later attached to the walls.) Grisaille is another technique that was employed on the walls outside the master bedroom and guest bedrooms. This monochromatic painting technique, usually in gray tones, creates a three-dimensional effect suggesting the illusion of elaborate molding.

Lunt did much of the decorative painting at Ten Chimneys himself, but he did bring in famed set designer and modern painter Claggett Wilson, whom the couple knew from the theater. Wilson assumed authorship of the mural work in the living spaces of the main house and the cottage. He resided in the main house for almost two years, illustrating most of the walls and many of the ceilings with the assistance of two local men. Keeping with Swedish tradition, the scenes are both biblical and whimsical and a pure delight.

Claggett Wilson, seen here in 1939, created many of the murals at Ten Chimneys. The costume and set design for *The Taming of the Shrew* was his first collaboration with Lunt and Fontanne.

AT THE HEIGHT OF THE GREAT DEPRESSION, the construction and maintenance of Ten Chimneys' many buildings kept a great many local people employed. In addition to the residential structures, the agriculture buildings—the horse stable and pig barn—were constructed between 1932 and 1942. The arrival court, vegetable garden, and flower garden were also installed during that period as was the one-story red-and-white wood pool house that recalls Swedish pleasure buildings built as follies on the grounds of nobles' estates—a concept borrowed from English, French, and Italian gardens. The pool house's multipaned windows are sympathetic to the Rococo period in Sweden, and its dome reflects the Swedish interest in Chinese architecture during the Gustavian period.

The 1930s were devoted to additions to and remodeling of the main house, financed largely by money the couple earned in their only talking movie, *The Guardsman,* which was based on their popular play. The architect of record at this time was the Milwaukee firm Eschweiler and Eschweiler, but scant documentation has been found regarding the extent of its involvement; it is generally accepted that Lunt had the design pretty well developed.

During their world travels either for work or pleasure, Lunt carried a notebook filled with the dimensions of every room at Ten Chimneys to aid them in their search for appropriate furnishings. The couple bought fine art, furniture, and decorative art in Spain,

Sweden, Hungary, and Italy, as well as antiques shops in Milwaukee. The Lunts spent decades building, remodeling, renovating, and decorating their getaway. In 1942 Ten Chimneys was basically complete.

Friends were always welcome. The main house had three guest bedrooms and two guest baths on the third floor. The friends who visited regularly, such as Noël Coward, Katharine Hepburn, Sir Laurence Olivier, Carol Channing, Helen Hayes, and Edna Ferber, were like an ensemble cast: they performed with Lunt and Fontanne summer after summer. Their comfort and familiarity with one another—some would stay two weeks or one or two months—overrode any irritating idiosyncrasies and assured a unity of performance.

The Lunts arranged their acting schedules so they could get away to Wisconsin at least part of every summer; they also tried to spend Christmas or Thanksgiving at Ten Chimneys. Eventually, the getaway compound became their retirement home.

ABOVE: The Lunts' home was also a getaway for their many friends. RIGHT: The red-and-white pool house is a playful, scaled-down interpretation of a Swedish townhouse.

IT IS NATURAL to think of actors creating a stage set for their personal lives, and the Lunts certainly did create one at Ten Chimneys for a play that went on, act after act, each day bringing a new comedy, farce, or drama. The couple retired to their Genesee Depot home and lived there until their deaths, Lunt's in 1977 and Fontanne's in 1983.

Ten Chimneys was inherited by Alfred's brother-in-law George Bugbee, who had remained after the death of Alfred's sister Karin for many years as caretaker. Bugbee kept the property and almost all of its furnishings intact. But the Lunts had not left money to care for the property in perpetuity and an estate of this size with numerous buildings was a tremendous financial burden for a single property owner.

After Bugbee's death, developers were interested in breaking up the property into smaller parcels. Due to the tenacious vision and Herculean efforts of one man—Joe Garton—Ten Chimneys was saved. Garton, who served as chair of the Wisconsin Arts Board and whose interest in education and the arts as well as his experience in restoring buildings was recognized by the state when it honored him with a Governor's Award in Support of the Arts, established a foundation that would restore the Lunts' home. It took more than seven years to raise the funds and complete the work, but today Ten Chimneys is a National Historic Landmark serving as a public museum and cultural center that hosts estate tours and programs for theater and arts professionals.

It is an extraordinary experience to walk into a room and see it as the owners left it. Ten Chimneys is not a re-creation of the Lunts' home; it is still their home. Today the estate comes alive for people the world over who tour Ten Chimneys for a brief getaway back to a setting where playacting was real and where Lunt and Fontanne were perpetually young and giving the best performances of their lives. •

The library is the quietest room in the house in terms of decor that says *domesticity* not *Broadway*. This was the living room of the original house before Lunt and Fontanne married.

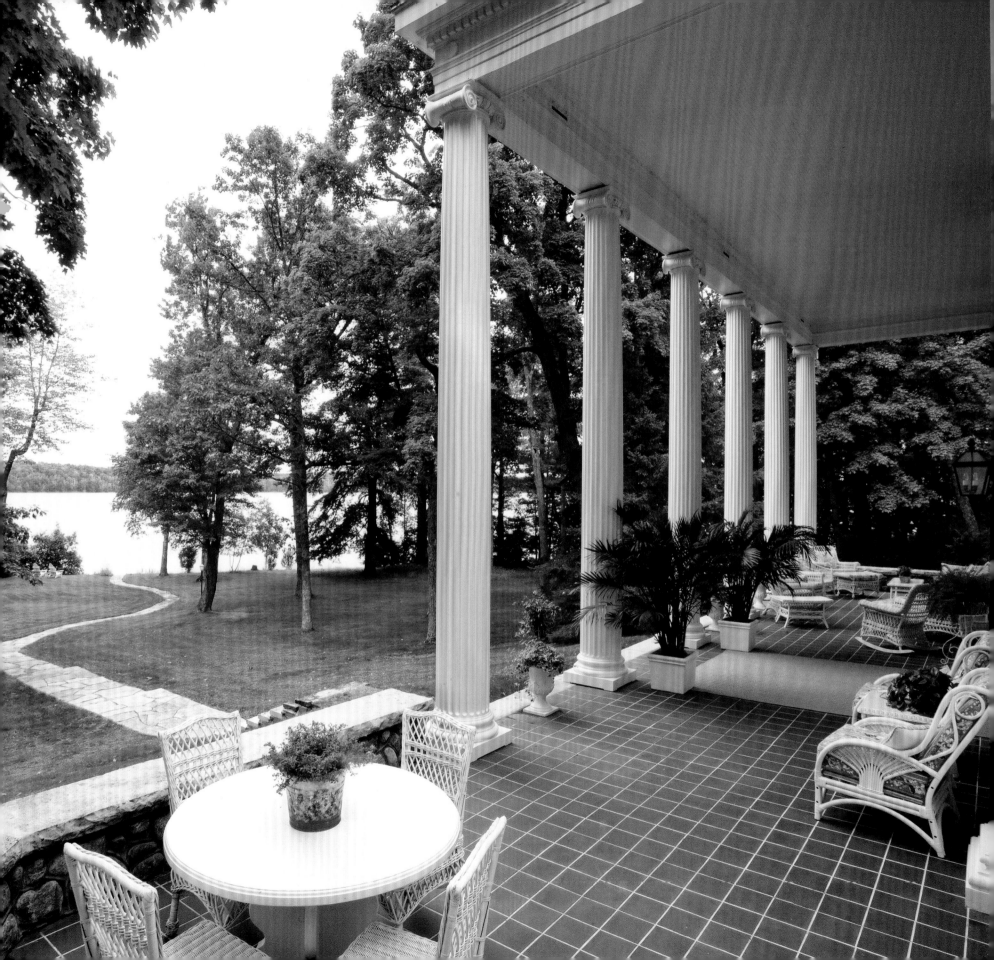

Fort Eagle

OPPOSITE: The Galpins enjoyed spectacular views of Big Sand Lake from their expansive lakeside porch at Fort Eagle.

SOMETIMES A GETAWAY is also a hideaway.

The cover provided by the hemlock and pines bordering Big Sand Lake in Vilas County proved just such a sanctuary for Homer K. Galpin, a shady character evading the law. Galpin earned the nickname "Homeless Homer" for his uncanny ability to never be home when law enforcement came knocking on the door of Fort Eagle, his North Woods getaway in Phelps, Wisconsin. Galpin was a lawyer and an infamous figure in Illinois politics during the Roaring Twenties, reputedly intertwined with gangsters and bootleggers, including Al Capone. From 1928 to 1930, as he evaded a Cook County subpoena concerning campaign funds that went missing under his care, he summered in Phelps and wintered in Sarasota, Florida, as part of the Florida "Chicago Colony" that included Mrs. Potter Palmer, members of the Field family, and the Ringlings from Wisconsin.

The building and financing of Galpin's extravagant nine-thousand-square-foot Colonial Revival mansion on the shore of Big Sand Lake has kept people gossiping and speculating for almost ninety years. Whatever spurious activities Galpin may have participated in in Illinois, his life was quieter in Wisconsin—so much so that some referred to him as a model citizen. He was also a major force in bringing tourism to Vilas County in the early 1900s.

Until a military road was constructed between Fort Howard at Green Bay and Fort Wilkins on the banks of Copper Harbor on Lake Superior in Michigan in 1869, the Wisconsin River was the major transportation route used to reach the North Woods. The railroad came to Eagle River in 1883 to transport hardwoods like maple, beech, and birch south; most of the white pine had already been lumbered. Soon after the train was established, hunters and fishermen followed.

In 1878 the state Legislature had put aside 50,000 acres of scattered timber land in Vilas, Lincoln, Iron, and Oneida counties for state parkland under the name Public Trust Funds Lands. Vilas County's scenery was recognized as a rare treasure: maples, oaks, birches, pines, and hemlocks combined to create an astonishing forest every season. Eagles, osprey, great blue herons, loons, ducks, hawks, grouse, and warblers were in abundance. Deer, beavers, otters, mink, porcupines, bears, and fox were commonplace, while bobcats, mountain lions, and timber wolves were less common but present. Walleye, Northern pike, and large- and small-mouth bass filled the county's 1,300-plus lakes.

An ecological haven for birds, fish, and wildlife, the area was also a treasure chest as far as lumbermen were concerned: the virgin forest held great appeal for powerful business interests. Nationwide, the Organic Act of 1897 was written to manage and protect forests, which included securing favorable water flow while supplying lumber. That year, bending to the will of lumber interests, Wisconsin repealed its Public Trust Funds Lands legislation. Phelps was one of the last areas in the state to be logged.

Farming in the cutover region was not a viable option because most of the soil was too thin and sandy for agriculture. In 1904, 40,000 acres in Vilas, Oneida, Iron, and Forest counties were placed in preservation to protect the headwaters of the Wisconsin, Flambeau, and Manitowish rivers from the ill effects of erosion caused in part by logging. By 1914 more than 3,000 acres statewide had been reforested with seedlings grown in state forestry nurseries of northern Wisconsin; Vilas County had been the first county to be replanted. Fish hatcheries were also constructed to stock the state's lakes. Today, 37,000 acres of state and national forest surround Phelps and its environs. Both tourists and residents continue to revere the area for its natural beauty, clean air, and sparkling lakes— just as tourists did in the early 1900s.

Tourism began in Vilas County in the 1880s, as hunters and fishermen camped in the woods or boarded with local families. In 1900 an overnight train ride brought tourists to Eagle River from Chicago; it then took a day's travel to reach Phelps by tote roads, the rough roads built by members of logging camps to transport supplies to the camps.

The remote nature of the area as well as the clean air of northern Wisconsin held great appeal for Chicagoans in search of a change from the city's hot, flat, crowded summer streets. Tourism advertisements from the early 1900s hyped Wisconsin vacation spots as restful, relaxing, attractive, clean, modern, well maintained, accessible, delightful, and pleasure filled.

Homer Galpin was a regular summer visitor to the area around Phelps, beginning in the 1890s. In 1903 he was elected president of the Eagle River Fishing and Shooting Club, a sporting club founded in 1891. Memberships were sold only to Chicagoans, many of whom were prominent in Illinois politics. During its first decade, the primitive club was a men's-only hunting and fishing retreat on the site of a former logging camp; the entire 800 acres had been logged of its white pine. The original 1890s clubhouse was replaced in 1924 by a rustic-style one made of hemlock logs and local stone, reputedly the state's largest log building at the time. Bedrooms rented by club members were located on the second floor, and families began to join the men on their expeditions. The land was owned by the group, but some wealthier club members started building cabins or cottages on the property. As more families spent time there the name was changed to the Big Sand Lake Club. Galpin was an active member, serving as its president three different times, with his longest tenure dating from 1924 to 1933. He is credited as the driving force behind the construction of the 15,000-square-foot rustic-style log cabin clubhouse built by local Finnish carpenters after the original log cabin burned down.

In 1926 Galpin's dream of a year-round weekend train from Chicago to Phelps came to fruition, largely because of his persistent conversations with his well-connected friends over several years. Galpin believed that summer people would enjoy the North Woods winter experience and that a train would be of economic benefit to the people of Phelps because it would encourage the tourist trade from Chicago. A sleeper train out of Chicago also would enable Galpin and others to become weekend commuters to northern Wisconsin. They would arrive on Saturday, enjoy two days in the North Woods, and then catch the sleeper train on Sunday night, arriving back in the city in time for the start of the workweek.

While his fellow club members were constructing cabins in proximity to one another, Galpin instead sought refuge across the lake. He had previously owned a rude fishing cabin on another lake, but in 1916 Galpin purchased 700 acres on the southwestern

LEFT AND RIGHT: Two different types of log construction—stockade (vertical) and traditional (horizontal)—are seen in these buildings, the earliest ones on this site. The stockade building is a sauna, and the traditional is Homer and Hilda Galpin's honeymoon cottage.

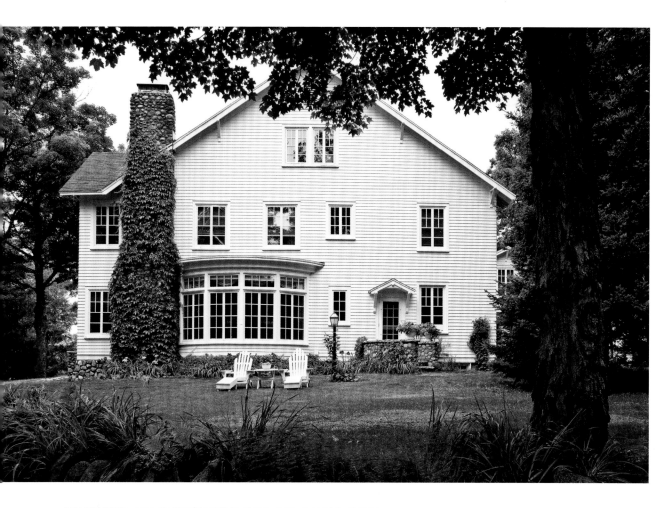

shore of Big Sand Lake from Hackley, Phelps, and Bonell, the largest landowners in the area. Galpin and his second wife, Hilda Jensen, whom he married in 1916, built a small log cabin referred to as the honeymoon cottage in 1919. Homer and Hilda resided there during the three years it took to build their first home, a small house, which was later enlarged to a grand Colonial Revival they named Fort Eagle after the eagles that still nest high in the pines.

The current estate is less than the original 700 acres, but since it includes more than a mile of Big Sand Lake shoreline the effect of isolation and grandeur is the same. The gravel road leading to the property off Sand Lake Road is easy to miss, but granite stone pillars and a handcrafted Arts & Crafts wrought-iron gate hint to the unique property beyond. The approach to the main house is via a narrow, mile-long road that carefully follows

TOP AND BOTTOM: The fieldstone fireplace of the Galpins' original rustic home was incorporated into their grander Colonial Revival.

the topography and curves to avoid trees left behind by loggers because they had no commercial value. When the Galpins built their home the forest was still immature from the logging of the 1890s; those trees stand sentinel over the property today. The road culminates at a circular drive and is punctuated by a water tower proclaiming "Fort Eagle" in gold lettering. The water tower, which can be relied on as a water source for fire suppression, stored the Galpin's drinking water and still provides irrigation for the extensive lawn.

The three-story residence—its immaculate white clapboards decoratively dappled with shadows from the white pine, oaks, and maples—is set on a slight rise that blocks views of the lake from the drive. Traditionally, lake homes consider the land side as the back door, since locals arrive at the opposite side via water, and Fort Eagle is no exception. Boaters can first be seen from the driveway approach to the house. To the west, several steps lead to a tiled terrace, from which a breathtaking view of Big Sand Lake is revealed. It is difficult to get a sense of the architecture upon approach, since the landscape view is so compelling.

From the lake the view of the house is astonishing. The combination of terraced lawn, the four-and-a-half-foot-high fieldstone foundation wrapping around the house, and the six eighteen-foot-tall Ionic columns topped with a balcony make one wonder, "Am I really in northern Wisconsin?" This Colonial Revival house would be at home on the banks of the Ocmulgee River in Georgia.

The facade is defined and dominated by a two-story porch. The roof is a front gable concealing a cross-gable roof behind, which results in an effect similar to a Greek temple—it's a formal portico applied to a North Woods getaway. The full-length terrace, which is spacious enough for groupings of wicker furniture that could easily seat twenty, is designed as an outdoor living room, with the columns framing scenes of the wooded lawn and lake. Three sets of French doors off the terrace give no clue as to which one is the front door. This lack of symmetry is a strong indication that the house was not designed by an architect who paid attention to formal rules within a style but by the homeowner, who gave higher consideration to interior floor plan configuration than to historically correct elevations.

The first house the Galpins built was a rustic home. The main house and the outbuildings—the sauna, guest cottages, and boathouse—were continually altered during the Galpins' lives. In 1927 the transformation from cottage to Colonial Revival occurred. All that remained of the original residence was the foundation and the stone fireplace.

Very little about the present Fort Eagle could be labeled vernacular architecture. Even the fieldstones forming most of the buildings' foundation walls are not local; they were transported from central Wisconsin. The wood-frame Colonial Revival is an uncommon interpretation of a style not commonly found in lake houses in northern Wisconsin. By the 1920s the popularity of wood Colonial Revivals was on the wane nationwide, especially in residential architecture; red-brick Georgian Revival homes were more typical. In selecting this style, the Galpins were obviously making a statement by replacing their cottage with a more formal showplace home that had more to do with Southern hospitality than the North Woods rustic heritage. They looked to a period revival style for their Sarasota home as well. Their Mediterranean Revival residence built in 1929 was typical of upper-middle-class winter homes constructed during the Florida boom years.

The house's floor plan is atypical of the Colonial Revival style. These homes usually have a center entry hall with coat, hat, and boot storage; in northern climates these halls also act as climate locks, keeping cold air from entering the main living room. The house has neither an entry hall nor a central hall; instead, the lakefront-facing French doors open directly into a 31-by-31-foot living room with 10-foot ceilings, an indication of the informal habits of lakefront summers. Fort Eagle was built with an oil heating plant. With spring arriving late and winter arriving early in the North Woods, a heating plant made sense in this summer home.

A graceful curved cantilevered staircase occupies the eastern wall of the living room while a rough-hewn stone fireplace dominates the west wall. An oversized arched opening melds the dining and living rooms; the openness of the plan is far more modern in its expression than the home's conservative exterior. A unique structural element consisting of inverted trusses with adjustable tension rods is exposed on the third floor. This bridgelike truss supports the roof while allowing for the unusually broad, open expanse of the first and second floors. Another unusual feature is the lack of hallways: rooms flow

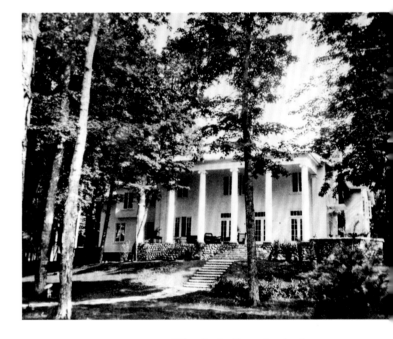

What looks like a simple clapboard house upon approach is surprisingly revealed as a Colonial Revival, on a grand scale, from the lake side, as seen in this circa 1927 photograph.

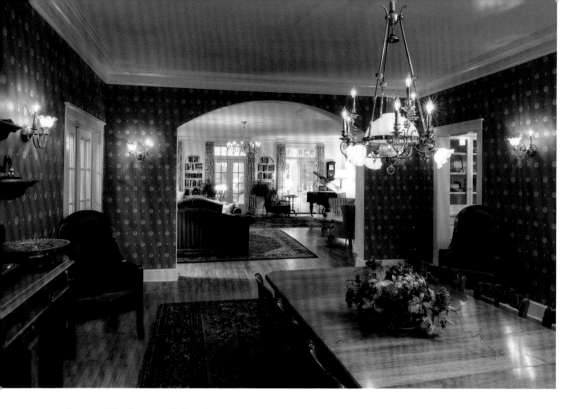

into one another with a familiarity that is appropriate to a lake house and conveys the casual result of adding rooms as needed. An additional clue to ad hoc additions is the frequency of one-step level changes between rooms, on the main level as well as upstairs.

Although childless, the couple built such a massive summer home so they could entertain a great number of local Phelps friends, including fellow members of the Big Sand Lake Club and friends they made from the Ringling circus. Hilda enjoyed entertaining wealthy Chicago friends, disadvantaged girls from Chicago, and local girls. The little girls could play dolls in the "dollhouse." Tea parties took place in the six-sided, screened, cottage-style gazebo teahouse overlooking the lake.

The Galpins had a number of staff who looked after the estate. A housekeeper traveled with them to Florida, but a caretaker couple lived at Fort Eagle in a rustic, one-story wood cottage just east of the main house. Lydia Loma Morey, a young Finnish woman, worked for the Galpins and had a room in the house. (She was the executor of their estate.)

Fort Eagle and other remote getaway properties were designed as self-sufficient complexes. About two miles away, Galpin established Eagle Farm, operated by the Peterson family. Cows, pigs, chickens, and vegetables were raised there to supply the Galpins as well as the Big Sand Lake Club. Any creature comfort, any function or amenity that an owner desired had to be available on-site. The Galpins had a garden house, a sauna, a six-stall garage, a stable, a storage building, and a single-story boathouse with three boat slips. (Homer was an avid gardener and boater.) The boathouse, in the same style as the teahouse, is a visual lesson in simple wood-frame construction: all the dimensions and connections of the piers, roof decking, floor decking, column post and its lateral bracing, roof beams, and jack and hip rafters are clearly visible. The scattering of outbuildings over the grounds gave it more the feel of an estate than the more typical camp feeling of clustered buildings in a similar style that is common in rustic compounds.

AFTER EACH OF THE GALPINS died in 1941, the estate was sold to a local lumberman who kept it only long enough to log off all the profitable hardwoods. Since the Galpins' time the property has operated as a beef cattle farm, a resort, and a retreat for a religious order; it also has been subdivided several times. Today, after a succession of ten owners, some more benevolent than others, the property has regained its place as a significant example of an intact North Wood's estate of the early twentieth century under the stewardship of

ABOVE: The house is fully winterized and the kitchen is up to date. Though snow falls early, and fall and spring are brief, the current owners enjoy meals in their dining room in all seasons. BELOW: Three-car garages are a status symbol in town. But on Wisconsin lakes it's all about the boathouse. The screened gazebo is topped with a golden eagle weather vane.

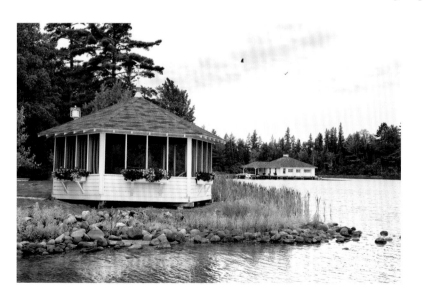

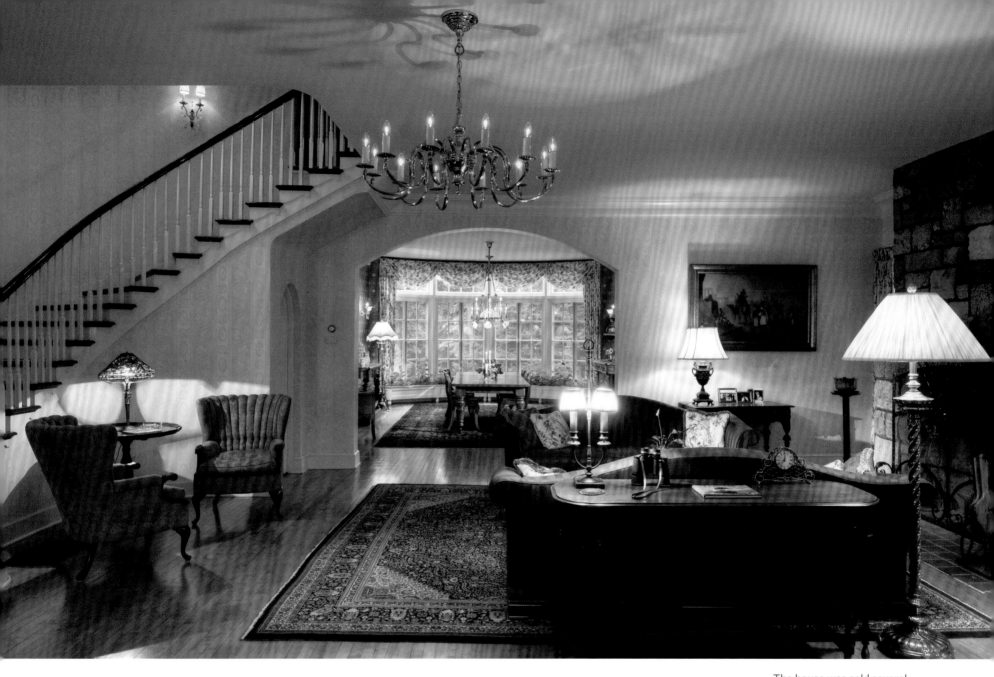

Stephen Kaniewski and his wife, Judith Peck, of Wauwatosa, who bought the property in 1996. For the past fourteen years they have been restoring the home and the outbuildings (some of which are being renovated as small guest cottages), making energy-efficient enhancements so they can enjoy the home as a year-round family getaway, and attempting to reassemble the original land holdings.

Before the couple bought the property it had been repeatedly vandalized. Many of the original fireplaces, floors, windows, and other interior details had been damaged or destroyed. Kaniewski and Peck have diligently and intelligently made decisions about period appropriateness when choosing interior decorations, from lighting to patterned wall coverings to paint colors in rich reds, blues, and yellows. The house is quite probably more

The house was sold several times after Homer Galpin's death and was abandoned for many years. Amazingly, the fieldstone fireplace and cantilevered stair remained intact.

authentically Colonial Revival now than during the Galpins' time; the Galpins furnished the living and dining rooms in a Western motif and had a fondness for pine paneling and stuffed fish and wildlife. Today the more formal rooms convey a strong Colonial or Federal influence, while the bedrooms express the family's personality more than an adherence to a style. Some Arts & Crafts details appear in fireplace tiles and wood molding details. Throughout the home antique and specially designed lighting fixtures enhance the ambience. Built-in interior window boxes continuously bloom with flowers thanks to an abundance of southern light.

While the first floor had suffered vandalism, the second floor with its seven bedrooms and three bathrooms was largely spared. The tile work in one of the original bathrooms—composed of intricate patterns, tiles of various sizes, and rich, warm color schemes—is an excellent example of the artistry and craftsmanship of tile setters. The third floor, originally a billiards room, is being renovated into a family room. Its balcony provides a magnificent view of eagles' nests and a distant view of the northern shore of Big Sand Lake.

The secluded wooded lake setting is without equal. Eagles nest in the tops of the tall pine trees, the lawn undulates down to the lakefront, and every room on the north, west, and east side has a lake view. The teahouse gazebo appears to float over the lake—providing just the place for a summer lunch, an afternoon card game, a late-night conversation, or a view of dawn breaking on the lake. In summer, flowers brighten its window boxes under the six-over-one, double-hung windows.

HOMER AND HILDA GALPIN were active members of the Big Sand Lake Club, and so are Stephen Kaniewski and Judith Peck. Homer Galpin may have been hiding out from the authorities, but he was nevertheless a larger-than-life presence at Big Sand Lake. The Kaniewski-Peck family is not hiding out from anyone, but they enjoy their North Woods getaway as much as Homeless Homer did. There is something about living in a house with a rich history, one where the original owners left their imprint and legacy, that encourages subsequent owners to solve the puzzle of the missing piece, to fill in the blanks, to respect the past, and then go forward into the future as boldly as their predecessors did to celebrate the beauty of the Wisconsin landscape in a revived Colonial Revival now on the National Register of Historic Places. •

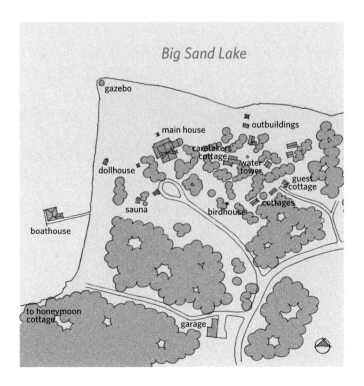

OPPOSITE: Two paths lead from the lake to the porch with seating for twenty. The lakefront facade has more the look of a Southern mansion, with six, two-story Ionic columns and a spectacular view of the 6,100 feet of shoreline.

Homer K. Galpin no longer lives (or hides) here, but the drive from the front gate is still long and reveals glimpses of the various outbuildings as visitors wend their way to the main house. Subject to foliage cover, the garage and the water tower to the southeast of the house may be visible upon entry.

Galpin's home is erected on a knoll overlooking the lake. Past the sauna and dollhouse is an elegant boathouse, and just beyond that is the rebuilt honeymoon cottage.

The current owners have reassembled much of the original acreage so that the site's basic bones remain; over time elements such as the dollhouse, ice house, and work shed have been moved to allow for better access, to reinforce privacy, and, most important, to maximize one's visual connection to a stellar setting.

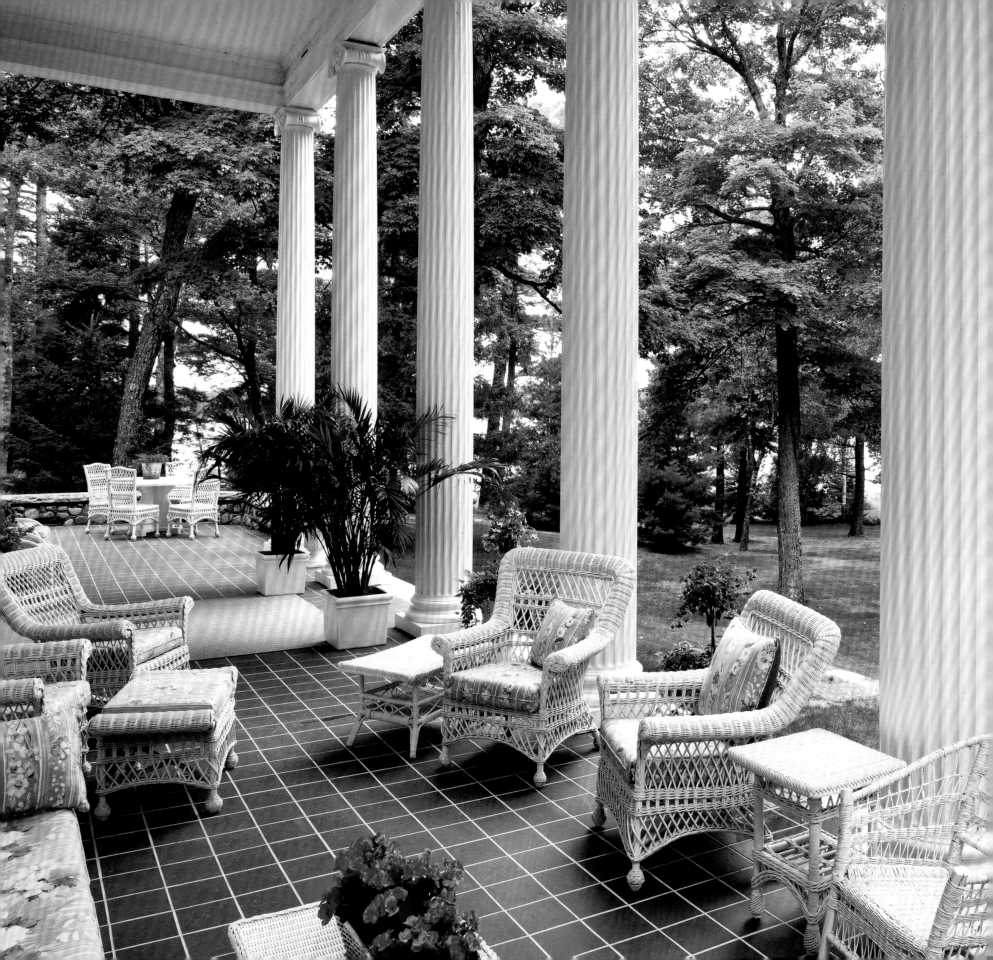

Appendix I: Map of House Locations

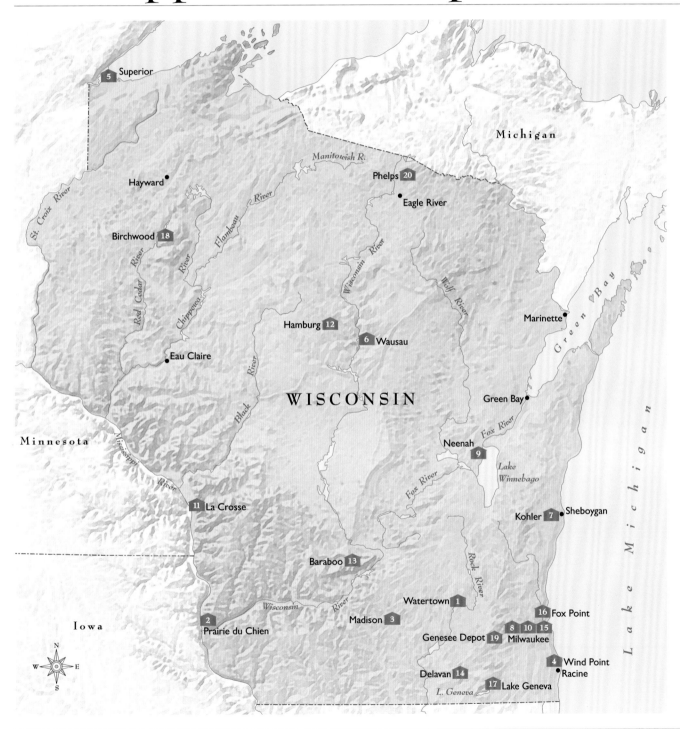

1. OCTAGON HOUSE
2. VILLA LOUIS
3. HAROLD C. BRADLEY HOUSE
4. WINGSPREAD
5. FAIRLAWN
6. CYRUS C. YAWKEY HOUSE
7. RIVERBEND
8. VILLA TERRACE
9. HAVILAH BABCOCK HOUSE
10. CAPTAIN FREDERICK PABST MANSION
11. HENRY A. SALZER HOUSE
12. WALTER AND MABEL FROMM HOUSE
13. HOUSE OF SEVEN GABLES
14. ALLYN MANSION
15. ADAM J. MAYER HOUSE
16. BROOKS STEVENS HOUSE
17. WADSWORTH HALL
18. ISLAND OF HAPPY DAYS
19. TEN CHIMNEYS
20. FORT EAGLE

Appendix II: Tools of the Trade

How Architects Did Their Drawings

The computer is changing the practice of architecture and eliminating the need for many of the original tools used in the realization of the homes described here.

While the Renaissance artist most probably drew with charcoal, it was not until 1560 in Borrowdale, U.K., that an uprooted tree revealed a vein of what we now call graphite. Proven a great drawing media, the material was soon inserted into a shaft of wood to become the pencil. In 1795 Joseph Conte blended graphite with clay and hardened the concoction in a furnace to create conté crayons. By the 1870s pencils were being mass-produced, and numerous designs for pencil sharpeners and pencil pointers were patented and sold.

Nineteenth-century draftsman also used croquil pens that were metal versions of the ancient quill pen with an open reservoir. Straight lines were "ruled" with a ruling pen whose line width was adjusted by a threaded screw connecting two flat metal nibs. John Jacob Parker of Janesville patented the first self-filling fountain pen in 1831, and Lewis Waterman patented his version in 1884.

In an office like E. Townsend Mix's, the most senior member would use wooden T squares and triangles to realize architectural projects in pencil sketches on paper. Less senior "tracers" would duplicate and "firm" or straighten up these drawings via pins pricked through the original to a copy below. The introduction of translucent media like tracing paper, vellum, and linen allowed the tracer to put one of these atop the original and trace in pencil. Since the new media was more direct and clear, drawings were redrawn more clearly in ink with ruling pens while notes were applied with croquil pens. Like the dress-making term, graphically infilling the void between the two lines that defined a wall on a plan was called the pocket or in French *poché*.

A typical completed project would have several hand-drawn copies retained in the office for record, review, and for bidding by the contractor. Offices set aside rooms or tables where the contractor could review these drawings and gather the necessary data for their cost calculations. Because of the nature of the practice—and how drawings were prepared and reproduced—the number of drawings were minimized while the amount of collaboration between the contractor and his shop drawings was maximized.

The process of blueprinting was introduced in the United States at the 1876 Centennial Exposition in Philadelphia. Vellums or linens placed over paper treated with a photo emulsion were exposed to an arc lamp and then treated with an ammonia developer to produce a white line on a blue background. By 1900 the number of tracers at firms like Ferry and Clas could

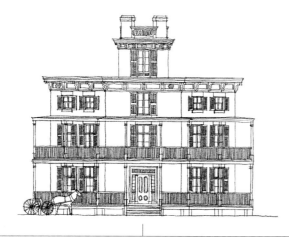

OCTAGON HOUSE
1854

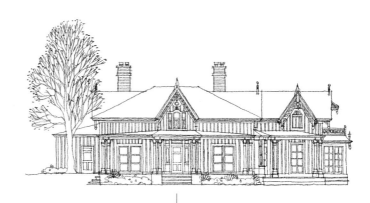

HOUSE OF SEVEN GABLES
1860

be greatly reduced while prints could economically be made available to many outside bidding contractors. While the contractor's table would remain a fixture in architecture offices into the 1960s, the architects' control and easy dissemination of their media served to further separate architect from contractor. Technology allowed architects to produce and better control the constructed outcome thanks to construction documents that had earlier been produced collaboratively in shop drawings by the contractor.

How We Did Our Drawings

All but one of the featured homes in this book were free-hand rendered in elevation and plan at quarter-inch scale, with many drawings running more than five feet in length. An architectural plan can be likened to a horizontal section cut approximately three feet above the floor. An architectural elevation is not drawn as we might see it from the street because that view would have distortion due to perspective; rather, it is an oblique view without distortion so that the construction crew can view each part as it would be built.

Some of the subjects had original elevations and plans that we could use as a base drawing upon which we could make updates of current conditions noted during our visits. Some of the subjects had very little documentation, which required us to construct a drawing from scratch.

The Captain Frederick Pabst Mansion had an accurately drawn visitors' guide plan but no elevation for one of the most ornate examples in this book. We created a digital photograph in the field, but distance and a drop in elevation resulted in a photo with some distortion due to perspective. We opened the digital image in Photoshop and what was originally a trapezoidal image due to perspective was squared off and stretched vertically by eye.

The City of Milwaukee has one of the best drawing archives of permitted buildings in the country. While it did not have the original Ferry and Clas drawings, it did have a drawing from the 1960s showing the Pabst footprint on a site plan with dimensions. Another recorded drawing for the added elevator yielded floor-to-floor elevations. These were already on microfiche and both were e-mailed to us. The scanned site plan was imported into our CAD program and scaled per its noted dimensions. We scanned the visitors' guide plan at our office and imported it into the same CAD drawing, where it was scaled to fit the footprint of the dimensioned site plan. Because the south elevation had been selected for drawing, we projected guide lines from the corners to establish the length to scale of that elevation.

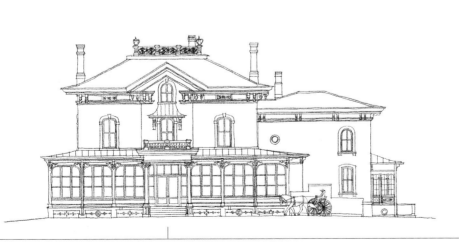

VILLA LOUIS
CIRCA 1870

ALLYN MANSION
1884–85

»

Then the digital photograph of the elevation was imported and it was scaled to fit the guide lines projected from the corners of the plan. A first-floor line was established at the front-door threshold. Using the archive information we drew guide lines at the correct elevations for the second and third floors—these were within inches of where they appeared on our photo elevation except for the foreshortened, stepped-back roofline. The roof was interpolated and drawn in CAD and the chimneys were extended as well.

The elevation does a certain amount of "jig and jags," which were accommodated by cutting the photo into vertical parts to meet the floor-plan projection. Can you spot the mistake we made? Consultation with the Pabst staff, their brochure, and the Wisconsin Historical Society carriage collection yielded a skewed carriage—which was also straightened in Photoshop and added to the elevation.

The plan and elevation were then drawn free-hand in pencil from these elaborate CAD base drawings and scanned. The scanned plan was opened in Photoshop, where *poché* and color-coded screens with identifying notation were added. The elevation was put into InDesign and printed onto 10-by-15-inch d'Arches watercolor paper. The paper was then mounted on a watercolor block and rendered in watercolor.

The use of a 3-D laser survey, which gathers a digital "cloud" of X, Y, and Z coordinates that in turn are assembled into a 3-D volume, would have done all this in half the time and at one hundred times the budget. •

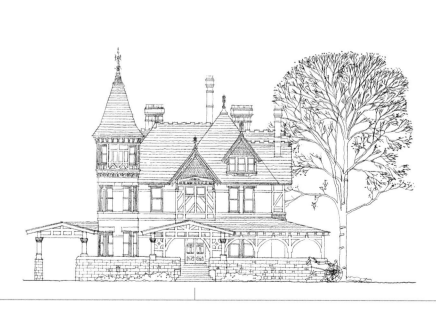

HAVILAH BABCOCK HOUSE
1887

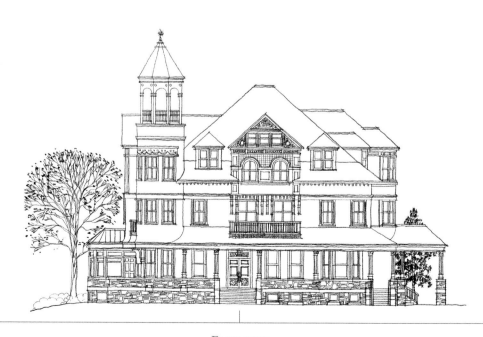

FAIRLAWN
1889–91

For Further Reading

Architecture and Styles

Bel Geddes, Norman. *Horizons.* Boston: Little, Brown and Company, 1932.

Benjamin, Asher. *The Architect, or Practical House Carpenter.* 1830. New York: Dover, 1988.

Comstock, William T. *Victorian Domestic Architectural Plans and Details: 734 Scale Drawings of Doorways, Staircases, Moldings, Cornices, and Other Elements.* New York: Dover, 1987.

Downing, Andrew Jackson. *The Architecture of Country Houses.* New York: Dover, 1969.

——*Victorian Cottage Residences.* New York: Dover, 1981.

Eastlake, Charles L. *Hints on Household Taste in Furniture, Upholstery, and Other Details.* New York: Dover, 1969.

Foy, Jessica H., and Thomas J. Schelreth, eds. *American Home Life 1880–1930: A Social History of Spaces and Services.* Knoxville: University of Tennessee Press, 1992.

Handlin, David P. *American Home: Architecture and Society, 1815–1915.* Boston: Little, Brown and Company, 1979.

Howard, Hugh. *How Old Is This House?* New York: Noonday Press, 1989.

Ierley, Merritt. *The Comforts of Home: The American House and the Evolution of Modern Convenience.* New York: Three Rivers Press, 1999.

Landscape Research. *Built in Milwaukee: An Architectural View of the City.* Milwaukee: City of Milwaukee, 1983.

Lewis, Arnold. *American Country Houses of the Glided Age (Sheldon's "Artistic Country-Seats").* New York: Dover, 1982.

McAlester, Virginia and Lee. *A Field Guide to American Houses.* New York: Alfred A. Knopf, 1984.

Newton, Norman. *Design on the Land.* Boston: Belknap Press of the Harvard Press, 1971.

Palmes, J. C. *Sir Banister Fletcher's A History of Architecture.* New York: Scribner, 1975.

Reps, John H. *The Making of Urban America: A History of City Planning in the United States.* Princeton, NJ: Princeton University Press, 1965.

Walker, Lester. *American Shelter.* Woodstock, NY: Overlook Press, 1981.

Wharton, Edith and Ogden Codman Jr. *Decoration of Houses.* 1897. New York: Norton, 1997.

CAPTAIN FREDERICK PABST MANSION
1892

CYRUS C. YAWKEY HOUSE
1901 AND 1907–08

»

Wisconsin

Adamson, Glen. *Industrial Strength Design: How Brooks Stevens Shaped Your World.* Cambridge, MA: MIT Press, 2005.

Chappelle, Ethel Elliott. *Around the Four Corners: A Pioneer History of the Washburn, Sawyer, Barron and Rush Counties.* N.p.: Chronoltype Publishing Company, Inc., 1971.

Davis, Tom. *Fairlawn: Restoring the Splendor.* Black Earth, WI: Trails Custom Publishing, 2001.

Derleth, August. *Bright Journey.* New York: Scribner, 1940.

——*House on the Mound.* New York: Duell, Sloan, & Pearce, 1958.

Eastberg, John C. *The Captain Frederick Pabst Mansion: An Illustrated History.* Milwaukee: Captain Frederick Pabst Mansion Inc., 2009.

Nesbit, Robert C. *Wisconsin, A History.* Second edition. Madison: University of Wisconsin Press, 1989.

Pinkerton, Katherene Sutherland Gedney. *Bright with Silver.* New York: W. Sloane Associates, 1947.

Robertson, Cheryl. *The Domestic Scene (1897–1927): George M. Niedecken, Interior Architect.* Contributions by Terence Marvel and essay by John Eastberg. Milwaukee: Milwaukee Art Museum; [Madison, WI]: Distributed by the University of Wisconsin Press, 2008.

——*Frank Lloyd Wright and George Mann Niedecken: Prairie School Collaborators.* Contributions by Terence Marvel. Milwaukee: Milwaukee Art Museum; Lexington, MA: Museum of Our Natural Heritage, 1999.

Szczesny-Adams, Christy M. "Cosmopolitan Design in the Upper Midwest: The Nineteenth Century Architecture of Edward Townsend Mix." Ph.D. diss., University of Virginia, 2007.

Wilder, Laura Ingalls. *Little House in the Big Woods.* 1953. New York: HarperFestival, 2005.

ISLAND OF HAPPY DAYS
1903–12

Index

WADSWORTH HALL
1905

ADAM J. MAYER HOUSE
1905–07

»

HAROLD C. BRADLEY HOUSE
1909

HENRY A. SALZER HOUSE
1912

TEN CHIMNEYS
1914–42

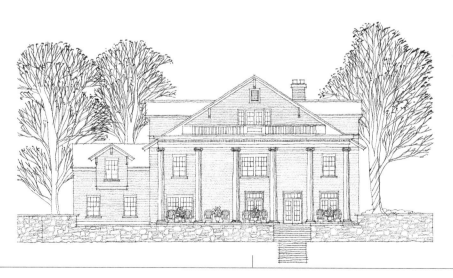

FORT EAGLE
1919, 1927

»

RIVERBEND
1921–23

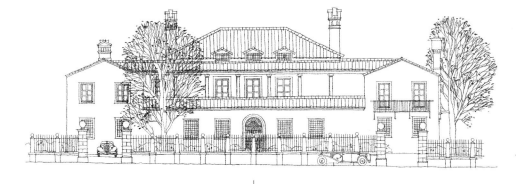

VILLA TERRACE
1923

FROMM BROTHERS CLUBHOUSE
1935

》

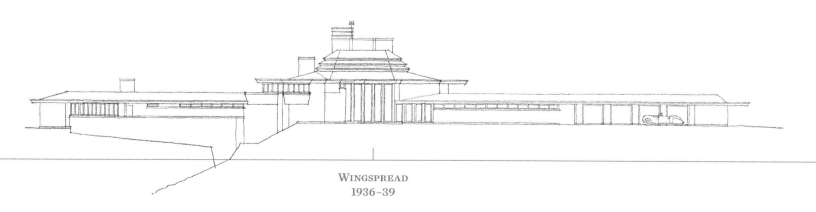

WINGSPREAD
1936–39

BROOKS STEVENS HOUSE
1939

Illustration Credits

All photographs © Zane Williams unless otherwise credited. Requests for prints or any other uses of the contemporary photographs should be directed to the photographer through his Web site, www.zanewilliamsphotography.com.

All plans and elevations © Louis Wasserman and M. Caren Connolly.

Photographs identified with WHi are from the Society's collections.

Front cover Allyn Mansion; **Back cover (top)** Island of Happy Days; **(bottom, left to right)** Wingspread, Cyrus C. Yawkey House, Fairlawn, Villa Terrace; **Spine** Octagon House

Pages ii–iii Henry A. Salzer House; **Page vii** photo by Pam Harris, Photography by Pam of West Bend, WI; **Pages viii–ix** Wadsworth Hall; **Page x** Fort Eagle; **Page xiv** Villa Louis, circa 1898, WHi Image ID 73674

CORNERSTONES Pages xvi-1 Harold C. Bradley House; **Page 4 (top)** WHi Image ID 12175; **Page 4 (bottom)** WHI Image ID 71199; **Pages 6 (right) and 10** Courtesy of Jannke Collection of Watertown History; **Page 12** WHi Image ID 66405; **Page 17** WHi Image ID 41982; **Page 20** WHi Image ID 23335; **Page 21 (above)** WHi Image ID 72269; **Page 21 (below)** WHi Image ID 72268; **Page 24** WHi Image ID 72237; **Page 26 (above)** WHi Image ID 71213; **Page 38** WHi Image ID 31857; **Page 40 (top)** *The Badger*, 1918; **Page 41 (left and right)** Courtesy of Bob Hartmann; **Page 47** WHi Image ID 40168; **Page 48** WHi Image ID 25894; **Page 52 (below)** WHi Image ID 39960; **Pages 53 (left and right) and 54 (above)** Collection of S. C. Johnson & Son Inc.; **Page 57** Historic Preservation Files, Wisconsin Historical Society, photo by Jim Draeger

VANGUARD Pages 58–59 Villa Terrace; **Pages 62, 67 (bottom), and 70 (top and bottom)** Courtesy of Douglas County Historical Society; **Page 75** Courtesy of Marathon County Historical Society; **Page 76** WHi Image ID 9218; **Page 79** Courtesy of Stewart Inn, photo by Don Trueman; **Pages 81 (above), 82 (right), and 87** Courtesy of Marathon County Historical Society; **Page 94** Courtesy of Kohler Co.; **Page 95** WHi Image ID 35866; **Pages 99, 101 (above), and 102 (right)** Courtesy of Kohler Co.; **Page 108** Courtesy of Villa Cicogna Mozzoni, photo by Vincent Berg; **Page 109** Courtesy of Engineered Storage Products Company, DeKalb, IL; **Page 111** Courtesy of Villa Terrace Decorative Arts Museum; **Page 115** Courtesy of Frank Lauerman III, photo by M. Caren Connolly; **Page 116 (left)** "Masterpiece," 48 inches h. by 35 inches w. by 7.5 inches d., Courtesy of Villa Terrace Decorative Arts Museum; **Page 116 (right)** Courtesy of Villa Terrace Decorative Arts Museum

RAGS TO RICHES Pages 122–123 Havilah Babcock House; **Page 126** Courtesy of Neenah Historical Society; **Page 129** WHi Image ID 41733; **Page 134 (left)** WHi Image ID 28719; **Page 136 (bottom left)** WHi Image ID 71152; **Page 136 (bottom right)** WHi Image ID 71153; **Page 140** WHi Image ID 47413; **Page 141** WHi Image ID 47550; **Pages 144, 146 (left), 147 (left), and 148 (above)** Courtesy of Captain Frederick Pabst Mansion Inc.; **Page 156** Courtesy of La Crosse (Wisconsin) Public Library Archives; **Page 157** *The House Beautiful*, October 1908; **Page 158 (bottom left)** Courtesy of Murphy Library, University of Wisconsin–La Crosse; **Page 159** WHi Image ID 36291; **Page 161 (top)** Courtesy of Murphy Library, University of Wisconsin–La Crosse; **Page 162 (top left)** Courtesy of La Crosse (Wisconsin) Public Library Archives; **Page 162 (top right)** Courtesy of Murphy Library, University of Wisconsin–La Crosse; **Page 168** *Time* magazine, February 24, 1936; **Page 169 (left)** WHi Image ID 71290; **Page 169 (right)** WHi Image ID 71292; **Page 174** WHi Image ID 71125; **Page 175 (top and bottom)** Courtesy of Fromm Brothers Historical Preservation

SETTING THE STAGE Pages 180–181 Adam J. Mayer House; **Pages 186 (top and bottom) and 187 (below)** Courtesy of Ralph and Pamela Krainik; **Pages 198, 199 (above and below), 204 (bottom), and 206 (top and bottom)** Courtesy of Ron Markwell; **Page 210** WHi Image ID 71549; **Page 212 (left)** Collection of Crab Tree Farm, photo courtesy of The Art Institute of Chicago; **Page 216 (top)** Clarence Fuermann, photographer. Photographic print mounted to cardboard album page, 7 ¼ by 9 ½ inches, George Mann Niedecken Archive of the Milwaukee Art Museum, Gift of Mr. & Mrs. Robert L. Jacobson, PA2007.45.16; **Page 216 (bottom)** Clarence Fuermann, photographer. Photographic print mounted to cardboard album page, 7 ⅛ by 7 ⅛ inches, George Mann Niedecken Archive of the Milwaukee Art Museum, Gift of Barbara Fuldner and John Eastberg, PA2007.45.8; **Page 222 (left)** 4-by-5-inch black-and-white negative, Brooks Stevens Archive, Milwaukee Art Museum, Gift of the Brooks Stevens Family and the Milwaukee Institute of Art and Design, BSA420; **Page 224** 8-by-10-inch black-and-white transparency, Brooks Stevens Archive, Milwaukee Art Museum, Gift of the Brooks Stevens Family and the Milwaukee Institute of Art and Design, BR 0599; **Page 225 (bottom)** 4-by-5-inch black-and-white negative, Brooks Stevens Archive, Milwaukee Art Museum, Gift of the Brooks Stevens Family and the Milwaukee Institute of Art and Design, BSA438; **Page 226 (left)** 4-by-5-inch black-and-white negative, Brooks Stevens Archive, Milwaukee Art Museum, Gift of the Brooks Stevens Family and the Milwaukee Institute of Art and Design, BSA433; **Page 228** 4-by-5-inch black-and-white negative, Brooks Stevens Archive, Milwaukee Art Museum, Gift of the Brooks Stevens Family and the Milwaukee Institute of Art and Design, BSA422; **Page 229 (left)** 4-by-5-inch black-and-white negative, Brooks Stevens Archive, Milwaukee Art Museum, Gift of the Brooks Stevens Family and the Milwaukee Institute of Art and Design, BSA437; **Page 229 (top right)** 4-by-5-inch black-and-white negative, Brooks Stevens Archive, Milwaukee Art Museum, Gift of the Brooks Stevens Family and the Milwaukee Institute of Art and Design, BSA432; **Page 229 (bottom right)** 8-by-10-inch black-and-white negative, Brooks Stevens Archive, Milwaukee Art Museum, Gift of the Brooks Stevens Family and the Milwaukee Institute of Art and Design, BSA247; **Page 230 (bottom right)** 8-by-10-inch black-and-white print, Brooks Stevens Archive, Milwaukee Art Museum, Gift of the Brooks Stevens Family and the Milwaukee Institute of Art and Design, BSA1238; **Page 231 (top left)** Courtesy of Jodi Peck

GETAWAYS Pages 234–235 Island of Happy Days; **Page 238 (right)** WHi Image ID 71142; **Page 238 (left)** WHi Image ID 71148; **Page 239** WHi Image ID 31144; **Page 245 (top)** WHi Image ID 71150; **Page 248 (left)** WHi Image ID 71145; **Page 250 (top right)** WHi Image ID 71149; **Page 250 (bottom right)** WHi Image ID 71151; **Pages 257 (top left and right) and 258 (bottom)** Courtesy of Stout's Island Lodge, from the Stout Family Albums; **Page 260** Courtesy of Adirondack Museum, photo by Seneca Ray Stoddard, P20129; **Page 264 (bottom)** Courtesy of Stout's Island Lodge, from the Stout Family Albums; **Page 268** WHi Image ID 71549, from the O'Brien Collection, courtesy of Ten Chimneys Foundation; **Page 270 (top)** WHi Image ID 71491, from the O'Brien Collection, courtesy of Ten Chimneys Foundation; **Page 270 (bottom)** WHi Image ID 71496, from the O'Brien Collection, courtesy of Ten Chimneys Foundation; **Page 275** WHi Image ID 71498, from the O'Brien Collection, courtesy of Ten Chimneys Foundation; **Page 276 (above)** WHi Image ID 71495, from the O'Brien Collection, courtesy of Ten Chimneys Foundation; **Pages 282 (bottom) and 283** Courtesy of Stephen Kaniewski and Judith Peck

Page 289 Mapping Specialists Ltd., Madison, WI

With the exception of the Villa Terrace plan, every plan and elevation in this book has been labeled to reflect each subject as it appeared in 2009. Additional drawing information for the subject houses was provided by: Engberg Anderson, Milwaukee, WI (Ten Chimneys); Frank Lloyd Wright Archives, Taliesin West, Scottsdale, AZ (Wingspread); Historic American Building Service, Library of Congress, U.S. Department of the Interior, Washington, DC (Octagon House); Isthmus Architecture, Madison, WI (Cyrus C. Yawkey House); Northwest Architectural Archives, University of Minnesota Libraries, Minneapolis, MN (Harold C. Bradley House); Quinn Evans Architects, Ann Arbor, MI (Villa Louis and Fairlawn); Wisconsin Architectural Archive, Milwaukee Public Library, Milwaukee, WI (Brooks Stevens House). Vehicles in elevations reflect the transportation modes of the original owners.